ARTISTS
ON
HORSEBACK

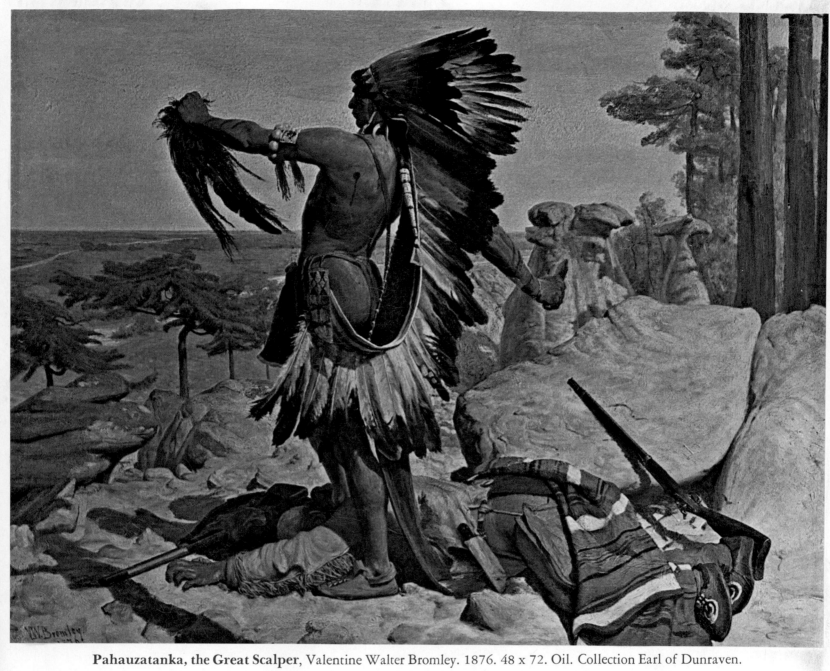

Pahauzatanka, the Great Scalper, Valentine Walter Bromley. 1876. 48 x 72. Oil. Collection Earl of Dunraven.

ARTISTS ON HORSEBACK

The Old West in
Illustrated Journalism
1857–1900

By Paul Hogarth

Published in Cooperation with the
Riveredge Foundation, Calgary, Canada

WATSON-GUPTILL PUBLICATIONS
New York

"As a Special Artist I have at all times felt that
I was not seeing for myself alone, but that others
would see through my eyes, and that eyes yet
unborn would do the same."

William Simpson, 1892

Manufactured in the U.S.A.
First Printing, 1972

An earlier abridged version of Chapter 3 has previously appeared
in *The American West,* 5, No. 6, November, 1968:4–17.

Library of Congress Cataloging in Publication Data
Hogarth, Paul, 1917–
 Artists on horseback.
 Includes bibliographical references.
 1. Illustrators, British. 2. Journalism, Pictorial.
3. The West in art. 4. Northwest, Canadian, in art.
I. Title
NC978.H59 741.6'0922 77-190518
ISBN 0-8230-0350-7

Edited by Margit Malmstrom
Designed by James Craig and Robert Fillie
Set in 14 point Garamond by Brown Bros. Linotypers, Inc.
Printed and bound by Halliday Lithograph Corporation, Inc.
Jacket and color plates printed by Largene Press, Inc.

Acknowledgments

One reason why the contribution of the European Artist to the documentation of the West has been neglected is the difficulty, in the United States and Canada, if not in England, of locating and obtaining access to files of defunct British periodicals. A far greater problem is locating the original drawings. Archives of even the more established publications, such as the *Illustrated London News,* suffered heavily during the air raids of World War II, and drawings which remained with the artists or their descendants have long since been dispersed. It was a pleasant surprise therefore, to discover that many still exist in various private and public collections in Europe, Canada, and the United States. Wherever possible I have included these, together with selected published examples of the artists' work. Notes and correspondence have also been drawn on to substantiate the date and duration of each artist's visit, where he traveled, whom he met, and how well he depicted what he saw. I have also drawn on current interviews in the press of Great Britain, Canada, and the United States, as well as on memoirs and reminiscences. In addition, attention has been given to the personal career of each artist, particularly his background before he crossed the ocean, as this frequently motivated his Western travels.

These relevant and often vital strands in my book could not have been made available without the help of many individuals in locating original documents or supplying photographs or information. In the course of several years of research and writing, I have incurred a great debt to many persons and institutions for their great assistance—in particular, to Mr. Eric L. Harvie, whose personal interest made available the facilities and assistance of his Riveredge Foundation in Calgary, which enabled me to work in Calgary, and to finally assemble my study of the documentation and art of the Old West as created by visiting British artists for the Victorian illustrated press. I should also like to express my appreciation for the help of the late John Hawgood, Professor of American History, University of Birmingham, England, whose authoritative and friendly understanding in appraising the draft of my manuscript helped me enormously. John C. Ewers, Senior Ethnologist of the Smithsonian Institution, Washington, D.C., and Director of its Museum of History and Technology, also read and criticized the entire study, providing stimulating comment on various points in many

of the chapters. Numerous scholars, librarians, and interested individuals include Eric Chamberlain, Department of Prints and Drawings, Fitzwilliam Museum, Cambridge; the Earl of Dunraven; my wife Patricia Douthwaite; Mrs. Dobell, McCord Museum, McGill University, Toronto; Eleanor P. Ediger, formerly Research Curator, Art Department, Glenbow Foundation, Calgary, now of the Riveredge Foundation; Mrs. Alys Freeze, Head, Western History Department, Denver Public Library, Colorado; Dr. J. Russell Harper, University of Toronto; Sir Harold Hartley; Donald Holden; Sidney C. Hutchison, Librarian, Royal Academy of Arts, London; Mrs. Helen Ignatieff, Sigmund Samuel Canadiana Collection, Royal Ontario Museum, Toronto; W. G. Ireland, Librarian and Archivist, Provincial Archives, Victoria, British Columbia; K. J. Lace, Librarian, Essex County Library, Chelmsford, England; the Earl of Meath; Patrick McCloy, Librarian, Glenbow Archives, Calgary; Barbara O'Neale, National Gallery of Art, Ottawa; the late Lady Olcin Wyndham-Quin; Graham Reynolds, Keeper of Prints, Drawings, and Paintings, Victoria and Albert Museum, London; James B. Stanton, Historian, Centennial Museum, Vancouver, British Columbia; Dr. Franz Stenzel, Portland, Oregon; Maryalice Harvey Stewart, Director, Archives of the Canadian Rockies, Banff; Mrs. Enid T. Thompson, State Historical Society, Colorado; Mitchel Wilder, Director, Amon Carter Museum of Western Art; Humphrey C. Woodville, Cambridge, England; and Mrs. Margaret Wunderlich and Rudolf Wunderlich, the Kennedy Galleries, New York. Other contributions are recognized in the notes in each chapter. The owner's permission to reproduce from certain original material or from rare books is gratefully acknowledged in each caption.

Finally, I would like to pay tribute to my wife's interest and support. Her forbearance with my travels in Canada and the United States and with my preoccupation with the problems of these artists is beyond thanks.

Contents

Most of the illustrations reproduced in this volume appear for the first time in book form, and many have never before been published in any form.

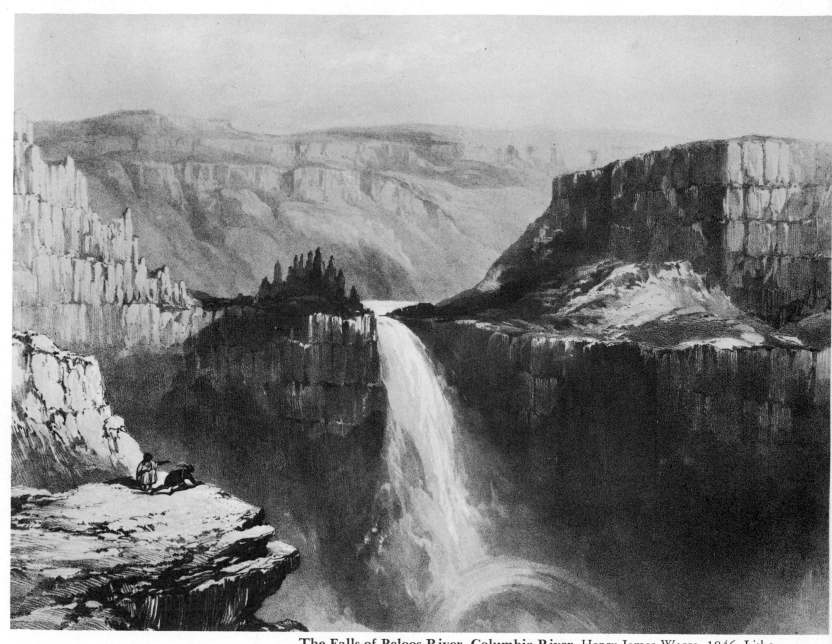

The Falls of Peloos River, Columbia River, Henry James Warre. 1846. Lithograph after watercolor drawing. From *Sketches in North America and the Oregon Territory* (London, 1848). Courtesy University Library, Cambridge.

Preface

The artist's record of the American West has long had a strong international flavor. When Captain James Cook visited Nootka Sound on the North Pacific Coast in 1778 he was accompanied by John Webber, a professional artist of Swiss descent. The English explorer correctly anticipated that Webber's pictures would help to compensate for "the inevitable imperfections of written accounts." Russian, French, Spanish, and English artists participated in subsequent maritime explorations of the West Coast. German, Swiss, French, and Mexican artists, as well as those from the eastern United States and Canada, explored the West beyond the Mississippi and Red rivers between the years of the Lewis and Clark Expedition and the Civil War. Although many of them produced illustrations for scientific reports, few of them lived to see their pictures appear in popular books or magazines.

It was not until after the Civil War that such popular pictorial magazines as *Harper's* and *Leslie's* sent Special Artists into the West to record on-the-spot impressions of the region and the variety of human activities in it for the pleasure and instruction of their many readers. They were followed in the decade of the 1870's by sophisticated English artist-reporters for the *Graphic* and the *Illustrated London News*. These were trained artists and experienced, widely-traveled reporters. They saw the varied landscapes, the wildlife, and the Western peoples—both red and white—through eyes accustomed to perceiving what was new and interesting in any locality and cultural situation. Strange customs, dramatic actions, even the incongruous and humorous appearance and behavior of civilized travelers in a wilderness region, were recorded in their pictures. And post haste they forwarded their pictorial impressions to their home offices. In print, their pictures had those qualities of freshness and acuteness of observation that we associate with the best work of modern news photographers.

Paul Hogarth introduces us to eight of the most able, perceptive, and productive English Special Artists who traveled in the western United States and Canada during the last three decades of the 19th century—from the completion of the first transcontinental railroad to the Yukon gold rush. The work of these artists differs in style and subject matter; they witnessed different aspects of frontier life in different parts of the West at different times. But the pictures which resulted from their ob-

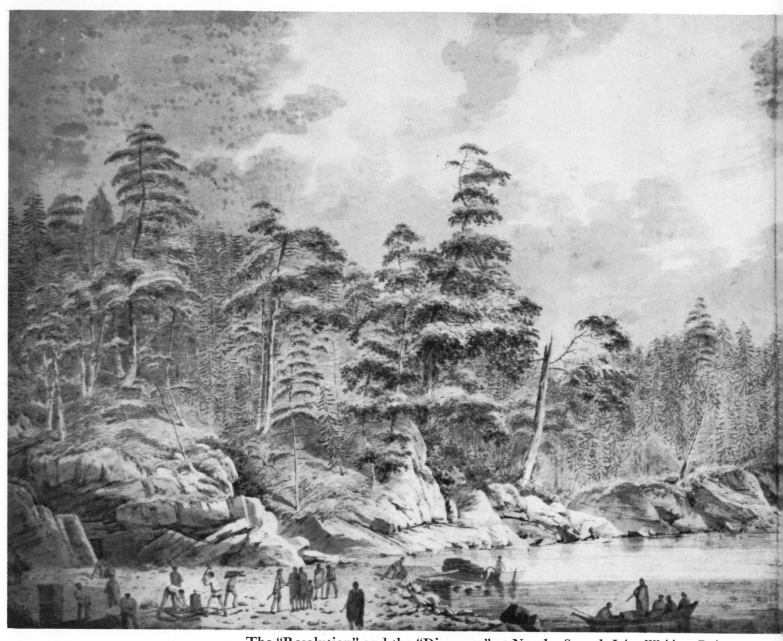

The "Resolution" and the "Discovery" at Nootka Sound, John Webber, R.A. 1778. 23¼ x 39. Oil. Courtesy National Maritime Museum, London.

servations played an important role in interpreting the American West to English-speaking peoples on the far side of the Atlantic. As historic documents, these pictures reveal the impressions of the American West that were conveyed to stay-at-home Englishmen during the period 1870–1900. They may even help us to understand the romantic appeal of the Old West to many present-day Englishmen.

No one is better qualified than Paul Hogarth to present the careers and works of these artists to us. He is one of England's foremost illustrators. For twenty-five years he has wielded an eloquent pencil on four continents as a Special Artist for English journals and for such American magazines as *Fortune, Sports Illustrated,* and *Smithsonian.* He has known

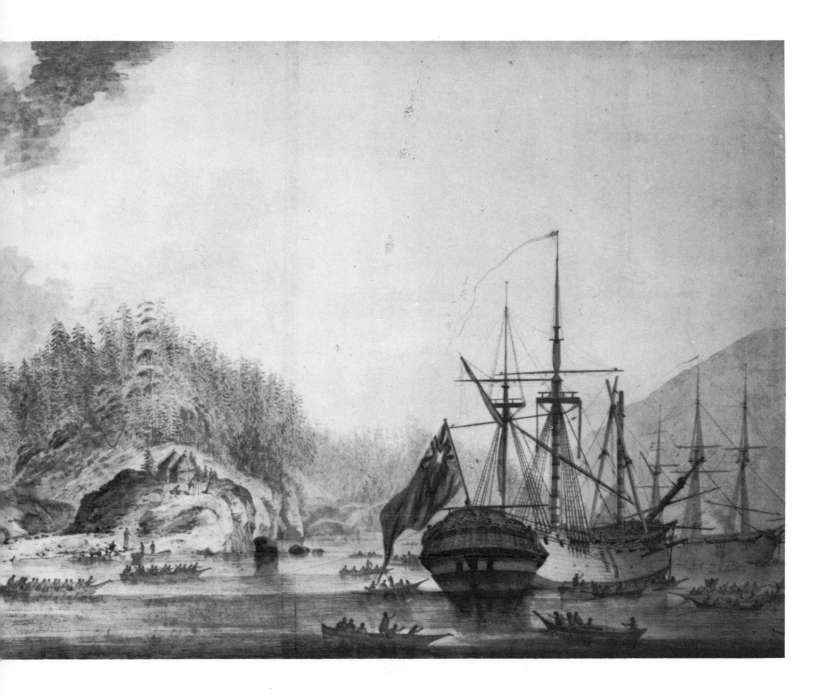

the loneliness of an artist-reporter working against time in a strange land; the problems of selecting the most insightful picture subjects; the necessity of meeting deadlines imposed by impatient, far-away editors. For this book, he has retraced the Western travel routes of many of the artists of whom he writes so engagingly. In obscure archives he has found little-known facts about their lives. He has examined their extant original works in widely scattered collections on both sides of the Atlantic, and he has assembled the most interesting examples of their art for our enjoyment. Finally, he has given us his opinions of these men's individual achievements as pictorial reporters and as contributors to the art of their times.

John C. Ewers

Foreword

The Old West is a shared legacy; the nineteenth-century British artist and his travels in North America is a story of rich and diverse interest, full of fascinating insights for both the scholar and the general reader, and intimately bound up with an epic, if not mythical, period of modern history. Yet there has been little attempt to chart that legacy in cultural terms. Americans, in general, if not Canadians, have long since forgotten the British involvement in the West. Too much water has flowed under that bridge. Perhaps most remarkable has been the neglect of Arthur Boyd Houghton as a chronicler of the Old West. But the story goes back further than the middle of the nineteenth century.

No other country could rival England in the number of artists who lived outside the mainstream of its artistic traditions and thrived as artist-adventurers. Some chose to spend years on voyages of exploration, recording the landscape, the flora and fauna of almost every region, for the archives of the Admiralty and the War Office.

One of the first to do so was the Anglo-Irishman John White (active 1585–93), draughtsman to Raleigh's Virginia expedition of 1585. Then, as the Napoleonic Wars ended, and as the Royal Navy began to survey the Western Hemisphere, others followed. John Webber (1752–93) spent three years with Cook on his third and last voyage, which took him to the Pacific Northwest. There were also officer-artists. One such was John Sykes (1797–1877), who accompanied the Vancouver expedition to explore the northern waters of the Pacific in 1797. Another was William Coke-Smyth (1797–1877), draughtsman to the Beechey expedition, which explored the Bering Strait and the Pacific coast in 1825–27. Coke-Smyth also reported on Mexican California. Yet another officer-artist was Henry James Warre (1819–98), who made an epic trip from Ottawa to Oregon and back in 1844 to write and illustrate a secret report on American infiltration for the War Office.

These artists, as I will show, were succeeded in the mid-nineteenth century by Victorian Special Artists, who were more or less permanently employed, traveling from one side of the world to the other as representatives of the new illustrated journalism reporting life and events in distant lands.

Adventures and travels, the opening up of new lands and territories, may be, and often are, motivated by a taste for the strange, the different,

the exotic. They may also be an escape from one's own environment or stem from the frustration of apparently insoluble personal problems. There can be little doubt that whatever the excuse, these artists were really seeking an escape from everyday existence in an increasingly industrialized society. In this sense, they were a continuing part of an earlier romantic movement and the precursors of a continuing twentieth-century wanderlust.

Much of my own career as an artist during the past twenty years has been spent as a traveling commentator. I therefore feel a personal affinity with such artists, which was particularly strengthened during my own travels in the modern West. This has often enabled me to risk the occasional inspired guess when research has stubbornly failed to ascertain a relevant fact. There is, too, the question of limits. I had intended to deal with both German and British artist-reporters of the Old West. But the material proved so rich that it was with regret that I had, on this occasion, to confine my study to the British.

This is a book I've had much pleasure in writing. But a book begun with confidence is finished with a feeling of inadequacy. There is much more to be said than can possibly be digested at any given time. I am well aware that many more artists visited North America than are represented here, and that I have only selected a handful whose accounts rise well above the average. I am also aware that whole areas of Western history remain untouched. Limited by time, I have in many instances done little more than give a sidelong glance at the historical context of these artists' work—and no one will be more aware of the omissions, the wrongly placed emphases, than myself.

This brings me to one more point. My book is intended as a contribution to revealing previously unknown pictorial documentation of the Old West. But in selecting illustrations for particular mention, personal preference occasionally intruded. For example, my judgment of the relative importance of the artists discussed may be open to question. I have indicated what I like, mainly as an artist, from the viewpoint of esthetic excellence, rather than striving for a literal representation of what the artists saw.

This then, is the story of the very Victorian phenomenon, the British artist abroad. This time, the place is the New World.

Paul Hogarth
Deya, Majorca

1.
Illustrated Journalism and the North American Frontier

VICTORIAN ILLUSTRATED JOURNALISM was fervently partisan, sustained by loyalties to a political philosophy no less than by vested interests. One who wishes to write of an art that flourished in such turbulent waters must of necessity provide something of an outline of its background. For without a reminder of the general climate of English nineteenth-century commitment in North America, the role played by British artist-travelers in reporting the Great West cannot be fully appreciated.

On the surface, there was much to draw the newly born United States and its mother country of England together. The predominance of British stock meant the dominance of British literature, law, and speech. Next to their common language, the most vital links were trade and investment. And throughout the century, with almost unlimited opportunities of growth and development, the British with money reaped a continuous harvest from the epic westward thrust of the young republic.

There was, on the other hand, much to keep the United States and England apart: the enmities created by the struggle for independence and the War of 1812; the anti-British attitudes of the Jacksonian democrats and the Irish-Americans; the constant fear that manifest destiny, which had stripped Mexico of California and Texas, would lead to the annexation of Canada; the constant wrangles over the boundaries of Maine, Oregon, and Alaska; the Trent Affair; the Alabama Indemnities Claim; the endless quarrels over fishing rights, the fur trade, and tariffs. At times, it appeared to many that the United States and England were moving toward a final and irrevocable confrontation.

Added to this was the American's typical sensitivity to any adverse European opinion of himself or his institutions, and most of all the somewhat condescending, if not downright hostile, attitude of the British ruling classes, "whose opinions," as Clarence Gohdes reminds us, "as expressed in speeches, in sermons, in books of travel, or in the London *Times* were received as the gruff voice of John Bull himself." Americans were considered vulgar upstarts; and the British establishment looked upon democratic government as it would upon the plague. (1)

But British radical and liberal opinion thought otherwise. In common with Americans, they shared a belief in religious dissent, cheap food, and an untaxed press. Most of all, they believed in the individual effort which could propel a man forward to success, whatever his origin. This, of course, was subversive doctrine to the conservatives of the time. Such thinking challenged the established order of things in which every man was supposed to know his place and keep in it, and where wealth and property were regarded as the prerogatives of those who were "born to them."

In fighting the conservative ideology, what better example could the democratic periodicals of the middle class point to than what was

1. Clarence Gohdes, *American Literature in Nineteenth-Century England* (New York, 1944), 2.

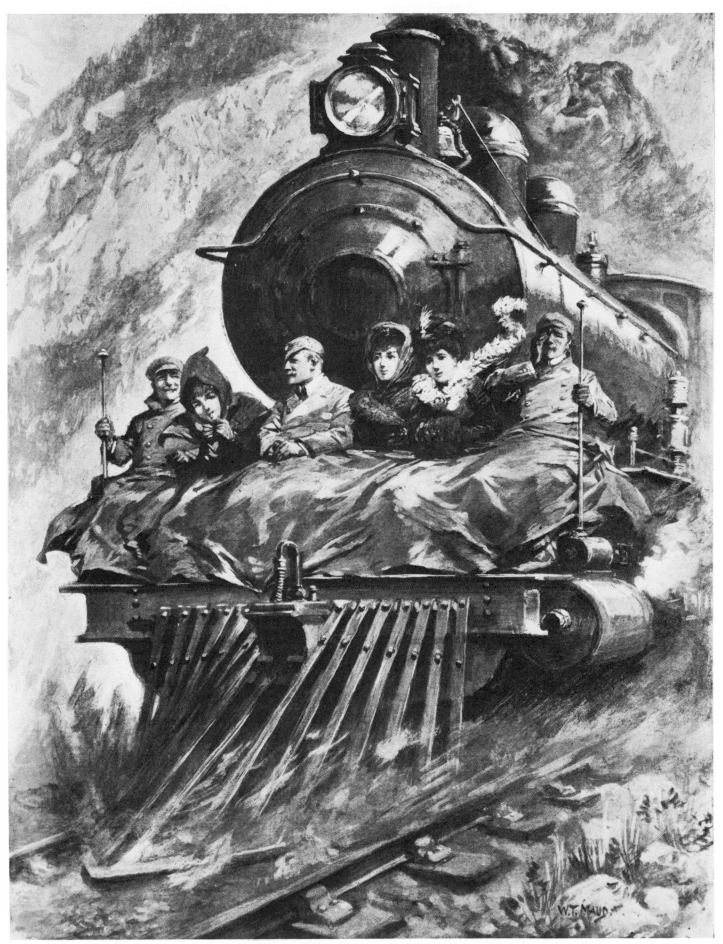

A Ride on a Cow-catcher, Sydney Prior Hall. Drawn by W.T. Maud after field sketch. Photomechanical halftone engraving after wash drawing. *Graphic,* 1901. The royal tours of the Canadian West seldom failed to produce colorful pictures.

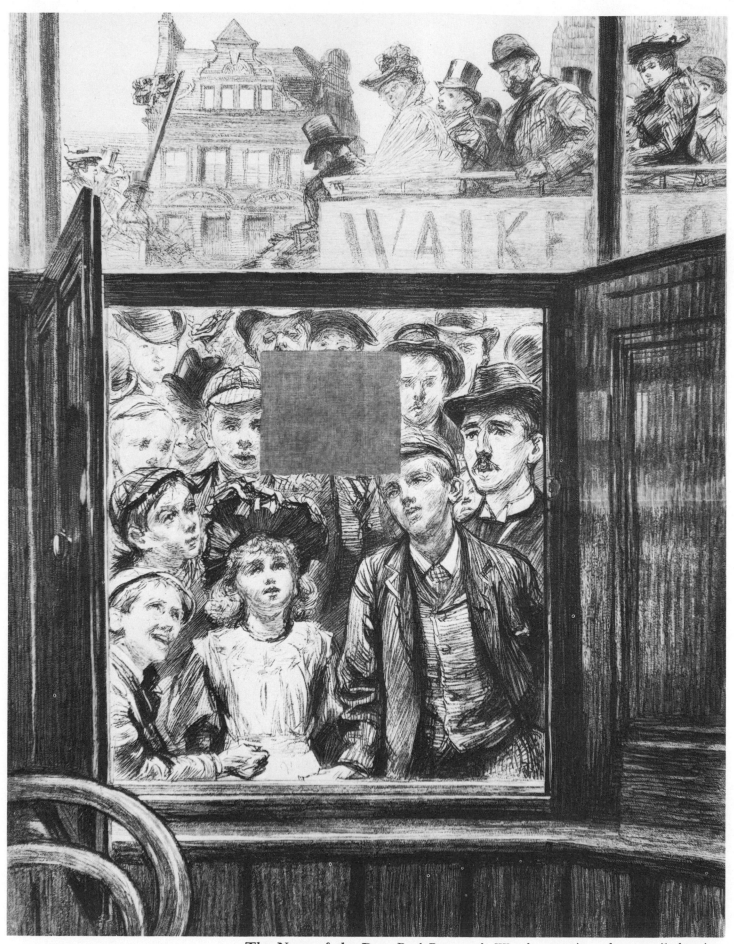

The News of the Day, Paul Renouard. Wood engraving after pencil drawing.
Graphic, 1892. The editorial offices of the London picture papers regularly exhibited
the latest drawings sent in by their Special Artists.

popularly thought to be the land of the free, the land of opportunity, America! By sending artist-correspondents to the United States to report on successive phases of development, the two major figures of illustrated journalism—Herbert Ingram of the *Illustrated London News* and William Luson Thomas of the *Graphic*—helped promote the change that would eventually vindicate their faith in self-help and the final triumph of the middle classes. (2)

The democratic periodicals could also point to the democratically minded, self-governing colonies. Canada, however, was and remained a different story. Nothing, it seemed, was able to keep her and the mother country apart. On the contrary, after the prodigal son had departed, much intelligent thought was directed at keeping Canada and England together. Lord ("Radical Jack") Durham's report, issued in 1839, proved to be a masterstroke, even though it was some years before responsible government finally resulted in Dominion status for Canada in 1867. True, Canada and England had their differences, but the British had learned to deal wisely and tactfully with the susceptibilities of the Canadians. There were disappointments too. Closer relations between the United States and England had an adverse effect on the scale of British financial involvement with Canada, diverting much-needed funds from investment in the westward growth of the younger nation. But this problem was largely solved by the initiative of Canadians themselves, who competed with the Americans for British capital and for immigrants to fill up their wide open spaces.

Many years would elapse, however, before the picture papers were equal to the task of reporting the North American scene. In the early half of the nineteenth century, without rapid means of travel, distances seemed enormous; obtaining pictures was difficult, and the process of reproducing them was painfully slow. To produce an illustrated weekly chronicle of events at home and in nearby Europe brought many problems, but to cover North America as well seemed to many an impossible task. Yet by the 1850's it was being done. (3)

First off the mark was the *Illustrated London News,* which the Nottingham printer and news agent, Herbert Ingram, launched in 1842. Ingram was hugely ambitious, with a keen, enquiring temperament. The leading weeklies, the *Observer,* the *Sunday Times,* and the *Weekly Chronicle,* only occasionally provided illustrations of notable events. But whenever they did so, the young news agent noted more copies were sold. Ingram decided to start his own paper; and because his customers always asked for the "London news," he promptly called it the *Illustrated London News.*

What he started was, in fact, a lively new form of journalism which presented the nineteenth-century world to the class that was changing it. The bankers, merchants, manufacturers, clerks, shopkeepers, and engineers had been on the move since the agitation for the Reform Act of 1832; they were more than ready for a paper which would reflect

2. Ingram, in his younger days a journeyman printer in London, had been exposed to the influence of the Great Reform Movement. His early associates—Henry Vizetelly and his first editor, "Alphabet" Bayley—were men whose ideas had been formed by radical and progressive opinion which urged the brotherhood of man, sympathized with continental revolutionary movements of the middle classes, and praised American republicanism. "Our business," states the editorial preface to the first volume of *ILN,* "will be with household gods of the English people, and above all, of the English Poor."

3. *ILN*'s success was not only due to the excellence of its illustration but to the ingenuity with which difficult technical problems were overcome. Shortly after his arrival in London, Ingram retained the services of Henry Vizetelly as art advisor. Art director, artist and master engraver, author and publisher extraordinary, Vizetelly was an important pioneer of illustrated journalism throughout the nineteenth century. It was, therefore, largely due to his guiding influence that *ILN* became an authoritative journal at all. Ingram, who had made a fortune from a patent medicine, as well as from his printing and bookselling business, originally wished to make his new venture a weekly crime sheet. Vizetelly, however, emphasized its importance as

a more factual medium for reporting the world at large, using professional artists as illustrators. Just as important were Vizetelly's efforts to adapt the time-consuming craft of wood engraving to the pressing deadlines of newspaper publication. Somehow, he also found time to write, and he was the author, under the pseudonym "J. Terwhitt Brooks," of a literary confidence trick entitled *Four Months Among the Goldfinders in California* (London, 1849). The book purported to be his "personal experiences." It fooled everybody for a long time and was thought to be an authentic eyewitness account. It was a best-seller and was translated into French, German, and Swedish.

4. Peter Biddlecombe, "As much of Life as the World can Show," *ILN*, May 13, 1967:40-3.

5. According to Henry Vizetelly, the following method was used to illustrate current events, foreign and national, before 1854. The morning papers were carefully read, and paragraphs which supplied good subjects for illustration were cut out and sent, with boxwood blocks, by special messenger to the artist employed. Vizetelly thought the historical painter John Gilbert (1817–97) to be the best of these artists, as he worked fastest from the slightest reference materials. Clippings and woodblocks went by hand every morning to his studio in Blackheath. By evening his blocks were being engraved. The rest of *ILN*'s "inside" freelance staff at this time included "Phiz" (Halbot K. Browne), George Cruikshank, H. G. Hine, John Leech, and Kenny Meadows. See, Henry Vizetelly, *Glances Back Over Seventy Years* (London, 1893). According to MacKay, rates of payment were liberal.

6. *ILN*, 2, 1843:121–22. A two-column engraving of Fort George on the front page illustrates news item in connection with the recent U. S. claim to the territory in opposition to the title of Great Britain. Text, entitled "Astoria, Oregon County," quotes description of

their growing sense of self-confidence and political power. Young Ingram could not have made his decision at a more opportune moment.

Public response was far greater than he had imagined it would be; it made Ingram wealthy, and made his paper the most successful weekly of the century. By the end of the first year of publication, circulation reached 60,000 and then, by leaps and bounds, it reached 80,000 in 1848, and 150,000 in 1852. By 1856, helped by the repeal of the penny newspaper tax, circulation reached 200,000 (4)—a remarkable figure in its day. The population of the entire United Kingdom had only just reached 20 million.

Readers found much of interest in the sixteen pages of the *Illustrated London News*. Early numbers were a mixture of penny encyclopedia, police gazette, travel journal, satirical sheet, and straight news-reporting. Domestic and foreign news was depicted with a lively eye for the destruction of old conservative regimes and the proclamation of free enterprise and democratic government. Readers found, too, that events in North America were reported with convivial objectivity. At first, the pictures left much to be desired; for they were rarely the work of competent observers. Some were sent from New York. Most were supplied by a light-hearted band of "news-illustrators" who worked from clippings of newsy subjects supplied by the New York correspondent. (5) Frontier forts in Oregon, (6) Mormon martyrs, (7) prairie fires in Illinois, (8) Cincinnati-in-the-making, (9) and war with Mexico (10) were usually depicted with the endearing melodrama of police gazette cuts.

Ingram had much better luck with events closer to home, publishing some excellent illustrations of the visits of North American Indians—including George Catlin's Ioways—during 1844–5; (11) and, particularly between 1847–54, with the epic theme of emigration. (12) Gradually, as transport facilities to and inside America improved, Ingram began to get more eyewitness pictures. Arrangements were made with artists who had immigrated to the New World to send back drawings and letters describing their impressions. The California gold rush, for example, saw the advent of the first British artist-correspondent, John David Borthwick, to report the West for a British paper. (13)

The 1850's brought a much more fair and sympathetic appraisal of the bustling young country. Allan Nevins, in his sourcebook *American Social History as Recorded by British Travellers,* informs us that one English traveler after another denounced the libels of earlier conservative reporters. The decade also brought a new era of steam, speed, and comfort to transatlantic travel; by 1856 the Atlantic was being crossed in nine days, (14) compared with the sixteen days of a decade earlier. Railroads, too, had penetrated the West as far as Chicago and St. Louis. Ingram decided the time was ripe for a special survey.

In 1857—the year the first Atlantic cable was laid—he sent his enterprising young editor, Charles MacKay, to survey the prospects. MacKay,

Oregon and the fort from the recently published *Narrative of the Voyage of H. M. S. Sulphur* by Capt. Sir E. Belcher (London, 1843).

7. *ILN*, 5, 1844:133. Single-column illustration, *Joe Smith, the Mormon Prophet*, with news item on his murder.

8. *Ibid.*, 388. One-third-page illustration, *American Prairie on Fire*, depicts herd of buffalo, deer, wolves, panthers, and prairie chickens running before the fire, and lone settler carrying his wife in his arms. Text, on same page, quotes description of fire at Alton, Illinois, sent by "Our Correspondent" from New York: "The terrific catastrophe of a prairie fire, such as our artist in New York [*sic*] has depicted, has been nowhere more vividly described than in Captain Marryat's *Adventures of Monsieur Violet*."

9. *ILN*, 6, 1845:356. *Cincinnati* illustrates short article quoting New York *Daily Tribune* announcement that "Cincinnati is advancing with giant strides to opulence and greatness . . ." and Charles Dickens' description of it as "a beautiful cheerful city" in his book *American Notes* (New York, 1870).

10. *ILN*, 8, 1846:411–12. Four uncredited illustrations: *Mexico—the American Indemnity on its way to Vera Cruz; Santa Barbara, Alta California; Anchorage at Yerba Buena; Mexico—Man's Hand Mountain*. Article, entitled "Mexico and California," comments on termination of war between Mexico and U. S., and quotes Albert Gilliam, *Travels over the Table Lands and Cordilleras of Mexico*, 1843–44 (London, 1846).

11. These appeared during the American artist's second exhibition in London. *ILN*, 5, 1845. Two illustrations: 93, *Iowa Indians at the Egyptian Hall, Picadilly* (text, 91, announces illustration as "a spirited sketch, from the pencil of Mr. Catlin, the celebrated North American traveller," then describes the group, which consisted of three chiefs, four braves, four squaws, a little boy and girl, and an infant, accompanied by the interpreter, Jeffery), and 121 (two-column illustration on front page), *Encampment of*

A Scallawag, Arthur Boyd Houghton. Wood engraving. *Graphic*, July 8, 1871. Westerners, thought Houghton, were "a hearty, genial, free-spoken and mannered people, full of go-aheadativeness, wide-awake to the main chance, despising holidays and days of rest, bent on accomplishing something, and bound to rise in the world." The backwoods rogue, or scallawag, however, was the exception. "You see them," he wrote, "lounging about the wooden shed stations along the Pacific Railway," and he correctly supposed that they followed the hard-living railroad gangs, living off greenhorns whom they inveigled into throwing dice or handling cards.

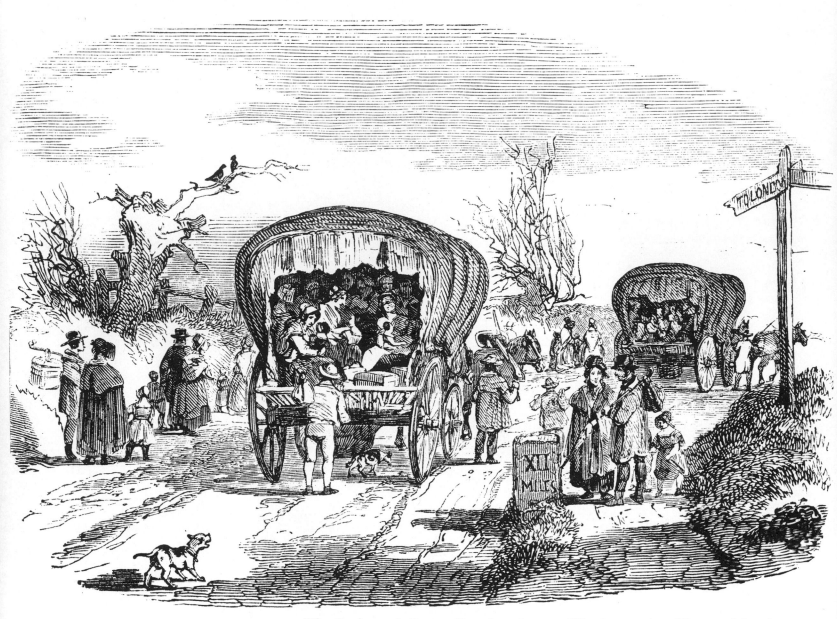

The Emigrant's Farewell, artist unknown. Wood engraving. *Illustrated London News*, 1844.

Ioway Indians, Lords Cricket Ground: The Welcome Speech. This second drawing by Catlin depicts the unusual spectacle of the Indian party encamped in tepees on that hallowed ground. Text states that the Indians exhibited their skill in shooting with bows and arrows in a grand archery fete, as well as in ball-play and characteristic dances. These displays proved to be so popular that calls and invitations were received from distinguished spectators, among them Disraeli, the future prime minister, who invited the Ioways to his home. Marjorie Catlin Roehm, *Letters of George Catlin* (Berkeley, 1966), 300. See also, *"Grand Fête Champêtre"* at Charlton House," *ILN*, 1845:9. Excellent half-page illustration by G. Harrison depicts charity event staged by Sir Thomas Maryon Wilson. Program included an encampment of Canadian Indians who staged various feasts and dances.

12. For typical example, see *ILN*, 5, 1844:397. Two-column illustration, 398: *The Emigrant's Farewell.* Text, entitled "Emigrants on their way to the place of embarkation," is sympathetic to the lot of emigrants whether they go to North America or the South Seas, stating that "Thousands quit the rural villages of this country to embark for distant lands, and yet but little notice is taken of it."

13. *ILN*, 20, 1852–74. Full-page illustration: *The California Gold District—Kanaha Bar, on a Tributary of the Sacramento, Where Gold was First Found—Miners Working the Bed of the American River.* Text, 73, states that the large view "has been sketched by Mr. John Borthwick, a clever watercolour painter, who first visited the locality as a gold-seeker, but is now settled in the neighbourhood, and is actively engaged in his profession, by taking portraits of successful adventurers . . ." Illustration, *Winter in California* (*op. cit.*, 22, 1853:212), may also be a Borthwick.

14. Frank C. Bowen, *A Century of Atlantic Travel* (Boston, 1930), 81.

15. *ILN*, 28, February 13, 1858: 158.

16. *Op. cit.*, March 20, 1858:297.

a Scots poet, journalist, and popular songwriter, had edited the paper since 1852. He remained in the United States and Canada for eight months, lecturing and getting acquainted "with new people, new scenes, and new modes of life." He wrote enthusiastically of life and progress in the great republic which "is so rapidly rising to overshadow the world," marveling at the "gigantic reproduction and extension of the civilisation of Europe, and especially of Great Britain, into new fields." After a short stay in New York and a leisurely visit to Boston, he headed south to Philadelphia, Baltimore, and Washington. He was present at a great ceremonial interview between delegations from three tribes of Indians—the Poncas, the Pawnees, and the Potawatomies—and their Great (and literally) White-headed Father, President James Buchanan at the White House on January 14, 1857.

He saw much of the Indian chiefs during his stay in the Federal capital, at the theater and in their hotel, as well as at the arsenal where they received rifles and muskets as presents, prior to their return West. But MacKay thought their doom fixed. "Between them and the whites there is no possible fraternisation. The white men, who act as the pioneers of civilisation and push their way into the far wilderness, are ruder, rougher and more ferocious than the Indians." (15)

MacKay then swung westward up the Ohio to Cincinnati, which, he was surprised to find, had "a population of nearly 250,000 souls and miles of well-built and handsome streets, many banks, warehouses and public institutions, worthy by their achitectural beauty to adorn any metropolis in the world." (16) The chief wealth of the city derived from hogs, but he left the slaughterhouses unvisited, content to believe the marvelous tales he heard of the dexterity of the slaughterers. He did, however, visit a more convivial source of wealth—the vineyards of "Ohio's green hilltops" to sample their chief product, Catawba Champagne—developed by Mr. Nicolas Longworth and his venerable vintager from Saxe-Weimar, Christian Schnicke.

Surviving four accidents to his train on the Ohio and Mississippi Railroad, the indefatigable MacKay finally arrived, none the worse for wear, on the banks of the Mississippi. St. Louis, he found, was an even more flourishing place, containing "within itself far greater elements of prosperity." No city in the world, he thought, offered such a vast assemblage of river steamboats. The city's manufacturers were numerous and important, and it boasted a celebrated type foundry which supplied the whole of the Far West with the types necessary to the creation of new cities in the wilderness.

After lecturing in New Orleans, MacKay retraced his steps northward, concluding his lecture tour with stops in Albany, Toronto, Ottawa, Hamilton, Montreal, and Quebec before returning to England. His fifteen lengthy articles, also published as a book, were accompanied by illustrations procured from a group of American artists (which include John Mix Stanley and Charles Wimar), and appeared during the first

17. According to an entry in the *Dictionary of National Biography*, 120–1, Charles MacKay (1814–89) was a well-known liberal spirit in British journalism. He was the assistant editor of the London *Morning Chronicle* (1835–44), whose weekly illlustrated numbers contributed to Ingram's decision to launch a picture paper. He became literary and political editor of *ILN* in 1848, and editor in 1852, resigning in June, 1858, after returning from his North American tour. From February, 1862, to December, 1865, he was again in the United States as a *Times* special correspondent during the Civil War. He was the author of several books concerning life in the United States, including the bestselling *History of the Mormons* (London, 1851) and *Life and Liberty in America*, 2 vols. (London, 1857). MacKay's two autobiographical works, *Forty Years' Recollections*, 2 vols. (London, 1877) and *Through the Long Day*, 2 vols. (London, 1887), also contain extended and additional material relating to both visits.

For his articles, "Transatlantic Sketches," see *ILN*, 32, January–April, 1858. These were illustrated with wood engravings after sketches and photographs, which include several Western subjects. For these, see *ILN*, 32, 1858:156–8. Text, 157–8, is entitled "Interview of Indians with the Great Father." Four illustrations, 156–7, include two interesting, uncredited illustrations, engraved from sketches: (full page) *The President [Buchanan] of the United States Inducing the Hostile Tribes of the Pawnees and the Poncas to Shake Hands* and (half page) *Presentation of Pawnees, Poncas and Pottowattamies to the President of the United States at the White House, Washington*. See also, *ILN*, 32, 1858:376–8. Text, "The Mississippi River," 376–8, has eight uncredited illustrations: 376, *Sioux Encampment, Upper Mississippi; Bluffs near Pairie du Chien; Junction of Missouri and Mississippi; Fort Snelling;* 377, *Lower Mississippi—Baton Rouge; Voyageurs; Woodchopper's Hut; The Graveyard*. "Transatlantic Sketches," 432, includes four uncredited illustrations: *The Broadway, St. Louis; Locomotive Engine on the Ohio and Mississippi Railway; St. Louis Mercantile Hall; Harrison House, Vincennes, Indiana*.

six months of 1858. They provided the most complete and up-to-date report on America and the West to appear in England, (17) and had a far-reaching effect in that they set the pattern for the illustrated serial dealing with the life and achievements of the Americans.

In 1860, Ingram himself decided to visit the United States. He needed a break from his mounting responsibilities, but his main concern was to increase the influence and circulation of his paper. Ingram saw his opportunity to combine business with pleasure when he was informed that the young Prince of Wales would make a North American goodwill tour during the summer. (18) American picture journalism at the time suffered acutely from lack of talented artists and skilled engravers, and was, therefore, unable to fully exploit coverage of a major political event of this kind. Accompanied by a small party, which included his first Special Artist in North America, George Henry Andrews, Ingram left Liverpool in the spring. He had, MacKay tells us, planned to visit all the principal cities of the West. But the visit ended in tragedy on September 7, 1860, when Ingram and his eldest son were among the three hundred passengers who went down with the excursion steamer *Lady Elgin,* returning to Chicago from Milwaukee, when it was rammed on Lake Michigan by the lumber schooner *Augusta.*

After Ingram's death, control of the *Illustrated London News* passed to his widow until his two younger sons, William and Charles, were old enough to take over as joint managing editors. Efforts were made to widen the paper's appeal, and circulation jumped to 300,000 in 1863, as it now became acceptable reading for the establishment. However, dropping its liberal sentiments was the price that was paid for this popularity; more conservative attitudes were adopted, including support of the Confederate cause, although its Special Artist, Frank Vizetelly, covered the Civil War from both sides. But the South went down fighting, and relations between the United States and England reached a breaking point; Lincoln's victory meant the end of the Southern aristocracy, which many English Tories had always hoped might form the basis of a new and independent nation.

During the decade following the Civil War, as England herself became more democratic, Anglo-American relations gradually entered a more harmonious phase. Continued emigration, (19) the steady growth of trade and investment, (20) and the tremendous increase in population and wealth of the United States were the main factors. Under these circumstances, the opposite poles of "conservative" and "liberal" opinion largely receded; traditional English upper-class hostility was gradually replaced by respect tempered with tolerant amusement at "our American cousins."

Inevitably, the ever-widening panorama of events—domestic, foreign, and imperial—and the continued growth of the reading public brought a challenge to the monopoly of the *Illustrated London News.* New picture papers appeared. Foremost among them was the London weekly

MacKay also sent materials to London for additional articles, which appeared during the same period. See, "Frontier Life in America" (unsigned text), *ILN*, 32, 1858. Two illustrations, 292: *Comanches Carrying off a Captive Girl* (from the painting by the German-American painter Charles Wimar, described in the text as "Charles Wimas [*sic*], an artist of St. Louis") and *Spearing Fish at Night*. Two illustrations, 336: *Pawnees Looking out for Enemies* (credited as after the painting by "an artist named [John Mix] Stanley, of Washington, whose opportunities for depicting the manners and customs of the aborigines have been numerous and peculiar") and *Trapping for Beaver* (described as a scene in Canada, artist not credited). See also, "Indians of the Far West," *ILN*, 32, 1858:400–2. Text, 401–2, tells of the expedition of Major William H. Emory and his survey of U. S.-Mexican boundary. Six uncredited illustrations, 400, after H. C. Pratt, one of the artists who accompanied the expedition and made series of Indian portraits (see, Robert Taft, *Artists and Illustrators of the Old West* (London and New York, 1969:278): *Diegeno Indians Travelling; Yuma Indians; Grizzly Bear, a Seminole Chief; Pimo Women; A Lipan Warrior; Papagos Women.*

18. This was the first time an heir to the British throne had visited not only Canada but also the United States. Memories of the War of Independence and the War of 1812 were still fresh. The United States, moreover, was generally credited in England with the resolve to annex Canada. The Prince of Wales' visit to the United States, therefore, was a bold diplomatic move to protect British interests and promote amicable relations. That it was a success was largely due to the gregarious personality of the eighteen-year-old Prince, who had a liking for Americans. By visiting Chicago, St. Louis, and Cincinnati, he saw something of what was then the West. He also found time to spend three days shooting quail on the prairies of Illinois at Dwight, where he and his aides were quartered at a cottage called "Prairie Home," owned by J. C. Spencer. For a full-page illustration of the royal shooting party, see *ILN*, 37, 1860:488, *His Royal Highness the Prince of Wales Shooting on the Prairies of the Far*

Graphic, founded in 1869 by William Luson Thomas, a former engraving contractor to the *Illustrated London News.* Circumstances were favorable. The transatlantic cable had been successfully laid in 1866; within a few months, businessmen and diplomats were exchanging cables like neighbors exchanging notes over the garden wall. Disraeli's Reform Act followed in 1867, beginning to break down the political obstacles between men of property and the rest of society. Gladstone's liberal cabinet implemented a series of supplementary reforms which in time would release new social forces and change the whole structure of Britain's future. Forster's Education Act went through in 1870, paving the way for mass readership of the popular press.

In this atmosphere, the *Graphic* made rapid strides. Dramatic events, like the outbreak of war between France and Germany in 1870, sent circulation up by thousands: 60,000 in that year; 120,000 in 1875; 250,000 by 1885. The *Graphic* became so successful that gossip began to predict the eclipse of the *Illustrated London News.* But the readership base of an ever-increasing population was widening, and the reading explosion of the 1890's pushed the circulation of both papers to a half million.

Thomas, cut from the same cloth as Ingram, initiated new departures in the style and scope of picture journalism. Ingram had pioneered improvements in printing; Thomas concentrated on quality of illustration and reproduction. As a master engraver, Thomas had worked closely with several of the Pre-Raphaelite painter-illustrators and their followers, the illustrators of the 1860's, and he recruited them as contributors to his new venture. An important innovation was Thomas' use of a different type of artist for the job of Special. The *Illustrated London News* had built up a reliable but unimaginative team: in war, they depicted men marching or charging like toy soldiers; in peace, too, they maintained the same healthy sense of distance between themselves and the action. The public, Thomas rightly felt, would be more interested if they could get a much closer look at what was actually going on. Like Charles Dickens, he held decided opinions on the moral obligations of journalism. In the *Graphic*'s early days, he favored pictures that told a story, and believed art should be enjoyed as much for its truth and closeness to life as for any esthetic qualities it may possess. Artists were urged to go out and depict the human melodramas enacted each day in the starkly underprivileged world of the Victorian poor.

Young artists who responded to his ideas abounded in England at the time. Some of the most suitable were Luke Fildes, Charles Green, Hubert Herkomer, Frank Holl, Arthur Boyd Houghton, and George Pinwell—artists who had helped to raise illustration to new heights in journals like *Good Words, Once-a-Week,* and the *Sunday Magazine.* Reproduced full page (12″ x 9″) or double page (12″ x 20″), their work for the *Graphic* gave the reader a front-seat view of what life was really like on the other side of the tracks. (21)

West. This is signed by Harrison Weir, a staff artist, but is almost certainly redrawn from a sketch by Dr. Ackland, the Prince's physician, who, according to Woods (the *Times* special correspondent), "went out with a gun in his hand and a pencil in his thoughts." See, N. A. Woods, *The Prince of Wales in Canada and the United States* (London, 1861).

19. Between the years 1861–70, emigration from British ports reached the figure of 1,133,000 for the United States and 302,000 for Canada. Heinz Gollwitzer, *Europe in the Age of Imperialism* (New York, 1969), 22. In one year (1870), British-born emigrants made up 23.93% of Utah's population, comprising 67.65% of all foreign-born emigrants. Philip A. Taylor, *Expectations Westward* (Ithica, 1966), 245.

20. Jackson, in his *The Enterprising Scot* (Edinburgh and Chicago, 1968), quoting Clapham, states that by 1869, when the first transcontinental line was completed, foreigners, the overwhelming majority of them British, were thought to have nearly £300,000,000 ($8,250,000,000) invested in the United States. The equivalent today would be £1,650,000,000, or approximately $4,125,000,000.

21. See Gleeson White, *English Illustration: The Sixties* (London, 1903; reprinted, 1970) for detailed review of magazine work by these artists.

22. In 1846, Thomas and his elder brother, the Special Artist and illustrator, George Housman Thomas (1824–68), went to the United States to take part in the promotion of two illustrated journals, the *Republic* and the *Picture Gallery.* This was a difficult period for illustrated publications in the U. S., and when both enterprises failed, the brothers returned to Europe. For further details, see *Dictionary of National Biography* and obituary notices, *Graphic,* October 20, 1900, and *Daily Graphic,* October 18, 1900.

Thomas sought to present a more dynamic picture of the United States, firmly believing that emigration was an answer to many of England's social problems. He had himself emigrated as a young man in 1846, and had worked on the engraving staff of two illustrated ventures in Boston and New York. Both had failed, and he had returned empty handed. Nevertheless, he saw the United States as the land of opportunity whose society reflected his own ideas for a more acquisitive, democratic way of life. The victory of the hard-working middle class of the North in 1865 made Thomas feel more certain of his views than ever. (22)

His opportunity to point out the contrast came with the opening of the new Pacific Railway in 1869. As everyone read the glowing newspaper accounts of the Golden Spike being driven at Promontory Point on May 10, the development of the West assumed a totally new dimension. The rails had pierced an unknown region, driving back the Indian and bringing in European civilization. Like the building of the Suez Canal (which opened in the same year), the Pacific Railway, over three thousand miles long, and built with mainly British capital, offered additional exhilarating evidence of man's capacity to triumph over the most formidable natural obstacles. Thomas decided that the event was important enough to justify sending his best available artist, Arthur Boyd Houghton, as his first Special to North America.

It did not work out entirely as Thomas had hoped. Unexpectedly, the observant Houghton depicted much that was questionable, particularly in New York. American readers were outraged. Nonetheless, his excellent "Sketches in the Far West" gave the new paper its first major Western feature and served Thomas' purpose admirably by helping focus public interest in the lands newly opened for investment and settlement.

As time went on, competition between the *Illustrated London News* and the *Graphic* became increasingly fierce and protracted, ranging across the seven seas and the five continents. Just as intensive was the rivalry to report the North American scene. Both American and Canadian officials and publicity men had a field day, playing one paper off against the other, issuing free passes, and arranging introductions and accommodations to obtain maximum exposure in both papers. Now that access to the vast new country was being made increasingly easier, the saga of a wild and wonderful utopia climbed a new peak of credulity. Pictorially, it offered the picture papers their most colorful material to date. The larger-than-life characters, the bizarre appearance of the boom towns, the stagelines and railroads and the colorful characters they carried; all against the background of a guerrilla war sporadically waged by hostile Indians. It became the subject matter of legendary episodes and set the stage for the Western adventure story in pulp fiction, comic strip, films, and television.

Editorial interest in the West rested on much less romantic founda-

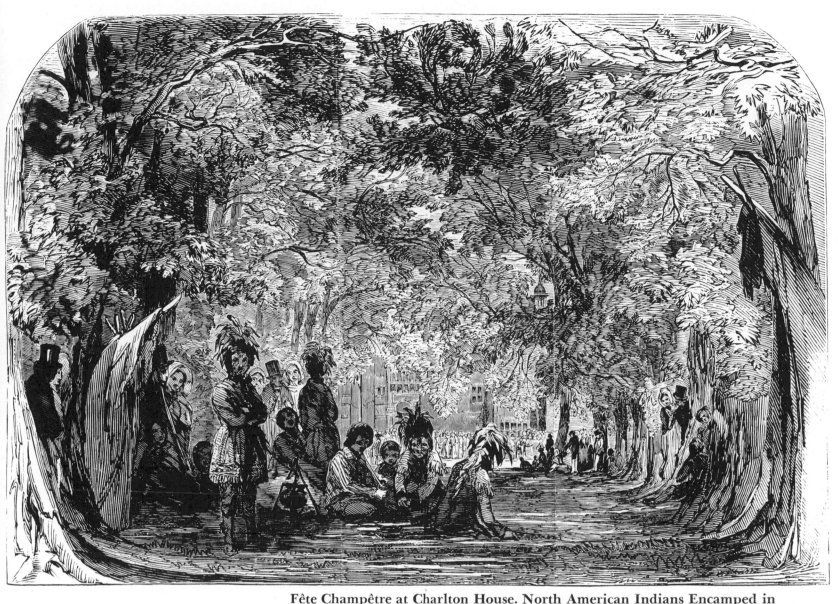

Fête Champêtre at Charlton House. North American Indians Encamped in the Park, G. Harrison. Wood engraving. *Illustrated London News*, 1845.

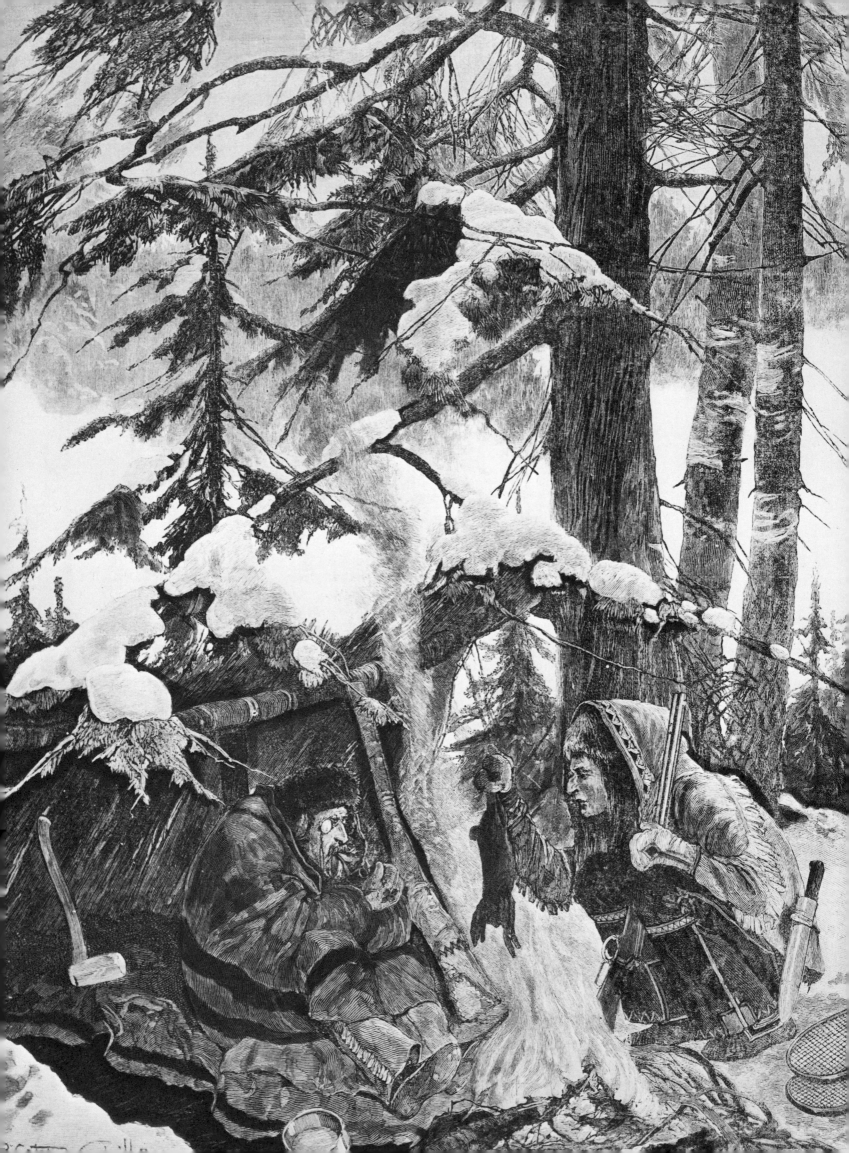

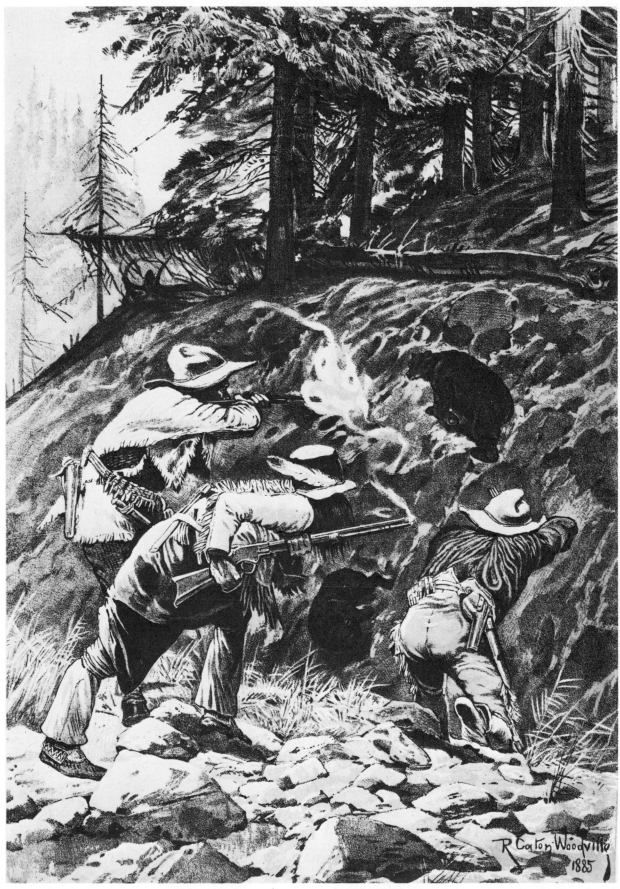

Christmas in the New World (Left), Richard Caton Woodville. Wood engraving. *Illustrated London News,* 1887. The *Illustrated London News*—particularly in its famous Christmas numbers—liked to feature the seasonal pastimes of lonely Englishmen pioneering on the farflung fringes of the Empire; in this instance, the snowy forests of Canada.

Hunting Old Ephraim in the Rockies (Above), Richard Caton Woodville. Chromolithograph after oil painting. *Illustrated London News,* summer number, 1885. Western hunting scenes such as this one, reproduced in color and suitable for framing, were popular with British sportsmen.

tions. Victorian England had been going through a large-scale urban revolution since the 1840's, with such dramatic increases in her industrial population that agriculture was unable to adequately supply sufficient meat. When cattle disease struck at herds throughout Britain and in Europe during the 1860's, the hungry British turned to the United States, the Argentine, and Australia for help. Experts in animal husbandry, and even a royal commission, were sent to the United States in the late 1870's to investigate the cattle industry. The reports were favorable; and as a result, the great cattle boom was on, with as much as 60% of a threefold increase in beef on the hoof going to the United Kingdom. By the 1880's a multimillion dollar trade had emerged. (23)

Such developments stimulated popular interest, and prompted William and Charles Ingram to take up the *Graphic*'s challenge and step up more effective coverage. Globe-trotting Specials, who had usually reported the course of the Empire, now included North America in their travels. The Ingrams were delighted when their famous Special, William Simpson, chanced to be in San Francisco and sent them drawings and dispatches of his impressions of the Modoc War of 1873. Even more of a scoop were Valentine Walter Bromley's romantic scenes of the Sioux, done on his trip with the celebrated sporting Earl of Dunraven, in 1874; and Melton Prior's pictorial account of the Jarrett and Palmer "Lightning Express" railroad trip from New York to San Francisco in 1876, (24) as well as his later series of Western railroad sketches along the lines of the Central and Northern Pacific. (25) And this was not all. Throughout the 1880's—particularly after the United States edition was launched in 1887—the *Illustrated London News* covered almost every event of importance, catering to the interests of its aristocratic sportsmen readers no less than to the businessmen concerned with investments in U.S. railroads, ranching, and mining.

Although they roamed far and wide throughout the United States and Canada, the English Specials did not cover the Old West in its entirety. The pressures of an expanding world of news must have resulted in curtailed coverage. Few, for example, strayed south of the Union Pacific toward the ranching country of the great Southwest in Texas and Arizona. Very possibly, this was an area in which the detailed written report carried greater weight than the perhaps more romantic illustrated coverage with those with money to invest in the cattle industry. Such written reports frequently appeared in the monthly reviews *Blackwoods, Fraser's,* and *The Cornhill.* Both the *Illustrated London News* and the *Graphic* found they could fill this gap in their reportage by obtaining stereotypes of illustrations supplied by *Harper's* and *Leslie's,* drawn by Remington, Zogbaum, and others.

The transcontinental railroads had opened up the Great West with the help of British capital, but even more money was needed to harvest and exploit its immensely rich resources. Only the British seemed prepared to invest liberally in the new lands of promise, and as every

23. Jackson (*The Enterprising Scot*), cites the effect of the reports of James MacDonald (a well-known cattle expert), which were published in the influential Edinburgh daily, the *Scotsman,* as well as the report of the Earl of Airlie, chairman of the Scottish-American Mortgage Company. The British, Jackson adds, may well have had as much as £9,000,000 (or $45,-000,000) invested in the American cattle business in the 1880's. Another aspect was the emigration of British nobles and gentry who left the Old Country to establish cattle kingdoms, or to look after investments in the Great Plains and Rocky Mountain West. Athearn informs us that Colorado Springs became a virtual British outpost and was nicknamed "Li'l Lunnon." See, Robert G. Athearn, *Westward the Briton* (Lincoln, 1953).

24. See the Biographical Notes at the back of this book for further information on Melton Prior and his travels in the western United States and Canada. His 1876 visit was made on the occasion of the Centennial Festival and International Exhibition, Philadelphia. This was rounded off by the transcontinental railroad trip. The artist accepted an invitation to join the press party of twenty journalists traveling at the expense of Jarrett and Palmer, the managers of Booth's Theater, New York. They had undertaken to transport their company for a run of Shakespeare's *Henry V,* due to open at San Francisco's California Theater on June 5. They made it in record time—three-and-a-half days. See, "Across America—Express Railway Trip," *ILN,* 69, 1876:56-9. Eleven illustrations: *Kitchen: A Few Civilised Indians on the Road; Sitting and Dining Room Arranged for Sleeping; Prairie on Fire; Pullman's Saloon Dining-Sleeping Car;*

A Gigantic Rabbit Drive, Cyrus Cuneo. Photomechanical halftone engraving after oil painting. *Illustrated London News,* 1911. The Old West was a memory when Cyrus Cuneo traveled through the United States in 1908. The Indians were no longer a menace and the troopers and cowboys had gone. Yet Cuneo, one of the last Special Artists, was still able to find plenty of colorful subjects for his paper— like this vast rabbit hunt staged by 2,000 farmers and their families.

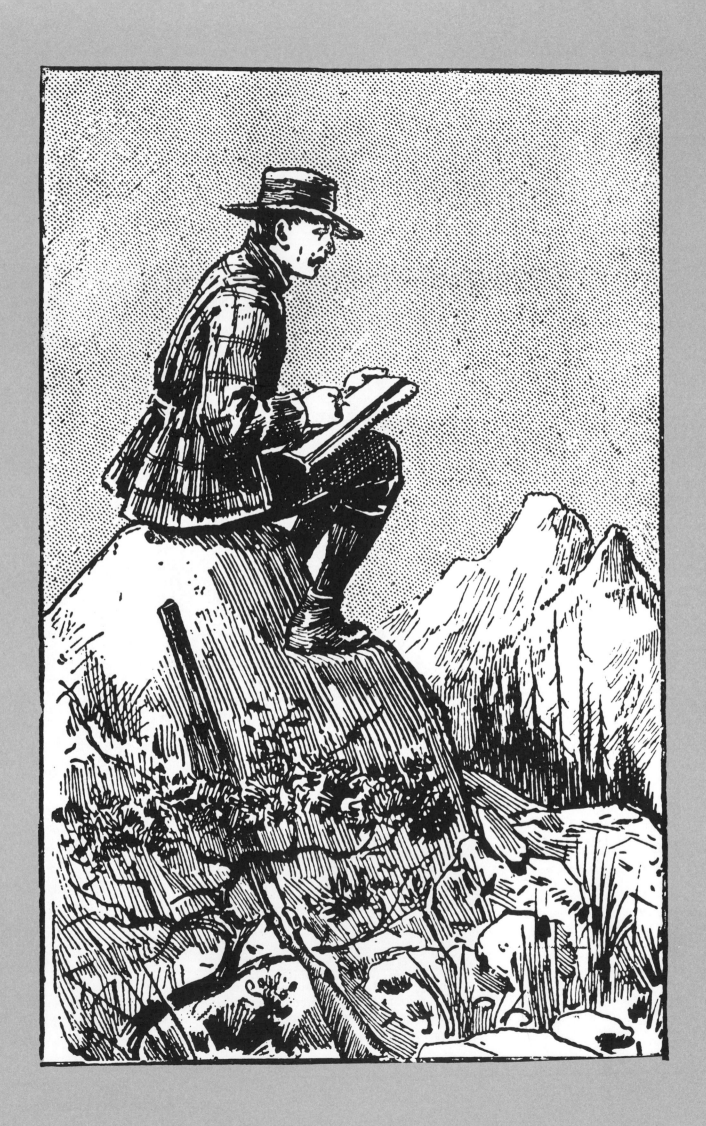

2. The Special Artist Reports the American West

SPECIAL ARTISTS DIFFERED from earlier artist-travelers who had explored and recorded the New World. While taking part in the pursuit of the exotic and the unknown, they were social commentators concerned with the life of the West, rather than with its flora and fauna. Most of all, they were interested in people. As a result, they were widely regarded as being nothing more than a new species of journalist. Indeed, some of them were. For not only had a Special to be capable of making accurate descriptive drawings, but he also had to have the necessary literary ability to pen explanatory descriptions—whether it be a column or two, a full-length article, or even a series written up from the customary diary or travel journal.

But it would also be true to define the Special as a new species of artist. By instinct or design, he had to know when to be where and how to get there in time for it to happen; and once there, he had to be able to make drawings under any circumstances. He also had to possess the rare and intuitive gift of extracting what was significant from the experience he was so briefly a part of. Writing in 1883, Harry V. Barnett, art editor of the *Graphic,* thought the Special must be an artist in the best sense of the word, "a man whose mind is not only open to various and broad impressions, but also stored with knowledge and strengthened by experience. He must," Barnett continued, "be gifted in some measure with the rare quality of imagination, not to picture the impossible but the power of vividly investing bare facts with spirit." Those who could do this, he concluded, were so few that a first-rate Special was a joy to the employer who could keep him. (1)

Mason Jackson, art director of the *Illustrated London News* for almost fifty years, was more down to earth. A Special, he thought, had to possess the physical strength to undergo fatigue, overcome formidable difficulties, and often incur personal danger in fulfilling his mission. The discomforts were appalling. "He will sleep on the bare ground," Jackson wrote, "wrapped in a blanket or waterproof sheet, and he will ride all night through a hostile country to catch the homeward mail. He is equally at home in the palace and the hovel, and is as ready to attend a battle as a banquet, or wind up with a run on the warpath among the American Indians." (2) Added to these discomforts were the then fatal hazards of yellow fever, cholera, typhus, and other tropical diseases. Frequently, the Special had to ride along with the Army, and at times, to do his share of the fighting. Obviously, to endure such an adventurous life, a Special also needed to have something of the explorer and the rough rider in him, as well as the ability to mix freely. Specials were, for the most part, hard living, tough, and extremely professional.

The English Specials who helped foster the legends in Europe of the Wild West were a group of divergent personalities. But in many respects they had much in common. Almost all came from upper-class or middle-class backgrounds and most were privately educated and well trained. Arthur Boyd Houghton was the youngest son of a naval aide

1. Harry V. Barnett, "The Special Artist," *Cassell's Magazine of Art,* 6, 1883:163.

2. Mason Jackson, *The Pictorial Press: Its Origin and Progress* (London, 1885), 328.

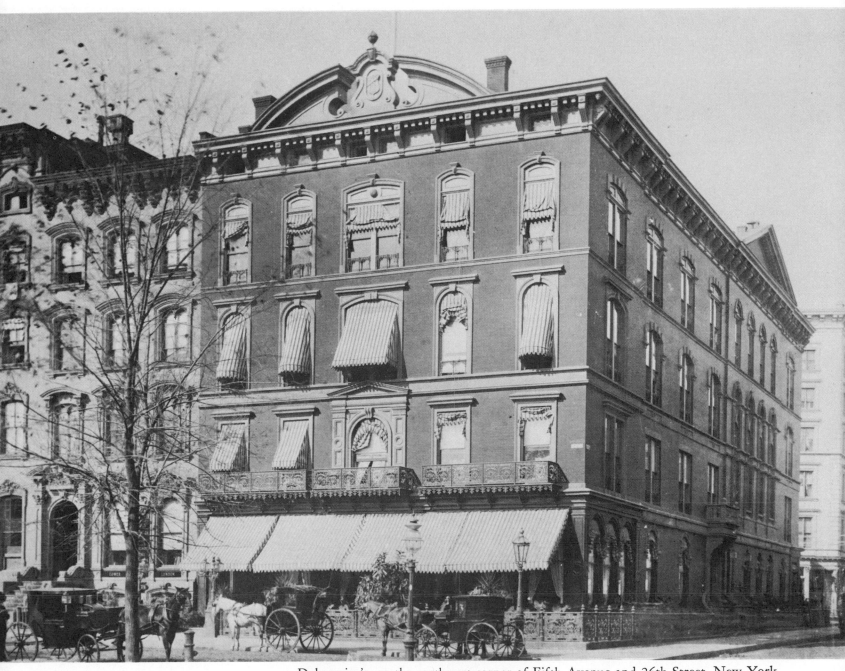

Delmonico's, on the southwest corner of Fifth Avenue and 26th Street, New York, was a luxury hotel with a restaurant renowned for the quality of its haute cuisine. Between 1869–90, it was the favorite haunt of British Special Artists and sporting aristocrats pausing to recover from the Atlantic crossing before continuing their travels westward. Courtesy New York Historical Society.

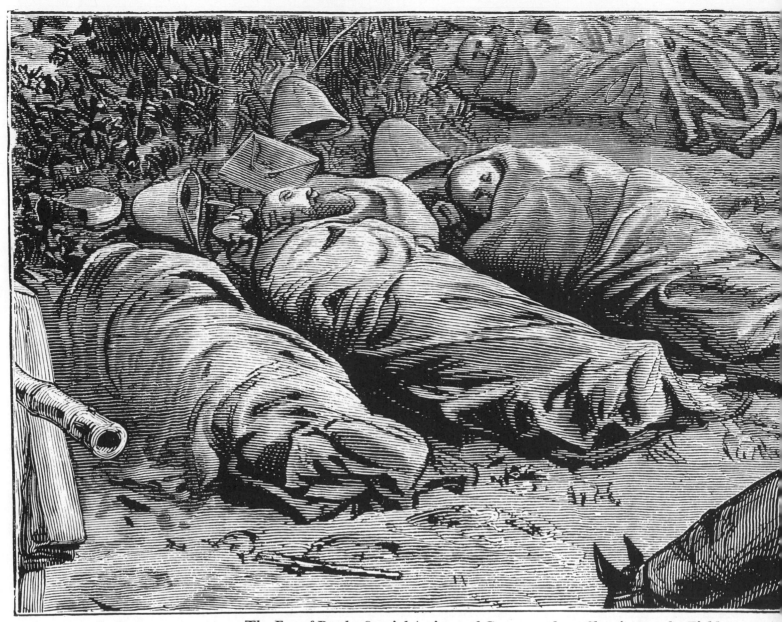

The Eve of Battle: Special Artists and Correspondents Sleeping on the Field,
William Simpson. Wood engraving after pencil sketch. *Illustrated London News,*
1868. The Special Artist gave up all ideas of comfort when on location. "When
darkness stopped a battle," wrote Simpson, "I have had to find a bed where I stood."
And so it was out West—the Special had to bed down beneath the stars in his
leather-bottomed canvas sleeping bag.

in the colonial service and had studied art at Leigh's Academy. Valentine Walter Bromley, Richard Caton Woodville, Charles Edwin Fripp, Sydney Prior Hall, and Inglis Sheldon-Williams were, remarkably enough, all sons of well-known artists, with cosmopolitan and upper-class connections. Bromley had been taught entirely by his father. Woodville and Fripp went on to receive a rigorous training at the academies of Düsseldorf and Munich. Hall studied at Heatherly's, the Royal Academy, and under Arthur Hughes, the Pre-Raphaelite painter. Villiers, too, studied at the Royal Academy. Sheldon-Williams studied at the Slade. Others, like William Simpson, had an artisan background and could not, therefore, afford such a prolonged art training. Simpson had been an apprentice lithographic artist to a well-known Glasgow firm, Allan and Ferguson, and had studied for a short time at the Glasgow School of Design.

Despite their academic qualifications, which led them to specialize as illustrators, or as history, military, sporting, and topographical painters, all embraced pictorial journalism as a relatively well-paid means of making an assured livelihood in a competitive and overcrowded profession. For most were married and even had children. Few of these Specials would admit to finding the fast-moving life irresistible, but they obviously did. Although modestly aware of their influence, they never thought it would last. The only compensation, they believed, was that there was something somewhere even more exciting. Almost all had had considerable previous experience as Specials. What they saw of America could, therefore, be set against not only what they had seen in England or in nearby Europe, but the world at large.

They traveled to America for various reasons, and they saw different aspects of life in the western regions of the United States and Canada. Houghton, a young Pre-Raphaelite illustrator, crossed the Atlantic in 1869 to depict the customs and manners of Brother Jonathan in the East and along the newly built Pacific Railroad. While Simpson, on his way back to England from the Far East was a fortuitous eyewitness of the Modoc War of 1873 in the Lava Beds of upper California. Bromley, while recording the Earl of Dunraven's hunting exploits of 1874, in the Upper Yellowstone, as well as acting as a Special, also took time off to paint the Crow and the Sioux. Woodville, traveling through British Columbia, Montana, and Wyoming in 1890, to hunt and to paint the great outdoors, joined the press corps at Pine Ridge to watch the last act in the tragedy of the Plains Indian.

Several Specials went on missions or to cover specific events. Hall accompanied a governor general of Canada, the young Marquis of Lorne, in 1881 on an epic two-thousand-mile safari—largely by horse and river transport—to help him promote the settlement of the prairies. Villiers, in 1889, went over much the same ground, but on the now completed Canadian Pacific, relishing every moment of a luxury Western tour made by Lord and Lady Stanley.

3. The more important of these artists included the Englishman Alfred Waud (1828–91), one of the most outstanding reportorial draughtsmen of the century. A celebrated Civil War Special who had left England at the age of twenty-two after training at the Royal Academy, Waud was a popular figure who features in the reminiscences of several British and American journalists of the Civil War period. A well-known photograph by Mathew Brady, taken at Gettysburg, shows him as a bearded giant of a man, in a wide-brimmed slouch hat, Norfolk shooting jacket, and riding boots. *Harper's Weekly* sent him south in April, 1866, to report on the aftermath of war. His "Pictures of the South" (*Harper's Weekly*, May–June, 1866) also includes scenes drawn in Cincinnati and Little Rock, the West of that time. He continued southwest, to find more typical aspects of frontier life. In Texas, he depicted an early aspect of the big cattle drives, which were just beginning. Waud's first trip West produced some of the earliest eyewitness drawings by artists working on assignment for an illustrated paper. His second trip, to Nebraska Territory, in 1868, produced the famous and often-reproduced *Pilgrims of the Plains* (*HW*, December 28, 1871:1200–1). For a full account of Waud and the American artists of *Harper's* and *Leslie's* as reporters of the West, see Robert Taft, *Artists and Illustrators of the Old West* (London and New York, 1953).

4. *ILN* started a New York edition in 1881, entitled the *London Illustrated News*.

Some went as settlers, only to return to the Old Country, unsuccessful or torn by divided loyalties. To this group belonged Sheldon-Williams, who emigrated from England at sixteen, in 1887, to establish a family farm at Cannington Manor, Saskatchewan. Fripp, who depicted the Trail of '98, had previously settled in British Columbia, in the hope of recovering from ill health induced by earlier travels in tropical Africa.

Both the New York picture papers, *Harper's Weekly* and *Leslie's,* had sent artists to cover the West immediately after the Civil War ended in 1865, and this may well have helped spark off editorial interest. (3) One can also detect the influence of later American delineators, such as Rufus Zogbaum, Henry Farny, and Frederic Remington. By and large, however, the Englishmen's view of America sprung from a well-established tradition of documentary art which evolved its own approach to the subject. Both the *Illustrated London News* and the *Graphic* were concerned with building and maintaining circulation in the United States and Canada, (4) just as leading American magazines were in England. They had, therefore, every reason to send their own men to obtain exclusive material.

Competition with American picture papers did not, however, furnish the only reason for British coverage of the West. Emigration, trade, and investment played an important role in generating a continuing reader interest; as well as the extraordinary fascination the Indian held for the European imagination. British editors, therefore, regarded North America and its West as a rich source of colorful material and kept in close touch with every phase of its breathless development.

Accordingly, the English Special Artists' choice of subject matter was frequently dictated by the varied interests of the readership. The merchant, the investor, and the prospective emigrant, for example, were mainly interested in pictures which told them about the growth of a given region, as well as what it was like getting there. Sportsmen, on the other hand, were naturally more concerned with a realistic rendering of the great outdoors which could communicate the nature of the wilderness terrain as well as every dramatic detail of a hunting or fishing expedition.

But a large number of readers, particularly later in the century, were drawn to a picturing of the West simply because, like the Empire, it spelled out romance, color, and adventure in large capital letters. The clerks, the shop assistants, the small shopkeepers, and the minor civil servants were now literate enough to realize how monotonous their lives had become. The enormous popularity of Beadle and Adam dime Western fiction, of Western serials and color plates in juvenilia such as *Boy's Own Paper* and *Chums,* and of expatriate storytellers like Bret Harte was but part of an insatiable appetite for tales and pictures of a West that never could really have been that wild. The weekly picture papers took full advantage of it.

By and large, the published illustrations, sketchbook studies, descrip-

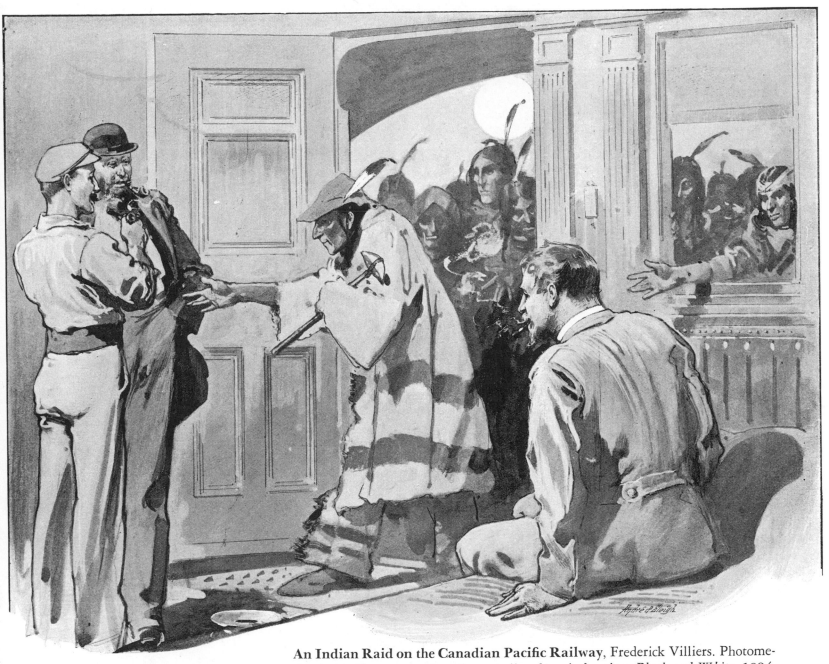

An Indian Raid on the Canadian Pacific Railway, Frederick Villiers. Photomechanical halftone engraving after pencil and wash drawing. *Black and White,* 1894. Special Artists did a great deal of traveling to and in the West by steamboat, railroad, stagecoach, and wagon.

Ute Squaws (Above), Arthur Boyd Houghton. Wood engraving. *Graphic,* July 23, 1870. The artist shows himself sketching on the run in the course of his travels in Nebraska, Wyoming, and Utah.

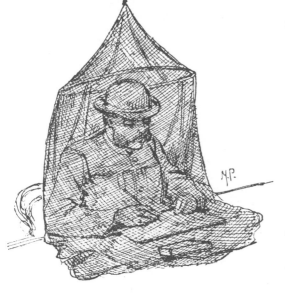

How We Have to Work (Left), Melton Prior. Wood engraving after pencil sketch. *Illustrated London News,* 1884. Exposure to hordes of fierce mosquitoes often made work impossible. The artist depicts himself using the mosquito net he always carried with him on assignment which had been specially made for him by his London outfitter.

tive notes, and articles reflect both the personal interests of the artists and the editorial viewpoints of the journals which paid their expenses. Bromley devoted most of his time to the Indians; Woodville to hunting; Sheldon-Williams to prairie farmlife; while Fripp's love of the outdoor life is reflected in his account of his adventures with the gold-seekers of the Klondike.

But all the artists were not so specialized. Houghton, interested in everything, devoted himself to a more general account of his impressions, depicting Indians, Mormons, and buffalo-hunters with equal zest. Simpson, too, after spending a week watching the U.S. Army in action against the Modocs, made side trips to indulge his admiration for the magnificent landscape of the Yosemite Valley, as well as to take a look at Brigham Young's experiment in Utah. Hall depicted scenes of life in the pioneer settlements of what are now Manitoba, Saskatchewan, and Alberta, as well as Indian tribal life, his traveling companions, and the Canadian Mounties. Villiers reported varied aspects of Indian and pioneer life along the three-thousand-mile railway excursion through Canada's changing prairie provinces.

Most travelers see new scenes through old spectacles, and these Victorian artists were no exception. The gregarious Houghton, who thought the average westerner "hearty, genial, free-spoken and full of go-aheadativeness," (5) obviously found comradeship among buffalo-hunters and Army officers a memorable experience and equal to any he found in his favorite haunts in bohemian London. Sheldon-Williams got on with the Canadians because they, like the English, "could get things done." Simpson, Hall, Woodville, Villiers, and Fripp—all specialists at reporting the course of fighting on the far fringes of Empire—found the imperialistic nature of the Old West a familiar aspect of the English-speaking world; they accepted it in the interests of progress. Only Simpson, who reflected on much of what he saw throughout his world travels, questioned the moral right of a powerful and civilized government to take land from a primitive people. The misanthropic Fripp, too, had certain misgivings. After a lifetime of observing the destruction of one nation after another throughout black Africa, he found the greed of the white man in the Klondike no less acceptable.

In their Western travels, Specials invariably had to burden themselves with a great amount of clothing and equipment. As they would frequently be away for at least three months, and often for six months or even longer, two trunks were needed. Climatic changes necessitated heavy coats, furs, and warm clothing generally, as well as some essential summer wear. Functions of interest to his paper also made it necessary for the Special to include a frock coat or a dinner jacket. Everyday or working gear usually consisted of a cape coat, or Ulster, a Norfolk or Melton jacket, and breeches with gaiters or riding boots. Most thought a Wolseley valise—a rot-proof canvas sleeping bag and hold-all named for Sir Garnett Wolseley, the well-known general—vital, as hotel ac-

5. *Graphic,* July 8, 1871:34.

commodation was not always readily available. A tin medicine chest and plenty of extra drawing materials were a necessity; and, as they almost invariably traveled alone, most Specials also carried a service revolver.

Working materials were largely confined to sketchbooks, pocket-size for making rapid sketches in pencil and of larger size for making the more detailed drawings in pencil, ink, and watercolor they would mail to their editors. A large stock of pencils, brushes, Chinese white, and ivory black was usually packed in different places, so that if a part were lost, they would never be without. Those who had been war correspondents, like Simpson, Hall, Villiers, and Fripp, carried field glasses, a canteen, and, after 1889, a small Kodak as a timesaver. A good horse could always be hired whenever necessary.

Inevitably, the Special Artist worked with one eye on his gold pocket watch. Whether he was able to finish his work depended on the nature and urgency of the assignment. If the assignment were war-reporting, like Simpson's coverage of the Modoc Campaign, such field sketches were, of course, hot news which had to reach London as quickly as circumstances would permit. Such sketches, however rough and scribbled with notes, enabled staff artists to redraw a complete news illustration. These sketches were folded and placed in the red press envelope, invented by W. H. Russell, the famous war correspondent of the London *Times*. By courtesy of post office officials everywhere, such packets were seldom delayed, and were very often expedited. But occasional loss of sketches made artists bite their fingernails with anxiety; losing packets of drawings meant fees would be so much less. To ensure this would not happen, they would go to any length to place them in safe hands. Sometimes this might involve the unfortunate artist in a ten-mile walk in the middle of the night, or as in Simpson's case, in a long, spine-jolting ride on a buckboard to the nearest post office.

The travel assignment which was not so closely tied to a specific event gave the artist much more time. Houghton's long journeys by sea, river, and railroad to and across the United States gave him ample time to not only develop his sketches but to take them still further as completely realized illustrations in ink on the polished, whitened surface of a boxwood block. Many of his Western illustrations were probably completed in this way on the return voyage to England.

Houghton, Hall, Woodville, and Bromley worked in a bold and frequently dramatic idiom which relied on a well-devised composition; but, generally, the style of the average Special is not easily identified. Prior to the widespread introduction of photomechanical process engraving, about 1890, original field sketches were usually subject to a dishearteningly emasculating medium of reproduction. It was a laboriously collective process, which began with the Special's sketch as the starting point of an illustration prepared by staff artists. Sometimes several artists would work concurrently on the same illustration before

it was traced in reverse or photographed on the surface of a type-high (about 1″ thick) wood block. The wood blocks were usually built up out of 3½″ x 2″ sections (thirty-six were required for a double-paged spread, twelve to eighteen for a full page). After engraving, the sections were assembled and fixed tightly together by means of brass bolts. A stereotype, or facsimile, was then made in copper and mounted on wood. Finally, in this form, the illustration was ready for printing.

Nevertheless, the spectrum of a Special's style was unexpectedly wide. Diversity was as much a distinguishing characteristic as choice of subject matter. Style ranged across the generalities of topographical landscape

Bolted wood blocks were introduced to speed up engraving. These blocks were made up of sections (usually 6 for a half page) which could be taken apart and distributed among a team of engravers. After being engraved, the sections were assembled and secured with brass bolts. A copper stereotype was then made and mounted on wood. In this form, the wood engraving was ready for printing.

through the closely focused precision of Pre-Raphaelitism, to the histrionic nationalism of High Victorian battle-painting of the Düsseldorf school and the snapshot conviviality of French impressionism.

These various stylistic idioms served each artist well, giving him the necessary technique to report whatever was of interest. The watercolors of the English topographical painters of the Grand Tour lay behind Simpson's ordered vision. In contrast, Houghton's chronicle of buffalo-hunting seems haunted by the unquiet spirit of Pre-Raphaelite medievalism. The melodramatic violence of Carl Friedrich Lessing inspired Woodville. Bromley's romantic and monumental compositions of the Sioux lay somewhere between the two. Impressionism, through the influence of Paul Renouard (a disciple of Degas), was undoubtedly the source of Hall's casual draughtsmanship.

As the century drew to an end, editors increasingly demanded greater accuracy, comparable to that of the camera. Such pressure caused the less esthetically oriented, such as Villiers, Sheldon-Williams, and Fripp, to handle their material with much less confidence. Faced with constantly advancing deadlines which demanded that they work faster, Villiers and Fripp unhesitatingly supplemented their use of a sketchbook with a Kodak. A decline in the quality of the artwork is very apparent even with the advent of vastly improved techniques of reproduction after 1890. Much of the blame for this can be laid on the shoulders of William Luson Thomas. He had done so much to improve the quality of illustration and reproduction, and now he sacrificed everything for the sake of receiving the scrappiest sketch on time. After all, he would have replied to criticism, he was running a newspaper, not an art magazine. The problem was the big lag between the time the drawings were done and the time they were received by the editorial office. Meanwhile, Thomas looked forward to the day when he would have his "pen-pencillers" electronically connected to his office, transmitting drawings in the form of illustrated cables! "Then," he smilingly told E. S. Grew of the *Sketch,* in 1894, "we shall be satisfied." (6)

Traveling through the West, the Englishmen expected much; and they were prepared for the worst to happen. And often it did. Steeped in James Fenimore Cooper, Mayne Reid, and George Catlin, who described a land peopled with noble savages and idealistic seekers after the simple life, they were frequently surprised to find their sources of inspiration outdated. Yet as the following chapters reveal, they were seldom disappointed. From their adventures they created a little-known yet uniquely Anglo-Saxon artform, its modest documentary purpose often concealing profundity of sentiment. Perhaps part of the answer to why they not only were able to endure the privations of a Special's occupation, but also managed to do some of their finest work under such conditions, is that they, like the pioneers, responded to the challenge of discovering an untamed land; they had only the conventions of Victorian art to blame if they did not entirely succeed in their efforts.

6. "Mr. William L. Thomas of the *Graphic* and *Daily Graphic*," *Sketch,* January 17, 1894.

A Special Artist on the Road, artist unknown. Wood engraving. From *The Pictorial Press: Its Origins and Progress* (London, 1885). For everyday mobility a horse was indispensable to the Special Artist. Although much of the West was serviced by mail and passenger stagelines, these were often few and far between. The Special's own mount was therefore essential to enable him to follow a story. Also, he would frequently be called upon, for want of any other means of transportation, to ride to the nearest post office, stageline, or railway station himself to get his drawings off on time.

3.
Off to the Plains!

Arthur Boyd Houghton 1870

"It is nothing less than inspiring—this thought of leaving civilisation all behind, to become a much-discovering Columbus among the new and likely enough hitherto untrodden wilds."
Arthur Boyd Houghton (*Graphic*, 1870)

Arthur Boyd Houghton (1836–75). The artist has shown himself with his wife and eldest daughter in this illustration entitled *True or False?* Wood engraving. *Good Words*, 1862. Courtesy Museum of Fine Arts, Boston. Harold Hartley Collection.

1. See, Vincent Van Gogh, *Letters to an Artist* (London, 1936), 77, 110, 114, 164–5.

AS A YOUNG, ASPIRING ARTIST, Vincent Van Gogh envied the ease of communication that the Special Artist, or artist-reporter, appeared to enjoy. Living in The Hague between 1881 and 1883, he sought to develop his own drawing as a medium of contact with others; the dream of becoming a contributor to the illustrated papers obsessed him. He was even moved to make speculative drawings "from the people, for the people," but was too timid to submit them. His indefatigable brother, Theo, kept him in touch with anything of interest in the latest issues. Theo's reports, plus a chance discovery of a set of bound volumes of the *Graphic* for 1870–75 in an auction, touched off a highly interesting correspondence between Van Gogh and another Dutch painter, Anton Van Rappard. In these letters there were repeated references to the English artist, Arthur Boyd Houghton, and his drawings of the American West. (1)

After scraping together the money to buy the volumes, Van Gogh told Rappard that he had "looked through them far into the night," finding "drawings by Boyd Houghton about America . . . I had no idea he was so interesting." Learning of the Englishman's untimely death in 1875, Van Gogh asked his brother to find out what he could about him. "I know drawings of his," the artist wrote, "of Quakers, and a Mormon church, and Indian women, and immigrants," adding that "he has something rather mysterious like Goya, with a wonderful soberness which reminds me of Meryon."

Van Gogh had every reason to feel excited. He had stumbled across one of the most interesting, yet little-known chronicles of the Old West: Arthur Boyd Houghton's "Sketches in the Far West," which appeared in the *Graphic* between July, 1870, and February, 1873, as the second half of a series of illustrated impressions entitled "Graphic America."

Houghton's Western illustrations in the *Graphic* differ from the usual gray engravings we are accustomed to seeing in Victorian picture papers. In the days before photomechanical techniques of reproduction, drawings had to be transcribed or duplicated on wood blocks; but Houghton's were reproduced with comparative freshness. So much so, that Van Gogh thought they resembled etchings. Houghton did not make sketches on paper; he drew in pen and ink on a polished box-wood block thinly coated with Chinese white to resemble the texture of the paper. Thus every line engraved was an exact facsimile of his technique. Working in a medium that usually erased the idiosyncrasies of an artist's style, he nevertheless succeeded in creating a strongly personal flavor.

Houghton's life was almost as tragically short as that of his admirer, Van Gogh. He died at the age of thirty-nine. Information about him is meager, but the few facts that have filtered through the recollections of friends and colleagues reveal him to be an impulsive and generous personality. Edmund J. Sullivan, an early biographer, describes him as a bohemian with a boisterous love of life. He was born in Bombay, where

2. A fashionable private art school in Newman Street, Bloomsbury, Leigh's Academy was the original for Thackeray's "Gandish's" in his novel *The Newcomes*. It was later known as Heatherley's.

3. After eight years of intensive travel in the West, George Catlin took his paintings and collections of Indian costumes and artifacts to England in the autumn of 1839. He spent the next 30 years in Europe, except for a five-year period in South America. His most important books were first published in London, 1841–68, and they exerted a constant influence on young English painters and illustrators. John C. Ewers in his important paper *The Emergence of the Plains Indian as the Symbol of the North American Indian* (Washington, 1965), for example, cites the first illustrated edition of Longfellow's popular *Hiawatha* (London, 1856). Sir John Gilbert (1817–93), historical painter and early mainstay of the *Illustrated London News,* was the illustrator, and he derived much of his inspiration from Catlin's work. The "Indian Gallery" was shown in London, Manchester, and Liverpool. See, Marjorie C. Roehm, *The Letters of George Catlin and his Family* (Berkeley, 1966). Thomas C. Donaldson, in his *George Catlin Indian Gallery,* 734, writes of Catlin's literary work that it had an enormous circulation, "probably more than double that of any other writer of the North American Indian. . . . It is safe to say that more than

his father, Captain Michael Houghton, was private secretary to Sir John Malcolm, governor of the province, which at that time was under British administration. In spite of the loss of the sight of one eye in boyhood, and the weakness of the other, young Houghton trained as a draughtsman at Mr. Leigh's celebrated Academy (2) in Newman Street, Bloomsbury, and shortly afterward, while still in his twenties, achieved a reputation as a leading illustrator of ornate table-books and literary magazines. He derived much of his style and many of his ideas from the then influential Pre-Raphaelite Brotherhood and contributed heady images of Arthurian swains commuting on horseback to court swooning maidens. His illustrations for the Dalziel editions of *The Arabian Nights* and *Don Quixote* are among the classics of Victorian book illustration. How, then, did such an artist come to make drawings of the violent, lusty young West?

Aiming for an honesty and simplicity neglected in the decorous and stylistic art of neoclassicism (particularly of the arch-villain Raphael), the Pre-Raphaelites often turned to the methods and subjects of medieval art. But being a part of late romanticism, they were understandably attracted, as well, to the natural, unspoiled frontier and "noble savage" of the American West. Like a great many English artists, the Pre-Raphaelites and their young followers must have seen the Indian gallery of the American artist George Catlin (3) during his many years in England, or have pored over his albums and travelogs (first published in London); and certainly they had read Longfellow's *Hiawatha* and the best-selling novels of James Fenimore Cooper. (4) Moreover, the majority of the Pre-Raphaelites were liberals or Christian Socialists, whose pro-American sentiments had been strengthened by their Union sympathies during the Civil War. It is not surprising, then, that Houghton accepted the challenge of recording America for the pages of the *Graphic*.

He left Liverpool in the middle of October, 1869, on the new Inman sail-steamship, the record-breaking *City of Brussels*. The trip to the shores of America, which took eight days, tried his physical stamina as well as his imagination. Reflecting on the long sea trip, the artist remembered Dr. Johnson's definition of a ship as "a prison with the chance of being drowned." Nevertheless, he was in high spirits, and from the very start his reports displayed a sense of relief from the everyday. (5) Observing the joys and sorrows of transatlantic travel, he noted the strange, wailing ditties of the sailors as they spread sail, the indefatigable, peripatetic energy of the habitual tourist, and the grave courage of immigrants huddled together in the steerage. "Theirs is, for the time, a hard lot," he wrote. "They must make many sacrifices to reach the promised land of plentiful work and high wages."

The *City of Brussels* disembarked its long-suffering passengers in New York harbor on October 24. Houghton spent the rest of October, November, and much of December drawing in the East. New York was in full flush of the boom that followed the end of the Civil War. Broad-

twenty thousand copies of the large work (the two-volume *Letters and Notes*) were sold." Harold McCracken states that the *North American Indian Portfolio* (London, 1841) went through five editions in the first year of publication in the United Kingdom alone. Just as influential, but because of their low price among a much wider and younger public, were *Life Amongst the Indians* (London, 1861), his book for boys, and *Last Rambles Amongst the Indians of the Rocky Mountains and the Andes* (London, 1868).

4. Houghton refers to his own reading of Longfellow's *Hiawatha* and Cooper's *Last of the Mohicans* and *The Deerslayer* in his articles. See, *Graphic,* July 16, 1870:57, and July 23, 1870: 88.

5. See, *Graphic,* March 12, 1870: 345–48, "On the Atlantic Steamer," four illustrations, and March 19, 1870:365–69, "In Mid-Ocean," five illustrations.

way belles and bewhiskered Irish cops, crowded downtown streets and ornate barbershops, trotting races at Harlem Lane and Tammany torchlight parades in Union Square, all absorbed his unusual talent for making the unnoticed significant. He went on to Boston, making some memorable images of an old-fashioned, snowy New England winter with streets full of hurrying citizens and horse-drawn sleds. But he was already making plans to go west. A note in the *Graphic* (Feb. 5, 1870: 239), tells us that "Mr. Houghton was on his way from the Strand to San Francisco by the Union Pacific route, calling at Liverpool and New York, and visiting the Shakers at Lebanon and the Mormons at Salt Lake City, and returning east via the Southern States." He did cross the continent to draw the Mormons, he visited the Shakers at Mount Lebanon, and he depicted life in Chicago and on the Western frontier. But no California drawings appeared in the *Graphic,* although some may well have been submitted. More than likely, however, the gregarious Englishman soon discovered that these places, on the way to and in the West—not to mention his experience with Buffalo Bill Cody—yielded much more material than he could possibly have anticipated. Perhaps for this reason his Western scenes are mainly confined to a Pawnee

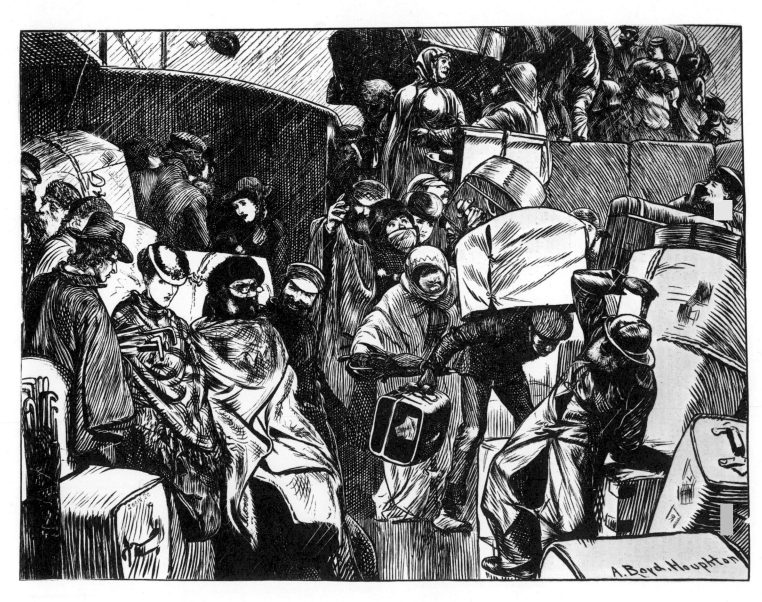

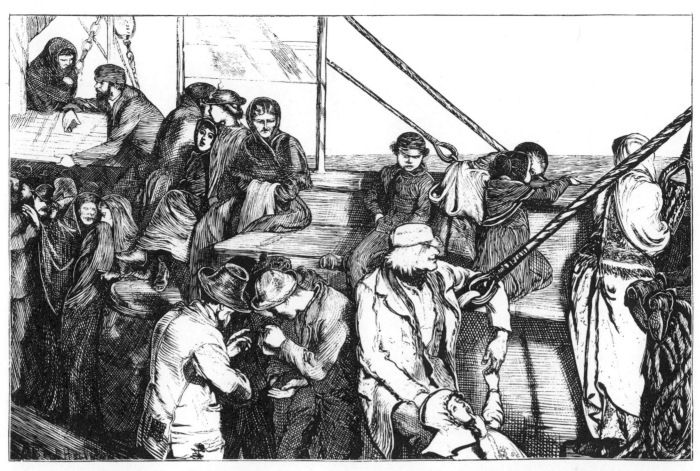

Steerage Emigrants (Top). Wood engraving. *Graphic,* March 19, 1869.

The Embarkation (Left). Wood engraving. *Graphic,* March 5, 1870.

Emigrants (Above). 1869. 5 x 4. Pencil. From the artist's transatlantic sketchbook. Courtesy Museum of Fine Arts, Boston. Harold Hartley Collection.

Seated Young Woman with Heads of Emigrants (Right). 1869. 6½ x 4¾. Pencil. Also from artist's transatlantic sketchbook.

New York Veils (Right). Wood engraving. *Graphic,* April 2, 1870. Houghton thought Broadway much like Oxford Street, London, but "different in the little details which betray the national traits and habits of the people who frequent it."

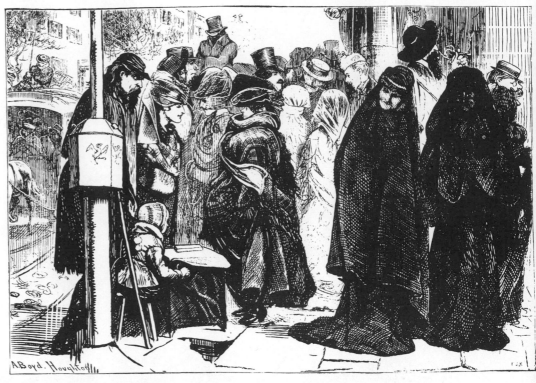

Barber's Saloon, New York (Below). Wood engraving. *Graphic,* April 16, 1870. At the time of Houghton's visit, New York was in the full flush of tremendous prosperity. Such scenes of city life —this one is probably the barber-shop of Delmonico's—provided the artist with rich material to feed his talent for making the ordinary unusual.

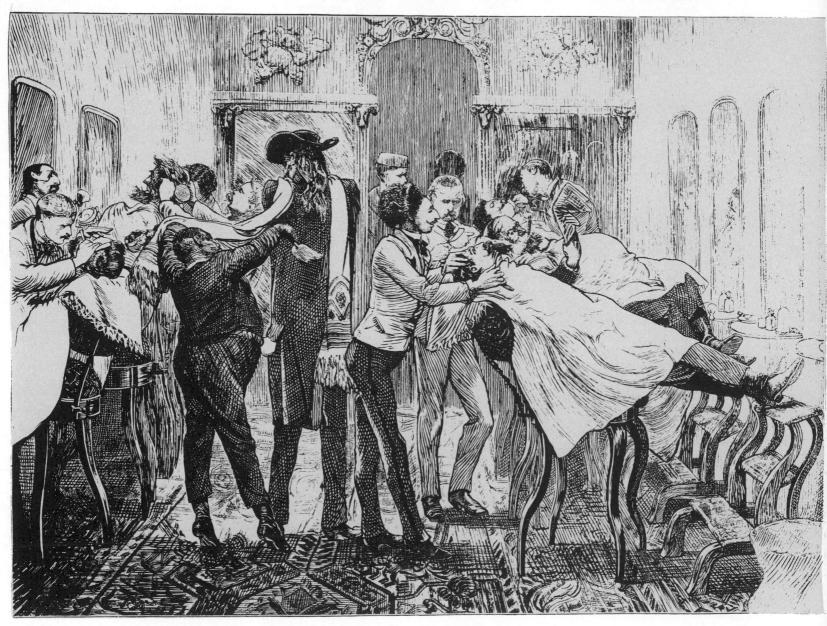

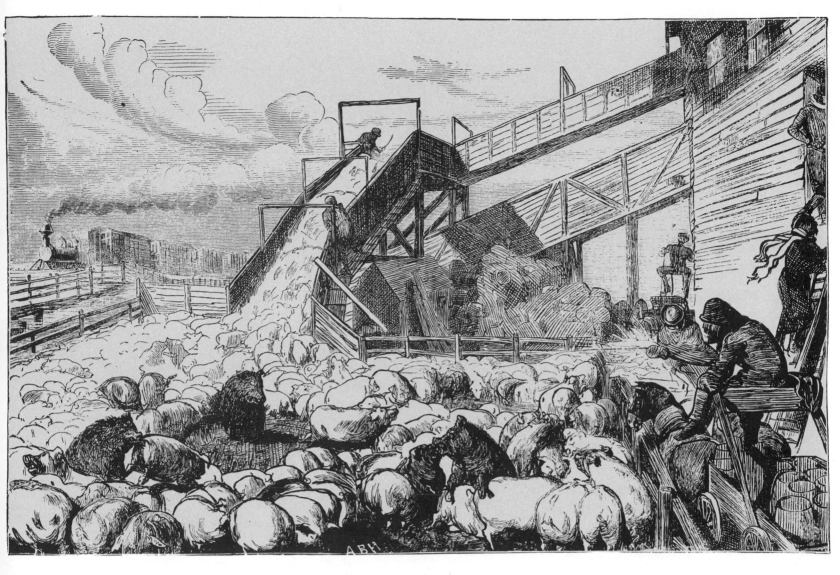

Pig-Driving in Cincinnati (Above). Wood engraving. *Graphic,* July 9, 1870.

Studies for *Pig-Driving in Cincinnati* (Left). 1870. 4¾ x 3. Pencil. From the artist's American sketchbook. Courtesy Victoria and Albert Museum, London.

agency, a buffalo-hunting expedition, and a visit to the Mormons—all subjects easily accessible from the newly opened Union Pacific Railroad.

Houghton was clearly stimulated by these sights and subjects, totally different from anything seen in Europe, and he sent a great amount of work back to England. A total of seventy-two published illustrations, thirty-four of which are Western subjects, were engraved after his drawings. In most instances, they were accompanied by articles or short texts edited from the artist's thoughtfully descriptive notes; for there was plenty of time to write as well as to draw during the long journeys by river and railroad.

Houghton took the train from New York to Buffalo, then continued to Cincinnati via Pittsburgh. "Our artist," the *Graphic* noted, "is off toward the setting sun. We shall now get beyond the thickly-settled cities and country of the Atlantic coast, the thickly-studded eastern and central states; we shall see no more the community of the staid descendants of staidest old Puritan refugees, nor fever-stricken children of Gotham casting their lives away in the pursuit of gold, nor burry-tongued Pennsylvanians with their mush and their Quaker neighbours, and their unpronounceable but exceedingly enviable Dutch patronymics. We are to follow in the unending trail which, for these many years, the vast multitude of emigrants—Irish, German, English, and Swede—have followed in search of new homes and the good fortune promised by a virgin land."

As the train puffed through northern Virginia, the artist was moved to inform his readers of the comfort of the new transcontinental trains. "The modern American train," he wrote, "is a perambulating first-class hotel whizzed by steam across a continent."

At Cincinnati he boarded a river steamer for the trip to St. Louis, where, before continuing his journey by rail to Chicago, he stopped to collect the necessary papers from General Sherman enabling him to visit and stay at Army posts and Indian reservations. He did not remain long in the Windy City—other than to note the beauty and grace of its women—and after a short side trip to the great pine forests of upper Michigan for a turkey shoot, he boarded the train for Omaha. (6)

When Houghton arrived in Omaha, it was late January, and the ground was thickly covered with snow. From inside his warm Pullman car on a Union Pacific express, the artist made a sketch of children sledding in the snow in a skating park, and wrote that "the children have a dashing, vigorous, and lusty look which betrays them as the children of the lusty far-western people." From a bird's-eye view of the city, published in 1868, the scene is readily identifiable as being a skating park situated between Farnham and Jones streets, close by the Union Pacific depot. West of Omaha, Houghton stopped off at Silver Creek or Clarksville and reported to the nearby Army camp at North Loup (later Fort Hartsoff) to arrange for a visit to the Pawnee reservation, then located in a fork of the Loup River near Genoa,

6. See, *Graphic,* December 23, 1871: 603. Houghton wrote that he was armed with a wonderful three-barrel gun (single-barrel shotgun above, rifle below,) while his companions each carried a Hawkins rifle. But the party was unlucky. "We unfortunately sallied forth, without dogs, and pounded along the corduroy road [a road made of logs] till we came to a likely place." Then "we skulked into the woods, and did our best, which was simply fun for the 'bubbley-jocks,' as without the canine element they lie as close and as still as hares."

The artist probably stayed at McPhersons Hotel, as a pencil sketch

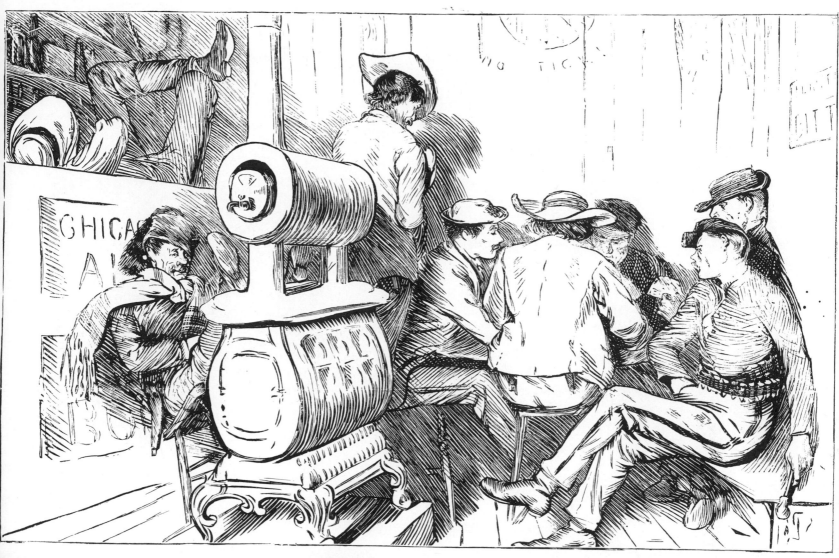

On Board the River Steamer—Playing at "Seven-Up"
(Above). Wood engraving. *Graphic,* July 9, 1870. At Cincinnati, Houghton boarded a steamboat which took him on the Ohio River to Louisville and Cairo, then up the Mississippi to St. Louis. He was appreciative of the grace of build, splendor of ornament, and luxurious comfort of the steamboats, but confessed to being in a perpetual state of nervous terror. "These great snorting steamboats," he wrote, "have a chronic propensity for racing. . . . There is no [more] fascinating or more dangerous sport; and when the steamboat, straining its iron lungs, and shooting out its hot breath in quick succeeding flames, ploughs through the waters and scrapes wildly over the snags and stumps you not only forget the dangers, but yourself urge on the race, and would throw on another shovelful of coal did you [not] know it would send the boiler howling in mid-air. Meanwhile, below stairs in the cabin, some of our rough-hewn Western friends are smoking and playing their favourite game of 'seven-up.' "

Study of Card Players (Left). Sketch for group in *On Board a River Steamer—Playing at "Seven-Up."* 3 x 4¾. Pencil. From the artist's American sketchbook. Courtesy Victoria and Albert Museum, London.

A Scene in the Prison at Chicago. Wood engraving. *Graphic,* July 9, 1870. Like Charles Dickens and other zealous Victorians, Houghton habitually observed low life whenever he found himself in a big city. Here the artist depicts himself inspecting the notorious lockup under the old Town Hall.

Sisters of Charity in Chicago. Wood engraving. *Graphic,* July 9, 1870. "There are," wrote Houghton, "communities of Sisters of Mercy in every part of the United States . . . [they] earned from the nation a heavy debt of gratitude during the Civil War by giving aid to the country's wounded heroes."

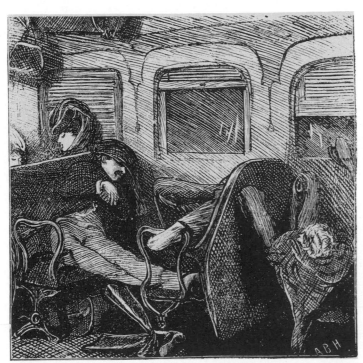

Taking a Nap. Wood engraving. *Graphic,* June 17, 1871. Eager to get to the West, the Artist left Chicago for Council Bluffs, Iowa, by the Chicago and Northwestern Railroad. Alas, the sleeping car was full and he was doomed to endure "the outrageous positions in which sleeping souls have for the moment to place themselves."

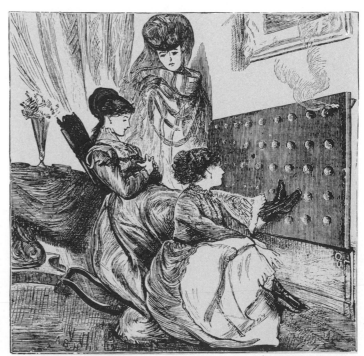

The Foot Warmer. Wood engraving. *Graphic,* June 17, 1871. In his hotel at Omaha, the artist was intrigued to find "some jauntily dressed young ladies, posing themselves before a unique contrivance . . . a flat square iron arrangement, hollow within, tight without; connected with pipes which come along the walls and through them." It was Houghton's first encounter with steam central heating!

of a young woman entitled *Bed-Maker, McPhersons, Tuscola* appears in his sketchbook. A scribbled note also gives the address of William Shafter of Tuscola, who may have been one of his hunting companions.

7. *Graphic,* July 23, 1870:88.

Nebraska. The Pawnees had provided a large number of scouts and mercenaries for the cavalry regiments stationed in the region, and in turn had received protection from attack by their old enemies, the Sioux. The Indian agent, Jacob M. Troth, probably acted as guide, for his name and address were written by the artist in a pocket sketchbook.

Several days at the agency provided Houghton with subjects for some of his best illustrations of frontier life, notably *Bartering with Indians, A Smoke with the Friendlies,* and *Pawnee Squaws.* These, together with a group of smaller drawings, formed a unique, if sad, report on the last phase of traditional Pawnee tribal life in and around their permanent villages of ancient earth lodges in eastern Nebraska.

Circulating in the village, the English artist soon discovered that his Pre-Raphaelite image of the noble and uncorrupted savage was completely outdated and had been replaced by the "commonplace reality of these modern days." He found that the Pawnees loved to gamble either inside their lodges or outside on the prairie, and that their favorite games, like those of most western card players, were seven-up, high–low–jack, whist, and euchre. "They are shrewd players," he wrote, "and can cheat as deftly as did the men with whom Little Nell's grandfather played in the churchyard." He also found they liked to get drunk on "fire-water," although he thought it very likely that the Indians derived their first experience with the beverage from the pleasure-loving Cavalier colony of Virginia, the Catholic one of Maryland, or just as likely from the English and French settlers of Canada. (7)

Houghton did, however, find something of the uncorrupted savage as he watched a group of Indian boys playing the traditional hoop and pole game. He depicted the scene, entitled *North American Indian Sports,* with lyricism as well as an obvious sympathy for the participants. The game itself, which was extremely popular among the Pawnee, was played on smooth ground with a small hoop or ring, six inches in diameter and poles or sticks about four feet long. The aim was to dart the point of the stick directly through the hoop and catch it on the two prongs at the heel. It was usually played by two competitors, although Houghton shows six. One of the players rolls the hoop in front of the others, and each tries to dart his weapon through the moving circle.

But the modern traveler, concluded the artist, must look long before he finds the musical laughter of Minnehaha and other belles of the forest. Were it not for their dress it would be difficult to imagine their sex. The faces of Indian women were wooden in their hardness and had a fixed expression. "That femininity is not feminine," wrote Houghton, "among the aborigines is easily accounted for when we think of the hard climate to which they are subjected, the fearful drudgery which they are called upon to undergo, and the enthralled condition in which their lives are passed."

Turning to the subject of love, Houghton thought it strong in the aboriginal breast. "The Indian," he wrote, "has a lion-like, chivalrous,

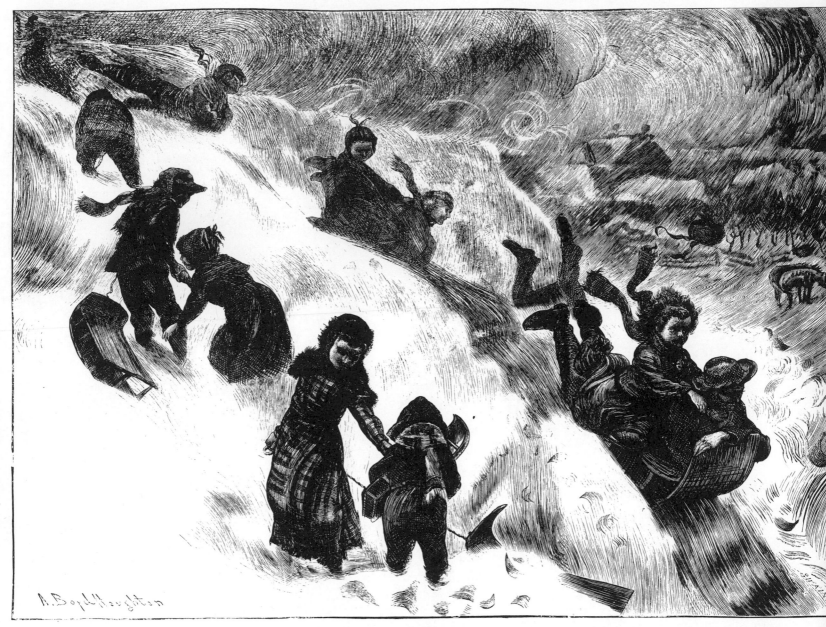

Coasting at Omaha. Wood engraving. *Graphic,* January 19, 1871. Omaha, Houghton found, was "one of those wonderful mushroom towns whose growth is almost visibly apparent." From inside the warmth of a Pullman car in the Union Pacific depot, Houghton looked out onto the park between Farnham and Jones streets and made a sketch for this scene of children sledding in the thick, crisp snow.

and often touching affection for his squaw, which causes him to guard her with extreme jealousy, often impels him to murder, and which is never dimmed by age, by ugliness, or even drunkenness." The same rudeness and strength characterized the relationship of an Indian mother for her children. "The Indian mother loves her boy, but she is not tender with him. From his earliest years he is . . . forced to take long journeys over craggy mountains, through boundless forests, and across dreary prairies, either jolted and shaken in the stiff basket at his mother's back, or when old enough, trudging by his warrior father's side. . . . While the white boy is crouched over his Latin Grammar, his mental arithmetic, and his History of the American Indian, the copper-coloured boy has already caught the infectious excitement of the chase, and has learned to plunge deep into the forest, among howling wild beasts and dangerous solitudes." (8)

8. *Op. cit.,* March 4, 1870:204.

As Houghton traveled further into the great open land of sky and tall grass, he wondered at the grandeur of the West. "After all that is written," he said, "it is hard for any reader who has constantly lived amid a thickly-settled civilisation to conceive of the sights and scenes of the wilderness in western America. The magnitude of its objects baffles the would-be delineator at the outset. Who can bring before us, either on canvas or in words, the effect of those prairies in which, although flat for miles and miles, men get lost, and die of starvation—whose wavy monotony is only broken by the wide and perfect circle of the horizon; of whose mountain ranges and those deep-down valleys which the world-wide traveller tells us are hardly matched in magnitude and grandeur by the Himalayas themselves."

Although the artist found the great silence of forest and mountain beautiful and sublime, he noted that the "vividly brilliant Western sky could become an unpitying and mocking firmament" unless you occasionally received the "rare and living message," and went on to add, "let the adventurous Cockney who thinks he would like 'that sort of thing'—meaning an extended residence in log huts, on solitary ridges, amid countless forests, and who has his daily newspaper with his coffee three-hundred-odd days a year, imagine a Daily [newspaper] coming out monthly, and then coming months after the date. Wars and rumours of wars have come and gone, ministries been overturned, the last aristocratic scandal been aired and forgotten, friends have been burned out, and our own valets have come into fortunes, but we know not of it, and mayhap, never shall." (9)

9. *Op. cit.,* July 29, 1871:117.

Houghton penetrated deeper still into the Great Plains, along the Union Pacific to North Platte, Nebraska. February was the best time to hunt buffalo. Edmund J. Sullivan, in his tribute "An Artist's Artist," quotes the artist's daughter Mrs. A. B. Davis as saying that her father met Buffalo Bill Cody and it was he who took Houghton buffalo-hunting. Cody, twenty-four, and over six feet tall, looked magnificent in a buckskin jacket, black slouch hat, and long hair hanging

10. While Houghton was still in Boston, the first installment of Ned Buntline's serial "Buffalo Bill, the King of the Border Men" appeared in the *Boston Transcript* (December 15, 1869) and in the *New York Weekly* (December 23, 1869). It was widely advertised as the truest and wildest story Buntline had ever written. This was probably read by Houghton, arousing his interest in Cody as well as the hope of meeting him on his trip through the West. At this time, the legendary Cody was retained by the Army as chief of scouts attached to the Fifth Cavalry under Brevet Major General Carr, stationed at Fort McPherson, Nebraska. During the long intervals in campaigning against hostile Indians, Cody had plenty of time on his hands; he became a sought-after guide for the hunting parties of American and foreign notables. It was during this period (1870–72) that Houghton met him. Cody briefly refers to the artist's visit in his autobiography. See, W. F. Cody (Buffalo Bill), *The Life of William E. Cody* (Hartford, 1879), 268: "During the winter of 1869–70, I spent a great deal of time in pursuit of game, and during the season we had two hunting parties of Englishmen there, one party being that of Mr. Flynn, and the other that of George [*sic*] Boyd Houghton of London—the well-known caricaturist [*sic*]." Cody's memory cannot always be relied on. There may even have been only "a [single] party of Englishmen, most prominent of which was Boyd Houghton . . . ," as stated by Elizabeth Jane Leonard and Juliet Cody Goodman, *Buffalo Bill, King of the Old West* (New York, 1955).

11. Major W. H. Brown (1837–75) of the Fifth Cavalry, was a veteran of the Civil War, and by various accounts, a gregarious and courageous character. He was stationed at Fort McPherson, 1869–71, and before the buffalo hunt had participated in several local actions against hostile Indians, including the Republican River expedition and the Niobrara pursuit. He is probably the well-fleshed, cowled, seated horseman supervising the crossing of Ash Hollow in *Crossing a Canyon;* and also the cowled, seated figure at the feast in *Buffalo Hunting —Camping Out*. He afterward partic-

over his shoulders. Out of this convivial excursion came some of the finest and most interesting illustrations of the entire series. (10)

The favored locale of these hunting parties was the tall-grass country between the Platte and Republican rivers, which abounded with game, particularly buffalo. Usually under the patronage of the Army, the parties started out from Fort McPherson. Fortunately for the artist, the winter of 1869–70 was a peaceful one on the northern plains, so the Army had time enough to join in the sport themselves. Special Order No. 19, dated February 15, 1870, issued by headquarters at the fort, authorized Brevet Lieutenant Colonel Campbell Dallas Emory, Captain of the Ninth Infantry, to command a mixed unit of the Ninth and the Fifth cavalries on a hunting expedition. Besides Houghton and Cody, the party included Brevet Major W. H. Brown, (11) who first introduced Cody to Ned Buntline, and who subsequently became a character himself in a dime novel.

For the romantic Houghton, the buffalo hunt was a completely new experience. Alternately enthusiastic and philosophical at the prospect of being involved as a participant as well as an observer, he exclaimed: "Off to the plains! It is nothing less than inspiring—this thought of leaving civilisation all behind, to become a much-discovering Columbus among the new and likely enough hitherto untrodden wilds. You half canonize yourself as a hero as you start out on a genuine buffalo hunt. The sport is Titanic—meat for gods and savages. How puny seem the home sports that your friends are indulging in with such zest 'in the north of Scotland.' You're fain to chuckle that henceforth you will take rank with the whilom [*archaic:* former] denizens of India who have returned to relate glowing tales of hair-breadth 'scapes by flood and field, in tiger jungles and the haunts of elephants; and that they will not alone win, unchallenged, the breathless admiration and sweet plaudits of the Desdemonas of West-End drawing-rooms." (12)

After journeying up and over the rolling sandhill country southwest of Fort McPherson—where all hands had to turn out to help the wagons across gullies and canyons—the party entered the pleasant, undulating habitat of the Republican River buffalo, and camped on Red Willow Creek in present Hayes County. Early the following morning, all members mounted and rendezvoused at the starting point of the hunt. It was not long before they spotted their first buffalo standing on the crest of a hill. Houghton was thoroughly impressed by the sight: "There stands the monster, stock still, gazing at them with the strong majestic gaze of his tribe. He is the forerunner, outpost, picket of his particular herd, browsing and keeping guard on the frontier of their domain. A great, tough-ribbed, hard and hairy-headed and bearded bull, he is one of that outer circle of buffalo which is always found among the cows and the young. He watches for two enemies—for the white, or Kiota wolf, a cruel rapacious beast, which stealthily pounces upon their young, their feeble, or their wounded; and for man, in the shape of Indians,

ticipated in several campaigns against Apache Indians in the Southwest, and was promoted to Brigadier General. A full biographical account of his military career can be found in George F. Price, *Across the Continent with the Fifth Cavalry* (New York, 1883).

12. *Graphic,* August 5, 1871: 135–6.

13. *Op. cit.,* July 29, 1871:117.

14. *Op. cit.,* August 5, 1871:135–6.

15. Cody, *Life of W. F. Cody,* 268.

16. This date was supplied by Marilyn Seifert of the Office of the Church Historian, Salt Lake City, who kindly checked the ms. history of Brigham Young.

who vie with the Kiota in their cunning and their greed. For while the white man attacks the buffalo face to face in the open day, the red man resorts to stratagem to entrap his prey. He poisons his arrows and conceals them in his breast; he envelopes himself in the Kiota's skin, and imitating the sneaking movements of the wolf, will follow and hang about a herd, often for miles. . . . The Indian is tigerlike in his ferocity when hunting the buffalo; his eyes gleam, his mouth foams, and his hideously painted countenance flows with the heat of his passion. Our party of whites, however, use their rifles, and when in close quarters, their knives and spears." (13)

The white buffalo hunters were themselves "Indianlike in their thin, high-cheeked, bony swarthy, long-haired, hard-featured physiognomies, as if a contrast with the Indians, and participation in their mode of life, had twisted them into a personal likeness. They are energetic, and matter-of-fact, cool, and daring; not select in language, but given, in a certain sense, to frequent cursory remarks, not mindful of the proprieties, but striding before you, and helping themselves first at table—a barrel top; yet free-hearted and good-tempered, and keenly zealous in sport." (14)

The expedition had been away for several days and had covered almost a hundred miles by the time the hunters returned to make camp in a grove of cottonwoods along the Platte River close to Fort McPherson. Here a "jamboree" or campfire dance took place that involved Houghton in a drinking bout with an unnamed friendly Indian chief. In *Buffalo-Hunting—"A Jamboree,"* a scene reminiscent of Alfred Jacob Miller's *Trappers Dancing Around the Campfire* (drawn some forty years previously), Houghton depicts the party dancing to the improvised accompaniment of a cooking-pot drum beaten by the stock of a revolver. There must have been many such incidents. The famous Cody himself told of how he arranged horse races, in which his champion horses Tall Bull and Powder Face were invariably the winners, for the amusement of Houghton and his party. (15)

The hunting party returned to Fort McPherson on February 23. But some days before, Houghton had reluctantly taken leave of his "hearty, genial, free-spoken" friends. At North Platte, he boarded a train that would carry him to the final stage of his travels, Salt Lake City. The train stopped at various towns and settlements en route, and he made sketches for several additional illustrations.

In Salt Lake City, Houghton stayed at the Walker House Hotel. The American "Turks," he found, were big raw-boned men with goat-tufts on their chins; their women, for the most part, very sorrowful and haggard-looking. He spent most of Sunday, February 20, in the Great Tabernacle, where he listened to the immense organ and a sermon by a "magnetic" Brigham Young. (16) From this experience he produced the masterly double-page illustration, *Service in a Mormon Tabernacle.*

Later, the artist was introduced to the Mormon leader and found him to be "a broad-shouldered, muscular man, nearly threescore and

VISIT TO A PAWNEE VILLAGE

The United States Army was fighting Indians throughout the West. Before the Civil War, Sioux, Cheyenne, and Arapaho took turns resisting the encroachment of their hunting grounds by the white man. After the war, as railroads pushed westward across the plains, the hostile tribes intensified their resistance. By 1868, the onslaught of Chief Red Cloud and his fighting men had closed the forts of the Bozeman Trail. The Pawnees, however, had long before decided that their day was done, that the only course open to them was to live in peace with their conquerors. When Houghton made his visit to the Pawnee villages along the lower Loup River, near Genoa in eastern Nebraska, he found a friendly if somewhat debauched people in the last phases of traditional tribal life. He also found that his romantic ideas of the Noble Savage were out of date. Yet he was receptive enough to see that much remained and to make note of it.

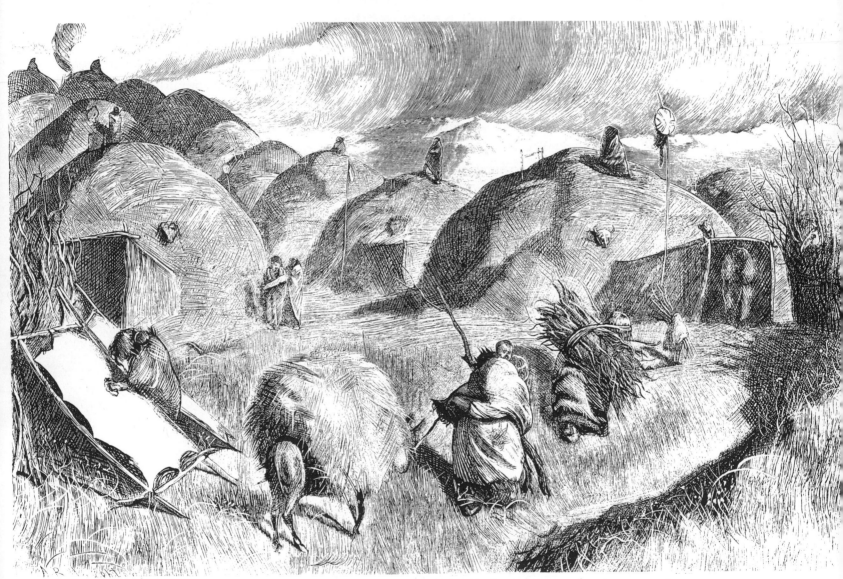

A Pawnee Village in Midwinter Wood engraving. *Graphic,* July 23, 1870.

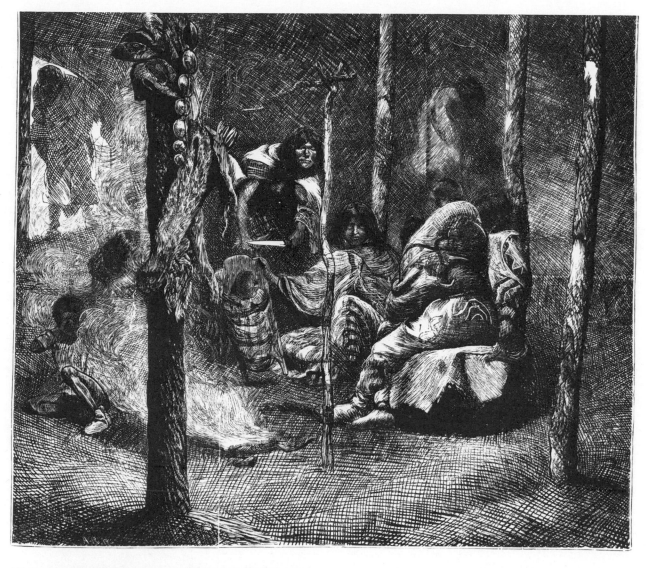

Pawnee Squaws (Above). Wood engraving. *Graphic,* February 22, 1873.

Study of Pawnee Indian (Left). 4¾ x 3. Pencil. Dated February 3, 1870. From the artist's American sketchbook. Courtesy Victoria and Albert Museum, London.

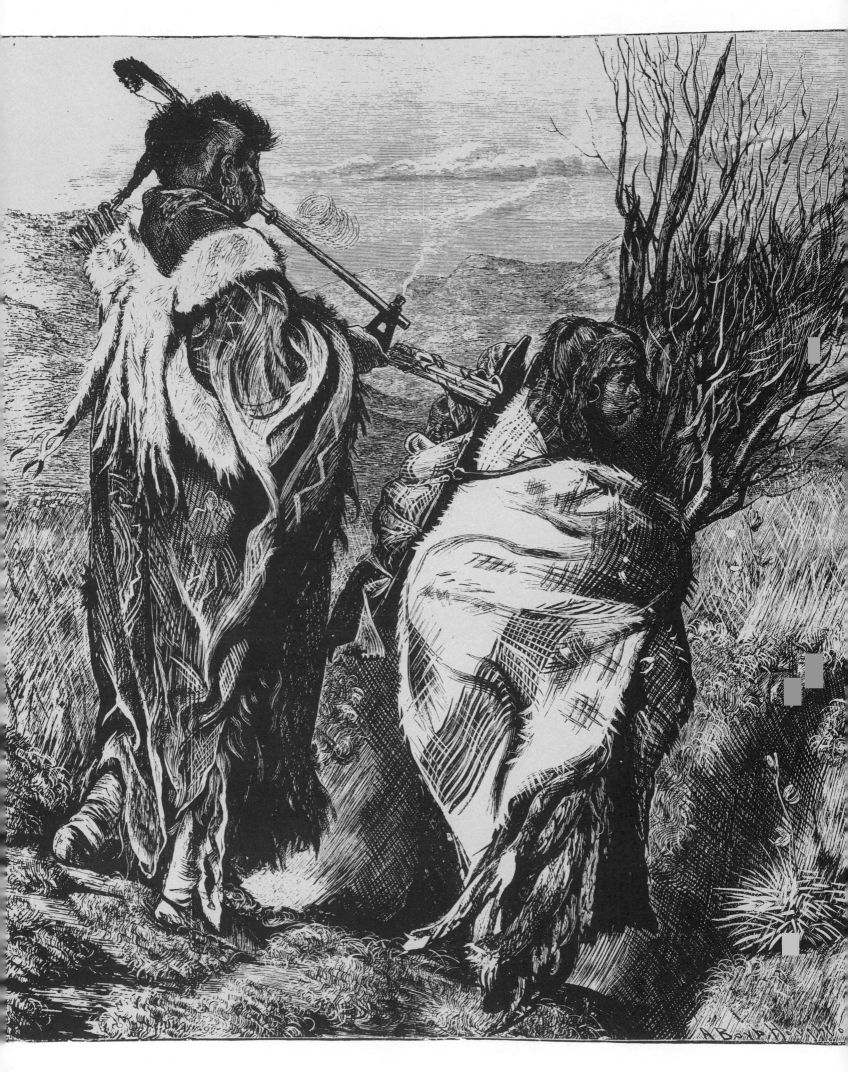

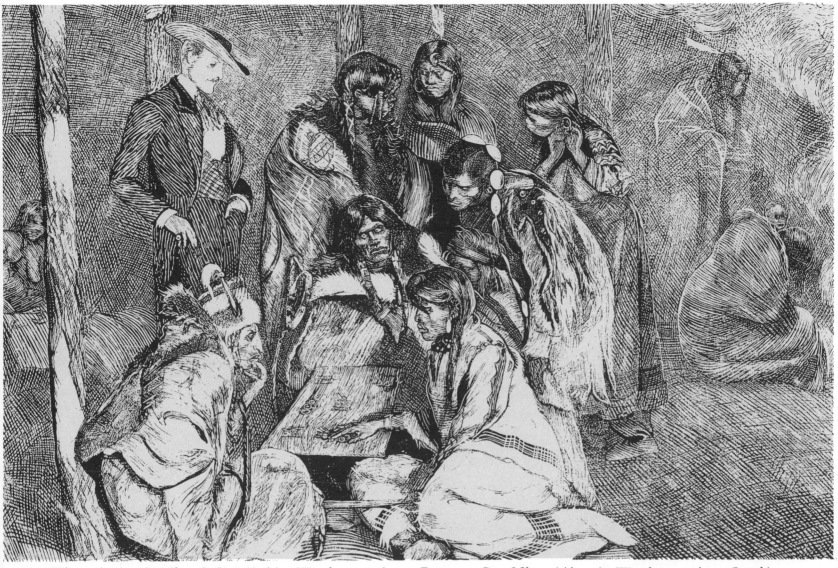

Hiawatha and Minnehaha (Left). Wood engraving. *Graphic,* July 16, 1870. Although in his "Hiawatha" Houghton could well imagine Longfellow's celebrated hero, the artist thought the poem "beautiful but misleading" as far as it applied to the heroine.

Pawnees Gambling (Above). Wood engraving. *Graphic,* July 23, 1870. "The Squaws," the artist wrote, "not only drink as sedulously as their lords, but they gamble even more sedulously." Here Houghton depicts a company of squaws, young and old, deeply engrossed in a game of chance. While the Indians quickly picked up such favorite games of the white man as cribbage, seven-up, high-low-jack, whist, and euchre, gambling had long been a venerable part of their traditional life.

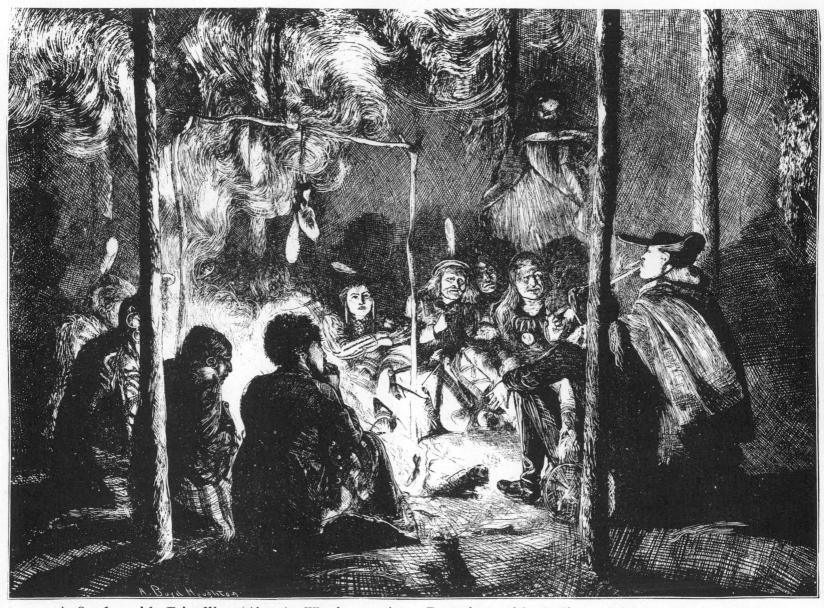

A Smoke with Friendlies (Above). Wood engraving. *Graphic,* November 4, 1871. The artist (the bearded, seated figure on the right) depicts himself with a white companion, possibly the Indian agent Jacob M. Troth, spending a convivial evening with Pawnee elders and braves inside the chief's lodge. Houghton was delighted to find his hosts "good-humoured, inexhaustible in cheery temper and laughter-loving." Warmed by such companionship, he thought the original possessor of the vast interior of America many-sided in character. "He has his faults and his virtues, his whims, foibles, comicalities, his good and his bad points, much as we have, the Pharisees of civilisation." Indian life, the artist concluded, was still as romantic as any that could be imagined and worthy of all the eloquence of the greatest bards.

Bartering with Indians (Right). Wood engraving. *Graphic,* March 11, 1871. "Swapping," wrote Houghton, "is an American passion, especially in the West." The Indian has brought a tomahawk, a pistol, and a fly-whisk, which he is anxious to trade for the smallest amount of tobacco or whiskey to the trading post. "The boy," adds the artist, "is a shrewd, sharp, cautious Western lad, prone, doubtless, to take advantage of the ignorance and eagerness of his customer."

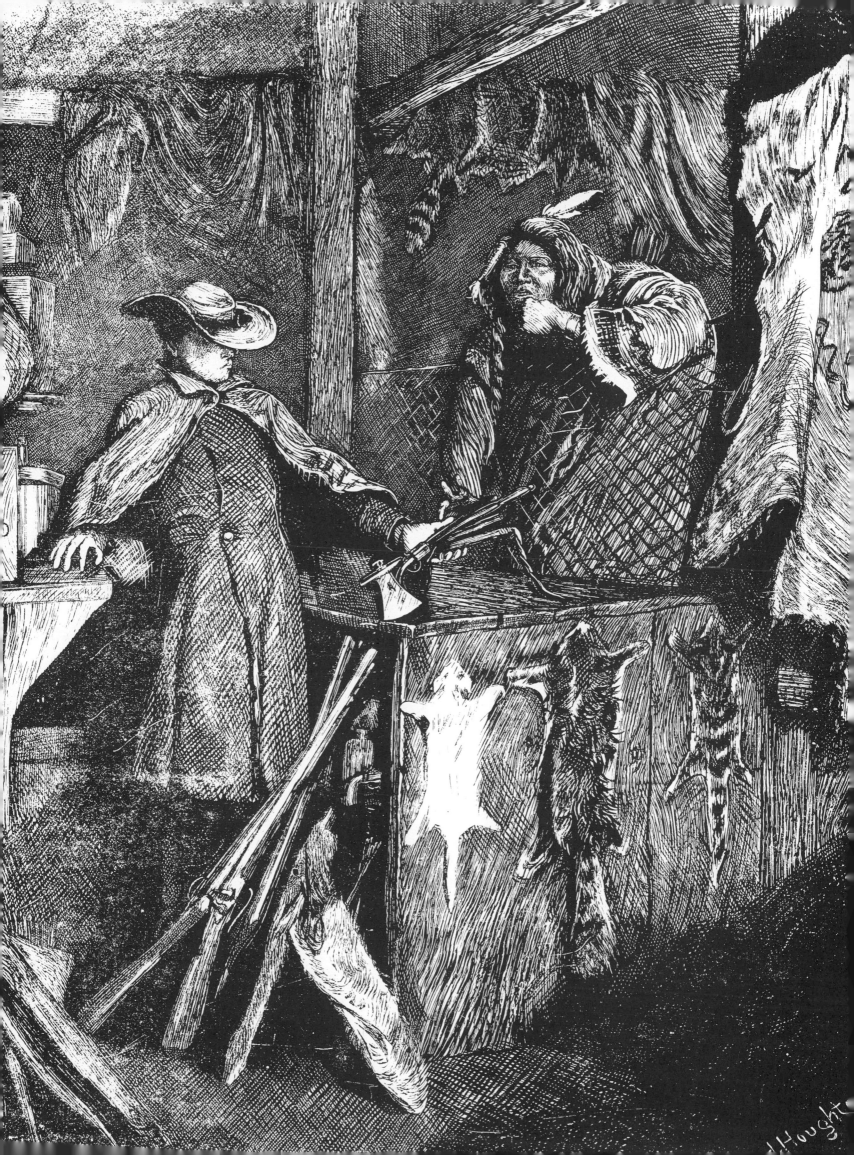

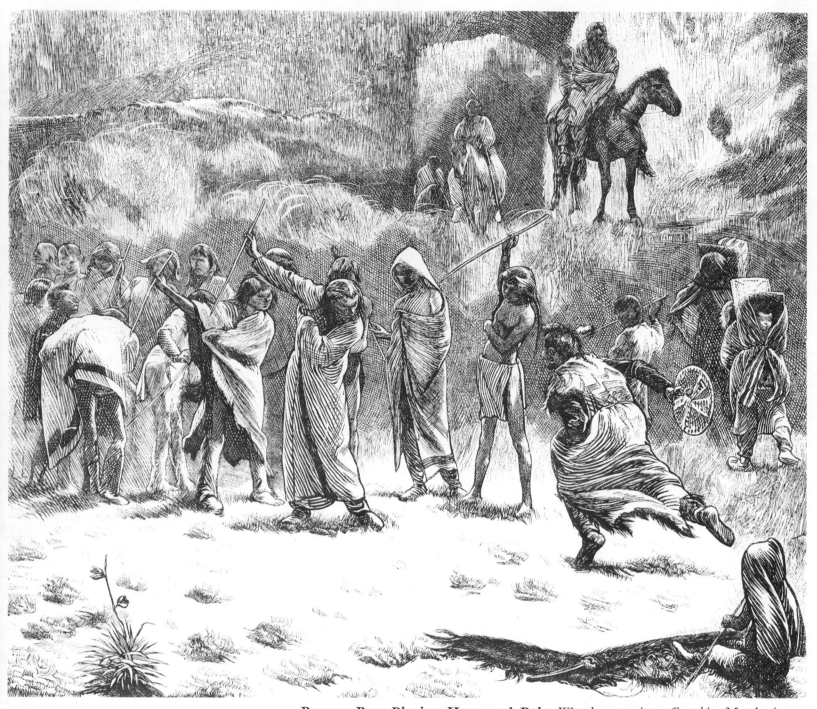

Pawnee Boys Playing Hoop and Pole. Wood engraving. *Graphic,* March 4, 1871. Noting that the games of the Indian were robust and physical, Houghton captioned this illustration *North American Indian Sports*. "His life begins and ends with the culture of the body . . . to overcome by the strong arm is his sole ambition, and if he does it, his supremist honour." Indian girls were no less masculine; they too joined in and "their muscles were as firmly knit as their souls were fearless."

WHEN THE BUFFALO ROAMED

Along both sides of the Platte River was a great open land of sky and grass. This was true prairie, with grass standing well above a man's head. It was a land full of wildlife, the old hunting grounds of the Indian, now already half eaten up by the encroachments of his civilized foe. Houghton thought the prairie sunsets as gorgeous as those in Italy, and the sunrises as brilliant as Turner's, "with an atmosphere of limpid clearness and intoxicating crispness."

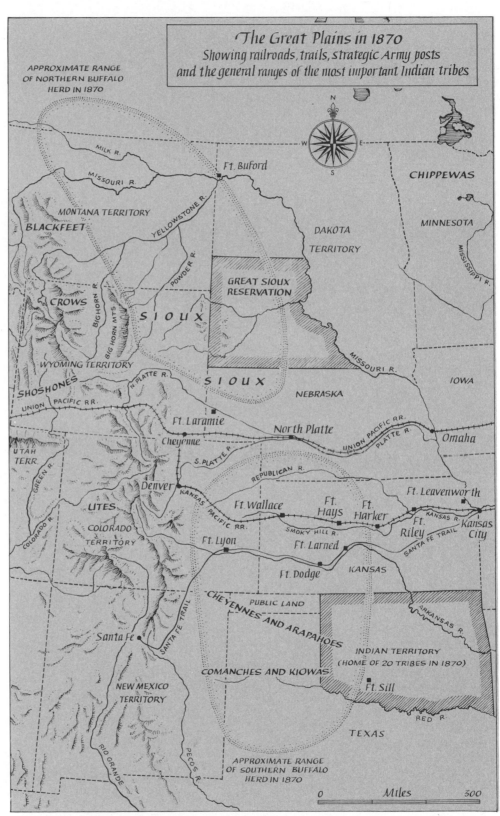

The Great Plains in 1870
Showing railroads, trails, strategic Army posts and the general ranges of the most important Indian tribes

The Great Plains at the Time of Houghton's Visit. From Ralph K. Andrist, *The Long Death* (New York: The Macmillan Company, 1964). Reproduced by permission of the publisher.

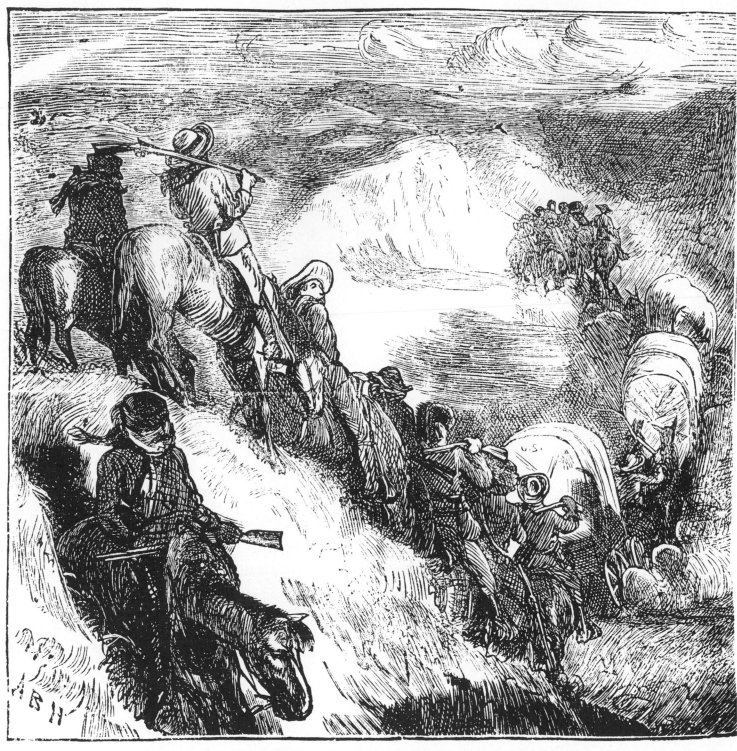

In Search of Buffalo. Wood engraving. *Graphic,* January 14, 1871. "[Our] expedition starts off with much hubbub, shouting and long-tongued zeal. The horses seem to scent already the sturdy strife, and snort and rear as they gallop forward. The drivers of the waggons, with their long cowhide whips, their broad flapping hats, their trousers stuffed into great rough boots, and the inevitable tuft, goat-like, on the end of their chins, stow away in their lantern cheeks a full quid of 'old Virginny,' take a final and long lingering pull at their whiskey flask, and shout their 'Go ahead, old Dobbin!' The hunters, accoutred not unlike the waggon drivers, armed cap-a-pie for the sport, are tramping off, some on foot, some leaning out of the back of waggons, the larger portion on horseback. All are in gay spirits, and the tobacco and whiskey are already in requisition. . . . The train winds out of the inhabited places; the hamlets become less and less frequent; the wheatfields and mining stations disappear one after another; nature resumes in the wilderness its virgin majesty; and you are at last among trackless hills and strange solitudes, experiencing a sensation which you recognize as wholly new."

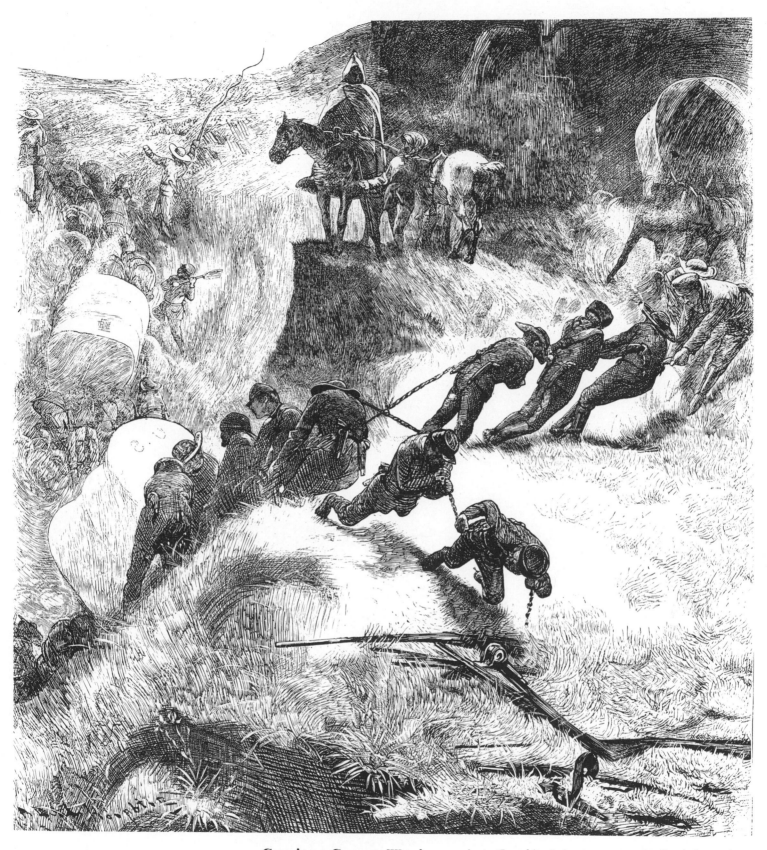

Crossing a Canyon. Wood engraving. *Graphic,* July 29, 1871. At first, the going was difficult. "All hands turn to, and likely enough, the hands which you brought kid-gloved and sleekly soft from Pall Mall club and West End drawing-room will be drafted into service now," Houghton wrote. "The beasts require much 'gee-ing' and 'haw-ing' not unaccompanied by sharp whip-cracks, and not too gentle 'slab-sided' blows. Meanwhile, one of the chiefs of the expedition sits aloft on the neighbouring ledge, overlooking the difficult operation below, now and then shouting out 'A little tighter, you there! Jake, give him more rope—slack down, you coons, slack down!' "

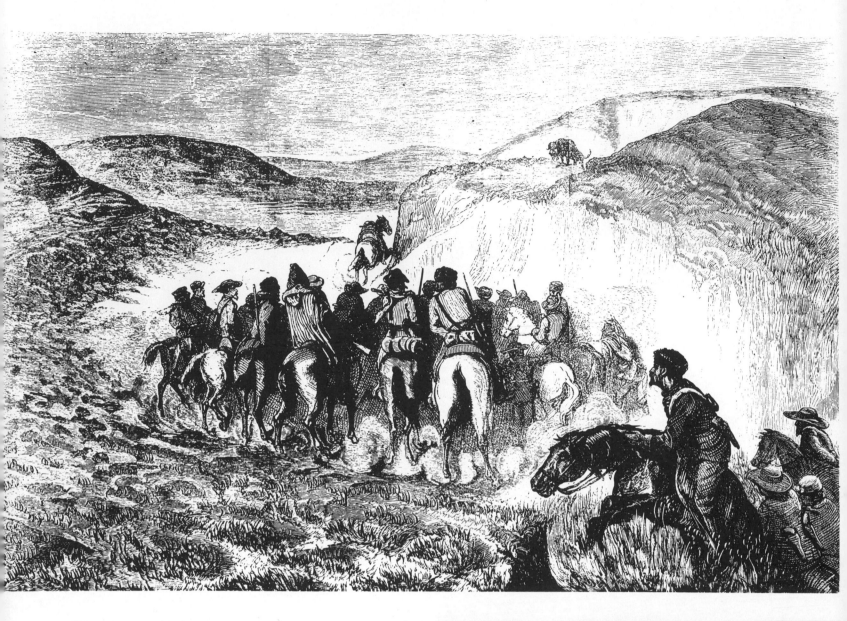

The First Buffalo (Above). Wood engraving. *Graphic,* July 29, 1871. The party suddenly halts. "Not far off has appeared, on the crest of a hillock a little above them, the first buffalo, which has gladdened their eyes and made the pulse of all beat faster."

Coming to Grief (Right). Wood engraving. *Graphic,* January 14, 1871. "One of our sportsmen," wrote Houghton, "has apparently had the bad luck to be provided with an independent-minded steed which has pitched him squarely over his head, and at the unluckiest of spots, for he finds himself rolling headlong down a steep craggy hill, with a dismal prospect ahead, in the shape of a yawning gap."

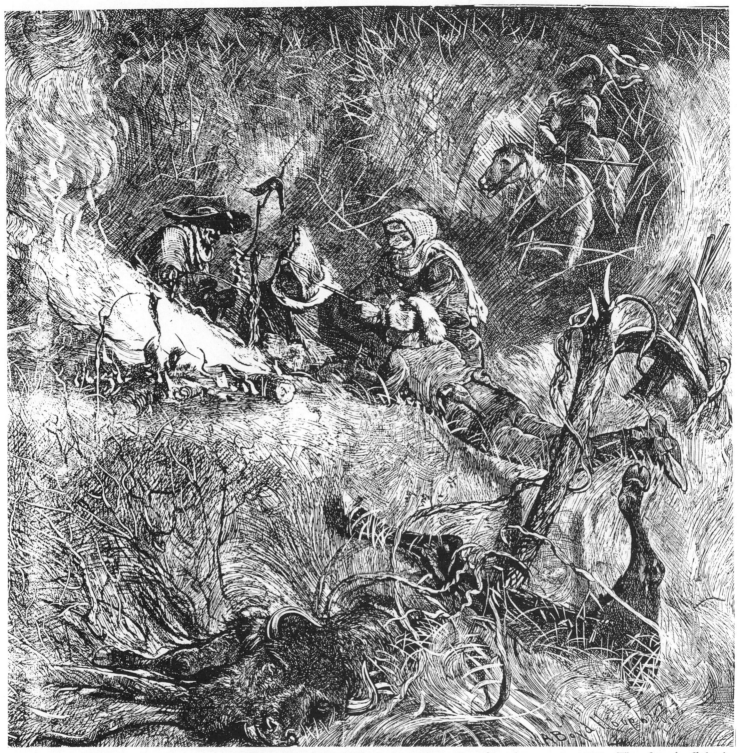

Camping Out. Wood engraving. *Graphic,* August 5, 1871. The first buffalo is shot, "and a real Anglo-Saxon cheer rings through the wilderness." The heroes of the day stretch themselves at twilight, full upon the soft grass, tired, yet full of the great event of the day, talking over its many incidents and mishaps, disputing, possibly not without profanity and heat, who shot the effective shot and brought down for good and all the mighty victim. "Mostly," continued Houghton, "the talk is generous and jolly, in the general good humour inspired by success, and aided, no doubt, by the whiskey and tobacco, long untouched, but which is now passed around without stint, and is abundantly patronised. The great deep red steaks that are deftly sliced by the cooks of the party off the animal, and as deftly broiled over the camp fires, and laid sizzling and hot before the hunters, appeal strenuously to the palates of the hungry fellows, and vie with the best which are served up in the famous steak-houses of the City [of London]. So day after day passes amid new dangers, compensated by new triumphs."

On the Scout (Above). Wood engraving. *Graphic,* March 9, 1872. While all the feasting was going on, the hostile Sioux were never far away; someone had to keep a sharp lookout for "stealthy, painted and feathered foes." On this occasion, it was the turn of the "captain" of the expedition—Buffalo Bill Cody himself—"crouching on a tree branch, with his gun tightly clutched, watching for hostile Indians."

A Jamboree (Right). Wood engraving. *Graphic,* September 23, 1871. Returning from the hunt, the party made camp in the cottonwoods along the Platte River, where they indulged in a more jubilant celebration—a jamboree or spree of monumental proportions—in which Houghton became involved in a drinking bout with a friendly Indian chief.

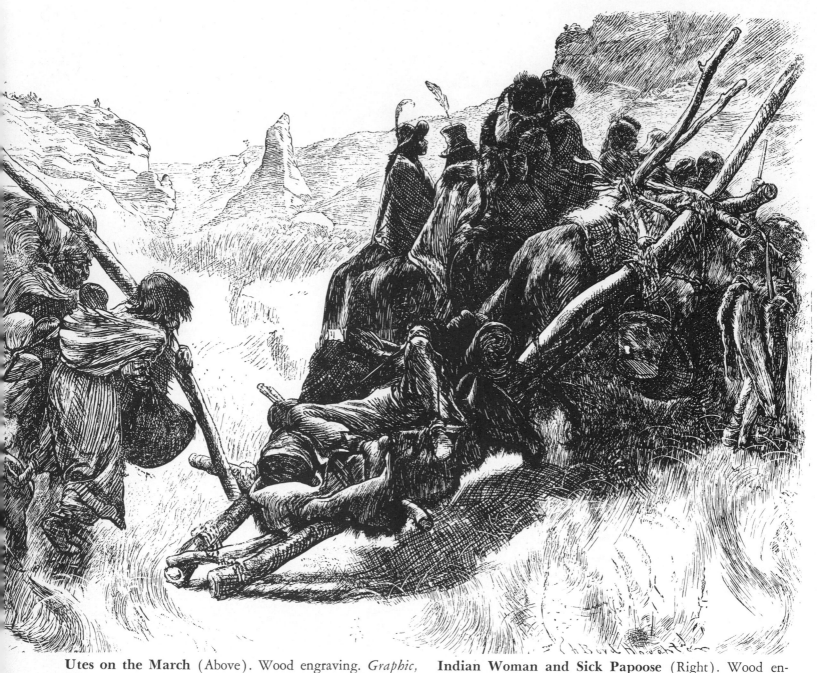

Utes on the March (Above). Wood engraving. *Graphic,* February 17, 1872. Leaving Fort McPherson, Houghton resumed his journey on the Union Pacific to Ogden and Salt Lake City. More than likely he saw this statuesque band of itinerant Utes from his Pullman car between Ogalala and Scotts Bluff. He noted the fondness of the male Indian for the cast-off finery of the white man. "They seize with great eagerness," he wrote, "on a shabby old silk hat, bound with a piece of tattered crepe, but they invariably surmount the prosaic stove-pipe head gear of civilised life with a feather." The squaw, "loaded with her papoose, her cooking apparatus and tent, trudges behind."

Indian Woman and Sick Papoose (Right). Wood engraving. *Graphic,* September 30, 1871. "The ancestors of this poor Indian woman were once the undisputed lords of the soil," wrote Houghton, pointing up the contrast between the settled life of the white pioneers and the nomadic life of the Utes.

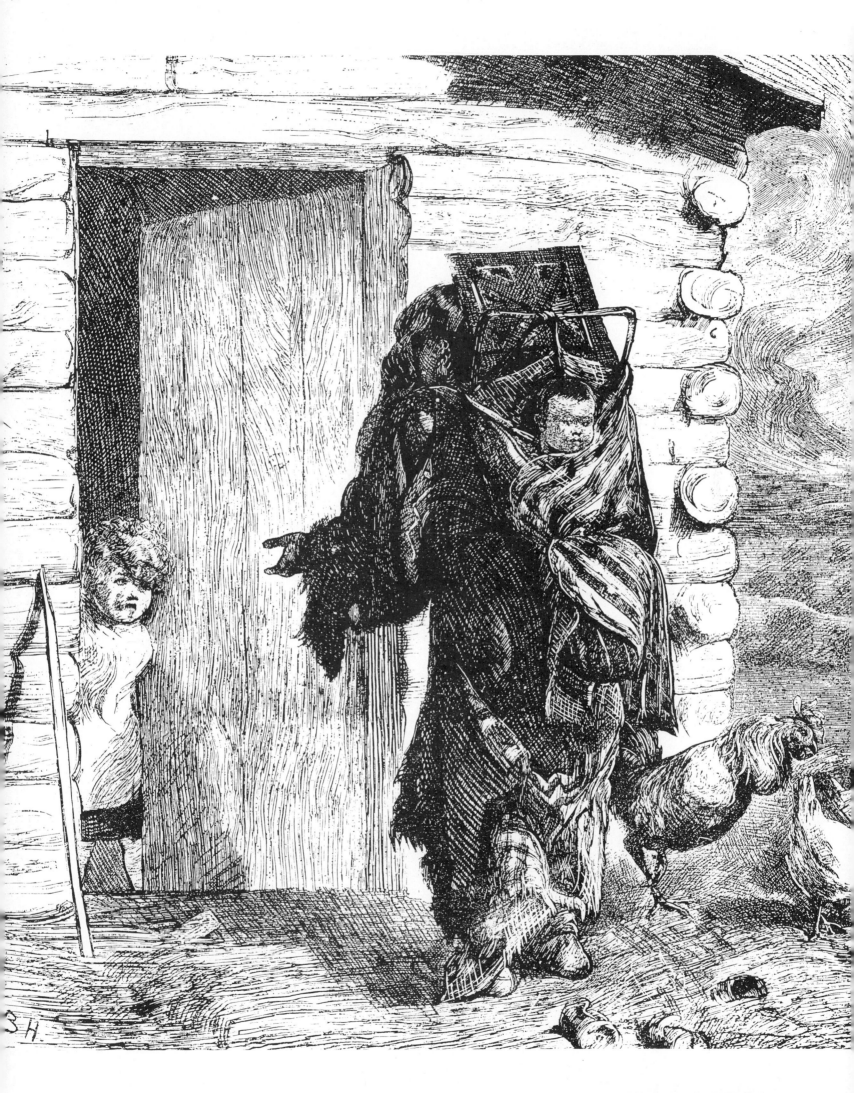

AMONG THE MORMONS

In 1847, "led by the Lord's providence," Brigham Young organized and led the settlement of Great Salt Lake Valley. Here, the Latter-day Saints, or Mormons, would be safe from the persecution they had known in Ohio, Missouri, and Illinois. Strong in faith and purpose, they plowed and planted, dug irrigation ditches, built houses, and founded towns. By 1860, more than 200,000 Mormon settlers were prospering in the future state of Utah. The majority had been recruited from the dispossessed and downtrodden of England, Scotland, Wales, and Ireland by a formidable missionary system which promised their Western domain to be as rich as Eden itself. Because Victorian England was concerned with religion, the Mormon Zion was a success story of particular interest to the readers of the *Graphic*. Houghton was traveling a well-trodden path; he was but one more in a procession of distinguished visitors curious to see the patriarchal, polygamous paradise. But he was the first English artist to make the trip and record his impressions since Frederick Piercy made his epic journey in 1853, chronicling his travels in *Route from Liverpool to Great Salt Lake Valley* (Liverpool, 1855).

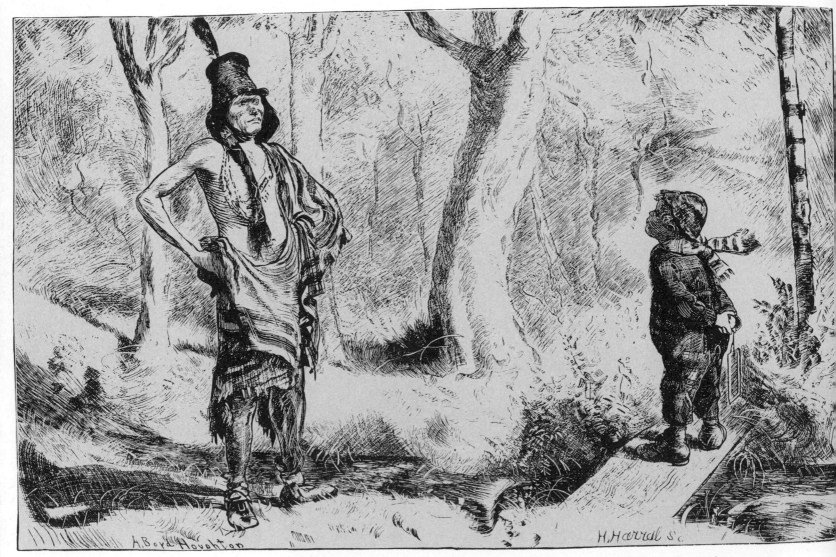

Great Hawk and Small Mormon. Wood engraving. *Graphic,* September 9, 1871. Houghton thought this former occupant of Deseret Territory, although not one of James Fenimore Cooper's chivalrous, graceful warriors, decidedly more picturesque than "the big raw-boned-looking men, with goat-tufts on their chins."

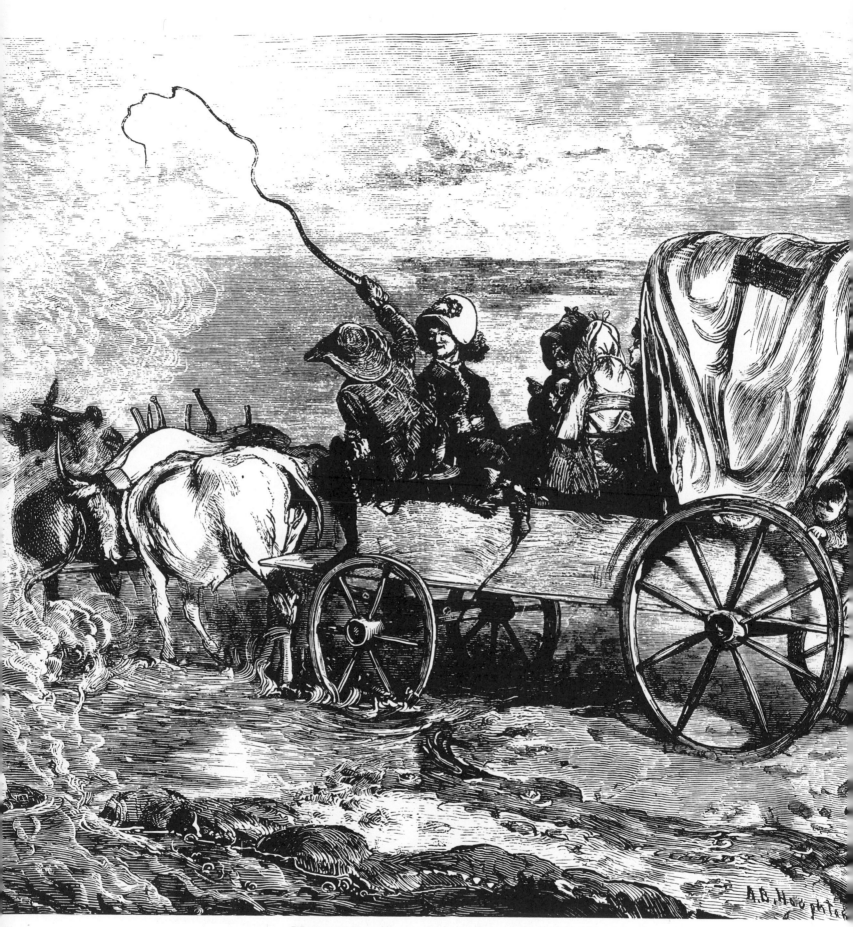

Mormon Family on their way to Salt Lake City. Wood engraving. *Graphic,*
November 4, 1871.

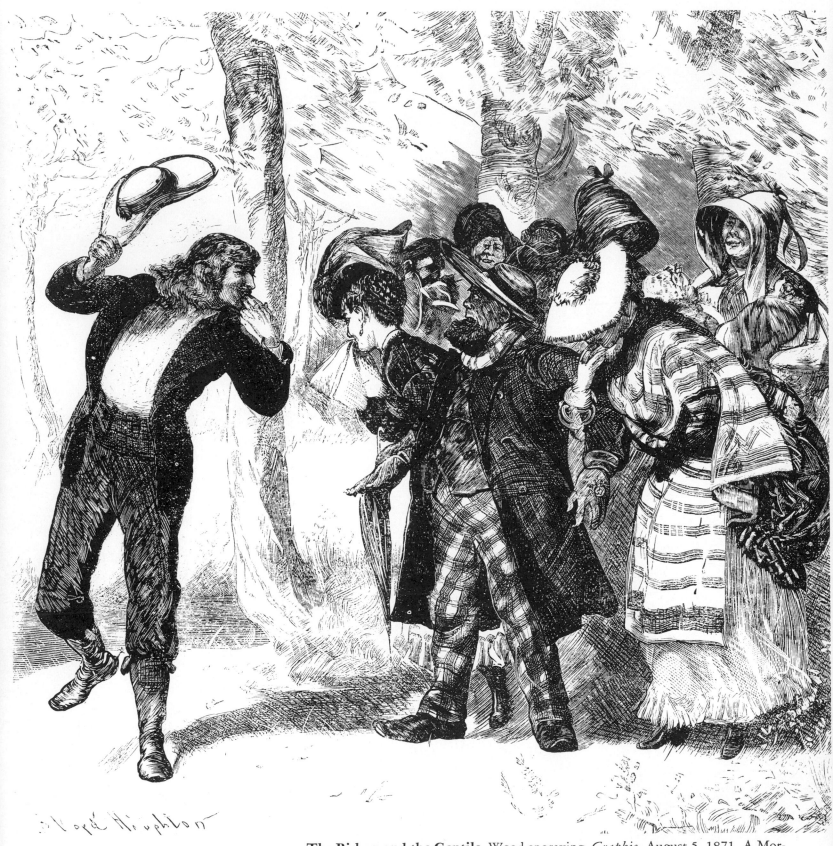

The Bishop and the Gentile. Wood engraving. *Graphic,* August 5, 1871. A Mormon Bishop, whom Houghton had heard addressing his flock, had protested that he did not hate Gentiles but preferred that they keep their distance. Houghton himself clearly thought there was another reason for these likes and dislikes.

Cornered (Left). Wood engraving. *Graphic,* July 8, 1871. Houghton found the streets of Salt Lake City "rectangular, and beautifully adorned by plenteous and umbrageous trees; and the houses of the Mormons, every one with its garden and grass lawn, its fruits and flowers, seem to the outward eye veritable abodes of homelike comfort." He shows us a little Mormon girl he found in one such house.

(Overleaf)
Service in the Mormon Tabernacle, Salt Lake City. Wood engraving. *Graphic,* September 2, 1871. Houghton spent most of one Sunday in the Great Tabernacle, where he sketched the administering of the Sacrament and listened to a sermon by prophet Brigham Young himself.

Sketch for *Service in the Mormon Tabernacle, Salt Lake City* (Below). 3 x 4¾. Pencil. From the artist's American sketchbook. Courtesy Victoria and Albert Museum, London.

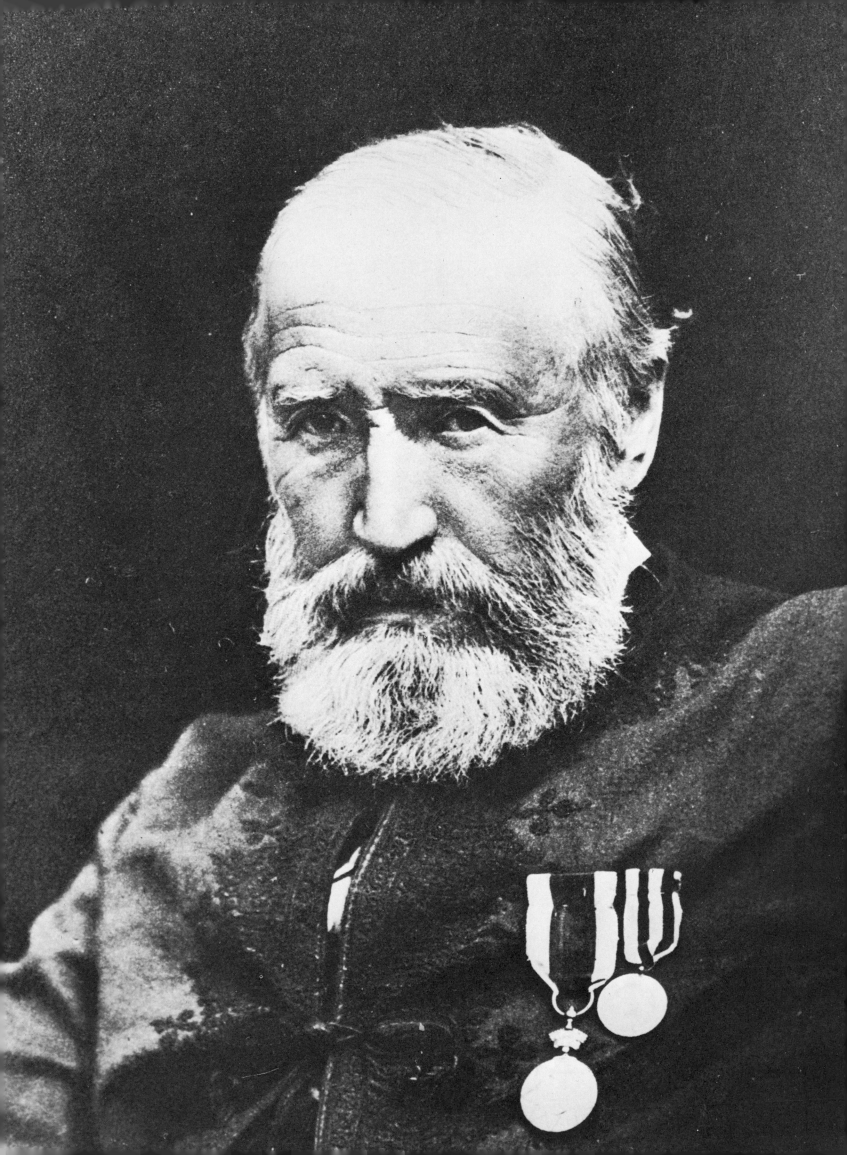

4. Witness to an Indian War William Simpson 1873

"The sense of justice in human nature must declare that these tribes have been cruelly wronged." William Simpson (*Meeting the Sun,* 1874)

William Simpson (1823–99).

EYEWITNESS PICTURES OF INDIANS on the warpath were hard to come by. Time did not permit the Special Artist to wait on the uncertainties of Indian warfare, though editors always hoped that somewhere along the line of travel, the "wild and woolly" West would run true to form and produce a sensational eyewitness account.

Only on rare occasions did this happen. But the war between the hostile Indians and the U.S. Army was no picnic. The artist who happened to be present when the shooting started ran the risk of losing his scalp like any other white man. Artists, therefore, were not present when the Indians scored their greatest victories! Nevertheless, a few made some highly interesting drawings of several minor campaigns. (1) One of the few Special Artists who had the luck and the opportunity to witness this aspect of Western life firsthand was the Scots artist, William Simpson. A famous war correspondent and world traveler, Simpson chanced to arrive in San Francisco shortly after the murder of General Canby and Dr. Thomas, members of the peace commission appointed by Washington to negotiate a settlement with the Modocs. Realizing that even a flying visit to the scene of this little-known frontier dispute would make excellent copy for his paper, the *Illustrated London News,* he called on General Kelton, of the Army of the Pacific, for the necessary papers and letters of introduction, then left immediately for the Lava Beds of Northern California. Simpson's eyewitness dispatches of the Modoc War, illustrated with a series of fifteen illustrations after watercolor drawings and pencil sketches made during a week on the spot, appeared in the *Illustrated London News,* April through June, 1873.

In his prime, William Simpson (1823–99) was regarded as the doyen of British Special Artists. He was a tall and imposing figure with keen blue eyes gazing out over a square white beard. Characteristically, he was a man of habit, with sound and sensible reasons for doing everything. He always wore a thick Scotch plaid cape coat when traveling, because he said, "it was as good as a bed when one was not to be had." Born in Glasgow, the son of a marine engineer, young Simpson began his education in a Perth writing school, where he remained for fifteen months. This was the only regular schooling he ever had, yet he became a fluent linguist in both European and oriental languages. In 1835, when he was twelve, he entered an architect's office in Glasgow, where he acquired a taste for drawing. Two years later, he was apprenticed to the firm of Allan and Ferguson, Glasgow lithographers. Impressed by his precocious and industrious personality, David Allan asked the youth to sketch old buildings for Stuarts' *Views of Glasgow.* This was an exceptional assignment. Most of the young Simpson's work had to do with plans and machinery and the design of ornamental tickets. But Glasgow was not the place for an ambitious young artist interested in travel.

Four years after completing his appenticeship, in 1851, Simpson

1. One of the first to do so in the context of illustrated journalism was the American Special Theodore R. Davis (1840–94) who covered General Hancock's summer campaign of 1867 for *Harper's Weekly.* See, John C. Ewers, *Artists of the Old West* (Doubleday, 1965), 12 ("Artists of the Plains Indian Wars") :195–202.

decided to try his luck in London, and was employed by Day and Son, a leading firm of lithographers regularly engaged in producing superlatively printed albums and portfolios for the best London publishing houses. In those days, lithographic establishments provided publishers with the services of an artist who supplied sketches or watercolors for artist-craftsmen to transfer to the prepared surface of a lithographic stone. Simpson's career as an artist really began in 1854, when war with Russia created a demand for lithographic scenes of the conflict. But after working from inadequate newspaper accounts, his employers agreed to his suggestion that they send him to collect his material on-the-spot. The artist arrived at Balaclava in November of that year, and remained with the British Army till the fall of Sebastopol. Simpson's plates for *The Seat of War in the East,* published by Colnaghi in 1855–56, are classics of documentary art and brought him instant fame as a pioneer war artist.

Simpson again visited the East in 1858. The Indian Mutiny of the previous year had focused public interest on the landscape and architecture of the country. To meet the demand, Day and Son devised a huge album of great size which kept the artist busy for three years making the field sketches, as well as a further four years after his return to England. By this time, however, the lithographic establishments were feeling the full effects of increased competition from the *Illustrated London News* and other picture papers. Day and Son went bankrupt; and because his work was reckoned as an asset, the unfortunate Simpson lost all rights to the two hundred and fifty watercolor paintings he had completed. Disaster unexpectedly turned into good fortune when William Ingram, son of the founder and now the proprietor of *Illustrated London News,* hired him as a Special Artist-correspondent with the privilege of owning both the copyright and the originals of his work. Simpson began a lifelong connection with the paper which only ended with his retirement in 1885.

As he began a new series of travels for the *Illustrated London News,* Simpson's career gathered fresh momentum. He went on a royal tour of Russia in 1866 with the Prince of Wales; to Abyssinia in 1868 with the British Army; to Egypt in 1869 for the opening of the Suez Canal; and to France for the Franco-German War, in 1870, where he was present at the fall of Sedan, Metz, and Strasbourg. He was in France again during the Paris Commune, noting in his sketchbook the fall of the Vendome Column and the burning of the city, as a colleague put it, "with cool composure."

The habit of pulling out a sketchbook on every possible occasion sometimes made the Special Artist the unfortunate object of great suspicion. He ran the risk of being thought a spy, and when caught red-handed, subjected to confinement by overzealous officials. Worse, he might be chased by irate mobs of patriotic citizens and end up a victim of summary justice. Because of his great height and military bearing,

2. Mason Jackson, art editor of *ILN*, relates several anecdotes of Simpson's adventures while carrying out various assignments for the paper. See, Jackson, *The Pictorial Press* (London, 1885).

3. Simpson, *Meeting the Sun* (London, 1874), 27:384–93. Simpson states that he had corresponded with Albert Bierstadt, the famous German-American painter whom he had probably met in London during 1866–69 while Simpson and his wife were traveling in Europe. From 1872–73, he was back in the United States and traveling along the Pacific Coast from his studio in San Francisco. Bierstadt had made arrangements for him to visit the Yosemite, but the trip was postponed until after his return from the Lava Beds. He returned to San Francisco May 2, and a few days later left the city for a week's sketching trip in the Yosemite Valley. On May 9 he was drawing the "Fallen Monarch" in Mariposa. The mountain vastness of the valley overwhelmed him. "Some places," he wrote, "are celebrated for the beauty of their scenery, others for grandeur or the wild and savage aspect. At the Yosemite, all these are found together, snow-capped peaks, domes of rocks, high walls of granite; perpendicular cliffs and pinnacles, waterfalls unsurpassed; woods like a primeval forest; and the greatest trees in the world, huge like giants before the flood. Eden itself could not have been more lovely." Simpson's field pencil sketches and studies from this trip are to be found in a separate sketchbook inscribed "Hankow-Japan-Yosemite, 1872–73" and is now in the Bushnell Collection, Peabody Museum, Cambridge, Massachusetts. The titles are listed in the Checklist of Published Watercolor Drawings and Illustrations of California by William Simpson in the notes at the back of this book. One full-page illustration, *The "Grizzly Giant" of Mariposa, California,*

Simpson himself had more than his share of adventures of this kind. During the Franco-German War, surveillance of war correspondents was particularly strict. To be seen drawing could mean not only arrest, it could mean summary execution. The Scotsman's answer to this problem was to make his sketches in books of cigarette papers, so that the evidence could be swallowed or smoked if need be! Later, in the privacy of his tent or hotel, he assembled the sketches and made a final drawing for mailing to London. (2)

Simpson was fifty when, in 1872, he embarked on his biggest assignment, an around-the-world trip. The *Illustrated London News* had sent him to draw the marriage of the young Emperor Tung-chin of China. From China he went to Japan, then crossed the Pacific in the P. & O. steamer *Alaska* to California. After staying for a month, finding in San Francisco, Northern California, and Yosemite, (3) much of interest for his paper, he continued to Utah (4) and Kentucky, (5) finally bringing his three-month stay and world trip to a close in June, 1873. (6)

At the time of Simpson's visit, Army commanders of the West were involved in an all-out effort to facilitate the advancing tide of white civilization by forcing the Indians to submit to supervision on agreed reservations. It was a difficult task. Not used to being confined, some tribes broke out, in an effort to regain their lost freedom. Others were faced with white invasion of the lands that had been left them: the railroads had greatly accelerated the rate of settlement, bringing homesteaders from the East and miners from the West; under such pressure, reservations shrank in quality and size. The Army had little alternative but to make open war on the Indians in order to consolidate the settlers' claims.

Indian history is notoriously full of broken covenants, and the Modoc War was a small-scale engagement; yet it was one of the more tragic, as it involved prejudice and treachery between rival Indian tribes, among the Modocs themselves, as well as between Indians and white settlers. The causes of the Modoc War were complex, but essentially it was the result of friction between the settlers and Indians and dissatisfaction with the unpredictable working of the reservation system. The Modoc Indians were a fiercely independent tribe who had resisted infiltration of their territory since the days of the fur traders. But war with the white man had reduced them to a small group. With two other tribes, the Klamaths and the Ya-Hoo-Skin Snakes, they were signatories to an 1864 treaty by which all three groups surrendered their old lands for a reservation in Lake County, Oregon. Unfortunately, the Modocs got the worst of the bargain; they were given lands six thousand feet above sea level, so poor in vegetation that they found it impossible to survive. Official delay in ratifying the treaty, followed by continual friction with the Klamaths—once allies, but now enemies—resulted in the majority of the Modocs leaving the reservation and returning to their old lands

with accompanying note by the artist, was published eight years later with a story entitled "The Big Trees of California" (*ILN*, 79, 1881: 454, 460).

4. A visit to Salt Lake City was Simpson's third Western excursion. The Mormons' staunch defense of their way of life, which included polygamy, continued to make a news story of major interest to European as well as American readers. Few visiting foreign artists ever failed to make the trip; a journey made much easier in 1873, by a spur from the Union Pacific line at Ogden. Brigham Young and other Mormon leaders were duly interviewed by the artist, but although an account of his impressions appears in his autobiographical account of his "Round the World" trip of 1872–73, *Meeting the Sun* (London, 1874), 28:394–403, no interviews or illustrations appeared in *ILN*.

5. After his visit to Salt Lake City, Simpson took the Union Pacific to Omaha. Here the Union and Central Pacific lines ended, and the traveler had the choice of two routes to New York. The usual route was via Chicago and Buffalo. The artist chose an itinerary which took him through St. Louis, Indianapolis, and Louisville. From Louisville, he made a side trip to visit the Mammoth Caves of Kentucky. This visit is described in *Meeting the Sun*, but illustrations with accompanying notes by the artist were not published until 1876. Returning to Louisville, he traveled via the Baltimore and Ohio Railroad to Washington. Here, the artist remained for two days, reporting his impressions of the Modoc campaign to the Commander in Chief of the United States Army, General Sherman. After a visit to Niagara and a boat trip down the Hudson, he finally sailed from New York on June 14, 1873.

6. A large exhibition of watercolors and drawings from this trip, entitled "Round the World," was held in London at the Burlington Gallery in 1874. Simpson frequently exhibited the fruits of his travels. He fought to maintain his earlier reputation as a topographical watercolorist, and worked up original field material or used it as a basis for larger and more finished watercolor paintings.

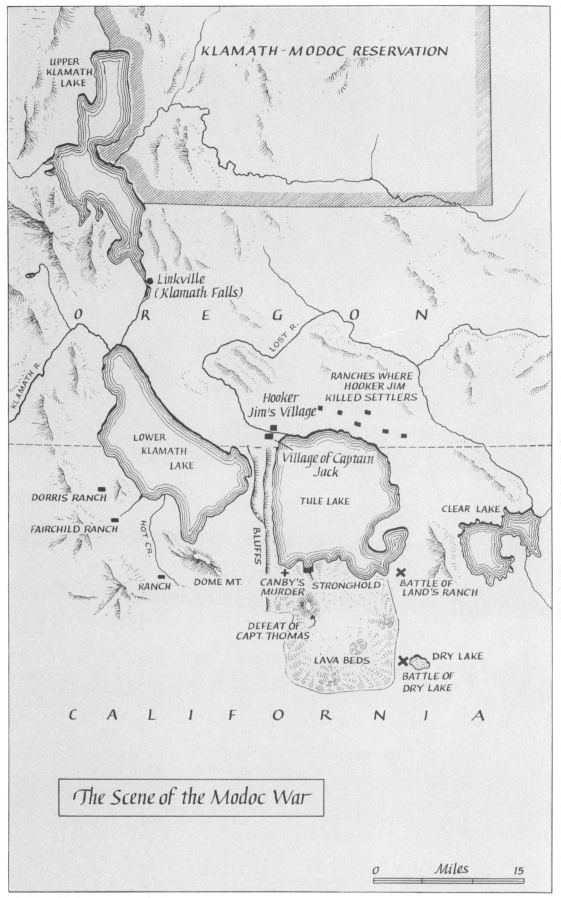

The Site of Events 1872–73. From Ralph K. Andrist, *The Long Death* (New York: The Macmillan Company, 1964). Reproduced by permission of the publisher.

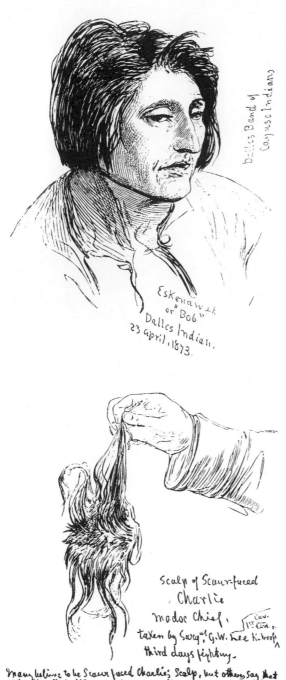

Dalles Band of Cayuse Indians

"Eskenawah or "Bob"
Dalles Indian.
23 april. 1873.

"Main Stake"
Wife of Modoc Indian Longman.

April. 1873.

Scalp of Scar-faced Charlie
Modoc Chief.
taken by Sergt. G.W. Lee K. troop
1st Cav. 1st Card.
third days fighting.

Many believe to be Scar-faced Charlie's Scalp, but others say that it either Charlie Millers or Steamboat Franks. W.S. april. 1873.

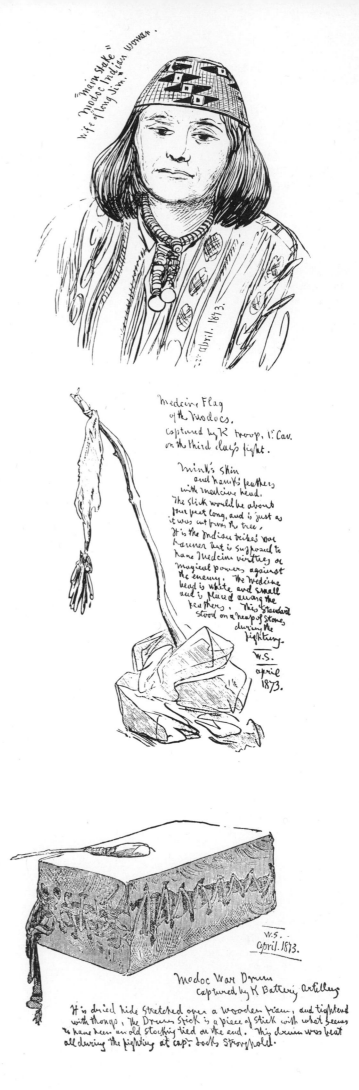

Medicine Flag of the Modocs.
captured by K troop, 1st Cav. on the third day's fight.

Mink's skin and hawk's feathers with medicine head. The stick would be about four feet long, and is just as it was cut from the tree, It is the Indian tribe's war banner but is supposed to have Medicine virtues or magical powers against the enemy. The medicine head is white and small and is placed among the feathers. This standard stood on a heap of stones during the fighting.
W.S. april 1873.

W.S. April. 1873.

Modoc War Drum captured by K Battery artillery

It is dried hide stretched over a wooden frame, and tightened with thongs. The Drum Stick is a piece of stick with what seems to have been an old stocking tied on the end. This drum was beat all during the fighting at capt. Jack's Stronghold.

Illustrated London News, May 31, 1873 (Above). The Modoc War was the biggest news story from the United States since the joining of the Central and the Union Pacific in May, 1869. By chance, the *Illustrated London News* had the field all to itself; no other illustrated paper had an artist-correspondent on the spot. Special Artist Simpson sent letters and sketches during a six-day visit to the front. Four of these, drawn by the artist after the Battle of the Lava Beds (April 15–17, 1873), appeared on the front page: (top left) *Eskenwah, or Bob, a Warm Spring Indian;* (top right) *Main Stake, the Wife of the Modoc Brave, Long Jim;* (below left) *the Scalp of Scar-faced Charlie,* taken by Sergeant G. W. Lee, K Troop, First Cavalry; (below right) *A Medicine Flag of the Modocs.*

Modoc War Drum (Right). Wood engraving after pencil sketch. *Illustrated London News,* May 31, 1873. Captured by K Battery, of the artillery. "This drum," wrote Simpson, "was beaten all during the fighting at Captain Jack's Stronghold."

on Lost River, near Lake Tule in Northern California. Attempts were made to persuade them to return, but without any guarantee of protection from the hostile Klamaths. The Modocs refused and expressed a wish to stay in their old home on Lost River. This was denied them.

As Simpson traveled through California, he learned a good deal about a complicated record of treachery and bloodshed, with massacres and raids going back over twenty years; there had been little mercy shown by either side. Everyone the artist talked to had declared that the greatest enemies of the Indians were the very commissioners appointed to look after their interests. Tactful, honest administrators certainly did exist, but they were as few and far between in California as they had been throughout the Old West. Mismanagement and blundering, coupled with flagrant embezzlement of Indian Bureau funds, frequently sparked off trouble on many reservations.

The resolve of the Modocs to continue their fight for a new reservation was renewed at dawn, November 29, 1872, when in spite of instructions to resort to force only if peaceable means were exhausted, Major James Jackson of the First Cavalry, with forty troopers, decided to solve the problem by making a surprise attack on the Modoc camp on Lost River. He hoped this move would force them to surrender and return to their abandoned reservation; but the attack was unsuccessful. The Modoc chief, Kintpuash, or Kientpoos, known to white men as Captain Jack, moved out a hard core of some forty-five warriors and their families to the volcanic fastness of the Lava Beds. By January 1873, the band had established a series of strongholds; defeating every attempt to dislodge them, with heavy losses to the white soldiers. The Modoc War was on.

In spite of this complicated state of affairs, there were those who continued to work for an amicable settlement. Added to the differences between the whites were those between the Modoc rebels themselves; Captain Jack's leadership was challenged by a group of incorrigibles led by Hooker Jim. This group had every reason to fight on, as they had carried out personally motivated acts of murder among friendly white settlers. At this stage, Captain Jack favored negotiations. He knew that the Army would stop at nothing to capture the Modocs who had killed the settlers. But he was out-maneuvered by Hooker Jim and his followers, who forced Jack to continue fighting. On the eve of war, Captain Jack unexpectedly proposed a new solution: the Modocs would not accept the Lava Beds as a new reservation; instead, he announced in a message to the commissioners of the Indian Bureau, "I wish to live like the Whites." Then he added, "Let everything be washed out, and let there be no more blood. I want the soldiers to go away so I will not be afraid." But he was told that the soldiers could not be sent away, and that he must evacuate the Lava Beds. As he could not feel safe in unconditional surrender, Captain Jack had little alternative but to continue fighting.

The present war was closely linked to an event of twenty-one years

found the accommodation appalling. "It was," he wrote, "a rude log hut, whose floor was not much different from the ground outside." His bed for the night was his trusted Scots-plaid cape coat. Morning ablutions were performed in a small stream near the end of the cabin. A dirty towel and a comb with two teeth, which hung on a piece of string fastened to a nail, hung at the doorway. An almost empty frame served as a looking glass. Disgusted with such primitive facilities, Simpson thought the proprietor could derive great benefit from the services of a missionary society in receiving the necessities of civilization, namely a sizeable cake of soap, brushes, combs, needles, and thread.

Eventually, after a tiring journey of thirty-six hours, Simpson reached Yreka. Little more than a mining camp in those days, it was a straggling town of a few streets, wooden houses, and more than its share of dust. Yreka was the nearest town to the Lava Beds, and the base of supplies for the Modoc Expedition. Here the stageline went north into Oregon, and transportation being scarce, the artist was compelled to use a letter of introduction to Colonel Stone of the Army Quartermaster's office in order to be granted priority of transport. He was given a light team with an Indian driver and driven out along the trail to the Lava Beds which lay eighty miles to the east, a journey of two to three days.

No sooner had the weary artist bedded down for his first night's stop, than news reached him that General Alvin C. Gillem had laid siege to the Modoc stronghold with Coehorn mortars, driving the Indians from their natural fortress in what was called the "Three Days' Fight" (April 15–17). Simpson correctly surmised that this might be the decisive blow and was now more anxious than ever to reach the Lava Beds. But shortly after reaching the next overnight stopping place, Ball's Ranch in the Butte Valley, a horseman rode in and announced that a young teamster named Eugene Hovey of Yreka had been killed and scalped in the first day's fighting. "Ball's Ranch," wrote the artist, "was full of teamsters en route with commissariat supplies, and the courier, who had just come in, was recounting the events of the fighting. When he told that the Modocs had escaped, and were probably scattered about with the object of murdering every person they came across, it produced a complete scare among the teamsters. They all declared, in language seventy-five per cent of which had reference to a hot region far beyond the limits of our geographical knowledge, that they would not go on to the front. The man who had brought me from Yreka also refused to go on. This was awkward for me," continued Simpson, as cool as ever, "as I was only about fifty miles from the scene of operations and yet I could not move a step." (10)

10. *Ibid.*, 296.

Around a blazing log fire that night, the artist heard more hair-raising reminiscences. "I was a good listener," he said, "for I was hearing tales which would have made novels or dramas." War held few surprises for the veteran Special, nevertheless Simpson was affected by the atmosphere of terror created by Captain Jack and his warriors. A special

correspondent, he reflected, was thrown into many and various experiences, but to be traveling in a wild region, with the country haunted by fierce and desperate Indians, and the certain fate that if caught his body would be left so mutilated that his nearest relatives could not identify it, while his scalp would ornament the shot pouch of a savage, was certainly an experience Simpson did not relish. Further food for more amusing reflection was the colorful language used by the teamsters, the chief peculiarity of which, thought the artist, was the enormous amount of profane swearing, "prefaced and concluded by old sacred and ecclesiastical phrases." A bad custom, one teamster confessed, but one that all were given to to such an extent that they could not overcome it!

No further news came during the night, so the next morning the teamsters debated whether or not they should chance their luck. But after the usual wild oaths were uttered in explanation of what they would do to Captain Jack, no one ventured a step. Then one tough and courageous driver said he would go if anyone else would. Simpson volunteered, which led to three other teamsters joining them. The party reached Dorris' Ranch by evening with all scalps safe; confidence was completely restored when a cavalry escort met them at Fairchild's Ranch the following day and took them into Gillem's Headquarters Camp.

On arrival, the first person Simpson met introduced himself as an Englishman named Edward Fox, correspondent of the *New York Herald*. Fox, whose famous exclusive interview with Captain Jack on February 28 instantly made him one of the war's most well-known correspondents, in turn introduced the artist to General Gillem and the officers. Simpson was greeted with great enthusiasm; it was thought that a celebrated artist of the famed *Illustrated London News* could now acquaint the outside world with the formidable physical difficulties of the campaign. The artist was told that there was no correspondent of an illustrated paper with the expedition, although the celebrated San Francisco photographer, Eadweard Muybridge, was busy taking photographs and stereoscopic views. Though the war was being ably reported by a press corps which represented the most important American daily papers, the public could not understand why a bunch of "savages" could keep six hundred troops, equipped with the most modern weapons, including Coehorn mortars, at bay. "The public had been misled by pictures in the New York illustrated papers," which, as the artist put it, "had evolved out of the inner consciousness of artists who had not been on the spot." (11)

Early the following morning, Simpson commenced his pictorial report by making a general view of Lake Tule, with the Lava Beds and Headquarters Camp. A stickler for accuracy, he wrote, "I have put in every tent." (12) From Edward Fox, who had accompanied the peace commission, he collected all the information he could on the assassination of General Canby and the Rev. Eleazar Thomas. From these, he made sketches for an illustration reconstructing the event, which had

11. Simpson may have been referring to *Harper's Weekly,* which had published the earliest illustrations of the Modoc War in April, 1873. These were drawn by E. A. Abbey and C. S. Reinhart after photographs by Muybridge.

12. *ILN,* May 24, 1873:496. *Lake Tule with the Lava Beds and Headquarters Camp.* Simpson letter

which accompanied the sketch for this illustration, as published the previous week, May 17, 1873.

13. This appeared as a dramatic double-page illustration, entitled *The Murder of General Canby by the Modoc Indians* (ILN, May 31, 1873:508–9). The illustration is credited as being "drawn from sketches and information obtained on the spot by Our Special Artist, W. Simpson." It is signed AH (Arthur Hopkins, a staff illustrator).

taken place on April 11, shortly before his arrival. (13) He then left for a three-day visit to the camp of Colonel Mason, the commander of the eastern unit which had taken Captain Jack's stronghold, and whose camp was near the recently evacuated Modoc positions. The war correspondent examined what is now the Lava Beds National Monument with an expert eye, noting the remarkable defensive qualities of the place, as he made drawings of Captain Jack's Cave, various strongpoints, and the eerie volcanic landscape which lay all around him. He marveled at the 1,500-year-old lava flows, high cinder buttes, and lava tubes. Anyone accustomed to fortifications, he reflected, might fancy that an experienced military engineer had planned it all. Long chasms and fissures served as trenches; there were zigzags, bastions, redoubts, redans, epaulments, curtains, and sallyports—every feature to be found in a fortified place, and all constructed of solid rock and as hard as iron. The Indians had supplemented these natural positions by throwing in rocks to fill up the gaps, thus completely covering themselves, so that they could not be seen by the attacking soldiers. Small rifle pits had been erected with blocks of lava on commanding points, "exactly," added the artist, "like those which played so important a part in the siege of Sebastopol." Simpson concluded that Gillem had too small a force to have ever contemplated a direct assault. It ought to have been the duty of those in command to have at least some idea of what they were attacking. To attack as Gillem had originally done, on January 17, without the support of mortars, was just about as hopeless as marching an army in the open before the guns of Metz and Strasbourg.

Captain Jack's successful withdrawal to new strongpoints made progress slow and uncertain; Simpson thought the war could continue all summer. When he heard a cavalry escort was leaving on April 26 for Yreka to meet General Jefferson C. Davis, successor to General Canby, he decided to accompany it. In doing so, the artist narrowly escaped death—he had planned to make a second trip to the Lava Beds the same day with Major Evan Thomas' ill-fated scouting party, which the Modocs ambushed and overcame by superiority of fire. Casualties were heavy; a final Army report gave twenty killed and nineteen wounded. Simpson grieved the loss of his officer friends, and deplored their fate. Recalling the sense of loss he felt on previous campaigns, he concluded that he had, with age, grown more sensitive about death.

As the artist made his way from the scene of the fighting, wagon trains of ammunition and supplies passed him on their way to the front. The war was now entering its final phase; under Davis' able command, the Modocs were shelled and mortared out of the Lava Beds and hunted down in scattered groups and forced to surrender. Hooker Jim's band was the first to do so, buying their freedom by helping the soldiers track down Captain Jack. Jack, with two remaining braves, five women, and seven children, was captured on June 1, 1873. For six months he had held off a force of over a thousand soldiers and settlers.

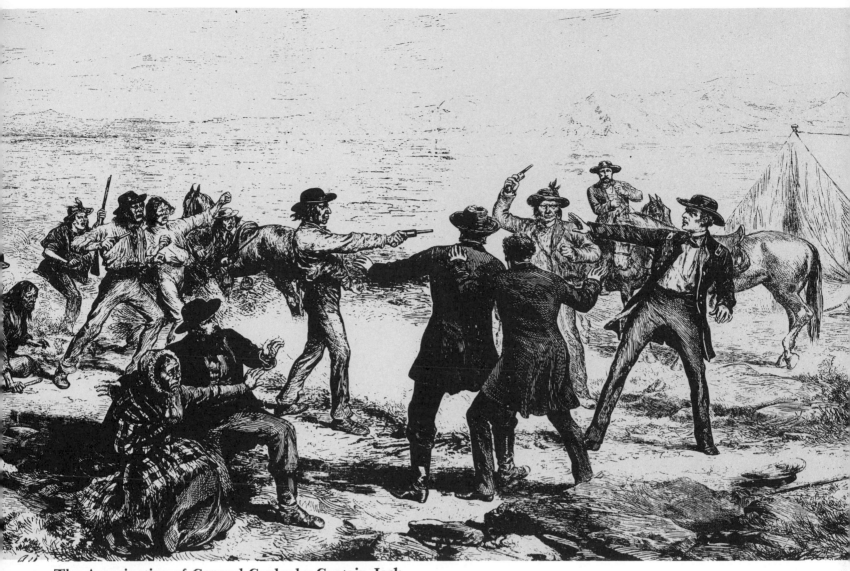

The Assassination of General Canby by Captain Jack.
April 11, 1873 (Above). Wood engraving. A reconstruction
of the event drawn by Arthur Hopkins from pencil sketches
and information supplied by William Simpson. *Illustrated
London News,* May 31, 1873. Originally published as *The
Murder of General Canby by Modoc Indians.* Captain Jack
(left) is shown in the act of shooting General Canby. Alfred
Meacham and the Reverend Dr. Thomas (center) face Bos-
ton Charley, who afterward shot Thomas. Frank Riddle and
his Modoc wife, Winema, are the seated figures on the left.

(Overleaf)
**The Lava Beds, Lake Tule, California. The Scene of
the Modoc Indian War.** Wood engraving after watercolor
and pencil sketch. *Illustrated London News,* June 7, 1873.
"Picture to yourself," wrote Simpson in a dispatch dated
April 25, "those marvellous rocks you see in a pantomime at
a London theatre, with ridges and walls of stone placed in
every direction; but, instead of fairies in glittering costumes,
with magic wands in their hands, imagine a lot of . . . Indians
with rifles, and you will have a general idea of the Lava Beds."

The Army totaled up the casualties with a red face: the Modocs had lost fourteen dead, four hanged, and one suicide; soldiers' and settlers' casualties were eighty-three killed and ninety-eight wounded. The cost of the expedition alone was estimated at half-a-million dollars. Captain Jack's fate was that of most Indian rebel leaders. Together with his comrades, Schonchin John, Black Jim, Boston Charley, and One-eyed Jim, he was tried and hanged at Fort Klamath on October 3, 1873. The following night his body was taken down and embalmed by an enterprising entrepreneur. Shortly afterward it toured the eastern United States as a sideshow: admission ten cents. The remaining one hundred and seventy members of the tribe, mostly old men, women, and children, were transferred to the Quapaw agency, a small reservation in the then malarial southeastern corner of Kansas. By 1909, when the government permitted them to return to a new reservation in Oregon, there were only fifty-one survivors.

As they appeared in the *Illustrated London News,* Simpson's drawings are gray and uneventful illustrations. Unlike the younger Arthur Boyd Houghton, he did not work directly on a wood block. His working method was that of an earlier generation of reportorial artists: he would make rapid sketches in a small pocket sketchbook, (14) and, if he had time, work the more important subjects up by redrawing to a larger size and adding color. Mailing time being always the Special Artist's deadline, he would be compelled to send off field sketches as they were, to be redrawn to his instructions by home artists in London. Simpson's published work, therefore, suffered an almost total loss of quality by an engraving technique far behind that of the rival *Graphic.* This is obvious in comparing the lively, fresh quality of the original sketches and watercolor drawings with the engraved versions. Nevertheless, his illustrations and letters of the Modoc War, drawn and written on location, provided British readers with an authentic (15) and firsthand account of the desperate courage and tactical skill of the American Indian at war; they are also a revealing chronicle of the ruthlessness of those determined to drive the Indian from even the poorest land, and if necessary, as General Sherman had pledged to President Grant, achieve "their utter extermination."

Simpson thought that it was only a question of time before all Indians would either be exterminated or absorbed into the predominating race. But though the supplanting of an "inferior" race by a "superior" race was not to be deplored altogether, "there is that in our hearts," he wrote, "which forbids our thinking of the extinction of a vast mass of human beings without some touch of sympathy." The judgment must be that the white man is an invader and spoiler. The hunting grounds belonged to the red man, and legal claim to them was undoubtedly his. "It is a law we have to deal with," Simpson concluded, "whereby the higher takes the place of the lower in virtue of its power to do so." (16)

14. Many sketches and studies of interest are to be found in a small pocket sketchbook covering the period April 23–May 1, 1873 in the Bushnell Collection, Peabody Museum. The titles are listed in the Checklist of Published Watercolor Drawings and Illustrations of California by William Simpson in the notes at the back of this book.

15. *ILN,* May 31, 1873:522 (Col. 1). Simpson submitted all his sketches to General Gillem and the officers in the Lava Beds for their approval of detail before sending them off to his paper.

16. Simpson, *Picturesque People* (London, 1876).

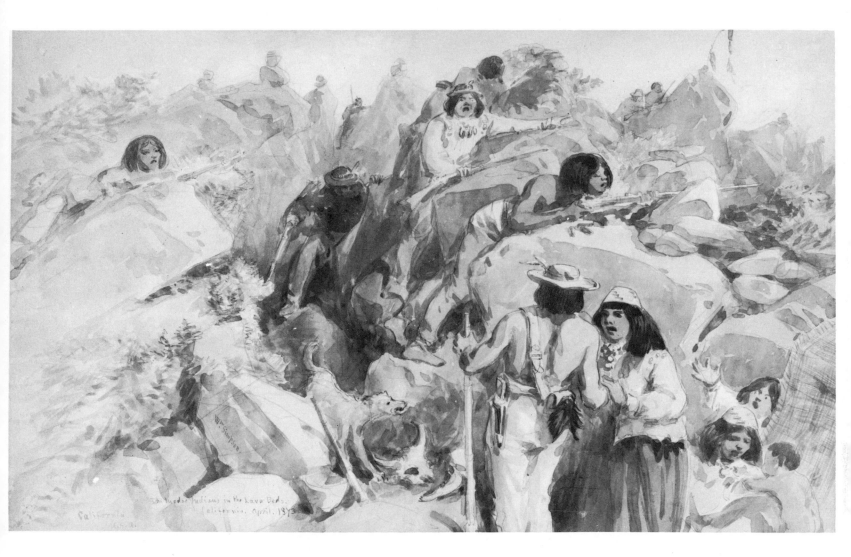

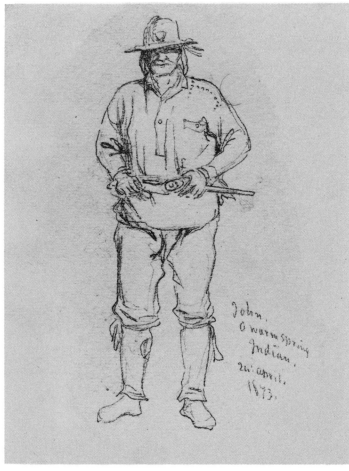

Modoc Indians in the Lava Beds (Above). 1873. 11 x 16½. Watercolor over pencil. Courtesy Peabody Museum of Archeology and Ethnology, Cambridge. David I. Bushnell Collection. That forty-five Indians could keep nearly six hundred regular troops at bay did not surprise the veteran war artist. "They knew the ground," he wrote, "many had breech-loading rifles, and were good shots, so that parties of the troops, who had to charge over open ground, against an unseen enemy, were placed at a great disadvantage. On the top of any projecting point the Modocs placed a couple or more stones, which had from the distance the appearance of men, thus distracting their enemies and causing them to fire at scarecrows instead of real Indians. On a high peak (above left) the medicine flag, or war standard, was placed, to represent supernatural powers working against their foes."

John, a Warm Spring Indian (Left). April 24, 1873. 6 x 4½. Pencil. From the artist's Modoc War sketchbook. Peabody Museum of Archeology and Ethnology, Cambridge. David I. Bushnell Collection. The Warm Spring Indians derived their name from the volcanic nature of the region north of the Shasta and Klamath rivers. Fiercely hostile to the Modocs, they supplied the Army with scouts during the campaign.

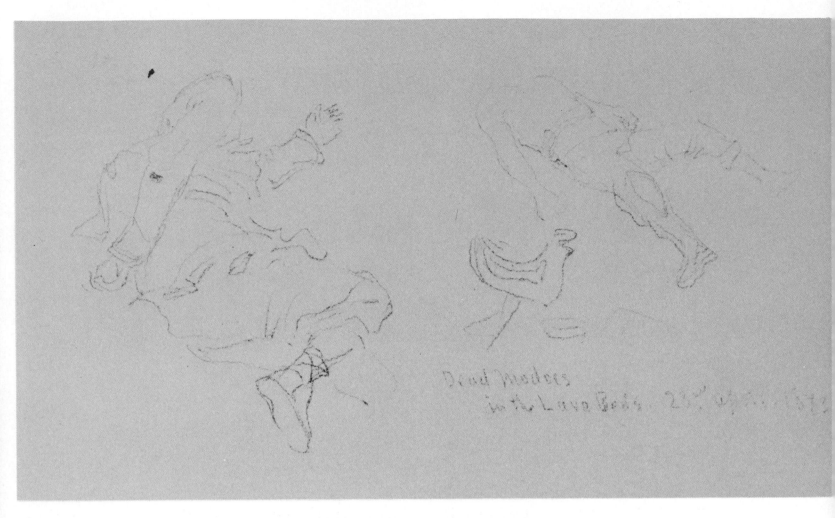

Dead Modocs in the Lava Beds, April 23, 1873 (Above) and **Dead Modoc Squaw, April 24, 1873** (Right). Both 4½ x 6. Pencil. From the artist's Modoc War sketchbook. Courtesy Peabody Museum of Archeology and Ethnology, Cambridge. David I. Bushnell Collection. Simpson made these sketches after the end of a three-day battle in which the army finally forced the Modocs to evacuate the Lava Beds.

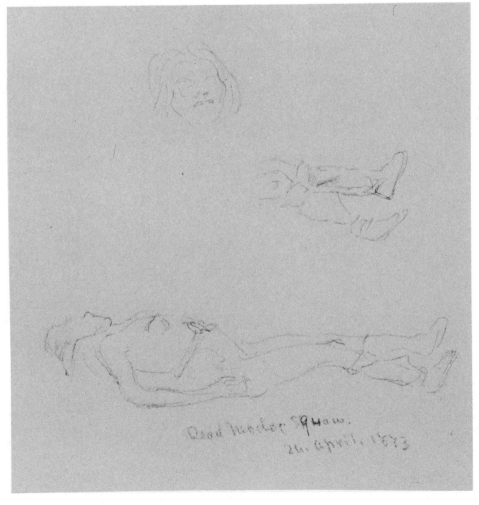

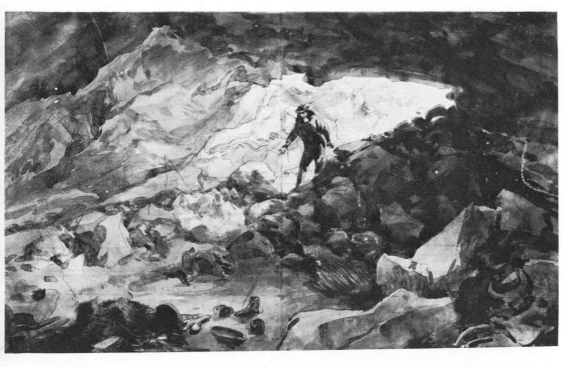

Captain Jack's Cave in the Lava Beds, Lake Tule. April 1873 (Left). 10¾ x 17¼. Watercolor over pencil. Courtesy Bancroft Library, University of California, Berkeley. Robert B. Honeyman Collection. After General Gillem had succeeded in driving the Modocs from their main stronghold on April 17, Simpson visited Captain Jack's Cave, where Captain Jack and his family had lived for over three months.

The Modoc War: Captain Jack's Cave in the Lava Beds (Below). Wood engraving. *Illustrated London News,* May 11, 1873. The same drawing as it appeared as an engraved illustration.

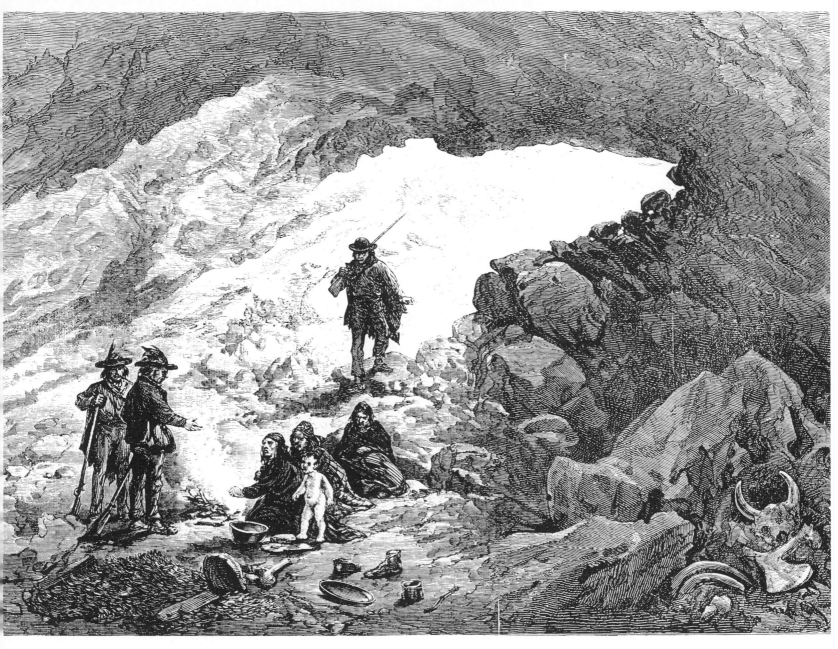

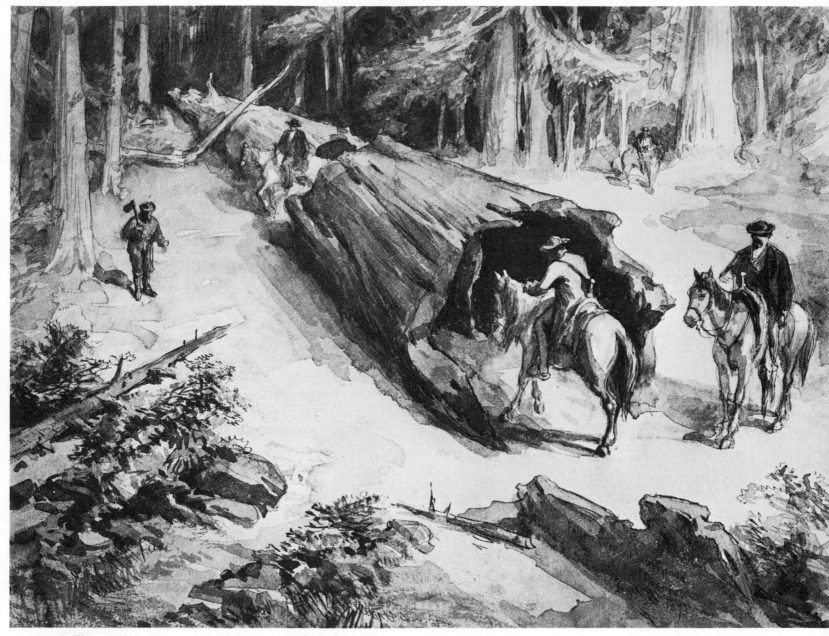

Fallen (Big) Tree at Mariposa, California (Above). 10¼ x 13⅝. Watercolor over pencil. Courtesy The Holden Arboretum, Mentor, Ohio. Simpson concluded his stay in California with a trip to the Yosemite. Overwhelmed by the vastness and beauty of the valley, he wrote that "Eden itself could not have been more lovely." He visited the Mariposa Grove and marveled at the size of the giant redwoods. Some had fallen, and through one, hollowed by time, the artist depicted himself making the customary ride on horseback.

The Grizzly Giant, Mariposa, California (Right). 9½ x 15¾. Watercolor over pencil. Courtesy The Holden Arboretum, Mentor, Ohio. The "Grizzly Giant" was believed to be forty centuries old and was over three hundred feet high. "If I were a Tree Worshipper," wrote Simpson, "I would look upon the Big Trees of California as the great gods of my system."

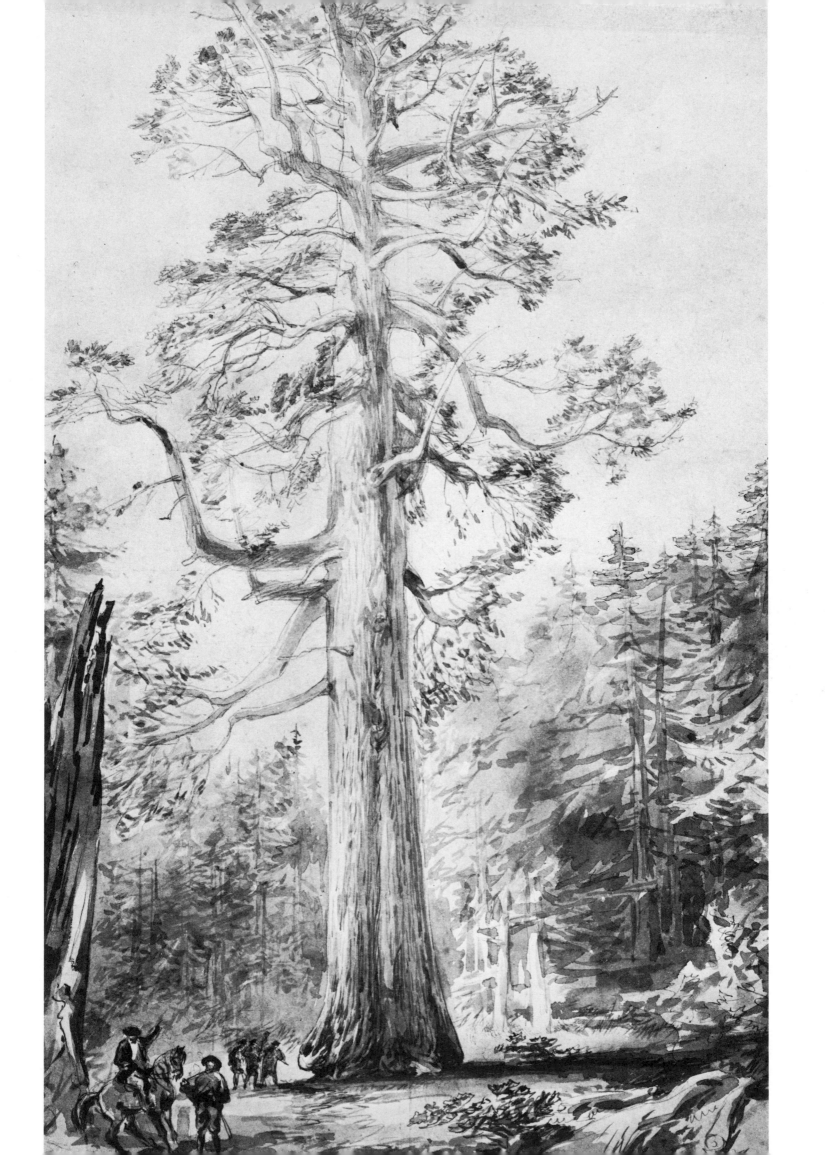

5.
Indians at
the Manor
Valentine
Walter
Bromley
1874

"Stronger and stronger grows the morn.
Higher and warmer spreads the now crimson
flood. The mountains all flush up; then blaze
into sudden life. A great ball of fire clears the
horizon, and strikes broad avenues of white
across the plain. The sun is up! And it is dry.
What is more, the horses are hitched; and with
a cry of 'All aboard,' away we roll . . ." Earl
of Dunraven (*The Great Divide,* 1876)

Valentine Walter Bromley
(1848–77). Wood engraving. *Il-*
lustrated London News, May 19,
1877.

IN VICTORIAN TIMES, the Royal Academy Summer Exhibition was one of the prestigious social events of the London season. A glittering throng from the Upper Ten Thousand, topped by a visit from Queen Victoria herself, annually viewed a vast and heterogeneous collection of massive, ornately framed pictures in the august galleries of Burlington House.

Here were subjects to satisfy every taste. Indeed, a painter's choice of subjects was the key to his success. The paintings most admired were the sentimentalized animals and chaste nude maidens; the luxuriously decadent scenes of the glory that was Greece and the vices that were Rome; the heroic last stands and the full-tilt cavalry charges of Empire; the problem pictures that presented people torn by the most violent emotions; the statesmen, beautiful women, and celebrities of the day; the lustrous studies of landscape and architecture in exotic, faraway climes. In short, whatever could be dressed up as a sensational or thought-provoking spectacle.

Yet the Royal Academy of 1876 revealed one subject hitherto overlooked. In the innermost sanctum, the Lecture Room, below Sir Lawrence Alma-Tadema's apparently innocent, reclining bacchante, *After the Dance,* hung an enormous shrimp-red nude of a Sioux chief wearing only a war bonnet, in the ghastly act of shaking the warm, bleeding scalp of his enemy—a prostrate white man. What Queen Victoria herself thought of the picture, we shall probably never know. But contemporary critics were somewhat less than appreciative. The *Times,* with commendable restraint, thought the picture a strange, foreign, and questionable subject which would surely only appeal to more exceptional tastes. "The artist," added the writer, "has not been timorous with his grim red-skin sitter. He has painted him in his war-paint, and his sweeping battle-crest of eagle's feathers, his foot on the neck of his foe, whose scalp he shakes in triumph with one hand, while with the other, he grasps the bloody knife which has just lifted his enemy's hair." After such a bloodthirsty confrontation, the critic thought it "a comfort to get home again for the quiet Surrey farmsteads which Mr. F. Walton paints with no less mastery in oil than in watercolour!" (1)

But the *Times* had underestimated the patronage of those with exceptional tastes. The hair-raising picture of the year, *Pahauzatanka, the Great Scalper* (see frontis), painted by Valentine Walter Bromley, found a buyer before it was even hung. And there were more to come! It was only the third of twenty such pictures—up to four feet high and six feet wide—commissioned by the Earl of Dunraven for his ancestral seat, Adare Manor, in County Limerick, Ireland. (2)

The theme of Bromley's strange masterpiece is something of a mystery. A review in the *Illustrated London News* referred to "a celebrated Red-Indian scalper, with an unpronounceable name," (3) but the identity of the victim is unknown. More than likely, Bromley's protagonists are symbolic. He may have taken his theme from the events

1. *Times,* Wednesday, May 31, 1876.

2. Redgrave, however, states that Bromley "painted about 20 large pictures for that nobleman [Lord Dunraven], depicting the country and people of the Far West." *Redgrave Dictionary,* 1878:56. As no records are available at Adare to verify the exact number of paintings

delivered, it is difficult to discover how many there may be in existence. Bromley died in April, 1877, just over two years after he returned from America. It is, therefore, unlikely that he had the time to complete 20 canvases of such a large size. Redgrave may have included the 12 original gouache and watercolor drawings which illustrated *The Great Divide,* as well as the three watercolor paintings listed in the Checklist of Paintings and Illustrations of Western Canada and the United States by Valentine Walter Bromley in the notes at the back of this book: a total of 21 pictures.

3. *ILN, May* 13, 1876:475.

4. *Art Journal,* 1876:261.

5. In the immediate period preceding his American trip, Bromley had contributed numerous illustrations of London life to both the *Illustrated London News* and the *Graphic.* After his return, he briefly visited Spain as a Special, and also worked as a Home Artist on Melton Prior's field sketches of the Civil War of 1875.

6. Dr. George Henry Kingsley (1826–92), younger brother of the

preceding the gold rush to the *Pa-Sapa,* or sacred Black Hills of the Sioux, in 1874, when the Sioux were making every effort to stop the gold-hungry white infiltration of their traditional hunting grounds. For he had himself accompanied Lord Dunraven on a hunting expedition in Montana and Wyoming territories. So the picture's "local truth," as the *Art Journal* put it, "is vouched for by the fact that he spent many months among the scalping nomads of the far West." (4)

The artist's patron, Windham Thomas Wyndham-Quin, the fourth Earl of Dunraven and Mount Earl (1841–1926), was a well-known figure in the United States. Since 1872, he had hunted on the Great Plains with Buffalo Bill and Texas Jack Omohundro. He had even set up a hunting lodge and game preserve, as well as a ranch, in Estes Park, Colorado. On earlier trips he had always regretted not having taken an artist with him to portray his hunting adventures, to say nothing of the magnificent landscape. "The love of hunting," he wrote, "is a passion that leads a man into scenes of most picturesque beauty . . . which he otherwise might never see [again]." On this, his fourth visit to the United States, but his third trip out West, he decided to take twenty-six-year-old Valentine Bromley along to preserve the experience for him.

The young artist cut a dashing figure at the time: tall, with fine eyes, well-shaped features, and flowing handle bar mustaches. He was born in London, and from childhood displayed a precocious gift for drawing, which was hardly surprising: his family had produced generations of artists. Under the paternal eye of his father, the painter William Bromley, he quickly absorbed the elements of a thorough academic training. By the time he was nineteen, he had followed on fast in the family tradition. "Val" Bromley, as he was known, was elected associate of the Royal Institute of Painters in Water-Colours, and then to the Society of British Artists; both stepping stones to membership of the Royal Academy. Besides exhibiting pseudo-historical fancies of the lost world of Shakespeare and seventeenth-century cavaliers, much of young Bromley's industry was given to book and periodical work. He contributed drawings to *Fun* and *Punch,* and he was frequently employed by the *Illustrated London News* as a Home Artist and, occasionally, as a Special. (5)

Bromley was, however, essentially a painter, and like many young English artists of his time, he was obsessed with the dream of a great adventure which alone would provide the exotic and colorful elements necessary for a successful Royal Academy picture. How the Dunraven assignment came his way can only be guessed. But one thing is certain— he realized that it was the chance of a lifetime, and accordingly made the most of it to produce some of the most unusual pictures of the American Indian ever painted by an Englishman.

Besides Dunraven and Bromley, the party included the Earl's personal doctor and old hunting companion, George Henry Kingsley; (6) his servant Campbell, "a limber-limbed Highlandman;" his Negro cook and

novelist Charles Kingsley, had served as a private physician to a number of prominent aristocratic families, including those of the Marquis of Aylesbury, the Duke of Norfolk, the Duke of Sutherland and the first and second earls of Ellesmere. He was a Fellow of the Linnean Society and a keen sportsman who knew North America well from frequent hunting trips with Lord Dunraven between 1870–75.

valet, Maxwell; and last but not least his faithful collie, "Tweed." A cousin, Captain C. Wynne, eventually joined them later in Montana.

The Earl belonged to the old school of wilderness travelers, preferring, wherever possible, traditional modes of travel. Instead of traveling by train from New York to Salt Lake City as he could well have done, he took his party across the Atlantic to Quebec, then to Montreal up the St. Lawrence River and through the Thousand Islands to Toronto. Then after a short ride on the Grand Trunk to Collingwood, another steamer voyage took them across lakes Huron and Superior. But this was not all. Loath to pass up any opportunities to fish trout and shoot wild duck, Dunraven hired a small fleet of canoes to take them to the American shore of Lake Superior. From Duluth they rode on the "embryonic" Northern Pacific to Bismarck, North Dakota, before embarking for a fifteen-day steamboat trip up the Missouri and Musselshell rivers. By the time they reached the Earl's newly acquired hunting lodge, some sixty miles from Denver, Colorado, it had taken the party two months to reach their objective!

Dunraven had much to attend to in Estes Park: he owned nearly four thousand acres of land, including the Evans Ranch. Marshall Sprague, in his *Gallery of Dudes,* informs us that the Earl was the major stockholder in a company formed to launch the hunting lodge and game preserve as a summer resort and cattle ranch, with plans for roads and trails radiating from a proposed big hotel (subsequently, the Estes Park Hotel, opened in 1877) to be built on Fish Creek.

But by the middle of August, when he had had his fill of business affairs, Dunraven decided to return north again for some big-game hunting and exploration in Montana Territory. He longed to visit the Upper Yellowstone country and judge for himself whether the thermal springs and geysers were deserving of the superlatives claimed for them. Texas Jack Omohundro agreed to lead the party, and General Phil Sheridan himself provided letters of introduction to the commanding officers at Fort Ellis and other military posts.

Texas Jack went on ahead to make the necessary arrangements, and after a few days the party joined him at Salt Lake City to fit themselves out with saddles, clothing, and other items of necessary equipment. From Denver they had traveled by rail to the Mormon capital. At Corinne, however, they left the train to complete the rest of the journey in a lumbering old stagecoach over what is now Interstate Highway 15. The stageline ran north to Fort Hall in Idaho and over the Monida Pass into Montana, a distance of over three hundred miles. All went smoothly, in spite of a "comical" driver who constantly quenched his thirst with draughts of neat whisky. "Our general intention," wrote the Earl, "was to get to Fort Ellis, or Bozeman, about 70 miles from Virginia City, to make 'Boteler's Ranch' (about 35 miles from Bozeman) our permanent camp, and to make expeditions from there, carrying only what we could pack on mules." (7)

7. Dunraven, *Past Times and Pastimes* (London, 1922), 89.

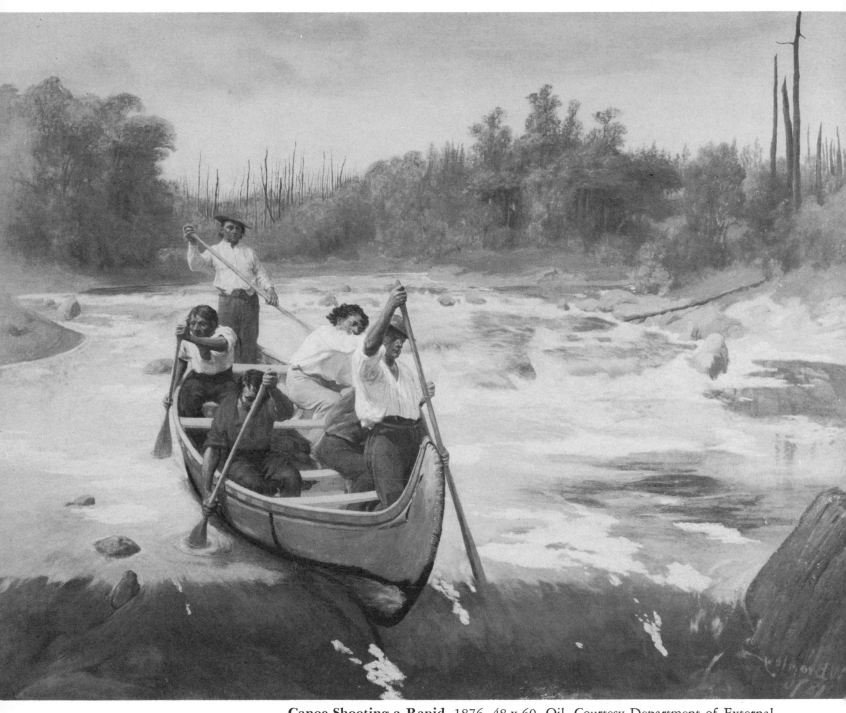

Canoe Shooting a Rapid. 1876. 48 x 60. Oil. Courtesy Department of External Affairs, Ottawa, Canada. From Fort William to Duluth on the American side of Lake Superior, the party traveled in a fleet of *canots du nord,* light birchbark canoes paddled by a sturdy crew of Métis "singing some old Normandy or Breton song." Dunraven thought such a way to travel "the poetry of progression."

A Noble Savage in Town. 1875. 16 x 8. Watercolor. Courtesy Earl of Meath.

Virginia City, then capital of the territory, proved to be a disappointment. At least at first it did. Along the hot and dusty trail, the party had looked forward to an oasis where they might "be washed, clean-shirted, rubbed, shampooed, barbered, curled, cooled and cocktailed." But no, this was not Denver. A street of straggling shanties, a bank, a Wells Fargo Express office, a blacksmith's shop, a few drygoods stores, bars, and that was it. Bromley caught sight of a mounted Bannack warrior, with quiver and bow, silver-mounted revolver, and a Winchester, riding into town, gazing with undisguised contempt at the sight of the newly arrived, top-hatted and frock-coated representatives of civilization. Dunraven promptly suggested he work the scene up as an illustration, entitled *The Noble Savage in Town*. Some time later, they found a clean and comfortable little inn, not to mention antelope and bear steaks, and revised their original unfavorable impressions of the town.

At Fort Ellis, the most important military post in the region, the party enjoyed the hospitality of Major Sweitzer and the officers of his garrison. The fort consisted of a large square, two sides of which were occupied by the soldiers' quarters, with the remaining side devoted to the officers' houses. Along the inside ran a wooden sidewalk, beside which "a few unhappy trees" struggled to grow. The interior space, a parade ground, was adorned with a tall flagpole; while its four angles were flanked and protected by what Dunraven described as "quaint old-fashioned-looking block houses, octagonal in shape, loop-holed, and begirt with a broad balcony, upon which sentries pace everlastingly up and down." Beyond the square were more barracks, washerwomen's houses, stables, stores, a billiard-room, blacksmith's and saddler's shops, a hospital, stores, and the magazine; all surrounded by a stockade fence.

Strategically, Fort Ellis commanded the valleys of the Yellowstone and of the three forks of the Missouri. Together with Fort Shaw and Fort Benton, it controlled all navigation on the river, as well as the three principal passes which break through the mountains from one river system to the other. It was through these natural thoroughfares—the Flat Head, Bridger, and Bozeman passes—that the hostile Indians of the plains made their raids into the Gallatin Valley, plundering isolated farms, stealing stock, and scalping unfortunate settlers.

Over brandy and cigars, the party was warned to keep their eyes "well skinned." Only last year the Sioux had run off two hundred head of cattle from under the very walls of the fort, and killed two white men. No doubt, the Major also informed Dunraven that part of the territory in which he planned to hunt was controlled by the Sioux; that the group ran the risk of running into war parties, and meeting the same fate as others who had been scalped, impaled, or burned alive. Under such conditions, "the only good Indian was a dead one." (8)

Dunraven thought the Indians were not as bad as all that, but kept his thoughts to himself. For one thing, he admired their intense love of freedom, and although he thought Cooper's noble red man had

8. *Ibid.*, 92, and Dunraven, *Great Divide* (London, 1876), 55, 134.

long been overdone, the Indians had, he felt, some excellent traits, and he confessed to a sneaking affection for them "in spite of the inconvenience." The Earl noticed, too, that Bromley had shown great interest in Indians, and suggested that the artist join Kingsley and himself for a visit to the Crow agency, some thirty miles distant.

It was a very large crowd of curious Crows that turned out to greet the Englishmen the next day. Like the Pawnees, they were generally peaceable toward the whites and provided scouts for the cavalry units stationed in Montana in return for protection from attack by their old enemies, the Sioux. At the time, their agency was situated at Mission River. A high stockade protected the agency. Bromley entered and found his first subject, braves unloading and receiving payment for buffalo skins outside the hide trader's store. (9) The agent introduced several chiefs who greeted the party in a friendly manner. The Earl and Chief Blackfoot did most of the talking, and the Chief displayed characteristic Crow shrewdness in negotiating a deal of blankets for a performance of dances.

Anxious to impress their guests, Blackfoot and his medicine man arranged a *coup* dance. Counting *coups,* or blows, gave Bromley an intriguing insight into the complex custom in which young braves or warriors narrated their brave deeds using the actual weapons or trophies as illustrations. However boastful they appeared, the truth had to be told or they would be disgraced. Dunraven, however, was unimpressed and a little amused. It reminded him so much of his undergraduate battle *coups* on the King's Road, Chelsea, after the Oxford and Cambridge Boat Race. The evening at the agency included a scalp dance, a bull dance, more complimentary speeches, and an invitation to visit the camp next day. (10)

Moving around the encampment the following morning, Bromley was deeply fascinated by what he saw. The tepees, or lodges, were pitched in a large circle. Each held from twelve to fifteen, or even twenty individuals: a community in itself. Outside the door of one was a spear on which was hung the chief's shield and a mysterious bundle. If a hawk or eagle happened to be the totem of the chief, one of these birds might be perched on the shield. The totems reminded him of a medieval knight's escutcheon or coat or arms, as the knights of old, too, used to display their shields and banners before their tents.

The squaws, like all Indian women, were slaves of their men, but they did not appear to object. He watched them chopping wood and carrying canvas buckets of water. Although coarse-featured, he noted their almost classic grace as they moved about in finely tanned chiton-like dresses of doeskin, beautifully decorated with intensely colored vignettes. The men, on the other hand, were tall and fine looking, with hair of incredible thickness and length; just as Catlin had, in fact, described them. (11)

The artist's pleasure in finding such material also pleased Dunraven. He and Bromley had not exactly hit it off. The younger man was less

9. This subsequently appeared as a full-page illustration entitled *Indians at a Hide-Trader's Hut (ILN, 69, 1876:344).*

10. Bromley illustrated the scene and depicted the Earl (right) and Dr. Kingsley listening to a young warrior relating a *coup* against the Sioux. *Great Divide,* frontispiece.

11. The strongly marked characteristics of the Crow Indians are described by Edwin Thompson Denis (introduced and edited by

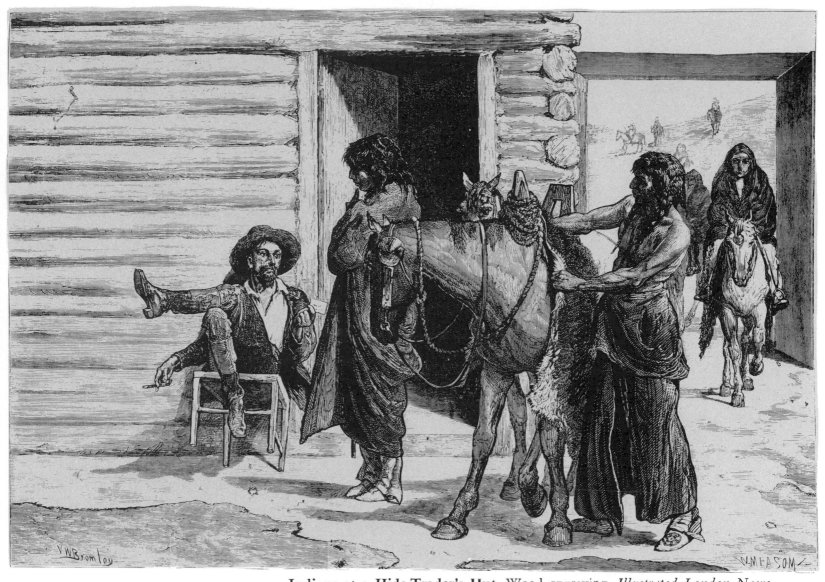

Indians at a Hide-Trader's Hut. Wood engraving. *Illustrated London News,*
October 7, 1876.

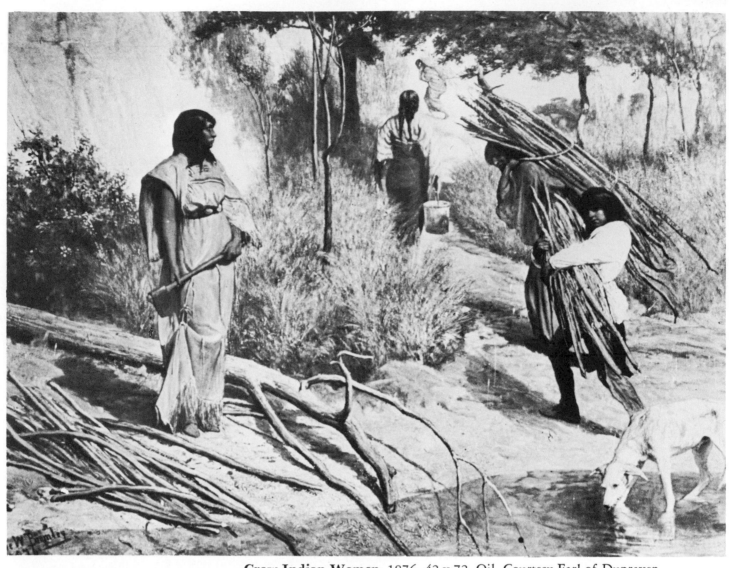

Crow Indian Women. 1876. 42 x 72. Oil. Courtesy Earl of Dunraven.

Crow Indian Burial. 1876. Courtesy Earl of Dunraven. Bromley was deeply moved by the mystique of the Crow burial ritual; the dead were placed in trees to dry out before reburial on the ground.

John C. Ewers), *Five Indian Tribes of the Upper Missouri* (Norman, 1961), and Catlin, *Letters and Notes,* 1 (New York, 1970), 50.

than robust and did not have much interest in using a gun. The long wilderness trips with all the talk and activity of hunting interested him much less than did the indigenous population. Unlike his predecessor, Sir William Drummond Stewart, and his more tractable artist, the American Alfred Jacob Miller (who painted the Green River county of Wyoming), Dunraven found his own artist less a faithful instrument than an individual reacting to things in his own way. He worked hard, sketching the busy domestic world of the Crow village with enthusiasm. The sketches produced some of his most interesting work, notably the superb oils, *Crow Indian Women* and *Crow Indian Burial,* and the watercolors, *Big Chief's Toilet, Counting his Coups,* and *Cache.*

Just as Dunraven and the artist were on the point of leaving, they were attracted by a great drumming and singing going on in a nearby lodge. Looking in, they found a group of young men gambling for the cartridges they had been given the previous night. All were playing the favorite Crow game of chance, *cache.* On the floor was spread a large buffalo robe to form a gaming table, and on either side, four men faced each other.

Cache was a hand game which consisted of holding a shell in one hand, changing the shell from one hand to the other and then holding them closed for your adversary to guess in which the cache, or shell, is, losing a peg if wrong. A row of pegs stood in front of each man, who either took one or gave one to his opponent, according to loss or gain. The pegs represented so much, and everything an Indian possessed was valued at so many pegs—a wife, a horse, and so on. Each party had a drum, and kept up, while his side was in, an incessant thumping, hoping to encourage the holder of the cache in his efforts, and trying to confuse the adversary. The stakes having been agreed on were placed on the robe, an equal number for each side.

When the Englishmen looked in, the game was at a most critical stage. "One side," wrote Dunraven, "had acquired very nearly all the sticks; they held the cache, and the others were pointing and very unsuccessfully. The winning side looked triumphant. The fellow with the cache shook and brandished his fists, and dashed them out, as much to say, 'you know you can't; you will never guess it right.' The opposite players were frantic; their drummer beat with all his might; they spirted out their song through set teeth in spasmodic jets; they violently struck their ribs with both elbows in unison with the time, expelling their breath in guttural grunts; their bodies shook, their muscles quivered and twitched; the veins in their temples stood out in knots, and beads of sweat trickled from their brows. Their eyes were starting from their heads with eagerness, as they noticed the rapidly diminishing pile of sticks [pegs], and watched the actions of their guesser. He literally danced as he sat and seemed an incarnation of nervous energy. To get at his naked body he held the tail of his shirt in his teeth, and at each unsuccessful venture he would smite his open palm with a

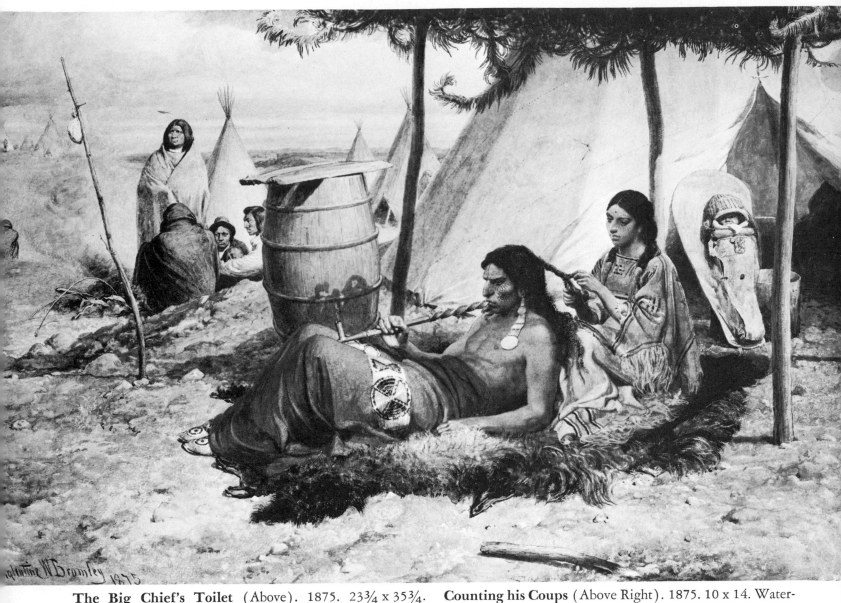

The Big Chief's Toilet (Above). 1875. 23¾ x 35¾. Watercolor. Courtesy Kennedy Galleries, New York.

Counting his Coups (Above Right). 1875. 10 x 14. Watercolor. Courtesy Earl of Meath. The Earl of Dunraven (right) and Dr. Kingsley (below) are pictured listening to a Crow warrior relating his adventures in war.

Cache (Right). 10 x 14. Watercolor. Courtesy Earl of Meath.

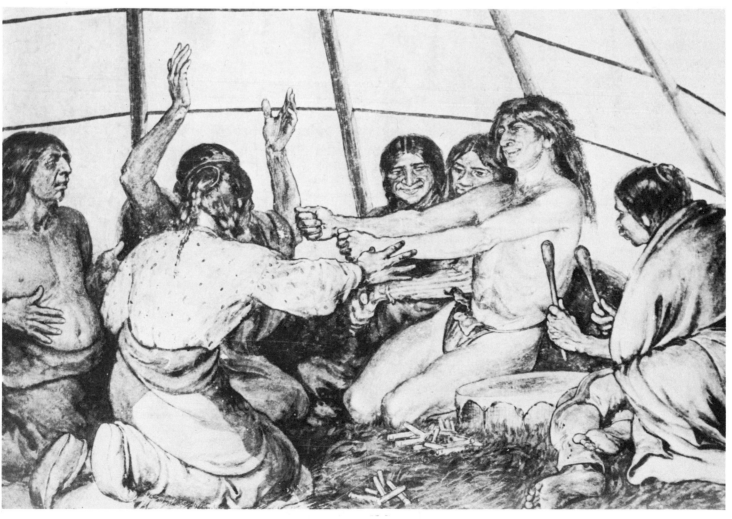

12. Dunraven, *Great Divide,* 99–102. The description of the Crow hand game was found in Stewart Culin, *Games of the North American Indians,* Twenty-fourth Annual Report, Bureau of American Ethnology (Washington, D.C., Smithsonian Institution, 1907).

13. The figure I assume to be Bromley is seen at the left helping Texas Jack (in buckskins) "cinch" a girth strap. Dr. Kingsley (right) hangs on to a more troublesome beast. Dunraven, *Great Divide,* opp. 139.

14. The mounted horseman is probably Texas Jack with Maxwell following on behind. *Ibid.,* opp. 149.

15. Yellowstone National Park was established by Congress as of March 1, 1872. But at the time of the visit of Dunraven and his party, it was little more than a poacher's paradise, lacking the funds necessary to police and develop its tourist attractions. Bartlett, *American West,* 6, 1969:10–16.

16. Knight states that the Sioux War was "in essence a war of aggression, by which the United States took what it could not buy. The treaty of 1868 had barred whites from the Black Hills, the sacred Pa-Sapa of the Sioux, and from the entire area north of the

resounding smack upon his brawny ribs, throw his body back on to his heels and swing it about, dashing his hands together above his head, as if supplicating for better luck next time." (12)

Altogether, thought the Earl, it appeared to be a fine pastime and just the thing to burn up superfluous energy on wet days when croquet or tennis could not be played. There might be some difficulty however; one's clothing would be somewhat in the way, and without the power of smacking oneself, or one's neighbor, the game would lack half its charm.

The two-day visit to the Crows had certainly put Bromley in a better frame of mind to record the party's next excursion. But now the Earl himself would suffer two weeks of frustration. The hunting out of Boteler's Ranch proved not to be of the best, although there were certainly adventures chasing elk, bear, and bighorn sheep guaranteed to make Bromley split his sides laughing. Bad weather hit the party with torrential rainstorms and thick mists, which gave the older members unwelcome twinges of rheumatism. Maxwell was so afraid of losing his scalp that he would not on any account stay in camp alone. Consequently, Campbell (the best shot) was obliged to remain with him. And if there were no Indians, he was in constant dread of bears or snakes. There was trouble, too, with the pack mules who would sometimes stampede out of fear of mountain lions, scattering their precious burdens along a difficult trail, to head back to Bozeman. Getting the packs secured to their backs at the start of each day was the subject of a spirited illustration, *Mule Packing,* (13) and Bromley, for the first time, included himself in the action. Fred Boteler himself was their guide, and in another illustration, entitled *A Yellowstone Highway,* (14) Bromley depicts the rugged character of their trail among the foothills of the Absaroka and Gallatin mountains following the Yellowstone River, toward Gardiner, the northern entrance to their objective, Yellowstone National Park. (15)

Nor was the party immune to the threat of attack by Indians. They had been warned by officers at Fort Ellis, and by the agent, Dr. Wright, and Chief Blackfoot at the Crow agency. Sioux war parties had the habit of hanging about the passes into the Gallatin Valley, looking for the horses of settlers, Crows, or prospectors bound for the Big Horn Mountains. There were anxious moments whenever a band of mounted Indians was spotted in the distance. The Sioux, however, discriminated between the Englishmen and other whites, probably realizing they were hunters. All went well, but Bromley illustrated several incidents along the Yellowstone River trail which expressed the party's fears. (16)

Once they had entered the Park, they could relax and enjoy the outdoor life. The Sioux were terrified at the strange sights and sounds in the mountains. So, after dinner, the group would smoke a pipe, or drink a pannikin of tea by the roaring campfire, listening to Texas Jack's endless yarns of cattle raids on the Rio Grande, or some escapade

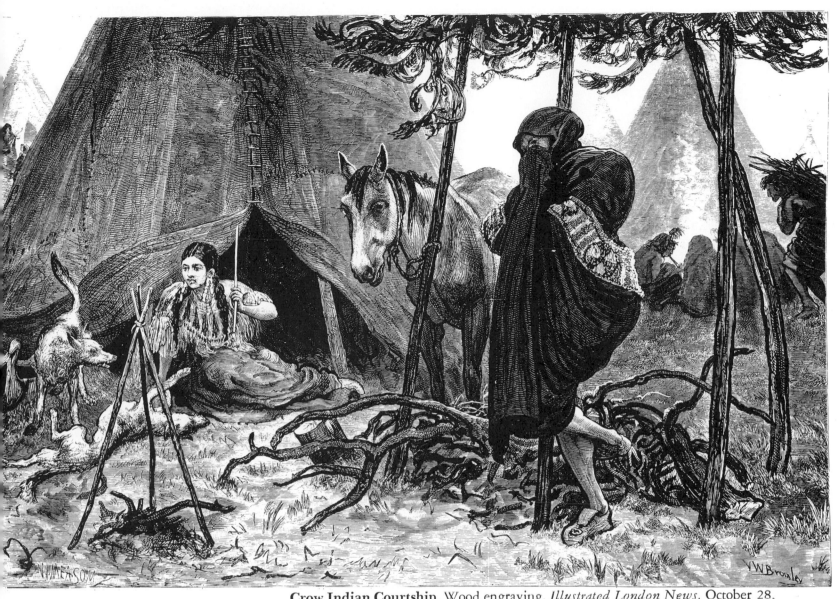

Crow Indian Courtship. Wood engraving. *Illustrated London News,* October 28, 1876.

Mule Packing. 1875. 9⅝ x 13¼. Watercolor. Courtesy Earl of Meath.

A Yellowstone Highway. 1875. 14 x 21½. Ink and wash. Courtesy Earl of Meath.

North Platte between the Black Hills and the Big Horn Mountains. Most of the Sioux had moved to reservations, but irreconcileables continued to roam the Sioux homeland, insisting upon expulsion of whites under the treaty. That became exceedingly difficult after Custer's expedition of 1874 found gold in the Black Hills." Oliver Knight, *Following the Indian Wars* (Norman, 1960), 160–1.

In the illustration *Indians by Jove!*, Bromley depicts the great plain of the Gallatin Valley with Dunraven (right) anxiously watching a cavalcade of mounted Indians through field glasses. Kingsley (left) gets out a Winchester just in case. Dunraven, *Great Divide,* opp. 210.

17. Marshall Sprague, *A Gallery of Dudes* (Boston, 1966), 166–7.

18. George Kingsley, *Notes on Sport and Travel* (London, 1900), 164–5.

with the Comanches, or maybe an adventure during the Civil War in which he fought with the Confederates. Then the pipes were let go out. Exhausted after the day's traveling, everyone yawned and went off to his tent, as Dunraven put it, "to glide into the utter oblivion of sound death-like sleep."

By the time the party reached Mammoth Hot Springs, the weather had improved enough for them to enjoy the sightseeing part of the expedition. Captain Wynne, the Earl's unpredictable cousin, had at last joined the group there. Then, guided by Boteler, they made their way east to Tower Fall, then south, through the Grand Canyon of the Yellowstone, over what is now the Dunraven Pass. Above them to the west was the peak that would also be named for the indomitable Earl, Mount Dunraven.

Continuing west, past Mary Lake to Lower Geyser Basin and Firehole River, they made their way up to the fantastic wonderland of the Upper Geyser Basin to gaze with awe at vast bursts of scalding water and the many-hued pools of steaming springs. Ancient volcanic vents emitted weird sounds. "The air," wrote Dunraven, "is full of subdued, strange noises; distant grumblings as of dissatisfied ghosts, faint shrieks, satirical groans, and subterranean laughter." Bromley however, seems to have been unimpressed, at least as an artist, and as far as is known, he made no attempt to put the Yellowstone excursion on paper. The illustration of Mammoth Hot Springs and Upper Geyser Basin in the Earl's book are not Bromley's but facsimile wood engravings of photographs taken by William Henry Jackson during the Hayden Survey of 1871. (17)

More adventures befell the party on the return journey to Boteler's Ranch. For a start, they ran short of food. The game had mysteriously disappeared. No matter how hard they tried, none had any luck. On one occasion, Dr. Kingsley succeeded in wounding a deer, and with visions of fresh venison steaks before his eyes, he decided to go it alone. But he failed, and as darkness descended there came the awful feeling that he was, in the expressive Western phrase, "turned round," and completely lost in the vast primeval forest at night. To make matters worse, a storm suddenly broke over his head. He slipped and stumbled on the wet grass, falling over rocks, struggling over masses of prostrate treetrunks. Again and again, he shouted and fired off his Ballard rifle. Then, when he had almost given up hope, his signals were answered by shouts and shots from Texas Jack and Fred Boteler, (18) who had gone out to search for him.

Back at the camp, Bromley, Dunraven, and the others crouched under an elk-hide shelter. Heavy raindrops splashed incessantly and the wind rumbled in the caverns of the cliffs, shrieking and whistling shrilly among the dead pines, dashing rain in their faces. As the storm gathered momentum, the tall firs bowed like bulrushes, swaying to and fro, fighting with the tempest. At intervals, as the gale paused as if to gather strength, there was heard through the continuous distant din "a long and pain-

Prairie Traveling: Sioux Indians in Sight. Wood engraving. *Illustrated London News,* March 17, 1877.

Doubtful Friends. 1875. 11½ x 16½. Gouache. Courtesy Earl of Meath.

Indians by Jove! 1875. 10 x 16. Gouache. Courtesy Earl of Meath. The Earl of Dunraven (right) anxiously watches Sioux horsemen. Dr. Kingsley gets out a Winchester just in case.

Stalking the Ram. 1875. 10 x 14. Ink and wash. Courtesy Earl of Meath.

fully-rending cr-r-r-rash, followed by a heavy thud, notifying the fall of some monarch of the woods."

During the next few days, misfortune again conspired to strike the party. Pack mules disappeared or had sore backs and could carry only light loads. Some of the horses gave up; Campbell and Maxwell were obliged to walk. Maxwell was so exhausted by it all that instead of waiting for a horse to be led back to carry him across the West fork of Gardner's River, he decided to ford it on foot. He lost his balance, fell, and was swept away downstream. Eventually, he was fished out, half-drowned, by the indomitable Campbell.

Finally, there was the episode at an unnamed hotel (probably the Association Hotel) at Mammoth Hot Springs, which, for reasons unknown to the party, had closed. Tired, dispirited, and hungry, they had carried the vision of a Saratoga of the Montana wilds in their heads since Wynne had shown everyone an advertisement clipped from a Helena paper, announcing a first-class hotel, with every possible luxury. Upon their arrival at midnight, the hotel presented a very different appearance. Where were the luxurious bath-houses, the commodious clubhouse, the restaurant, the lodging-houses, the eminent physician, and the civil and obliging guides who were willing to convey travelers to the geysers and back again for modest remuneration, and do anything and everything to add to one's comfort? An owl hooted dismally; a skunk walked disdainfully across their path; squirrels were the only guests in the clubhouse. Disgusted, the party camped on the bare floors.

By now Dunraven and his companions had had enough. Fred Boteler was paid for all his time and trouble, and the party retraced their steps to Fort Ellis and Bozeman. It snowed heavily in Virginia City, where they remained for two days, and the stage ride to Corinne subsequently proved to be another nightmare. But all the exhausting discomforts of the trail were quickly forgotten when they climbed aboard the Pullman of an eastbound train.

Dunraven returned to his hunting lodge in Dunraven Glade, Estes Park, to work on the notes for his book, in between more hunting trips with Dr. Kingsley and Texas Jack. Bromley returned to England to work up his sketches as illustrations and paintings. Some seventeen were used to illustrate the Earl's book, which appeared in spring, 1876. A further set of four were sent to the *Illustrated London News*, while others were to form the basis of the twenty large paintings Dunraven planned to hang with his Bierstadt landscape of Long's Peak, (19) his Verner buffaloes, (20) and his large and varied collection of hunting trophies.

Much to Dunraven's sorrow, and Dr. Kingsley's too, Bromley died in April, 1877, probably before he finished the paintings. (21) No matter what the *Times* thought of the *Great Scalper,* or how often the young artist had irritated Dunraven with his challenging views on the hunting of wild and beautiful animals, the huge picture was given pride of place among the hunting trophies and memorabilia of Adare Manor.

19. *Long's Peak* was painted in 1877 by Albert Bierstadt from sketches made on a trip to the Estes Park area of Colorado at the invitation of the Earl of Dunraven, who was trying to convert the Park into a baronial estate. The painting is now in the collection of the Western Department, Denver Public Library. *American West,* 3, 1966:ii.

20. Frederick Arthur Verner (1836–1928), a Canadian painter of Western life and landscape who, after painting in Canada, 1862–80, worked mainly in England where his buffalo pictures were popular with sportsmen. The Earl of Dunraven possessed two, which are now in the collection of Lady Muriel Howarth of Carnforth, Lancashire.

21. An obituary notice published in the *Athenaeum* (May 5, 1877:185) stated that Bromley "suffered from a severe attack of smallpox. During removal to hospital for this disease, it is said, [he] caught cold, which produced congestion of the lungs." Sir Roy Harrod, the artist's nephew, also informed me in a letter dated October 16, 1963, that "his smallpox was misdiagnosed and that he was given a mustard bath."

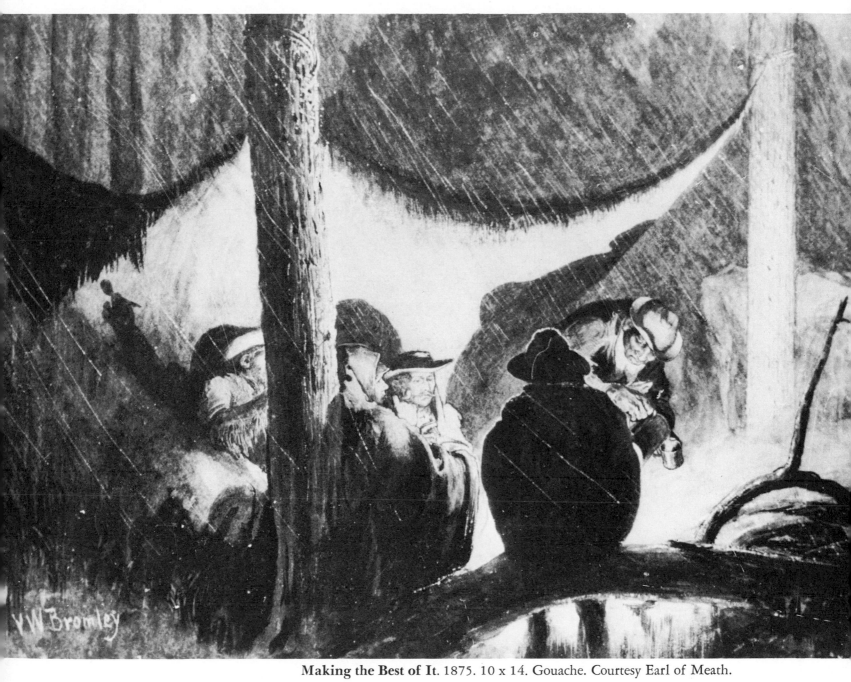

Making the Best of It. 1875. 10 x 14. Gouache. Courtesy Earl of Meath.

Sydney P Hall

6. Westward with Lorne Sydney Prior Hall 1881-82

"Mr. Hall has confined himself too much to sketching Indian pow-wows." Manitoba Free Press, Winnipeg, 1881

Sydney Prior Hall (1842–1922). Wood engraving after a pencil self-portrait. *Graphic,* December 17, 1881.

FOR SEVERAL DAYS the *Caspian* of the Allan Line out of Liverpool had been lurching through mountainous seas toward the Halifax approaches. On the morning of June 25, 1881, the ship had encountered stormy weather, and its saloon passengers were exhausted from lack of sleep. At 3:00 a.m. everyone had been awakened by the sudden stopping of the engines and the stamping of feet overhead. Fearing catastrophe, all had hurriedly thrown on dressing gowns; cabin doors were anxiously opened, and questions asked of the harassed crew. Then the cry, "Man overboard!" was heard. In the turbulent seas, a seaman had lost his balance while lashing a lifeboat. Attempts were made to launch a boat but were abandoned. Lifebuoys were flung, but the man had been wearing oilskins and heavy sea-boots. He drowned instantly.

A half-dressed man, in his late thirties, solemnly watched the tragedy. Modest in manner with lively, intelligent eyes and a pointed beard, he looked more like an absent-minded professor than a sharp-eyed artist. But the incident, one of many on an eventful voyage, had been duly drawn and described. The artist was Sydney Prior Hall, Special Artist for the *Graphic,* who had come to Canada at the personal invitation of the Governor General, the Marquis of Lorne, to join him on a promotional tour of the western provinces of the young Dominion. (1)

Sydney Prior Hall, born in Newmarket, Cambridgeshire, in 1842, had cherished an ambition to be an artist since childhood. But his father, Harry Hall, the noted painter of sporting scenes, did not approve of art as a profession for his son. Nevertheless, he dutifully gave him some pointers, then packed him off to London to study at Heatherley's and with the well-known Pre-Raphaelite painter, Arthur Hughes. But it all led nowhere, and young Hall returned home to comply with his family's wish that he adopt a more respectable profession, the Church. Then, an unforeseen event gave him one last chance. Shortly after he graduated from Pembroke College, Oxford, with a Master's degree, the first number of the *Graphic* appeared, and its editorial claim to be a "faithful Literary and Pictorial Chronicle of the times" revived his hopes. Once again, Hall decided to chance his luck, and he sent off drawings of the University Boat Race. To his delight, they were published.

Events abroad also helped further his newly found success. War broke out between France and Germany in 1870; William Luson Thomas' urgent need for articulate and resourceful artist-correspondents compelled him to interview his French-speaking contributors. (2) Young Hall was sent for, and passing the test with flying colors, the artist was invited to join the *Graphic's* team. His spirited dispatches, no less than his vivid drawings, won him a permanent place on the staff. Sydney Hall, however, was considerably less of a war artist than an informal reporter of journeys with adventuresome members of the royal family and men-of-affairs. These journeys began in 1876, when, as a member of the Prince of Wales' entourage (3)—and representative

1. Hall had first become acquainted with the Marquis of Lorne in 1871, when he painted his marriage to the Princess Louise, sixth child of Queen Victoria. He had accompanied the couple on their journey from Liverpool to Ottawa in the winter of 1878. He had depicted the duties and pleasures of viceregal life for his paper, and had relished the adventure of a moose hunt in the wilderness of western Ontario, during which he had enjoyed himself in spite of a completely frostbitten nose. Luckily he was close to a cabin, where a trusted companion directed him to hold his nose in cold water, and rub gently. Argyll, *Passages from the Past* (London, 1907), 418.

2. William Luson Thomas sought the ideal artist-reporter throughout his life (see "Mr. William L. Thomas of the *Graphic* and *Daily Graphic*," *Sketch,* January 17, 1894: 637–8). He vacillated between the artist who could write and the journalist who could draw, but finally chose the latter. The premature death, in the same year (1875), of three leading illus-

trators who worked for the *Graphic* (Houghton, Pinwell, and Walker) compelled him to look outside the tightly drawn lines of the Victorian art world. His aim was to discover a more news-orientated yet creative equivalent of the socially acceptable artist who was *persona grata* with the establishment.

3. Until the advent of the Eastman Kodak box camera in 1889 ("you press the button, we do the rest"), drawing remained a popular accomplishment among the more cultured members of the British royal family and the nobility. Instruction and guidance were often provided by socially acceptable Special Artists, which gave them the privilege of being a member of the party or entourage, much to the jealousy of colleagues who had to put up with far less luxurious facilities.

4. The Marquis of Lorne (1845–1914), later ninth Duke of Argyll, was Governor General of Canada from 1878–83 and one of the most popular appointees to the office. As a boy, he had run away from Eton to join Garibaldi, but the war had ended before he could get to Italy. Later, he accompanied his father on visits to Wordsworth, Tennyson, Swinburne, and Browning. Following the example of Prince Albert (the consort of Queen Victoria), as an active patron of the arts and sciences, Lorne dedicated himself to his duties with all the reforming zeal of the nineteenth-century liberal. He contributed to the development of Canada's intellectual and cultural life by establish-

of the *Graphic*—he depicted the seven-month State Tour of India in a way which rose to the occasion when events of significance presented themselves, but did not neglect the less formal sidelights. The artist was to develop this facility with great style in a series of two hundred and fifty sketches and drawings of the epic Western trip with Lorne.

The time was opportune. The British middle classes of the 1870's knew little of their immense overseas empire. The average citizen was inclined to regard it as an exotic world where multitudes of dark-faced pagans outnumbered an intrepid minority of high-minded missionaries, explorers, and military commanders. There were, of course, the thinly settled colonies—a remote and wild Australia and New Zealand, where remittance men flourished alongside exconvict squatters in slouch hats, bushrangers, and sheep. Canada was generally thought of as a vast space, colored red on the map, consisting of snow, forest, and prairie; lonely Englishmen hewed down pines to build log cabins. Redskins, picturesque but troublesome, hampered settlement, as did half-breeds and quarrelsome Frenchies. Adventure, fame, and possible fortune might be the prize. But it was not a life for average men.

Disraeli, however, who rediscovered imperialism for England, brought idealism to the job. He wanted to harness the patriotism of the British in an age of growing imperial rivalries. Germany was united, as indeed was the United States from Atlantic to Pacific, and Russia had consolidated her authority over large regions of Central Asia. How could the farflung but unorganized empire of Britain hold together before these challenges? To many, the solution appeared to be the establishment of a greater Britain overseas.

Thus began a call of duty that involved many young British aristocrats in the service of Queen and Country. Among these was young John Douglas Campbell, the Marquis of Lorne. In July, 1877, Disraeli summoned him and told him that "one of our great vice-royalties" was vacant. After a few days, Campbell decided to accept the offer and proceed to Canada—sprawling, empty, and mixed in population, but a fruitful field for the right man. (4)

Sydney Hall found the young Governor General with his hands full. Canada was on the threshold of effectively incorporating its vast northwest into the Dominion. The framework of a great state had been established in 1867, but nobody could predict for how long the structure would stand the strains to which it was now being submitted. Much remained to be accomplished, but available resources seemed puny for such a mammoth task. Unlike the United States, Canada had not effectively occupied her West. Vast wilderness regions saw handfuls of farmers here and handfuls of trappers and miners there. Further settlement seemed beyond the powers of Canada's four millions. A transcontinental railway, which would provide access as well as develop trade and communications with Japan and the Far East, was the only answer. Moreover, such a railway would open up the rich lands for

ing the National Gallery, Ottawa, the Royal Canadian Academy of Art, and the Royal Society of Canada. Greatly attached to the arts, he was himself poet, composer, and naturalist. His *Memories of Canada and Scotland* (London, 1884) contains interesting if histrionic Longfellow-inspired tributes to the beauty of the West, and to the Indians. He was also an enthusiastic artist, and he recorded most of the many countries he visited. Both Princess Louise and he made a large series of watercolor drawings of their various travels in Canada and the United States. A selection of Lorne's pictures of the Western expedition appeared in the *Illustrated London News* (November–December, 1881). His father, as Duke of Argyll, was one of the few members of the British nobility who publicly expressed sympathy with Lincoln's cause during the Civil War; and as a result, all doors were open to the young Marquis when he made his first private visit to the United States in 1866. This, as MacNutt points out, was a factor which played an important part in the settlement of various disputes between Canada and the United States, in which Lorne acted as a trusted moderator.

settlement by the surplus population of Great Britain. All in all, the purposes of British power and influence would be served.

Although the world economic depression of the 1870's kept the project in cold storage for several years, it became more and more apparent that the West had either to be settled or lost. The mounting pressure of American expansion, which had built two transcontinental railroads and had almost completed a third, and was beginning a fourth, was already pushing against the thinly held forty-ninth parallel. American farmers were moving up into the Red River country of Manitoba to homestead. Could British sea power be depended on to save the Canadian West from sharing the fate of California, Texas, and Oregon?

Unexpectedly, the arrival of Sitting Bull, in 1876, brought matters to a climax. After annihilating Custer at the Little Big Horn, the Sioux had crossed into Canada and had ended up as the reluctant wards of the Mounted Police. But the situation was a tricky one. The United States was swept by a public desire to destroy the Indians once and for all. Reports repeatedly reached Washington alleging that bands of Sioux were following the buffalo back over the border and skirmishing with American garrisons. Canada was held responsible for every isolated foray. If Canada could not discipline the Sioux, the United States would. Inevitably, Britain was the bogey and Canada the chopping block for many of the anti-British speeches with which the American public was regaled. On this occasion, the approaching presidential contest of 1880 provided a platform, and the Sitting Bull affair provided an issue for those who sought election to office by stirring up the historic distrust of John Bull. Under these conditions, it took the sustained diplomatic efforts of Lord Lorne, Sir Edward Thornton (British ambassador in Washington), and Prime Minister Sir John Alexander MacDonald to settle things and convince Canada to expel the Sioux. Finally, in July, 1881, Sitting Bull led the half-starved and disconsolate remnants of his army back over the border to surrender at Fort Buford.

Clearly, the 1880's were critical years: although it was difficult to finance such a project, the Canadian Pacific Railway could no longer be postponed. Lord Lorne's term of office began to acquire a flavor of exuberant optimism as work began on the great venture. A new pioneering spirit emerged as news of cheap and fertile land quickened the stream of westward emigration. Encouraged by the railway, thousands of farmers set out from Ontario to establish the first homesteads in what are now Manitoba and Saskatchewan. Many more thousands were needed, but no great number could be moved until the line crossed the thousand-mile barrier of bleak and rocky wilderness known as the Shield. Completion date was set for the end of 1881, which gave the Canadian Pacific time to plan a campaign to attract settlers from Britain. Every expedient must be used to ensure that they would come.

This was easier said than done. The American transcontinental rail-

way companies were no longer transport companies, but actually huge land-owning companies who, through numerous land and emigrant societies, had been active in Britain since the 1860's. Both the Union and Southern Pacific employed a well-tried repertory of "booster" techniques, and seldom missed an opportunity to compare Canada with the United States in the most unfavorable terms. In what amounted to a war of persuasion, those who contemplated emigration had been convinced that the Canadian West was, by comparison, a great cold land which would not break easily to the plow. Surprising as it may seem, this was a conviction shared by a large and influential section of the British press, not to mention the merchant bankers of Edinburgh and London. The Canadian Pacific leaders and the Prime Minister had a brainwave: a tour of the West by Lord Lorne, the Governor General himself, well reported and publicized, would be the best way to show Britain that the Canadian West offered prospects and opportunities in settlement and investment equal to any offered by the United States.

The young Governor General responded to the challenge with great personal enthusiasm. The expedition, he believed, would provide a great opportunity to extol the virtues of Canada, and so, if successful, vindicate his duties as viceregal representative of his august mother-in-law, Her Gracious Majesty Queen Victoria. He used his influence to the full to persuade leading journals to send their best men, paying their expenses out of his own pocket. Some resistance was encountered from editors, but Lorne's royal connections triumphed with those who mattered most. John Walter, the editor of the *Times,* after admitting that he himself felt that life in Canada was so commonplace that little news of any consequence was likely to come out of it, gave in and appointed Charles Austin to represent the paper. The second correspondent needed no persuasion; he was the indefatigable and persuasive churchman, the well-known Reverend Dr. James MacGregor, D.D., who had worked among the crofters of the Hebrides and the poor of Glasgow. As correspondent for the influential Edinburgh *Scotsman* and *Courant,* what he would have to say would carry great weight among his shrewd and cautious countrymen. The third was Charles Roche, who represented the Glasgow *Telegraph,* the Quebec *Gaulois,* and the Rouen *Journal de Rouen.* The only artist of the party, Sydney Hall of the *Graphic,* was joined by another, who unexpectedly turned out to be the Governor General himself. Not to be outsmarted by its younger rival, the *Illustrated London News* had responded to an inspired hint from Lord Lorne that his own sketches would be made available.

The Canadian press, however, took exception to the failure to invite its representatives to join the party on the same terms. Except for reporters of local newspapers who would remain with the party temporarily, the pro-West Toronto *Globe* was the only Canadian journal to have a correspondent with the press corps.

In addition to the gentlemen of the press were the Governor General's

personal staff. These included Colonel Sir Francis de Winton, private secretary; Captain Bagot, comptroller; Captain Vernon Chater of the Ninety-first Regiment and Captain Percival of the Second Life Guards, aides-de-camp. Canadian officials included the Commissioner for Indian Affairs, Edgar Dewdney. Dr. Colin Sewell of Quebec was the physician of the party. A retinue of servants included Lord Lorne's personal chef, M. Boquet, who was promptly dubbed *Maitre Cuisinier de la Prairie.*

All preparations completed, the viceregal party left Toronto by rail on July 19, for Owen Sound, on the shores of Georgian Bay. This opening phase, as MacNutt informs us, lasted some eleven hours, owing to what Austin, the correspondent of the *Times,* called the embarrassing eagerness of the Canadians to have meetings and deliver addresses to their governor general. The ninety-five-mile route had taken them through wild forest. Dust, sun, and speechmaking were exhausting, and the party, sixty in number, were glad to climb aboard the *Frances Smith,* a tiny lake steamer which carried them across the translucent waters of Lake Superior to Prince Arthur's Landing in Thunder Bay.

Here the craggy Shield country, through which the first French *voyageurs* had reached the prairie, awaited them. The going was difficult, but the small army of railroad-builders had already blasted their way through the granite peaks and muskeg and completed much of the line. The party boarded a special train of three flat cars fitted with awnings, and a carpeted caboose furnished with sofas and easy chairs. By early evening, they had completed a run of two hundred miles to the end of the track at Lake Wabigoon, and were tucking into an alfresco dinner beneath the tints of a fading sunset.

The next day, however, brought their toughest obstacle, the formidable Seven-Mile Portage between Wabigoon and Eagle lakes. This they had to reach on foot themselves, laboring under the burning heat of a July day, made even more unbearable by a recent forest fire. The gallant Marquis, however, was the first to reach the lake, eventually arriving at the Canadian Pacific construction camp known as Eagle Lake City.

The long hike over rock and muskeg was quickly forgotten as the astonished Lorne gazed out onto a fleet of gorgeously painted and beflagged canoes, manned by white and Indian *voyageurs,* waiting to escort him and his party to a camp on Garden Island. "Here," wrote Hall, "in the heart of the North American continent, the Heir of the Argylls was welcomed by Murdoch Reid of Winnipeg, arrayed (in spite of bloodthirsty mosquitoes) in true Highland costume, and striking up from his gaily be-ribboned pipes, the welcome strains of *Heiland Laddie!*" (5)

The *pièce de résistance,* however, followed a few days later, when a gourmet dinner was served under the stars! Nothing, it seemed, was too good for the guests of the Canadian Pacific Railway, and after their arduous adventures, appreciation was both spontaneous and sincere. "At dusk," wrote Hall, "Summit and Mile lakes having been traversed,

5. Hall, *Graphic,* September 5, 1881:235.

Lord Lorne. Pencil. *Graphic,* October 1, 1881. Courtesy Public Archives of Canada, Ottawa.

Dr. MacGregor. Pencil. *Graphic,* December 17, 1881. Courtesy Public Archives of Canada, Ottawa. Dr. MacGregor obtained temporary immunity from mosquitoes by wearing long-armed white leather gauntlets and a gauze veil fastened by a rubber band round his sun helmet.

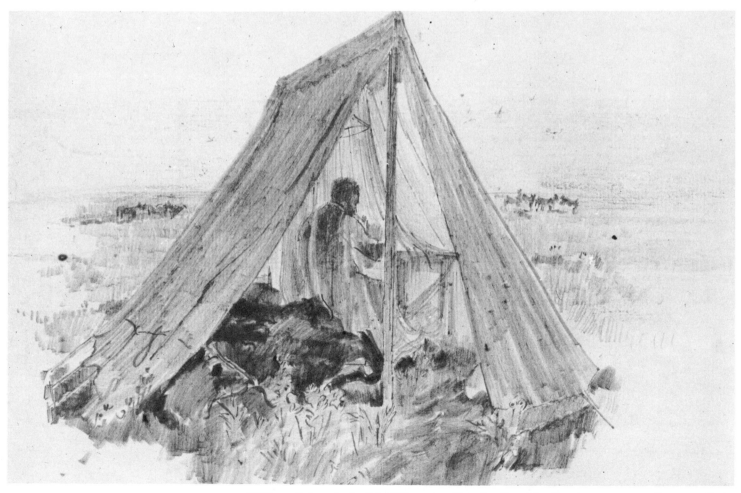

"Times" Austin in his Wigwam. Pencil. *Graphic,* October 1, 1881. Courtesy Public Archives of Canada, Ottawa. Each member of the press corps had his own tent in which to write up his impressions of the epic two-month trip.

Captain Bagot, Comptroller of the Expedition. Pencil. Unpublished. Courtesy Public Archives of Canada, Ottawa.

Dr. Colin Sewell, M.D., of Quebec, the Physician. Pencil. Unpublished. Courtesy Public Archives of Canada, Ottawa.

Captain Vernon Chater of the 91st Regiment, Aide-de-Camp to Lord Lorne (Above). Pencil. Unpublished. Courtesy Public Archives of Canada, Ottawa.

Monsieur Boquet, Lord Lorne's Cook and "Maitre Cuisinier de la Prairie" (Right). Pencil. Unpublished. Courtesy Public Archives of Canada, Ottawa.

Stern of the S.S. Frances Smith—Passing Through Wilson's Channel, Lake Superior. Pencil. *Graphic,* August 27, 1881. Courtesy Public Archives of Canada, Ottawa. After an eleven-hour train ride from Toronto to Owen Sound on Lake Huron, a hundred-mile journey through wild forest brought the party to Collingwood on Georgian Bay. Here they were glad to board the S.S. *Frances Smith,* a little lake steamer which was to take them past Manitoulin Island, into Lake Superior and on to Prince Arthur's Landing, later Fort William and now the city of Thunder Bay. Hall's sketch shows members of Lord Lorne's entourage, including Colonel de Winton (far right) and Dr. MacGregor (front right).

Prince Arthur's Landing (Above). Pencil, dated July 25, 1881. *Graphic,* September 10, 1881. Courtesy Public Archives of Canada, Ottawa. From the vantage point of the Queen's Hotel, Hall sketched part of the train which was to take the party on the first completed portion of the line to Lake Wabegoon. Powered by a Portland locomotive, it consisted of three flat cars, a caboose (christened the "Pullman" and furnished with sofas and easy chairs), and a wood car. A large crowd had gathered for the occasion, and they cheered vociferously as the train gathered steam and rattled away in the direction of Fort William.

Barge, Carrying Lord Lorne and Party (Right). Pencil. Inscribed "Yacht carrying His X. sketched from tug." *Graphic,* September 5, 1881. Courtesy Public Archives of Canada, Ottawa. For sixty miles a small steamer tugged the party in a barge along Eagle Lake, which until recently had never known anything but Indian canoes.

a final portage brought the camp to Dryberry Lake, where two huge campfires were burning." Dr. MacGregor added, "it looked more like a scene from fairyland than actual life. A broad balsam-carpeted approach led up to the largest of ten spacious tents, ranged in a line close to the water . . . each tent had two four-post beds, with mosquito curtains. Two candles, attached by birch bark to the top of a stick were already lit. There was every comfort . . . every article of furniture had been cut out of the forest but a day or two before." Iced champagne and an elaborate banquet were later served on spotless white linen.

The rest of the journey to Winnipeg took the party through the lakes and portages of Keewatin, the "Land of the Northwest Wind." Finally, Winnipeg was reached on another completed portion of the railway from Rat Portage.

Ten years previously, Winnipeg had consisted of little more than a few wooden shanties. It was now a rapidly expanding, well-built city, with a population of twelve thousand; and its future as a great grain center and the capital of a wealthy province was predicted by the shrewd MacGregor. It might be unfinished and far from beautiful, but as Austin remarked, it was too much to expect that a wealthy heiress should also have good looks! The fertility of the rich, loamy soil, as black as coal, appeared inexhaustible. Immigrants were pouring in, and the thriving young city abounded in schools and churches. In spite of all this bustling activity, Winnipeg took time off to welcome the first governor general to visit the West. The redoubtable Donald Smith (later Lord Strathcona) of the C.P.R. was on hand to greet him at his house, Silver Heights, where a huge triumphal arch, resembling the front of Inverary Castle (the Argyll seat in Scotland), added to the festive atmosphere of the occasion. From Winnipeg, the party traveled to the end of another section of the railway at Portage la Prairie. Under Van Horne's merciless pressure, the line was now being pushed forward at the fantastic rate of a mile and a half a day. Each of the party advanced the iron way by several yards by laying a cross tie in commemoration of the day.

At Portage la Prairie, the railway again ended. From here on, Lord Lorne and his party would make the rest of their journey to the Rockies in a train of horse-drawn ambulances, buckboards, and Red River carts. Colonel de Winton, as military secretary, assumed management of an impressive cavalcade which now consisted of seventy-seven men, ninety-six horses, twenty-seven vehicles, and twenty-one tents. In addition to the Governor General and his personal staff, the press corps, and government officers, there was a large group of guides, interpreters, and servants. A detachment of forty-seven Mounted Police under the command of Colonel Herchmer completed the expedition.

From the front seat of his jolting ambulance, Hall sketched the Mounted Police escort. Stretched in a long line across the boundless prairie, the artist thought they looked "like so many red ants." As they were seldom out of the saddle, the Northwest Mounted Police were

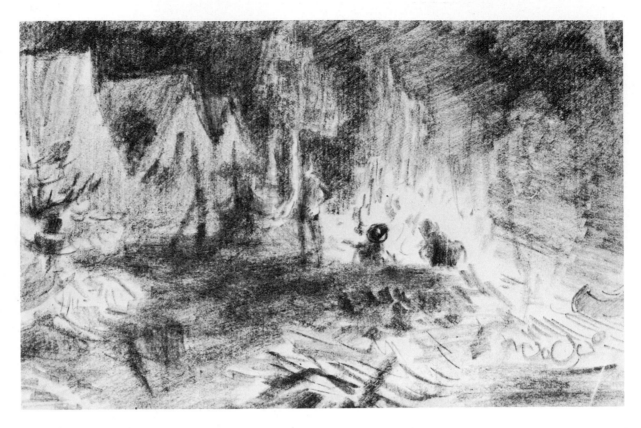

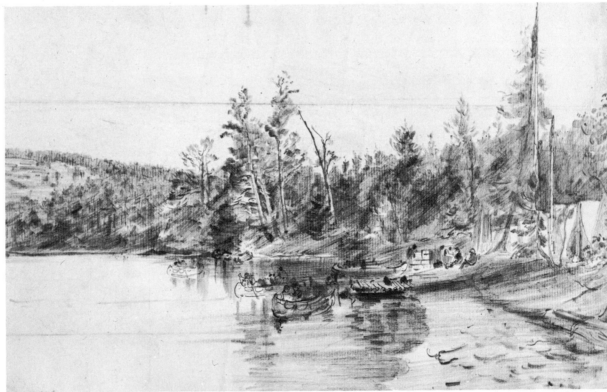

Camp Scene, Dryberry Lake (Top). Pencil, dated July 28. Unpublished. Courtesy Public Archives of Canada, Ottawa. **Dryberry Lake** (Below). Pencil. *Graphic,* September 5, 1881. Courtesy Public Archives of Canada, Ottawa. In the wilderness country of western Ontario and eastern Manitoba, the party traveled alternately by train, steamer, canoe, or on foot, making portages through deep forests of jackpine and muskeg. Under these conditions, the gourmet dinner under the stars which awaited them was as unexpected as it was remarkable.

A View of Winnipeg from amongst the Lightning rods of St. Boniface College (Right). Pencil and wash drawing heightened with white. Unpublished. Courtesy Public Archives of Canada, Ottawa.

Lightning rods of St. Boniface College.

Winnipeg. Pencil. Inscribed "view from top of St. Boniface College." *Graphic,* September 5, 1881. Courtesy Public Archives of Canada, Ottawa. In 1881 Winnipeg had a population of 12,000. Hall found it a boom town, growing rapidly on incredible harvests of golden wheat grown in the rich, black, loamy soil. He also found it ugly and unfinished. But Austin, the *Times* correspondent, put the artist's mind at rest. Is it not too much to ask, he said, to expect that a fabulously wealthy heiress should have good looks too!

magnificent horsemen. In those days, they wore a uniform similar to the British Dragoons, white helmets with a heavy brass spike and a red tunic with yellow facings (the famous Stetsons came later). Their nomadic life enabled them to turn their hands to anything—mending a saddle, shoeing a horse, driving an ambulance, even providing medical attention and legal advice. Hall captured their extraordinary sense of duty in vivid portrait sketches of Colonel Irvine and Major Crozier, both steely eyed veterans who were the living embodiment of honesty, courage, and loyalty.

Like a small army campaigning in a distant land, the party wound in single file through an ocean of succulent grasses, following a trail which the Indians and the Hudson's Bay Company had used for generations. At times, the prairie appeared limitless, its vastness enhanced by what Hall described as the "enormous vault of heaven." Horses, wagons, and men, he added, looked "like dots." Yet he found the country to be much less monotonous than he had expected. It was, he discovered, broken up with lakes and hills, and even salt plains, bluffs, and valleys.

Each day they had to be up and away by sunrise to complete a daily march of thirty to forty miles, traveling at an average rate of five miles an hour in three stages. Between nine and ten o'clock a halt was made for breakfast, and all the horses were turned loose on the prairie. Lunch followed at two. Somewhere about six, the half-mile-long train of wagons and ambulances would come to a stop. Colonel Herchmer would then ride out to locate the previously arranged campsite, which would supply the essentials of wood and water. On his orders, the carriages were wheeled around to form a line; the baggage wagons which followed formed another. Every move followed a well-practiced plan; each wagon was numbered and each driver knew exactly what to do. Horses were unyoked, and a few minutes later were scampering or rolling in the long grass. The escorts pitched the tents in a double line, forming a street, with the large mess tent standing out from the rest. Servants brought in the luggage, fixed the camp beds and mosquito curtains, and, unless there was a lake nearby, carried water for the nightly baths. The camp now appeared like an animated village, with fires blazing in all directions. Hall particularly liked an early arrival, as it was delightful to lie about in the sweet-scented grass, which was full of flowers and aromatic plants; or to work quietly on his drawings or diary at the door of his tent as the fiery sun went down. But he would almost as eagerly enjoy smoking a pipe and swopping anecdotes around the campfires.

During the halts to rest the horses, there would be impromptu fishing and hunting expeditions. Every one of the thousands of lakes and ponds passed on the prairies swarmed with fish and wild fowl. There were many species of salmon and varieties of trout; game was usually blue and green teal, American widgeon, the black-headed duck, and, of course, the ubiquitous prairie chicken. Hawks, buzzards, cranes,

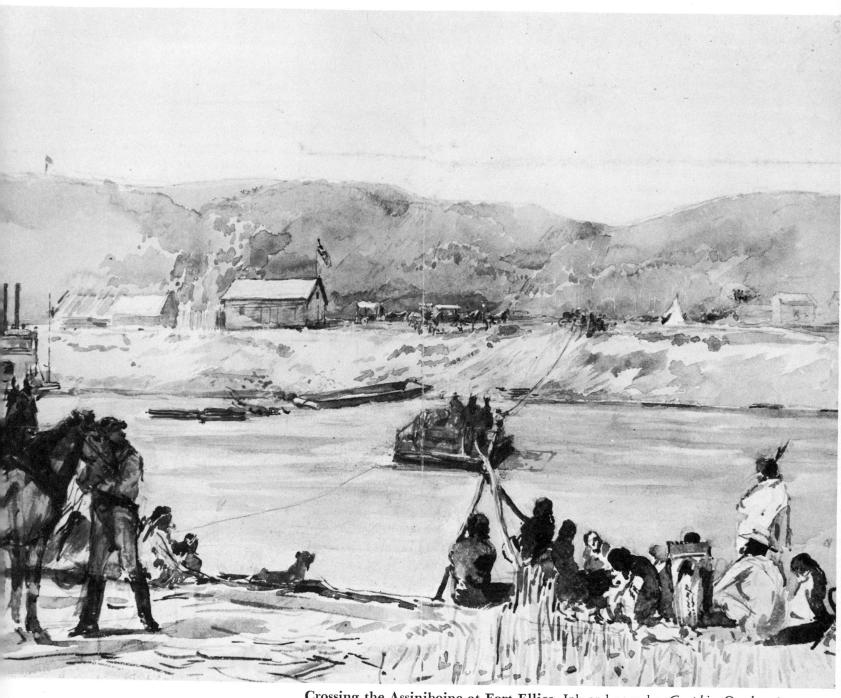

Crossing the Assiniboine at Fort Ellice. Ink and gouache. *Graphic,* October 1, 1881. Courtesy Public Archives of Canada, Ottawa. The railway had been left behind at Portage la Prairie, and the cavalcade became horsedrawn and continued to Fort Ellice, Fort Qu'Appelle, and later, Fort Carlton. Difficult river crossings abounded, but the Mounties, who combined the handiness of sailors with the dash of soldiers, were more than equal to the occasion. The Assiniboine was crossed at Fort Ellice. "Our horses," wrote Hall, "were got onto the ferry-boat, team by team, without difficulty, the boat being pulled across the stream hand over hand by the rope."

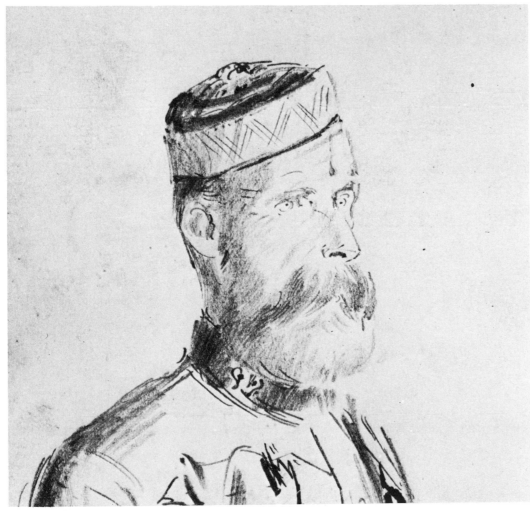

Mounted Police (Above). Pencil. Unpublished. Courtesy Public Archives of Canada, Ottawa. Stretched in a line across the prairie, the Mounted Police escort, Hall thought, looked "like so many red ants."

Colonel A. G. Irvine (Left). Pencil. *Graphic,* December 31, 1881. Courtesy Public Archives of Canada, Ottawa. The steely-eyed devotion to duty of the Mounties is well conveyed in Hall's portrait sketch of one of its first officers, who was Commissioner at the time of Lord Lorne's Western expedition.

SYDNEY PRIOR HALL 149

and grouse also abounded. At Red Deer River, between Battleford and Fort Calgary, one of the last buffalo hunts in Canada took place on September 5, when several members of the party chased and killed three bulls. It was the first herd seen for years. Ironically, one of the guides was Chief Poundmaker himself.

Dr. MacGregor's fiery sermons, too, were always good for a welcome diversion. Every Sunday morning, and every afternoon during the week, the little Scots minister conducted divine service. Frequently, in spite of a prearranged time signal, they went on too long and delayed a day's march. His congregation often included a few Indians, who, attracted by the short, dark medicine man, thought something had to happen as the result of his incantations. When not preaching, MacGregor was urging Hall to draw more of the landscape, and not to limit his attention to men and horses, which, he said, "were more or less alike all the world over."

A journey on the stern-wheelers *Northcote* and *Lily* up the Saskatchewan River to Prince Albert and on to Battleford gave the party a much needed break from the jolting they had received crossing the prairie. The broad, swift-flowing river wound its way through parklike landscape of great beauty. Glorious August sunsets fringed the golden prairie grass with gold, amber, crimson, and purple. Then one morning the white walls of the Government House of the Northwest Territories at Battleford were seen in the distance; shortly afterward, Governor David Laird conveyed the party to their lodgings. Here at Battleford, Lord Lorne was kept busy listening to the complaints of settlers: land surveys had not been completed, and even the most respectable settlers had only squatter's rights. Which way would the railway go? Which were railway lands and which were not? All awaited government action which would make or unmake fortunes. The complaints of the métis (half-breeds, or those of mixed blood) were also heard and action promised in support of their claims.

It was now early September and heavy morning frosts compelled the travelers to wrap themselves in overcoats and blankets. From Battleford to Fort Calgary lay another vast stretch of prairie, not entirely without danger. A journey of twelve days took the party through long wet grass and bad weather, and, for the latter part of the trek, they were three thousand feet above sea level. Horses died of exhaustion, mosquitoes swarmed about the wagons, and prairie wolves, too close to the camp for comfort, howled dismally at night.

One of the guides was Poundmaker, the great Chief of the Cree Indians. The *Globe* correspondent described him as being over six feet tall with a refined, intelligent face. His gestures were graceful and expressive and his small, delicately shaped hands made the meaning of his Cree sentences almost as plain to everyone as the English of the interpreters. As Poundmaker was a famous storyteller, Lord Lorne was anxious to hear him. In the warm glow of the mess tent he told the

Dr. MacGregor Interviewing David Laird, the Lieutenant-Governor of the North-West Territories. Pencil. Unpublished. Courtesy Public Archives of Canada, Ottawa. The inimitable MacGregor is seen here in the course of his duties as a newspaper correspondent, interviewing the most powerful legislative and administrative power between Winnipeg and the Rockies.

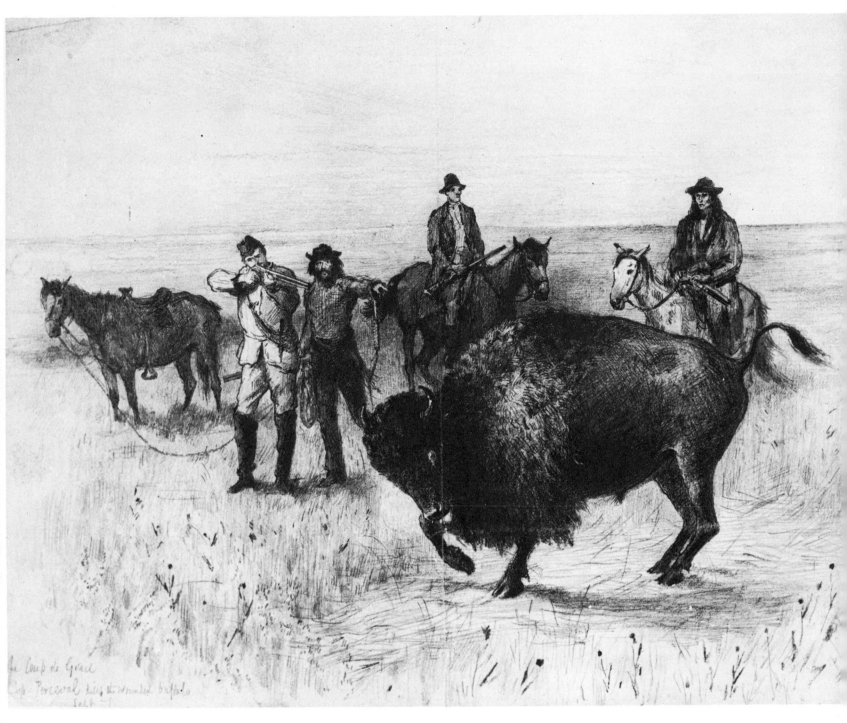

The Coup de Grâce, Captain
Percival Kills the Wounded
Buffalo (Above). Pencil and
watercolor. *Graphic,* November
26, 1881. Courtesy Public Archives of Canada, Ottawa. On
September 5, a herd of buffalo
was seen. Three of the beasts
were shot down in one of the last
buffalo-hunts on the Canadian
prairies.

Old Catholic Church, Battleford, Saskatchewan (Left).
Pencil. *Graphic,* January 14,
1882. Courtesy Public Archives
of Canada, Ottawa.

SYDNEY PRIOR HALL 151

tales of the red deer whose horns proved to be the horns of a spirit, of the giant otter which was three fathoms long, and of the grizzly bear which brought luck to the Crees in their wars against the Blackfeet. Outside the night wind whistled drearily, keeping the flopping folds of the tent in constant motion. Candles set in buffalo vertebrae shed a flickering light upon the solemnly expressive face of the storyteller. Lord Lorne and his entourage, caps drawn tightly over their heads and overcoats buttoned up to their chins, were deeply moved, and made a most attentive audience.

Although all fell under the spell of his unusual personality, Poundmaker did not succeed in concealing the reservations he had about the Great Brother-in-law, as the Governor General was called, and his party. It then leaked out, probably as the result of investigations by the Mounties, that the "tobacco message" had gone out to Poundmaker's chiefs. Tobacco usually meant trouble. Many of the party were thankful that they had been provided with a strong Mounted Police escort.

Previously in Saskatchewan, settlers who had been interviewed on the way were awed with the incredible fertility of the soil. Wheat grew man-high, and oats gave extraordinary yields. The Bible was quoted, to prove that these settlers had indeed come to the Promised Land. But now, the party also saw the darker side of the picture—the widespread and abject poverty of the Indian tribes. Lorne himself thought that, considering their starving condition, "it was amazing how well we got on with them." (6) During the 1870's, the buffalo hunts had gradually ceased, forcing the Indians to abandon their nomadic ways of life and adopt a more settled existence. In fact, extinction of the buffalo had long been predicted. But when it finally did come, in 1880, the Indians were totally unprepared. At first, they reacted by demanding help and supplies, and when these were not forthcoming, they became desperate and raided cattle herds and ran up huge debts at friendly trading posts. Meanwhile, about half the Plains tribes tried growing crops and were proving themselves to be good farmers; but the other half seemed too demoralized to make the common effort required. Powwows were the main means of contact with the Indian tribes, and the paternalistic Lorne, well aware of the government's shortcomings, used every opportunity to urge them to cultivate reservation lands.

The biggest and most important powwow took place near Blackfoot Crossing on the Bow River in what is now Alberta. As the party made their way down into the valley where the tents had been pitched, close to the bank of the river, the golden light of early evening rested on the horses and ponies grazing in the buffalo grass, a full moon rose to the east. Roaring campfires added to an effect that was both strange and beautiful.

They were now in Blackfoot country, and over on the north side of the river lay Blackfoot Crossing. On a yellow-brown flat beyond the

6. Argyll, *op. cit.*, 467.

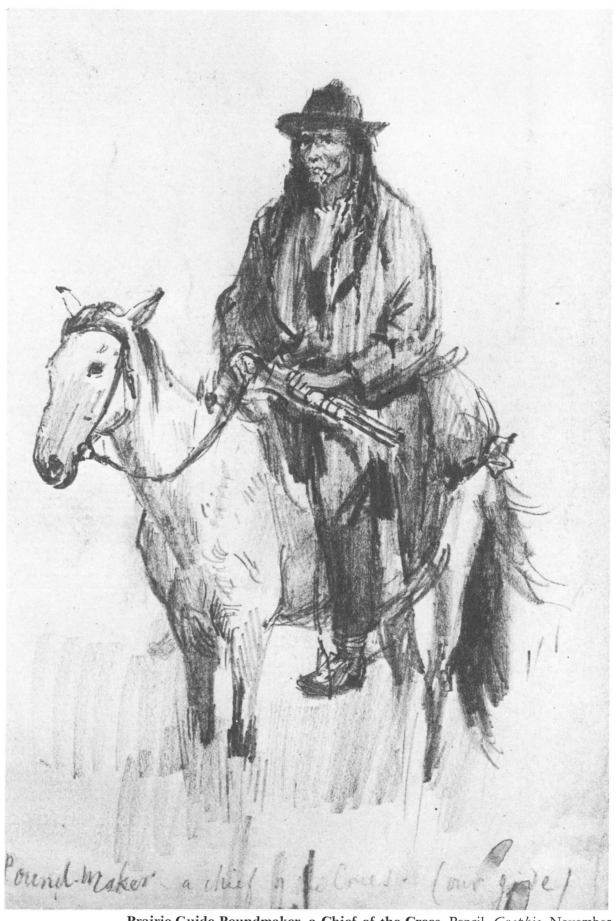

Pound-Maker a chief *h* *Cree* (our guide)

Prairie Guide Poundmaker, a Chief of the Crees. Pencil. *Graphic,* November 26, 1881. Courtesy Public Archives of Canada, Ottawa. The great chief of the Crees guided the party from Battleford over the prairie to Fort Calgary. He impressed everyone with his strong and gracious personality, but all could feel his veiled hostility toward "the Great Brother-in-Law," as he called Lord Lorne.

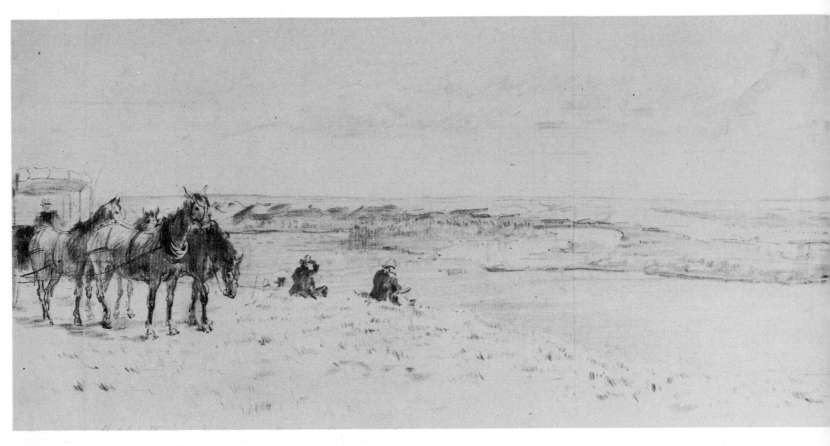

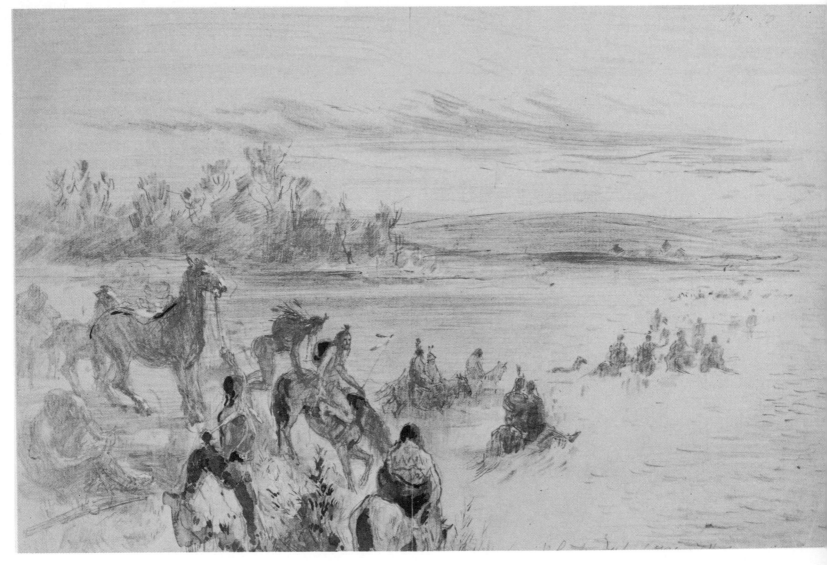

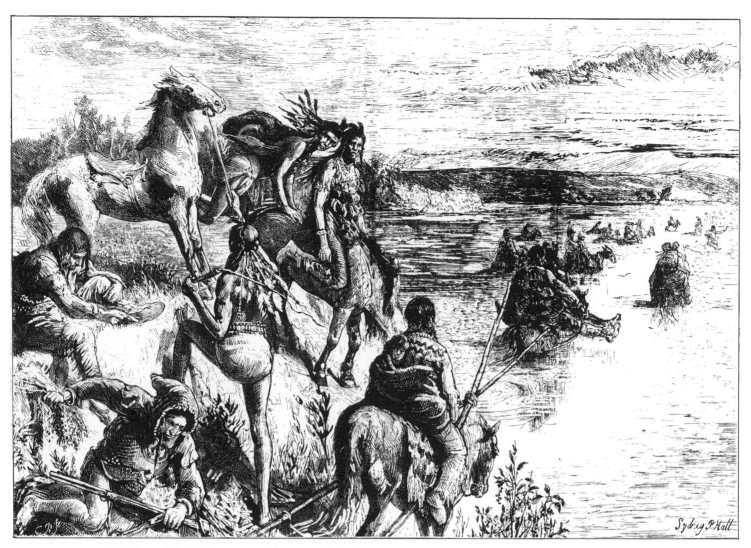

Lord Lorne Sketching at Blackfoot Crossing (Above Left). Pencil. Unpublished. Courtesy Public Archives of Canada, Ottawa. On the high bluff overlooking the Bow River at Blackfoot Crossing, the hard-working Marquis temporarily forgot the obligations of office and paid tribute to the beauty of the Western landscape by indulging himself in his favorite pastime.

Blackfeet Crossing the River (Left). Pencil sketch for illustration, *Blackfoot Crossing. Graphic,* January 28, 1882. Courtesy Public Archives of Canada, Ottawa. The sun was setting as Hall made this sketch of the Blackfeet returning to camp after the powwow. "They made for the ford on the Bow River, which has its name from them," he wrote, "Moccasins and leggings were pulled off, and blankets tucked into studded belts. Ponies were urged down the steep bank with vehement heel, pulled round the under jaw, and lashed by the short Indian scourge, . . . they were of all colours, pintos, roans, chestnuts, duns, buckskins and whites. Many had to bear two braves in all their war paint at once, and sometimes, when over the brink of the bank, to bear the shock of the second brave, who leapt upon their haunches. Nor were all the riders braves or bucks. There were squaws amongst them, not to be distinguished from their lords in manner of riding. A big ear-ring, a beaded jacket, or a papoose behind, would betray them . . . even the great Chief Crowfoot and his lady [took to] the water, which they did like the others, passing along the golden highway."

Blackfoot Crossing (Above). Wood engraving. *Graphic,* January 28, 1882. Courtesy Public Archives of Canada, Ottawa. The same illustration as it appeared in the *Graphic*.

river was an encampment of two thousand Blackfeet. Dark blue smoke curled up from countless campfires. Here, Crowfoot, the great leader of the Blackfoot confederacy, and his braves awaited the Governor General. While the party was at dinner, doubtless enjoying another of Monsieur Boquet's prairie specialities, Lord Lorne agreed to a request from Crowfoot that the great powwow, or council, take place the very next day.

There was great activity in the Blackfoot camp from sunrise on. Then, at nine, for almost an hour, a motley and colorful cavalcade of tribesmen and their ponies fought their way across the swift, deep river; yelling and firing their Winchesters as they approached the blue and white striped awning which shielded the Governor General and his staff from the hot sun. The copper skins of the Indians; the scarlet, blue, purple, green, orange, and brilliantly striped blankets; the glistening brass ornaments; the buff and brown moose and buffalo skins made into tunics; the vividly dyed feathers and rich furs; all blended into a strange and luxuriant mingling of colors, expressing a more barbaric splendor than anything the party had yet seen. "Crowfoot was the first to appear," wrote Hall, "followed by his fellow-chiefs, and Bullhead, chief of the Sarcees, each bearing the Union Jack as a banner, which they placed before the Governor. After them came the braves, tall powerful men, who took their appointed places without the least confusion." In a large double-page illustration of the event entitled *The Pow-wow at Black Feet [sic] Crossing,* (7) Hall gave the readers of the *Graphic* a taste of the historic nature of the occasion.

Although decidedly picturesque, the council revealed nothing but the familiar plight of the Plains Indian, but Crowfoot was determined to convince Lorne. "He illustrated his speech," wrote Hall, "by holding up a tin cup to show how much flour was doled out to each of his people—poor flour too, and he compared himself and his tribe to that empty pannikin, for so they had been since the buffalo had left them." (8) But the Blackfoot chief's pathetic gesture only raised a laugh. The French half-breed interpreter had bowdlerized his eloquent plea as, "He say he damn glad to see you, but he say he damn hungry!" Crowfoot also exhibited a dollar bill, observing that such pieces of paper in former days passed for five dollars. He did not understand the remarkable depreciation in their value.

The Blackfoot chief's pleas were made at a time when the depression of 1879–82 drastically reduced expenditure in the Department of Indian Affairs. Unfortunately, this took place when the Indians were adjusting to reservation life and were not yet self-supporting. Food supplies were cut and the Indians felt themselves taken advantage of. Once again, they felt themselves cheated by the white man of their lands, their freedom, and their means of subsistence. The council broke up with confessions of loyalty made to the Great White Mother, but already Crowfoot's adopted son, the Cree chief, Poundmaker, had con-

7. *Graphic,* November 5, 1881: 464–5. In addition to making a large illustration for the *Graphic* from his numerous sketches, Hall was commissioned by the Marquis of Lorne to paint a large oil of the event. A large charcoal and watercolor cartoon entitled *Conference of the Marquis of Lorne and Blackfeet Indians, September, 1881,* is in the possession of the Public Archives of Canada. The painting itself, entitled *Last Indian Council Held on Canadian Soil between the Governor-General of Canada, and Crowfoot, Chief of the Blackfeet Indians, 1881,* is in the collection of the Gilcrease Institute of American History and Art, Tulsa, Oklahoma.

8. Hall, *op. cit.,* November 5, 1881: 459.

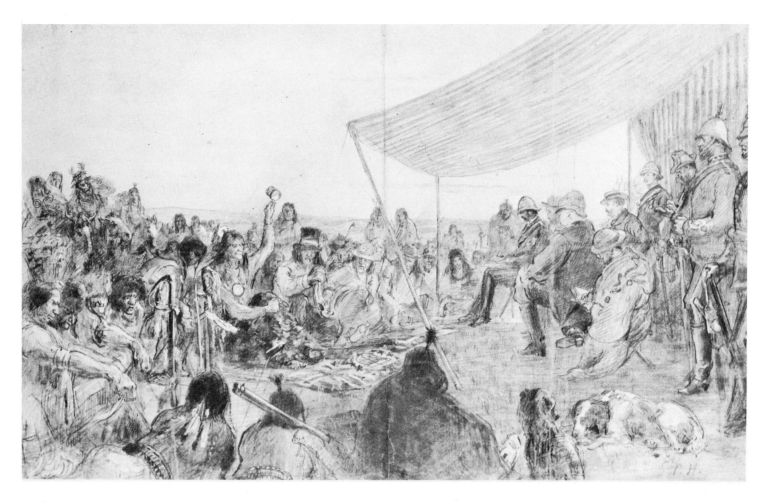

The Pow-wow at Black Feet [sic] Crossing, September 10, 1881 (Above). Pencil, wash, and watercolor. *Graphic,* November 5, 1881. Courtesy Public Archives of Canada, Ottawa. This historic event took place on broad, flat ground, to the south of the Governor General's camp on the Bow River at Blackfoot Crossing. This drawing was done on the spot and was the basis of the oil done later (pp. 160–161).

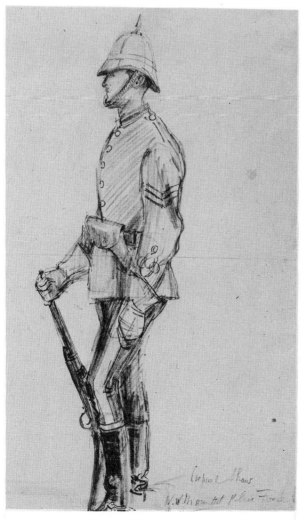

Corporal Shaw, Northwest Mounted Police Force (Left). *Graphic,* November 5, 1881. Courtesy Public Archives of Canada, Ottawa. The Northwest Mounted Police uniform was devised to remind the Indian of the British soldiers, for whom he had the greatest admiration. At the time of Lorne's tour; the uniform was similar to that of the British Dragoons (Stetsons came later).

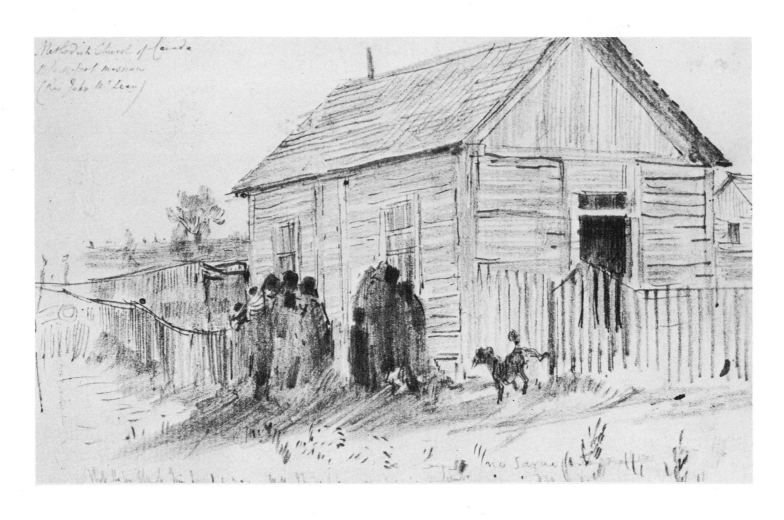

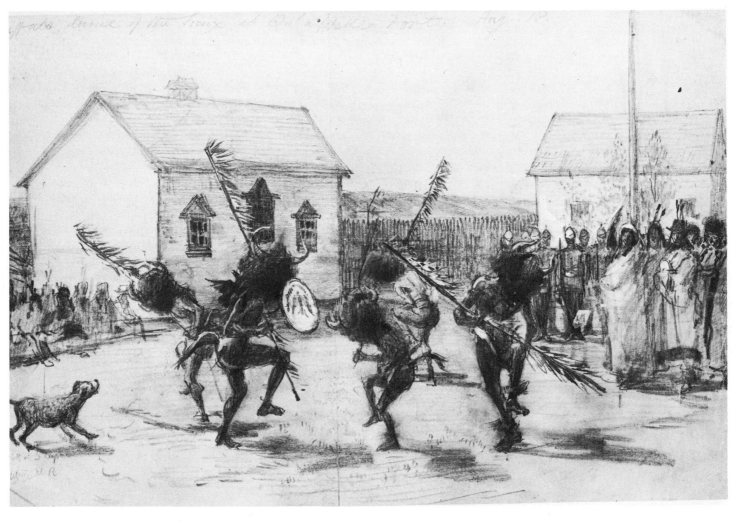

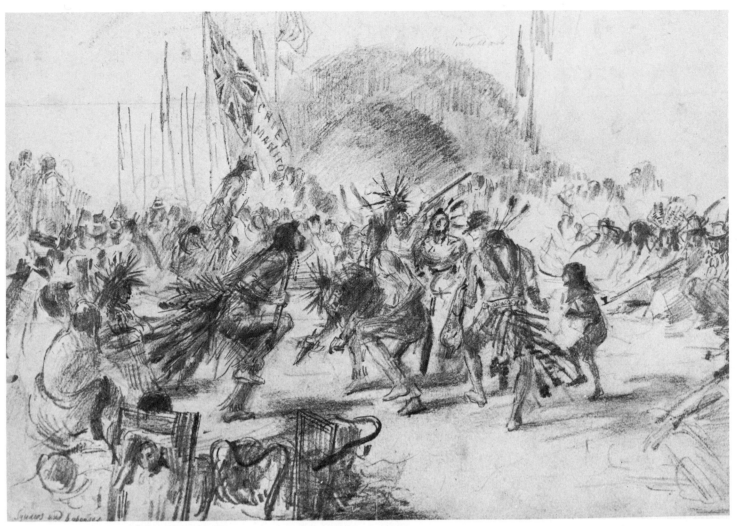

Methodist Church, Blackfoot Mission, Fort Qu'Appelle (Above Left). Pencil. Unpublished. Courtesy Public Archives of Canada, Ottawa.

Ojibway (or Chippewa) Indians dancing a Sioux dance at Rat Portage (Above). Pencil. *Graphic,* October 22, 1881. Courtesy Public Archives of Canada, Ottawa. After the Marquis had been called to order by Manitobaness, the great chief of the Ojibways, for unfulfilled promises, the Indians performed dances. "As the tom-toms responded to the quickly-plied stick," the artist wrote, "one fierce brave stood up and led off the dance, followed by a second and a third, until a score or more warriors were on their feet."

The Sioux Buffalo Dance, Fort Qu'Appelle (Left). Pencil and watercolor. Dated August 18. *Graphic,* November 19, 1881. Courtesy Public Archives of Canada, Ottawa. Sioux buffalo dancers reminded Hall of the devil dancers of Perahara he had seen at Kandy with the Prince of Wales on the royal tour of India in 1875. "Huge masses of matted hair hid every vestige of the human face divine," he wrote, "and the horns . . . and the tails, tucked in behind (as buffaloes carry them when angry) heightened the diabolical effect. They moved in a circle, to imitate the movements of buffaloes pawing the ground, jerking their heads from left to right; tossing them, and grunting with a spasmodic ugh-e-ugh." The guard of honor of Mounties quietly watched. But these antics were too much for a quixotic dog!

(Overleaf)
Last Indian Council Held on Canadian Soil between the Governor-General [the Marquis of Lorne] and Crowfoot, Chief of the Blackfeet Indians, 1881, Sydney Prior Hall. 60 x 80. Oil. Courtesy Thomas Gilcrease Institute of American History and Art, Tulsa, Oklahoma. Hall's large canvas was painted in 1887–88 to remind the Marquis of Lorne of the highlight of his Western expedition. Chief Crowfoot now stands directly facing Lord Lorne, who has been moved forward to confront the great Indian leader. The other known principals include Mr. Edgar Dewdney, Commissioner for Indian Affairs (behind Lord Lorne in straw hat and whiskers); Colonel de Winton (seated in white helmet behind Mr. Dewdney); Captain Percival (standing right); and Mr. Charles Austin (behind with beard and slouch hat). In the foreground are Dr. MacGregor (seated, holding notebook); Colonel Herchmer (standing behind with spiked helmet); and Captain Chater (stooping to collect papers).

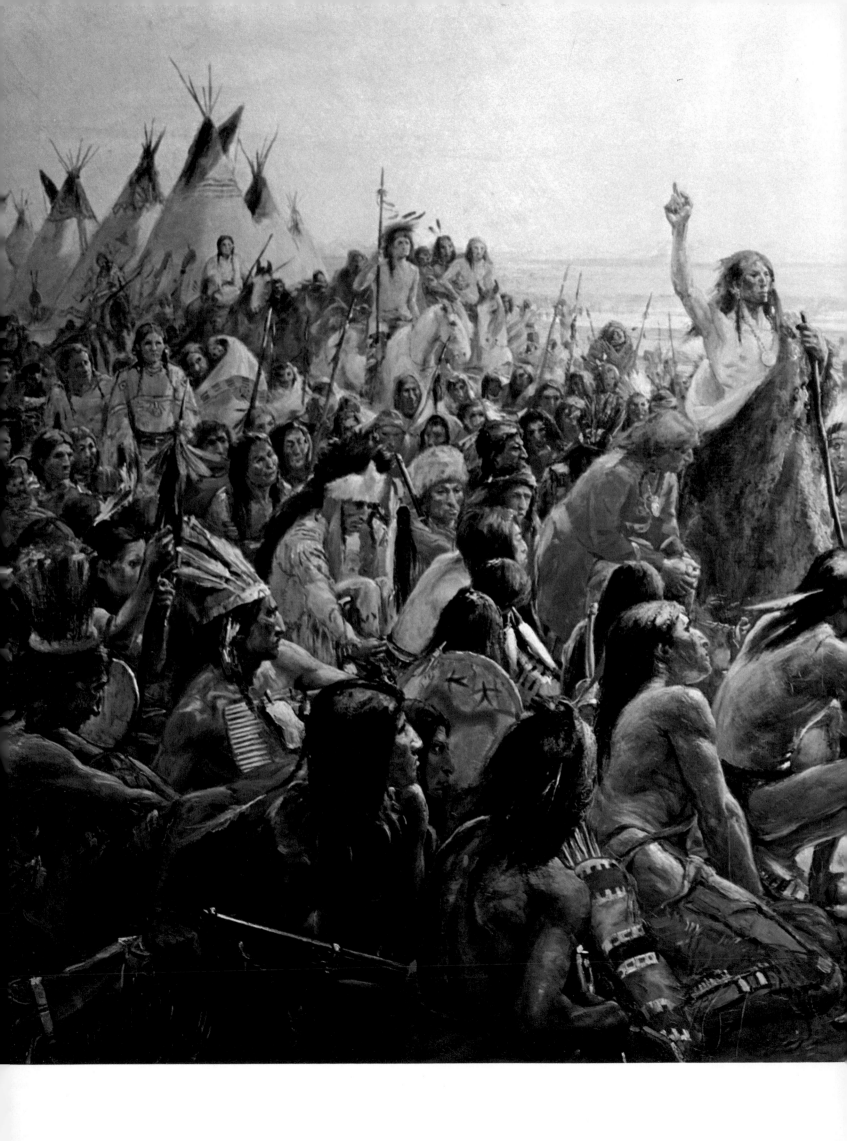

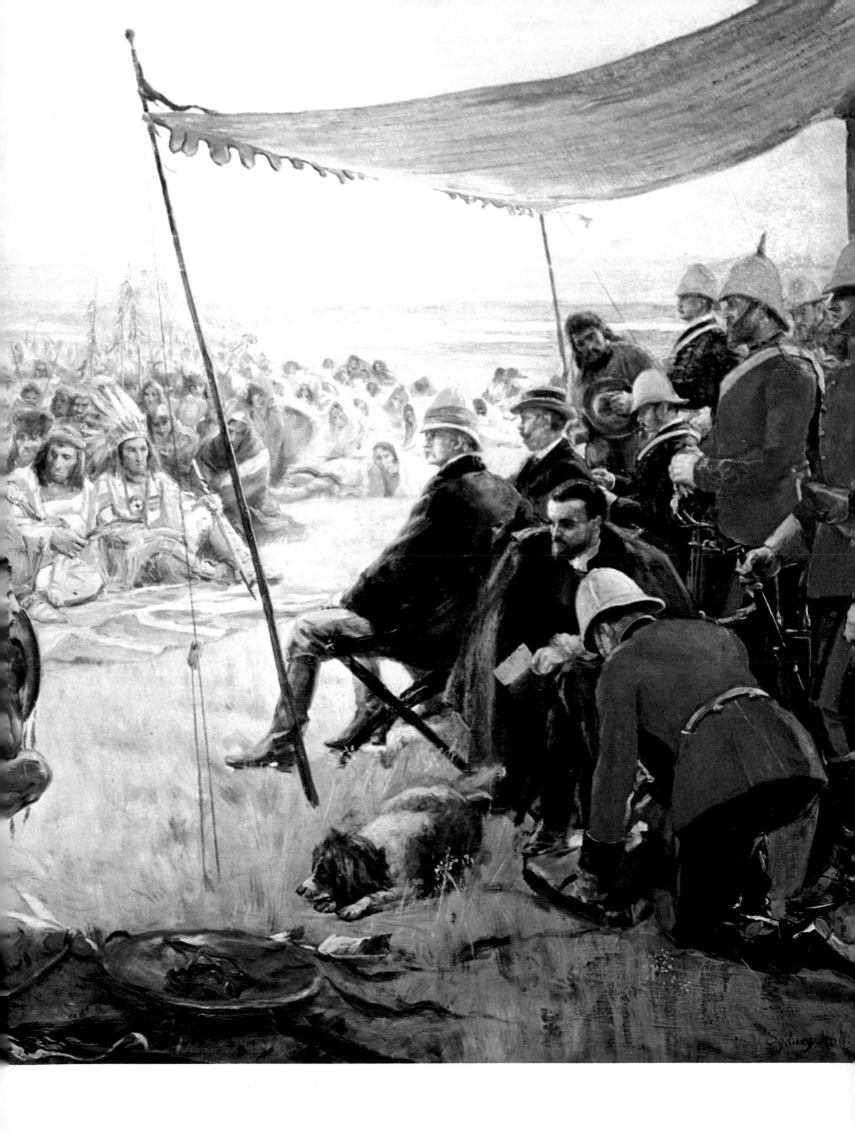

9. Further appeals to Lord Lorne were unsuccessful; and in 1884, in spite of Crowfoot's role of moderator, Poundmaker joined with Big Bear, the chief of the Plains Crees. At this meeting, it was decided to confer with Louis Riel, which resulted in the Northwest Rebellion of 1885.

10. Hall, *op. cit.,* November 19, 1881: front page.

vened a conference of various tribes to give additional weight to the demands for concession. (9)

After the speechmaking and airing of grievances, the Indians staged races and ceremonial dances. Hall was beginning to tire of these. Earlier, at Fort Qu'Appelle, the Sioux gave a performance of the buffalo dance, but he noticed that their buffalo heads were shams, more or less. The horns were wooden painted ones. "Poor Sioux!" he had written, "Not a buffalo had been sighted for four years." Hall's drawing of the event, *A Buffalo Dance, Fort Qu'Appelle,* (10) reveals a corresponding change in the reporting of Indian life since the earlier decades of the nineteenth century. Bodmer's awestruck vision is replaced by Hall's light-hearted sketch of an event obviously staged for visiting celebrities, while the men and their squaws earned a living as harvest hands and household servants. Crowfoot, however, staged a much more realistic show, adding, in the words of the Toronto *Globe*'s correspondent, "several rather grotesque displays illustrative of Indian warfare." Finally, presents were distributed and the great council ended.

The tour entered its final phase as the party headed in the direction of Fort Calgary. Ten miles to the south of Calgary on the Bow River, Colonel de Winton succumbed to the lure of ranching and selected land to establish a cattle ranch. (He returned in 1883, with his two young sons.) After looking about Calgary, then a modest settlement scattered around the police fort, the Governor's party was ferried across to the north shore of the Bow. There they were met with democrats (horse-drawn buses) and driven to the Cochrane Ranch at Morley to witness a display of horsemanship.

Boats had been built in Calgary to carry the party east by river, but at the last moment the river passage was countermanded and the party returned to Ottawa via the United States by way of Fort MacLeod, Fort Shaw, and the Union Pacific Railway. The rugged peaks of the Rockies, shrouded in blue haze, glittered in the sunlight as the party drove through the cattle country of southern Alberta. Swift-running streams of cold, sweet water wound about the valleys, watering a rich and limitless expanse of buffalo grass. This was unsurpassed stock land, and large ranches were rapidly being established in the High River country.

What "wild west" Canada could boast of was to be found at MacLeod, which was unlike anything seen by the party so far. The fort itself was enclosed in a stockade outside the village, which was built on a dusty flat by the Bow River. Its one filthy, straggling street was lined with one-story buildings, whitewashed outside. Inside, they were smokey and dingy. Grocery stores sported billiard tables, and cigars and soft drinks were offered at exorbitant prices. The most colorful spot was Camoose (thief) House, a saloon run by a former Indian trader and preacher. When the traveler entered he found himself face to face with the ominous sign of a bulldog pistol, bearing the words "Settle

The Beginning of Calgary. Pencil. Unpublished. Courtesy Public Archives of Canada, Ottawa. Calgary was an outpost of the Mounted Police, with only a few pioneers, but Lord Lorne thought the place might become more than a name some day. He named the territory Alberta, after his wife, Princess Louise Cardine Alberta.

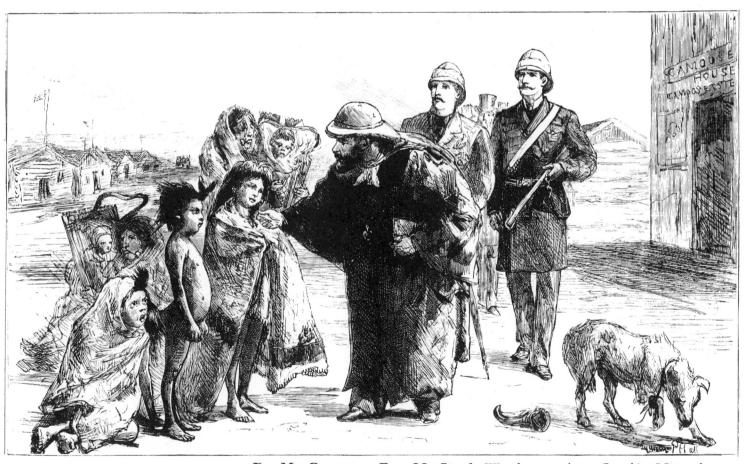

Dr. MacGregor at Fort MacLeod. Wood engraving. *Graphic,* November 9, 1881. Hall depicts the dynamic Doctor passing one of the most colorful bars of the Old West, Camoose (thief) House, while strolling down Main Street, MacLeod, followed by Lord Lorne and Captain Chater.

11. MacNutt, *Days of Lorne* (Fredericton, 1955), 10:94–5.

12. According to an account by Dr. MacGregor published in the *Scotsman* (October 28, 1881), Lord Lorne and party, after being royally entertained by General Ruger at Fort Shaw, Montana, were provided with ambulances and escort to the Union Pacific branch line at Dillon. Here, on the Utah and Northern Railroad, a Pullman car was placed at their disposal to take them to Ogden, where they joined a train from San Francisco on the Union Pacific. At Omaha, after traveling nearly 6,000 miles, the party broke up, Lord Lorne and part of his staff going northward to Winnipeg to make a much-quoted speech at the Manitoba Club, and the rest, including Hall and Dr. MacGregor, going on to Quebec via Chicago, Toronto, and Ottawa. Both sailed for Liverpool from Quebec on October 15, 1881.

Up." Hall added, "It is not closed on the Sabbath, or any other day." The place was crowded with ranchers (everybody was a rancher, whether a bull whacker, mule skinner, or trader), who laughed uproariously as the help in the inner room behind slammed the door in the faces of hungry travelers. But finally the signal to enter was given and the throng rushed in, Mexican spurs clinking, shouting all kinds of oaths, which, declared the correspondent of the *Globe,* would never have been understood in Toronto, let alone anyplace else. (11)

At the fort, Lord Lorne was welcomed by a guard of honor commanded by Inspector Francis Jeffrey Dickens, third son of the famous novelist, who was to spend the last years of his short life in the Mounties. Settlers gathered to meet the party, and the Governor General visited more farms and ranches. The tour officially ended at Lethbridge. Winter was near, and storm clouds massed threateningly overhead as the party crossed into Montana. Travel-stained and weary, Lord Lorne and his entourage received a warm welcome at the border from Colonel Kent of the Third Infantry and his two aides, lieutenants Stouch and Thies. After suitable refreshment they then continued to Fort Shaw where an even more enthusiastic reception awaited them. (12) "There might," as Hall put it, "have been only Chinese servants at the Fort to do the cooking. Nevertheless, the party got as good as they might have expected from Delmonico's." Over cigars, Anglo-American relations reached a new high in cordiality, when to the delight of the Americans, Captain Percival announced his solemn intention to settle in Montana after hearing Colonel Kent's description of the wide variety of game available.

Lorne, however, staunchly stuck to his guns. On October 11, in a long and eloquent speech at the Manitoba Club, Winnipeg, he severely trounced those who had sought to disparage the potential of Canada's Great West. "These were," he exclaimed, "men who are born failures and will fail till life itself fails them." Nothing, he thought, could exceed the fertility and excellence of the land which extended along the whole course of the Saskatchewan River and to the north of it. He had found, too, plains land of the finest quality. Excellent water could be found everywhere. Moreover, Canada's West was not a "great lone land." It was not "flat, dreary, unwooded, devoid of animal life, and depressing in the extreme." There could not be a greater mistake than to think so. Over the whole region, bands and clumps of trees were numerous, never more than twenty or thirty miles apart. Swamps and lakes teemed with fish and fowl. "The open prairie," he cried, "is a green sea of rich grasses, over which the summer winds pass laden with the odour of countless flowers."

The Marquis told his audience of the great beds of coal and described the extraordinary fertility of the Bow River country, assuring his listeners that ranchmen from Montana, Oregon, and even Texas all preferred it for stock-raising. Not only, he said, would there be immediate riches, but in the future Canada would be "a land of power" among the nations.

The Hon. Mr. Norquay, Premier of Manitoba (Left). Pencil. *Graphic,* September 10, 1881. Courtesy Public Archives of Canada, Ottawa. Hall thought the Premier, whose mother was a pure Cree Indian, a remarkable man of gigantic stature. The Winnipeg *Manitoba Free Press,* however, thought the artist had made him the full cousin to an Indian chief, and that this would only confirm "the opinion held by the majority of Englishmen that Manitoba was inhabited chiefly by Indians and buffalo."

Interviewing an Eighteen Months' Settler (Below). Pencil. *Graphic,* October 1, 1881. Courtesy Public Archives of Canada, Ottawa. Hall found the settlers of Saskatchewan—the one he sketched was an Englishman, Mr. Rogers of Addenham, Cambridgeshire—enthusiastic about the fertility of the new Eden. Nevertheless, they were confused about the legality of their claims. Claim-jumping was incessant. They worried, too, about which way the railway would go. Lorne promised action.

13. Toronto *Globe*, October 13, 1881.

14. "Into the Lone Land: An Interview with Sydney Hall, the Artist Journalist," Toronto *Globe*, October 11, 1881.

15. Much of the lively, anecdotal quality of Hall's reporting of the tour is retained by the relatively advanced wood engraving techniques developed by Thomas, in which photography was now used to transfer the original drawings to the wood block. The engraver also sought to retain a greater measure of the immediacy of the sketches by occasionally isolating them in white space.

16. *Op cit.,* Toronto *Globe*.

Men would spread from east to west along the lines of latitude. (13)

In Britain, the lengthy and detailed accounts of the fertility of the boundless land waiting for men to go and take possession of aroused the widest interest and comment. Lord Lorne's widely reported speech and Dr. MacGregor's articles for the *Scotsman* did much to convince those Scots farmers with a little capital that they had much to gain by emigrating. The articles by Austin in the *Times,* on the other hand, helped elevate Canada's potential economic status, thereby tempting British investors. Sydney Hall proved himself no less valuable a publicist, although he would have modestly shrugged off the compliment. "I am only an artist," he told a *Globe* reporter, "and my opinion of the country could go for but little." (14) Nevertheless, in one hundred drawings, appearing almost weekly from August, 1881 till February 1882, the hard-working artist reached an even wider audience. Moreover, the lively human and anecdotal quality of these sketches helped to make an entirely new image for Canada. (15) "Sketches," he said, "always set a person to thinking, and they might convey ideas which written description would not, and prompt people to read and become better acquainted with the country." (16) And he was right. During the following year, over seventy thousand settlers entered western Canada. Their arrival did a great deal to increase confidence in Ottawa's ability to effectively settle its great lone land. Although thinly spread, this first wave signaled, at long last, the opening of the Canadian West.

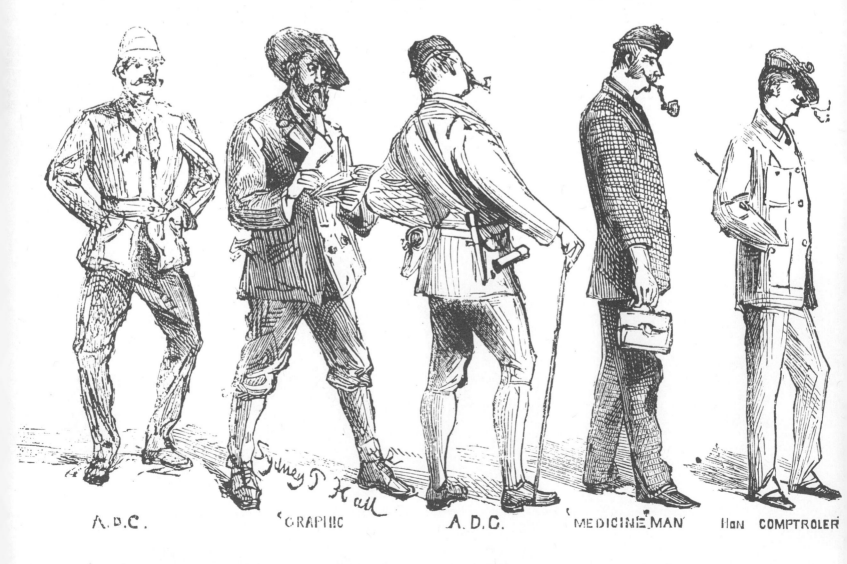

A.D.C. 'GRAPHIC A.D.C. MEDICINE MAN HON COMPTROLER

Lord Lorne and Suite. Wood engraving. *Graphic,* December 17, 1881. Like a company of strolling players, Lord Lorne and his entourage file onstage to make their final curtain call before vanishing into the pages of history. From right to left: His Excellency the Marquis of Lorne; the Reverend James MacGregor, D.D.; Colonel Sir Francis de Winton with "Rab;" Charles Austin of the *Times;* Captain Bagot; Dr. Colin Sewell, M.D.; Captain Vernon Chater; Sydney Prior Hall of the *Graphic;* Captain Percival.

'TIMES' MILITARY SECRETARY HIS REVERENCE (COURANT) HIS EXCELLENCY

7.
The Open Air Life

Inglis Sheldon-Williams 1887-90

"This a tale is for old-timers,
And for all who read the promise
Of a new and stately nation
Sister to a great republic
Daughter of an ancient kingdom."
Inglis Sheldon-Williams ("Farmer Leckie's Homestead," 1927)

Inglis Sheldon - Williams (1870–1940). Self-portrait. 1924. 18 x 14. Oil. Courtesy Glenbow Art Gallery, Calgary. Inglis Sheldon-Williams Collection.

DURING THE SUMMER of 1882, a legendary chapter in the history of the American West opened in what is now southeast Saskatchewan: Prime Minister Sir John A. MacDonald gave Captain Edward Mitchel Pierce, a former British Army officer, a large grant of fertile prairie land in exchange for his promise to establish an English colony. Pierce's grant lay east of Moose Mountain Indian reservation, west of the second meridian, and four miles southeast of Moosomin, then at the end of the westward-building Canadian Pacific. The Captain called his project Cannington after his village in Somerset; and sympathetic postal officials added the word Manor, to distinguish it from Cannington, Ontario.

To attract Englishmen of means to join him, or to finance their sons to do so, Captain Pierce wrote letters to the English press extolling the healthy climate, the abundance of game, and the opportunities for self-advancement. All could live as princes, he said, on very little money. To the smaller gentry of England—harassed with uneconomic estates (1) and large families, or desirous of fresh fields in which to invest their capital—Cannington promised new horizons. And if there were any doubt about one's own ability to farm in a strange land, an adventurous son or two could be sent on ahead to learn the mysteries of cultivation. Almost a hundred settlers came with their families to take up homestead land, or as premium-paying pupils. (2)

Under Pierce's tough and able leadership, the settlement rapidly took shape. The Captain himself paced out the townsite and showed the carpenters where to place the pegs. Following the example of the self-contained villages on the huge country estates of the English ducal nobility, Pierce formed a trading company to build and own various public facilities. Apart from a church, vicarage, and school, these consisted of the celebrated hostelry, the Mitre Hotel; (3) a gristmill; a blacksmith's shop; a carpenter's shop; and, of course, a store with a post office, where twice a week the stage from Moosomin to the United States border drew up to disgorge yet another tenderfoot Englishman, complete with straw hat, cricket bag, and gun case. (4)

The Captain's "pups," as his premium-paying pupils were dubbed, were a high-spirited lot, with an insatiable appetite for good living and good hunting. One of them, Arthur Le Mesurier, was still around in 1952. He told a reporter (5) that he went out for what he described as the "sport of the thing," adding that he had "got tired of shooting lions and tigers in India and heard there was good game in Cannington." The only difficulty was getting the hired hands to do anything. Pierce's farm instructor, one Scotty Bryce, was quoted as saying, "I was glad when the young gentlemen took up tennis so I could get on with the work!" (6) Nevertheless, many persevered and even used their inheritances to combine business with pleasure and to establish, as did the famous Beckton brothers, stock farms and processing plants for agricultural products.

Once out of their apprenticeship, the "pups" and their masters re-

1. Reasons for the interest in Cannington Manor and other similar colonization schemes are not hard to find. England, the "workshop of the world," had lost much of her legacy of being a prosperous farming community in her transition to being the world's most highly developed industrial economy. W. J. Reader (*Life in Victorian England*) tells us that this prosperity had rested on the unprecedented demand from the industrial towns for food. From about 1870, however, fast ocean transport and refrigerated storage enabled farmers and ranchers in Argentina, Australia, and New Zealand to compete in England: tinned meat began to come in from Argentina in the 1860's, and from Australia and New Zealand shortly afterward. "Most serious of all," Reader states, "the Americans, the Civil War over, thrust railroads into the meat and grain lands of the Far West."

All this food came in untaxed, and from the late 1870's on, the prosperity of British farming began to crumble. "The landowners' prop of prosperous farming was," Reader adds, "knocked from under them." The more astute ducal families, he continues, whose immense properties included large areas of London and other cities, as well as the mining rights of key industrial areas, were in a strong position to meet the challenge; but the smaller gentry, entirely dependent on rent paid by their tenants, the increasingly impoverished yeomen farmers, suffered big reductions in their income.

Since an estate was family property, claims could be heavy. Portions

had to be found for sons, daughters, and dowagers. Large Victorian families accelerated the breakup of the large estates, and frequently members of the family used their inheritance to capitalize emigration. William J. Reader, *Life in Victorian England* (London and New York, 1964), 2:30–33.

The vast virgin lands of western Canada beckoned tantalizingly to the more adventurous. Many became increasingly attracted to the imperialist concept of a Greater Britain overseas. Such spokesmen as Sir Charles Dilke (the author of *Greater Britain*, 1868) and James Anthony Froude (who wrote *Oceana, or England and Her Colonies*, 1886) expressed their feelings when they pointed to the polluted civilization of Britain and emphasized the fresh air and more wholesome living that the colonies were so well able to supply. Both were influential publicists of the imperial idea and depicted the glowing future that awaited the Anglo-Saxon race if its various homes overseas could be settled and developed. The Dominion Government, anxious to speed the immense task of filling the empty prairies, encouraged various schemes, among them cooperative farms, philanthropic enterprises, and colonization companies. England's gentry (and its ally, the impoverished upper end of the middle classes) began to cherish the idea of having a mission to fulfill.

2. Although the pupil system prevailed in various other settlements and colonization projects throughout western Canada, Mrs. Hewlett states that it was a special feature of Cannington Manor. Under the system, parents placed checks for $500.00 (in those days £100.00) in the pockets of their adventurous sons, prior to their departure from the Old Country. A. B. M. Hewlett, *Cannington Manor* (Saskatchewan Diamond Jubilee and Canada Centennial Corporation, 1965), 16.

3. Lloyd George (later Prime Minister of Great Britain) was a guest at the Mitre Hotel while visiting Canada as a young, unknown solicitor in the 1890's. When the bartender shot tobacco juice over his head while serving his meal, he joined the host of British travelers in expressing traditional disapproval of the remarkable custom. Hewlett, *ibid.*, 7–8.

vived the carefree world of pre-industrial England, in which willing peasants did everything that was necessary for the squire to enjoy himself. Surprising as it may seem, the willing peasants, in this case, were independently-minded Canadians, joined by penniless immigrants with sometimes bitter memories of the Old Country. But on the prairies, the idea of Empire provided a sense of unity which was gradually being lost back home. Moreover, Captain Pierce, although regarded by many settlers as a proud and arrogant autocrat, won the respect of the Canadians because he had a plan that would and did benefit all. But, obviously, the most important reason for their support was the common need for the capital resources he commanded. The extra work of constant building gave many a pioneer family its start, enabling it to endure the hard times.

The "dudes" brought many welcome diversions to the raw monotony of pioneer life. Their houses, for example, were the talk of not only Cannington but the entire Northwest Territory; as furnishings—from grand pianos to crystal chandeliers—had to be freighted forty arduous miles by oxteam from the railhead at Moosomin. Certainly, the most impressive home was Didsbury, the residence of the Beckton brothers, which still stands. Built of multicolored stone hauled from the surrounding Moose Mountains, this vast mansion of thirty-two rooms even boasted a bachelor wing, known as "Ram's Pasture," for a new generation of "pups." All the amenities of a West End club were provided, from leather chairs to carved woodwork and a mahogany billiard table. Harrison, the valet, served drinks to an endless procession of happy-go-lucky remittance men, prospective settlers, and visiting sportsmen; dinner was served by an English butler in full dress.

In this "England of the prairies," the loneliness associated with pioneering was simply not allowed to exist! A crowded social calendar evolved around a nucleus of sporting clubs which catered to rifle shooting, tennis, cricket, horse racing, and football. The most exclusive sporting club was the Hunt Club, its strictly formal dinner being the outstanding indoor event, after the last fox hunt of the season. There was even a race track, built in 1887, and said to be the finest in the West. The annual race week attracted lovers of good horseflesh from all over the Dominion and the United States, not to mention the Indians who raced their ponies and held a powwow in the village.

In spite of the overwhelmingly sporty tone of the colony, culture, too, flourished. There was an orchestra, and a thirty-two-voice choir that presented an Easter oratorio with unfailing regularity. There were summer sketching parties. A dramatic society staged classics, comedies, sketches, and operettas to rapturously enthusiastic audiences of "gentlefolk" and "Canadians." The more serious-minded—a circle of young bachelors who, in contrast to the "pups," worked for board or wages—organized a literary society which discussed such topics as the moral implications of Tennyson's *Idylls of the King* and the stories of Rider

4. A. B. M. Hewlett, "England on the Prairies," *The Beaver,* December, 1952:23.

5. Mary Ann Fitzgerald, "The Fabulous Venture at Cannington Manor," *Winnipeg Free Press,* October 16, 1952. An estate, Reader says, was mainly a means to finance fishing, hunting, and entertaining. "Hunting," he adds, "shooting and field sports generally symbolized the outdoor life which the gentry as a class regarded as the only proper life for a man . . . therefore sport required moral, almost mystical attributes as well as being an absorbing pastime. Sport meant blood sports. Team games developed much later, with middle-class suburban associations." Reader, *op. cit.,* 32.

6. Hewlett, "England on the Prairies," 21.

7. Cannington's literary scene helped spawn its only published novel, Harold Bindloss' *A Sower of Wheat* (London, undated), a wishful and melodramatic saga in which a penniless intellectual hero wins the girl of the Golden West, who turns out to be the daughter of the wealthy "Colonel Cannington," obviously none other than Captain Pierce himself!

8. Inglis Sheldon-Williams ms., *The Track of a Rolling Stone,* 1. For an account of the colonial experience of Rider Haggard and Rudyard Kipling, as well as the success that followed, see Morton Cohen, *Rudyard Kipling to Rider Haggard* (London, 1965), 1–9.

Haggard and Rudyard Kipling. Such discussions among young men—for the most part from prominent public schools—were taking place in distant British dependencies throughout the world; and inevitably, they sparked off attempts to describe or depict the frontier experience. (7) The success of Rider Haggard's *King Solomon's Mines* (1885) and Kipling's *Plain Tales from the Hills* (1888) had made it abundantly clear that an extended stay in the colonies could provide more than just a farm; it could also provide the means to make a triumphant return to the Old Country. (8)

Cannington Manor's intellectual life, however, as colorful as it apparently was, failed to produce a Haggard or a Kipling. But the sketching parties did produce an artist of some note in Inglis Sheldon-Williams, painter and illustrator. His drawings, which illustrate various reminiscences of pioneer life, appeared in the newly founded *Daily Graphic* between 1890 and 1894, and again in the *Sphere* in 1903. They incline toward the devil-may-care approach of the young Victorian Englishman, but they do provide an unexpected glimpse of the gentleman-pioneer caught in the act, as it were, of trying his luck out West.

The illustrations themselves belong to a light-hearted and patriotic genre of pictorial reporting peculiar to the time. Photomechanical techniques were gradually superseding wood engravings of black and white drawings. The result was more informal drawings. Sheldon-Williams' technique derived from the sketches of officer-artists like Baden-Powell (who sent in pictorial narratives of their more successful colonial adventures) and professional *Daily Graphic* illustrators like A. S. Hartrick (whose task it sometimes was to redraw such sketches as line illustrations in ink). Working with such clear-cut mediums as pen and ink, and chalk and wash, which were then reproduced photomechanically, Sheldon-Williams was able to create a much more lively and spontaneous quality than the artists of the previous decade were able to achieve.

Letters and autobiographical notes reveal Sheldon-Williams to be of resolute personality, bound by strong ties of class and by family loyalties, but divided in his attachment to England and Canada. Because of this, much of his life was spent shuttling back and forth to revisit the prairies he loved so much and where he had spent ten adventurous years establishing a homestead at Cannington Manor.

When he left England for Canada at the age of sixteen, young Inglis Sheldon-Williams found it hard to believe his schooldays were over, even though his strong-minded mother had prepared him for the task of restoring the family's "fortunes." To this end he had spent the long school holidays on farms and in blacksmith's shops and had also learned to ride and shoot. Temporarily, he would have to abandon a cherished hope of following in his father's footsteps and becoming an artist.

Born at Elvetham, Surrey, in 1870, Inglis Sheldon-Williams was the

9. Quoted by Mary B. Galloway in her ms. notes, *The Inglis Sheldon-Williams Collection*, 2 (Glenbow Foundation, 1965).

second son of five children, whose parents had seen better days. He belonged to the impoverished smaller gentry, a cultured family with an artistic and military tradition. His paternal grandfather, John Godwin Williams, was a marine painter attached to the court of Adelaide, Queen of William IV. His father, Alfred Sheldon-Williams, said to be a gentleman farmer, was a struggling animal-painter who contributed sporting scenes to various periodicals. He died in 1880, leaving his wife Harriet with five young children and fifty pounds. Relatives shunned them, but Harriet, apparently "a strong-minded individualist," (9) took matters into her own hands. No time was lost in moving the family out of England to Germany, and later, to Belgium, where she may have supported them by working as a governess to one of the many English families living in Karlsruhe and Ghent. In 1883, she returned to place young Inglis in Merchant Taylor's, a famous public school which taught the virtuousness of working hard to the sons of the impoverished gentry.

By the time the boy had completed his education, Harriet decided that Canada was the best solution to the family's difficulties. All would emigrate, but the two eldest sons would go first to learn what they could with a view to taking up homestead land and establishing a family farm. Ralph, the eldest, left for Manitoba in 1886; Inglis, with ten dollars sewn into his shirt, left in March, 1887.

His first job was working for farmer Tommy Green of Brandon, Manitoba, for five dollars a month and board. Work was hard but the young man liked the active open air life. Each day he built up the woodpile with a bucksaw "very early in the morning, very late about the night time." (10) He also had to milk the cows. As spring became summer, he harrowed ten acres a day with a team of four ponies. Just when things were going well, he was fired, when it was thought that he and Tommy Green's pretty daughter were taking a fancy to each other. "We were," confessed the artist, "but her parents were interested in the attention of a neighbouring [and presumably more affluent] farmer." (11)

10. Inglis Sheldon-Williams ms., *Farmer Leckie's Homestead*, 1. (Farmer Leckie was in fact Tommie Green, Sheldon-Williams' first employer.)

Sheldon-Williams' public school education, with its emphasis on duty, self-reliance, the outdoor life, and mixing easily with other people, served him well in his pioneer adventures. (12) In spite of his youth, therefore, he kept the family's predicament in mind and looked around for fresh fields to conquer. There was really never any need to look far. After all, the family was gentry, even if poor. Young Sheldon-Williams must have carried, as was the custom, letters of introduction to friends, distant relatives, and probably Captain Pierce himself. He tells us that he arrived at Cannington Manor in the early summer, and took lodgings with Sam Whitlock and his wife. Sam, "a Canadian," had built the Captain's house and had been one of the first pioneers to settle in the village. The young Englishman was welcomed by the Pierce family and other established settlers, but was expected to attend church and behave himself. Very soon, however, the carefree bachelor gatherings of less

11. Sheldon-Willliams, *Track of a Rolling Stone*, 1.

12. In the mid-nineteenth century, most upper-class English boys were not sent to a public school to become scholars, but to become reasonable, well-educated men of the world. Outdoor activities which provided useful skills for frontier life were a source of prestige. From the 1870's, these were organized, and included membership in the officer cadet corps, horse-riding, as well as various sports such as tennis, fencing, and the handling of gun. Reader, *op. cit.*, 9:21.

serious Englishmen began to absorb his energies. On one occasion he found himself "milking cows in my dress suit at 4:00 a.m. after a dance." Mrs. Whitlock, who had taken him under her wing, advised him to devote more time to farming!

Farming was hard and tedious work, but as the persuasive Captain Pierce exerted the full force of his personality, the young man decided that in every way, Cannington Manor would be the ideal place for the family to settle. He took Mrs. Whitlock's advice and lost no time in filing a claim for a quarter section of unoccupied homestead land in the village. (13)

Extra funds would now be needed to build a house and buy farming equipment. Inglis thought of his brother Ralph, then working in Winnipeg, and decided to ask him to share the responsibility of his project. But Ralph refused and he had to go it alone and make the money himself. In the more established cattle country of southern Alberta, well-paid work was plentiful, so, anxious to see more of the country before settling down, he decided to chance his luck in the Pincher Creek district, where a sprinkling of aristocratic British families were breeding horses in the sun-drenched rolling foothills. He climbed aboard a westbound train at Winnipeg, but on arrival accepted the first job offered and spent the summer working as a ranch hand for the Duthies, a newly married Canadian couple.

Pincher Creek itself had been named in 1868 by white prospectors after they had lost a pair of pincers there, and it had kept its name even though the rusted tool was found in 1874. The Mounties had first settled the district for breeding horses, and before long, attracted by the abundant wild hay, settlers started moving in to raise beef herds.

The Duthie place lay on the banks of Pincher Creek about fourteen miles from the present town of Pincher Creek, forty miles east of the Rockies. There, he was given a comfortable room in the hayloft, fireflies and all. Throughout that summer the young Englishman acquired many pioneering skills, although he confessed to an inability to learn market prices. He quickly discovered that his picture of ranching was idealistic. Not only did the ranch hand need to be a versatile rider, but he was expected to be proficient at an unending round of other duties. If one had to do nothing else but work for a living, the West was not such a happy hunting ground for the youth who had failed at everything else.

A professional cowboy, when seeking a job, was careful to make sure that there would be no extra jobs like milking cows, cutting stove wood, digging postholes, or helping with the hay harvest. Tenderfoot Sheldon-Williams had no such choice. Each day, just as he had finished breakfast, the ubiquitous foreman would appear, suggesting in no uncertain terms that he accompany him for "another important lesson," this time, the most arduous of chores—digging postholes for fences. By midday, the young pioneer was broken-backed, sick of his task, and of the West as well!

13. Under the Dominion Lands Act of 1872, a settler was permitted to take up a quarter section (160 acres) of unoccupied land on even-numbered sections. Odd-numbered sections were reserved for sale or, when required, for schools. After three years, a settler could file a claim of ownership with a government land office if he could show proof that he had occupied and improved his homestead.

Cutting Out Steers on an Alberta Ranch, 1903. 7 x 10. Gouache. Unpublished.
Courtesy Kennedy Galleries, New York.

14. In his autobiographical notes, the artist refers to his mother also sending him copies of *Macmillan's Magazine* in which he discovered Rudyard Kipling's short story, "Yussuf." He also refers to reading *Harper's* and seeing illustrations by Edwin Austin Abbey, which obviously contributed to arousing his interest in drawing for illustrated periodicals. Sheldon-Williams, *Track of a Rolling Stone*, 1.

15. Mrs. Duthie stated that "among her most treasured possessions were several watercolour pictures painted in 1886 [*sic*] by Sheldon-Williams, an English Artist. He lived at Cannington Manor . . . and wanted to see the country and came to the Alberta ranch and stayed all summer." The exact number of watercolors in Mrs. Duthie's possession is not given. They were said to be "several" and depicted the ranch house and its outbuildings in various settings, including the Rockies. Kells interview with Mrs. Duthie, ca. 1930, 1.

A 7″ x 10″ black and white gouache drawing entitled *Cutting Out Steers on an Alberta Ranch, or Canadian Beef, Alberta Ranch, N.W.T.*, which was in the possession of the Kennedy Galleries, New York in 1970, suggests that the artist also turned to record the routine duties of a ranch hand. It is dated 1903, but it was probably redrawn as a magazine illustration from an earlier sketch, and as I have found no evidence that Sheldon-Williams returned to Alberta before 1915, this may have been made in 1887, his first summer in Canada.

As he got used to it, the artist found the strenuous physical life and the air, like champagne, had built up "a strong constitution." But books and magazines were hard to get. Everyone at the ranch who could read had at least one book, whose well-thumbed pages were as familiar to everyone else as they were to the owners. Once in a while, his mother would send him *Macmillan's Magazine* and *Harper's;* both journals were in their prime and their many fine illustrations kept the flames of his ambition alive. (14) Sensing that his needs would also be of a more practical nature, she also sent him socks; one at a time, as samples, to avoid customs duty. Besides reading and painting watercolors of the Duthie ranch and the distant Rockies, (15) his only other pleasure was the occasional trip to the nearest cattle town, accompanied by a trainload of cattle. And no doubt, this glimpse of civilization was a source of delight, although the artist confessed to a hopeless timidity with women.

As the nights grew colder, Sheldon-Williams made preparations to leave the Duthie ranch and return to Cannington Manor. He had saved most of his pay, which enabled him to proceed to the next stage of what he now called the "grand matriarchal enterprise." His mother had written to tell him that they would now like to join him in the spring of 1888—the following year.

His first winter at Cannington Manor was a busy one. After the first blizzard (following October, the month of Indian summer), the pioneers quickly prepared for the dark winter ahead. Houses and cabins were banked with dirt and cellars filled with preserved eggs, salt pork, potatoes, and other necessities. The artist's first task was to "raise" or build himself a cabin on his land; but this was done in a day with the help of an English clergyman's two stalwart sons. It was a temporary affair, he wrote, "one thickness rough board covered with tar paper." It could be heated in five minutes, although if the stove went out the temperature would just as quickly drop to below zero. Vital supplies, such as nails, coal oil, and delicacies like marmalade, had to be hauled in by oxteam from Moosomin. Logs for the family house had also to be cut and hauled from the nearby wooded forests of the Moose Mountains.

To his delight, Sheldon-Williams found that winter at Cannington Manor was a time of cheerful socializing. When he was not imbibing at "stag" parties at the "Ram's Pasture," or more likely at the Mitre Hotel, the young Englishman's cabin itself became the scene of an American-style "surprise party" on a cold winter's night. Describing and illustrating one such occasion for the *Daily Graphic* (February 26, 1890), he wrote of the bachelor, "resting after his day's work, reading on a tilted chair, with his dog and his gun and his axe—a Robinson Crusoe-like group, but not without its allurement. Suddenly his solitude is broken by the arrival of a crowd of uninvited guests; they have descended upon him unawares. They enter, willy-nilly, and 'fix-up' his house for dancing; the ladies prepare the refreshments; and the ball begins." Square dances, he dryly noted, are mostly in favor, and these

16. "A Surprise Party in Manitoba," *Daily Graphic*, February 26, 1890: 12–13.

go on to the small hours. Then, "when everybody is tired out with fun and frolic, everybody goes and the host comes in for the cakes and ale which are not disposed of." A legacy the artist felt he more than deserved as he had now to replenish his empty larder! Nevertheless, he welcomed it as very wholesome exercise when the thermometer read zero and the wind howled. (16)

Not to be put off a day longer, Mrs. Harriet Sheldon-Williams and the rest of her brood arrived at Cannington Manor in May, 1888. The impoverished homestead was beginning to take on the appearance of a well-equipped farm, with stables and outhouses for horses, hens, and cattle. The artist does not tell us of his mother's reaction to his remarkable achievement, but she must have given way and expressed her pride. Ralph, the erring brother, was summoned to return to the family fold; the farm, now worked by the three brothers and their two sisters, began to take shape and prosper.

In those days farming on the plains *was* hard work; and just how hard it could be is expressed in the artist's four vigorously painted scenes published in the *Sphere* (August 22, 1903). Headed "Canada as a Wheat Grower," they depict some of the risks and how they were overcome by the pioneers. The first, *Threshing in Winter,* shows a large outfit threshing a crop. "This work," wrote Sheldon-Williams, "generally begins after the freeze-up as farmers are busy up to the verge of winter getting as much stubble ploughing done as possible in readiness for the next season's wheat crop, which has to be hurried in directly the frost is sufficiently out of the ground." (17)

17. *Sphere*, 14:164.

When winter finally did put a stop to any further work, this was the time to haul the wheat to the railroad at Moosomin. *Taking the Grain to Market—30 Degress below Zero and the Snow Rising* illustrates the perilous nature of that forty-mile journey, which could end in a farmer's being told to "take the price offered or take your wheat back home again!" (18)

18. *Ibid.*

The perils of winter, however, could be more than equaled by a dreaded prairie fire which could cost a settler everything he possessed. "After the all-important harvest is gathered in," wrote the artist, "the thrifty settler endeavours to snatch a few hours to store more hay before the autumn frosts have killed the rank slough grass. This is the prairie fire season and he liable to be called away at a moment's notice by the harassed fire guardian of the district," whom Sheldon-Williams depicts as himself, riding through the settlement turning out the inhabitants to fight their common enemy. (19)

19. *Ibid.*

In those days the only protection against prairie fires lay in making sure that every homestead had two or more rings of land plowed around the house and outbuildings; the land between the plowed rings was always kept cultivated, and upon a fire's approach, the grass was burned, and a "break" fire started on the threatened side which burned slowly back against the wind, broadening the protecting strip of land between

20. This began in 1896, when he finally received his Life Drawing Certificate. The following year his youngest sister, Dorothea, joined him and together they lived in a studio once occupied by Sir Edward Burne-Jones in Chelsea. The outbreak of war in South Africa launched him on his career as a Special Artist, and he undertook a series of assignments for a new London picture weekly, the *Sphere*. After he had spent four months covering various episodes of the South African War (1899–1900), he proceeded to report the Coronation Durbar of Edward VIII at Delhi, India, and also the Russo-Japanese War (1903–4). Finally, he spent a year in France during World War I as a war artist for the Canadian War Records. Sheldon-Williams, *Track of a Rolling Stone*, 2, and Mary B. Galloway, notes, 4–6.

21. Although he returned to Saskatchewan in 1904, it was not until a later visit in 1913 that he he enjoyed recognition in Regina; this led to private and official commissions and also to an invitation to establish a Department of Fine Art at Regina College in 1916. He held the post for a year before he decided to rejoin his wife in England and undertake work for the Canadian War Records. Times were hard in England after the war was over. Accompanied by his brother Ralph, and his sisters, he returned to Canada in 1919 with the hopes of finding commissions as the result of an exhibit at the Regina College. But he was back in England in 1920. He returned to Canada for the last time in 1922, before returning to Europe. A representative collection of pictures resulting from Sheldon-Williams' continued involvement with Canada may be found in the Norman MacKenzie Art Gallery, Regina (University of Saskatchewan), and the art gallery of the Regina Public Library.

22. The Cannington Manor Historic Park, ten miles northeast of Manor and forty miles northeast of Oxbow, was opened in July, 1965, to celebrate Saskatchewan's Diamond Jubilee.

23. Inglis Sheldon-Willliams in an introductory note to his ms., *Farmer Leckie's Homestead,* written while resident in Hampstead, London, December, 1938.

the homestead and the fast approaching conflagration. Plowing this ring, or fireguard, the artist added, "was almost invariably put off till the last moment." In the final scene of the series, *Ploughing the Fireguard*. Sheldon-Williams again portrays himself and one of his sisters frantically ploughing the vital rings which alone will save the family home.

Captain Pierce died in June, 1888, as his plans were developing; or so it seemed on the surface. Gradually, as the long-awaited branchline from Moosomin failed to materialize, it became obvious that gracious living was impossible without the railroad. The dream of living like princes on very little money faded. Several wealthy settlers sold out, and drifted back to England, or established new settlements in the more attractive climate of British Columbia.

While this was going on, Mrs. Sheldon-Williams died in 1890. It was the end of the family enterprise Inglis Sheldon-Williams had worked so hard to build. Released from any further responsibilities, he decided to go ahead with his old ambition to become a professional artist. He returned to England in 1891 to prepare for the Slade School by taking private lessons. Wherever he had lived in Canada, he had made drawings of life and landscape. Now, more than ever, he was anxious to get a proper art training and establish himself as a painter and illustrator.

The death of Harriet Sheldon-Williams made the family hesitant about staying on in Canada. The artist returned in 1894 and rented the house and farm to a Canadian family, but the house burned down after it was accidently set alight by the tenant's children. Sheldon-Williams now decided to wash his hands completely of Cannington and sold out. On the proceeds of the sale of the land and the insurance from the fire, he returned to London in 1896 to enter the Slade School and begin a new and different chapter of his life. (20)

Cannington slowly became a ghost town: the bachelors spread abroad, some to the South African War, others to the Klondike to pursue another dream, and some returned, like Inglis Sheldon-Williams, to the Old Country to take up professions to which they were more suited by background and education. But some would be drawn back again, as he was, to participate in developing the cultural life of the young and fast developing nation. (21) By 1914, Cannington Manor had become a legend. (22)

Looking back in his old age in 1938, Sheldon-Williams summed up his nostalgia for the pioneer life of the Canadian prairies: "The cordiality of social life . . . under primitive conditions, the free exchange of implements and commodities necessary to life—almost amounting to common ownership; a class distinction between man and man unconsciously based on what he could do, rather than on what he had." These things, the old artist thought, against a background so beautiful even in the severity of its winters, were among the most vivid and cherished memories of his whole life. (23)

THE LIGHTER SIDE OF PIONEER LIFE

The loneliness of prairie life seemed not to exist at Cannington Manor. A year-round cycle of resourceful socializing made—to the outside observer at least—for a communal life that came close to resembling universal brotherhood. Winter, especially, was a time to get together. Sheldon-Williams made this pictorial report entitled "A Surprise Party in Manitoba" of an event perpetrated by the girls of the settlement. Obviously everyone enjoyed himself, even the bachelor-victim. All the illustrations were photomechanical line engravings after pen drawings, published in the *Daily Graphic,* February 26, 1890.

The Bachelor at Home and Happy. "Behold the bachelor!" wrote the artist, "resting, after his day's work, with his dog and his gun and his axe—a Robinson Crusoe-like group."

The Unbidden Guests Arrive. "Suddenly his solitude is broken by the arrival of a crowd of uninvited guests; they have descended upon him unawares."

Fixing Up the Room for the Ball. "They enter, willy-nilly, and 'fix-up' his house for dancing; the ladies prepare the refreshments, and the ball begins."

The Dance. "Square dances are mostly in favour, the limited accommodation of a bachelor's establishment not permitting promiscuous gyration."

The Bachelor Has to Refurnish. "When everyone is tired out with fun and frolic, everybody goes, and the host comes in for the cakes and ale which are not disposed of—a legacy which he deserves—for he has to replace his household goods by himself."

Farming in Manitoba: A City Clerk's Experiences. Photomechanical line engraving after pen drawing. *Daily Graphic,* August 10, 1894. Manitoba experienced a resurgence in the mid-1890's. Sheldon-Williams produced this comic strip to warn well-to-do young emigrants against being duped into paying premiums to learn farming, or purchasing partnerships in farms without knowing what they were letting themselves in for. "Though numbers of English gentlemen stick to the work and find the life a grand one," he wrote, "a City [of London] office is not good preparation for farm life."

LITTLE GRAY HOMESTEAD IN THE WEST

Although the well-to-do English gentlemen-pioneers of Cannington Manor brought gracious living to the wide prairies, they employed others to work their farms and other enterprises for them. Less well-to-do gentry, like the Sheldon-Williams family, started from scratch and had to buckle down and do the work themselves. These scenes, published in the *Sphere,* August 22, 1903, in which the artist depicts himself working the family farm, capture the grueling labor involved in prairie homesteading during the 1880's.

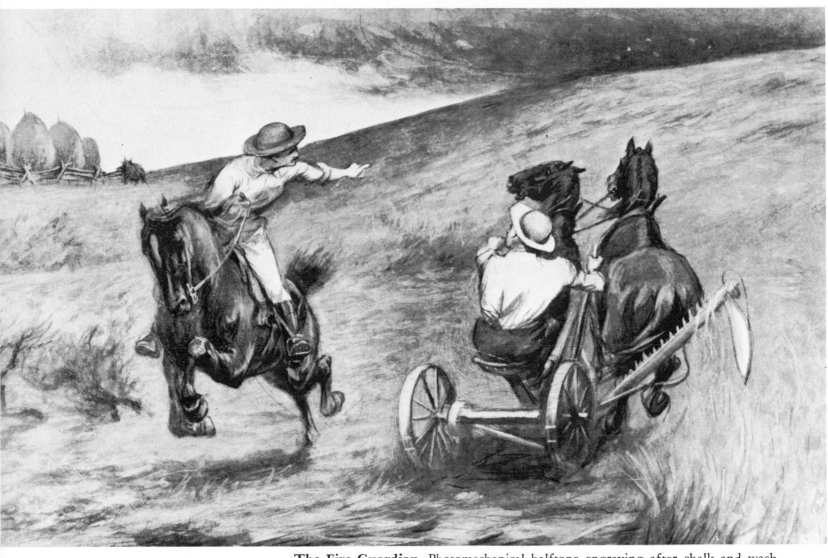

The Fire Guardian. Photomechanical halftone engraving after chalk and wash drawing.

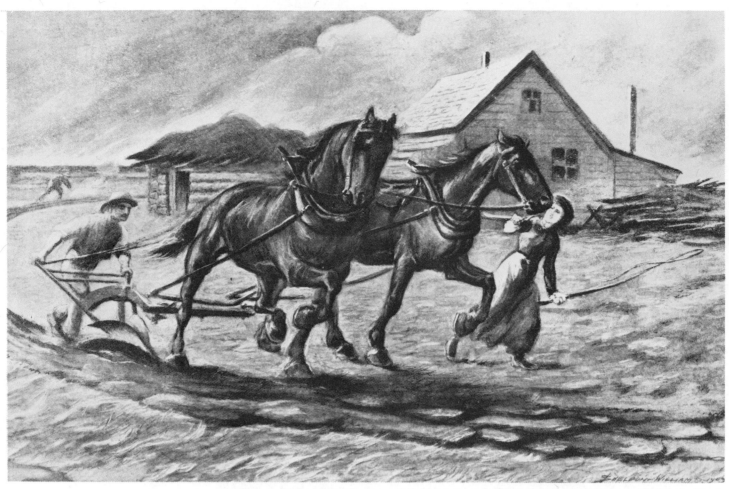

Ploughing the Fireguard (Above) and **Threshing in Winter** (Below). Both photomechanical halftone engravings after chalk and wash drawings.

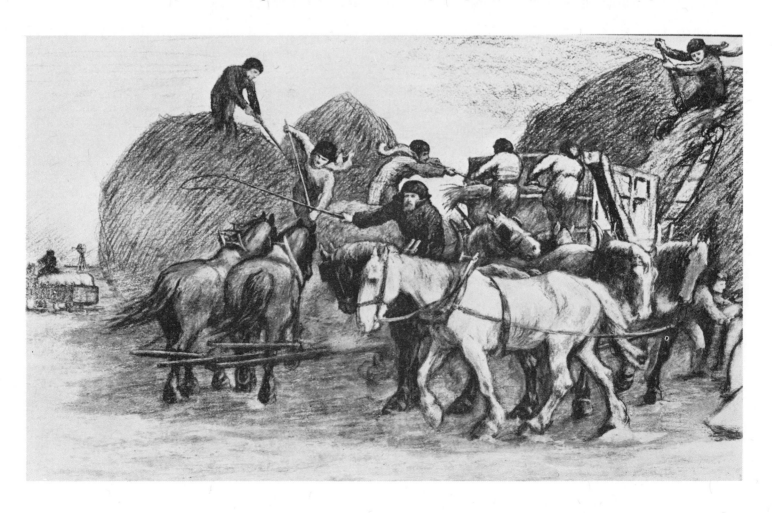

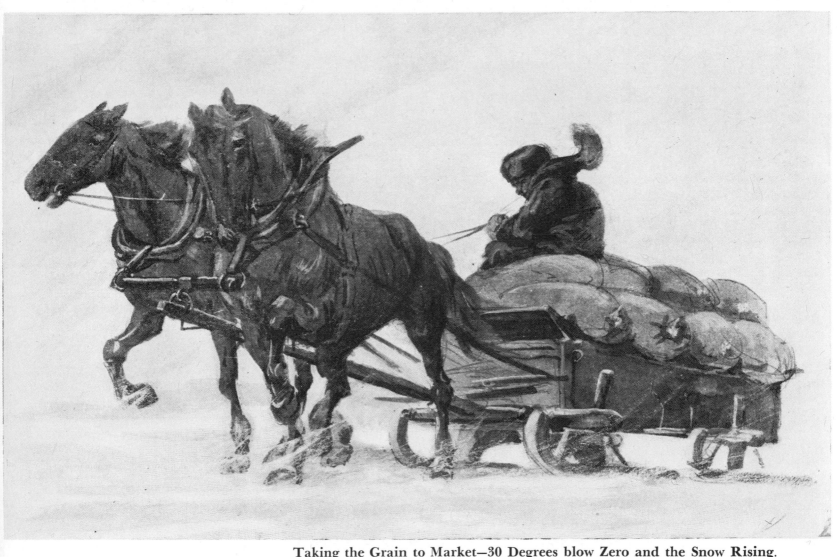

Taking the Grain to Market—30 Degrees blow Zero and the Snow Rising.
Photomechanical halftone engraving after chalk and wash drawing.

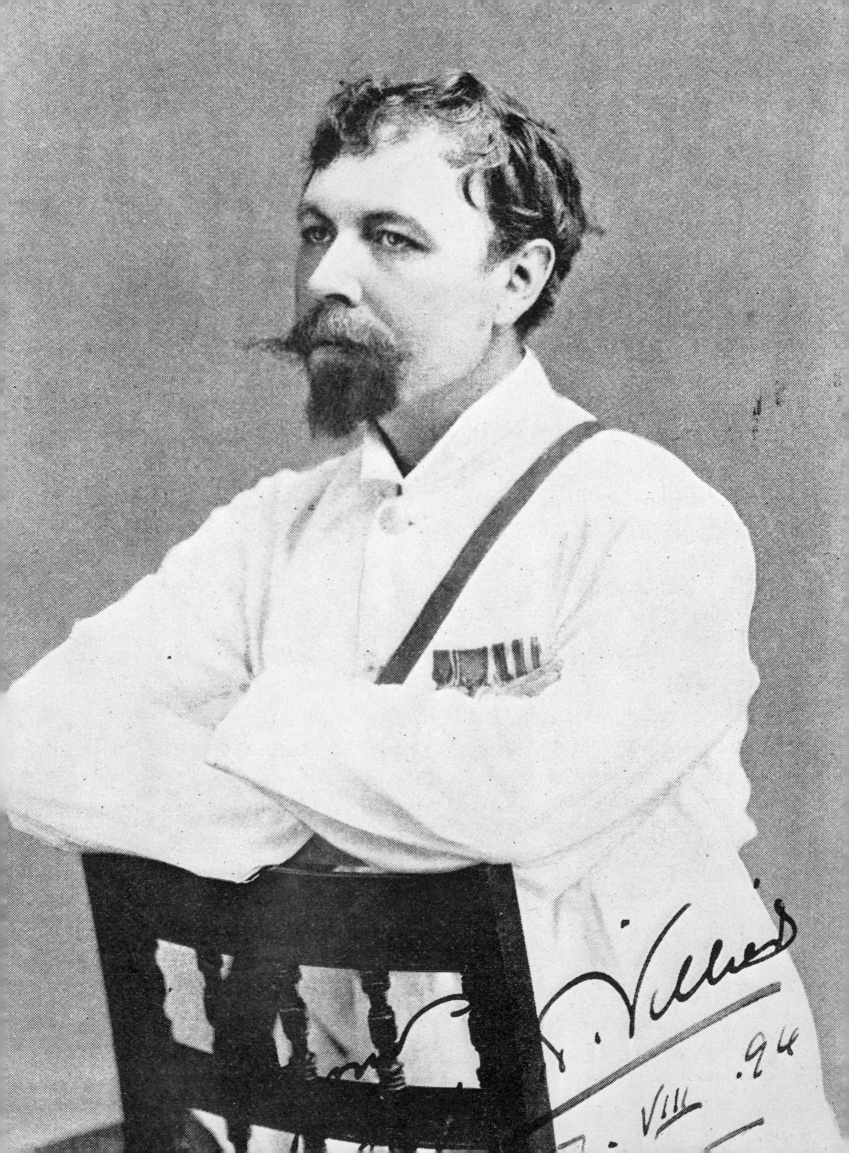

8.
To the New West on the Canadian Pacific Railway

Frederick Villiers

1889

"I have seen Canada's far western cities . . . in their swaddling clothes, a collection of log cabins and shanties, grow in a few years into townships with palatial buildings of brick and stone." Frederick Villiers (*Peaceful Personalities and Warriors Bold*, 1907)

Frederick Villiers (1851–1922). From a photograph published in *Black and White*, August 8, 1891.

The Kitfox. One of a series of three illustrations entitled *Three Claimants to Alberta*. Photomechanical line engravings after ink drawings. *Daily Graphic,* April 18, 1894.

The Indian on his Cayuse. From the same series.

SPECIAL ARTIST Frederick Villiers embarked at Liverpool with great zest. He was an inveterate traveler, and it was early autumn, September, 1889; a pleasant time to make an Atlantic voyage to North America. One of the most enjoyable routes was by the Straits of Belle Isle, across the Gulf of St. Lawrence, and up the St. Lawrence River to Quebec and Montreal. Though the Allan Line steamers did not go at the fancy pace of their counterparts on the Queenstown-New York run, they got out into the boisterous Atlantic in much less time and were every bit as well-officered and comfortable. From Rimouski, at the mouth of the St. Lawrence, where the mails were landed, to Quebec, the scenery was magnificent: a panorama of forest-clad mountains, landlocked bays, and rocky islands, with here and there a small settlement nestling in the foothills. At the Citadel of Quebec, the landscape began to soften, and fertile lowlands studded with little villages and townships, surrounded with rich foliage, stretched from either shore to form the beautiful valley of the St. Lawrence.

Villiers was thirty-eight and referred to himself as one of the most vagrant of Specials. Born in London in 1851, and educated in France, he had developed an enthusiasm for military life and travel as a boy. He studied at the South Kensington Schools and the Royal Academy; and he fed the flames of his wanderlust by poring over the latest issues of the *Graphic* and the *Illustrated London News.* His own career started in 1876, taking him some eighty thousand miles to cover eight campaigns as a famous war correspondent. The Bulgarian Czar, King Ferdinand, thought Villiers had seen more fighting than any soldier alive.

He once wrote that the first fighting he saw was the Russian crossing of the Danube during the war between Russia and Turkey in 1877. The scene also provided the quickest sketch he ever made: a fellow journalist, the celebrated Archie Forbes, agreed to be his postman if he could have a drawing ready in twenty minutes—it was rough, but it was ready, and the *Graphic* ran a fine double-page illustration as a result.

The next stop was Malta, where in 1878 he sketched British troops en route to the northwest frontier of India. The British Resident in Afghanistan had been mysteriously murdered. As a countermeasure, the British occupied Kabul and forced the Amir Yakub to abdicate. Villiers remained for some months in 1879, but found the fighting desultory and that it provided unsatisfactory material. Australia was next: dinner with Viceroy Lord Lytton at Simla; P. & O. steamer from Bombay. Then in 1880, the International Exhibition at Sydney; on to Tasmania, New Zealand, Hawaii, San Francisco, and New York; and across the Atlantic to London—his first girdling of the globe.

Villiers settled down to paint for a few months, and even had a picture on the walls of the Royal Academy, but the studio was no place for him! The 1880's were stirring times for an Englishman fond of the adventurous life. Returning to London from a grouse-shooting party in Scotland, William Luson Thomas told him that Arabi Pasha was

stirring up a revolt in Egypt. Once more he started on his travels, covering the bombardment of Alexandria in 1882, and the Battle of Tel-el-Kebir; the campaigns against the dervish in the Sudan in 1883–44; and finally, the Nile Expedition to relieve the ill-fated General Gordon in 1885.

By this time, Villiers himself had taken on the appearance of a soldier, with his handsome, erect figure, imperial-style beard, waxed mustache, and curly hair. An illustration in the *Graphic,* published in 1886, depicts him in full traveling garb, slouch hat, corduroy jacket, shooting breeches, and gaiters, with field glass, revolver, and canteen slung across his shoulder. It was from the Villiers of the Egyptian Campaigns that Kipling drew his hero character, Dick Heldar, the unfortunate Special Artist who loses his sight and his girl, in the novel *The Light that Failed* (1899). Now, after almost a decade on the warpath, Villiers had arrived in Canada to report a peaceful imperial mission. He was on his way to Ottawa to join the party of Governor General Lord Stanley's official tour of the West on the Canadian Pacific Railway.

Stanley was apparently a popular and successful governor general. The nation-building Prime Minister, Sir John Alexander MacDonald, who had seen seven governors general come and go, thought him one of the best. He enjoyed life in Canada. Judiciously, he worked to promote goodwill, and the fruits of his efforts—as indeed those of his predecessors—can still be recognized today. Most of all in Alberta, whose vigorous caste of ranchers constitutes the nearest thing to an aristocracy in North America.

Like the Americans, Canadians found that one of the most effective ways of promoting the rapid growth of civilization and progress in their newly opened territories was the long-distance railway excursion. Statesmen and businessmen were taken west from Ottawa or Montreal on what was usually a highly convivial jaunt at the expense of the Canadian Pacific Railway. There was a catch to it, of course. But not one that would cause any sleepless nights. While sampling the legendary hospitality and marveling at the wonders of the West, such important guests could hardly refuse to lobby or boost the interests of the company and not visit coal, gold, and silver mines; grain farms and flour mills; lumber camps and ranches; and last but not least, answer addresses of welcome, encourage newly arrived immigrants, and listen to talkative Indians.

Few such V.I.P.'s worked as hard or displayed such genial expertise at the task as did those carefully chosen English noblemen who had to make at least one trip West during their term of office as officers representing the Crown to the Dominion of Canada. Such a man was Lord Lansdowne's successor, Lord Stanley of Preston (1841–1908).

The second son of the fourteenth Earl of Derby, a former Prime Minister of England, Frederick Arthur Stanley could trace his ancestry as far back as 1485, when Thomas, second Lord Stanley, Sovereign Lord

1. Randolph Churchill, *The King of Lancashire,* 2 (London, 1959).

of the Isle of Man, transferred his allegiance from Richard III and turned the tide to set the crown upon the head of Henry Tudor, Henry IV. No other English family, Randolph Churchill assures us, could show a longer record of unbroken devotion to the affairs of state. (1) Lord Stanley endeavored to continue the tradition. Educated at Eton, he served in the Grenadier Guards as a captain before embarking on a moderately successful political career. Between 1868 and his appointment as Governor General in 1888, he was successively Lord of the Admiralty and Financial Secretary for War, the Treasury, the Colonies, and for the Board of Trade. He was, potentially, one of the wealthiest of men as heir-presumptive to immense properties which included sixty-nine thousand acres of land in northwest England, including most of Liverpool. Since childhood, he had been a close friend of the pleasure-loving Prince of Wales (later Edward VII) whom he affectionately nicknamed "Tum," sharing his enthusiasm for fine wines, fishing, and fast horses.

Now forty-eight, and in the first flush of his prime, he faced the responsibilities of his new office with a stoic sense of professional commitment. He would ensure that imperial policy was efficiently carried out. British colonial policy was liberal, but Whitehall looked to the day when the colonies would increase in population and practice self-government, attached of course by ties of loyalty to Mother Britain. His goodwill tour would help to strengthen these ties.

But the trip also had importance for the future of Canada itself. Four years had elapsed since the last spike had been driven in the young Dominion's first transcontinental railway. Now there were new problems to be overcome. The newly opened Western lands had failed to attract more than a trickle of new settlers: the United States continued to be the main goal for immigrants of British stock. Moreover, a world depression had reduced the demand for the staple product of the prairies. The monopolist clauses of the Canadian Pacific Railway charter, which, it was said, gave a kingdom in exchange for the West's iron horse, angered farmers. As a consequence, the company's shares began to lose ground on the London Stock Market. At such a difficult time, Lord Stanley, a leading member of a rich and powerful family on intimate terms with the royal family, and the Baring brothers, *the* merchant bankers of London, could be an important and valuable ally.

The tour proceeded by special train on the Canadian Pacific mainline from September through October, 1889, and took Lord Stanley and his party from Quebec to Vancouver, a distance of three thousand miles, then the longest stretch of railway in the world. Travel was confined to daytime so the party would see as much as possible. Besides Lord Stanley and his wife, Lady Constance, the party included their son, Edward; his wife, Lady Alice; their daughter, Isobel; a friend, Miss Kitty Liston; two of Lord Stanley's aides, Mr. Groschen and Sir J. Grant; and Frederick Villiers, Special Artist of the *Graphic,* who had

joined the party at Ottawa. Two maids; a French cook; Lord Stanley's valet, clerk, and footman; Edward Stanley's servant, Harry; and the train's conductor and security guard, Sergeant Rogers, completed the party.

The special viceregal train itself was an impressive sight. A wood-burning locomotive of the American two-truck shay type with a tea-kettle chimney provided the power. At the front of the engine, over a huge kerosene lantern, hung a large pair of moose antlers; while below, attached to the cowcatcher, was a gaily decorated, railed-in platform with comfortable seats so that the members of the party could avail themselves of the view. It was no less impressive inside. Next to the engine was the parlor and sleeping car the *Nagasaki,* the interior of which Villiers thought surpassed any he had seen on the American continent for beauty of design and upholstery. A second carriage was used for baggage, stores, and as a dressing room for young Edward Stanley. The last carriage, the *Victoria,* was the viceregal car, and was divided into six parts: a kitchen, three luxuriously appointed bedrooms, and a private bathroom. In the rear, looking onto the track, was Lady Stanley's apartment; it had large windows and was furnished with red plush sofas and easy chairs.

North Bay, Ontario, was the first stop, then Missanbie, Port Arthur, and Fort William. Entering the prairies on September 21, Lord Stanley, Edward, and an aide donned their warm Inverness cape coats and "fore-and-aft" caps, and sat with Lady Constance on the cowcatcher for the first time. She was thrilled and thought it "more like flying than anything else." (2) Here, as well as in the great ranching country of southern Alberta, the party saw something of the destructive effect of prairie fires. "Some evenings," wrote Villiers, "we would actually dash through one of these conflagrations, the flames lapping the trenches on either side of the permanent way." Villiers, sensing a dramatic subject, promptly made a sketch of such a scene. (3)

En route, the party encountered small groups of pioneers who had journeyed from mines and farms of western Ontario to listen to the whistle-stop speeches which ended with rousing cheers and "God Save the Queen!" But it was not till the party arrived in Winnipeg that Lord Stanley's reception assumed a more spectacular form. The "bull's-eye" city of the West was the center of the ebullient and staunchly Anglo-Saxon "Canada Firsters," and gave the viceregal party a rousing welcome. "Though it was pouring with rain, and the streets were a foot thick with the tenacious Winnipeg mud," wrote Villiers, "a torchlight procession, in which the whole populace seemed to join, surged round the Viceregal carriage en route to Government House." Here, His Excellency and Lady Stanley remained as guests of the Governor of Manitoba, John C. Schultz.

More sightseeing and speechmaking followed. "Colleges, convents, hospitals all day long," sighed Lady Constance in her journal. But she

2. Lady Stanley, ms., *Journal,* entry dated Saturday, September 21, 1889.

3. See, *Graphic,* 40, November 30, 1889: front page. *Lord Stanley and Friends Watching a Prairie Fire from the Cow-catcher.*

Arrival of the Governor-General in Winnipeg. Wood engraving. *Graphic,* November 2, 1889. The visit of a governor general was always an event throughout Canada, though it was even more so out West. Winnipeg, bigger and more prosperous than ever, gave Lord and Lady Stanley a rousing welcome. "The whole populace," wrote Villiers, "surged round the Viceregal carriage en route to Government House."

The Settler at Work. Also from the series entitled *Three Claimants to Alberta* in the *Daily Graphic,* April 18, 1894.

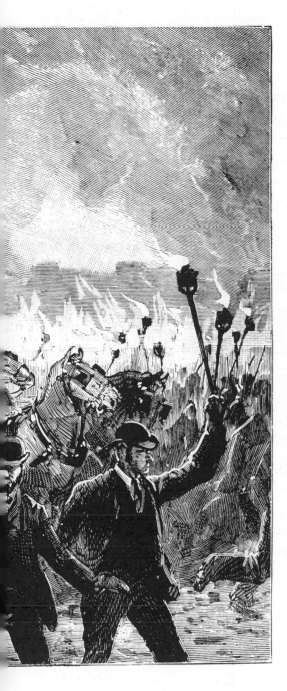

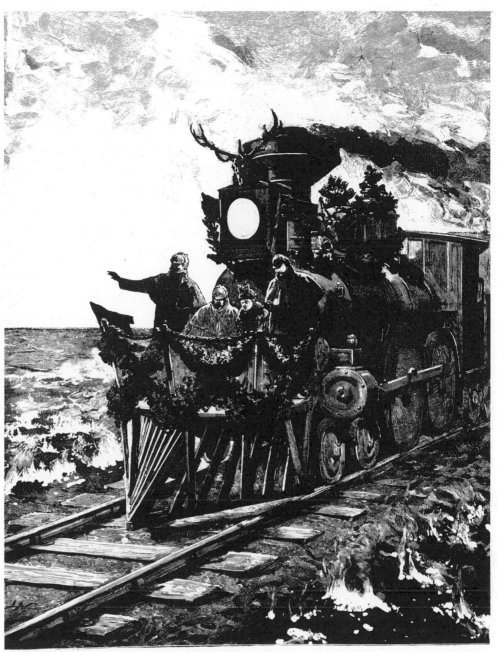

Lord Stanley and Friends Watching a Prairie Fire from the Cowcatcher.
Wood engraving after pencil sketch. *Graphic,* November 30, 1889. Riding cow-
catchers proved an irresistible attraction at all times, and most of all when fire
swept the tinder-dry prairies east of Regina.

4. Lady Stanley, *op. cit.*, entry dated Wednesday, September 25, 1889.

5. *Ibid.*, entry dated Tuesday, October 1, 1889.

6. *Ibid.*, entry dated Friday, October 11, 1889.

7. Villiers, *Peaceful Personalities and Warriors Bold* (London, 1907), 19:260. In this chapter, the artist also writes of his impressions of the phenomenal growth of western Canada since his first visit. See, 259–61.

8. Lady Stanley, *op. cit.*, entry dated Friday, October 16, 1889.

added with almost professional pride, "F[rederick] dined at the Manitoba Club . . . and made a wonderfully good speech." The dinner, too, was excellent; the wines were particularly appreciated as Government House was, to Lord Stanley's acute dismay, "a temperance establishment, nothing but ginger beer or ginger ale to drink," although, continued her Ladyship, "champagne was always going when no one could see!" (4)

After they left Winnipeg for Regina, the party stopped to visit the brand-new crofter settlement near Saltcots. Forty-nine families of Scots peasants had arrived in the spring. "Already," wrote Villiers, "they had broken up several acres, dug wells and made clearings to avert the terrible prairie fires." Such colonies of hardy peasants adapted far more easily than most other British immigrants to the windswept, treeless plains. All were found busily preparing for the long, harsh winter. In one hut, her Ladyship noted, the family had brought its own spinning wheel and loom, and the women were making warm clothing while their men plastered the exterior walls of their log cabins with mud. (5)

Lady Constance, however, thought prairie life not at all attractive. She preferred the more glamorous Indians, even though their wild welcomes, "shooting and yelling and firing guns," almost caused her heart to stop beating on several occasions. The first reservation to be visited was that of the Crees near Grenfell, Saskatchewan. Here she received a deputation of "fine-looking men all painted and dressed in embroidered clothes with rugs round them and feathers in their hats." Villiers made a drawing of the scene which depicted Lady Stanley and her companion, Kitty Liston, perfectly groomed and at ease, in visiting dresses complete with bustles, greeting a line of grimacing, befeathered chiefs.

Indians should, she felt, *always* be dressed up like this. But at the Blood reservation on the Belly River, in what is now Alberta, Old Red Crow and his chiefs, anxious to please, greeted the visitors in government-issue dark blue coats and brass buttons. Not, Lady Constance thought, "so well worth seeing as paint and feathers!" All ended well, however, when she was presented with a pipe and tobacco pouch by Chief Calfshirt. Although very much taken aback by such an unfeminine gift, her ladyship appreciated his friendly gesture. (6)

The Blackfoot reservation at Gleichen, near Calgary, she found the most interesting of all. Here, the celebrated Crowfoot—who had told the Marquis of Lorne that the Great Mother should give her children more to eat—did not neglect the opportunity to press his case for increased rations. Villiers, like Hall, was struck by his resemblance to Gladstone. "His fine bold eyes," he wrote, "had a similar fierce glare in them when he warmed to his work." (7) Although nearly sixty, he remained erect and tall, and carried himself with majestic bearing. He probably appeared—as was his custom—in a scarlet coat, buckskin breeches and shirt, wearing a huge treaty medal which hung from his neck to his waist on a fine chain. Lady Constance thought him "a very fine old man." (8)

9. See, *Graphic,* 40, 1889: 667, for note with illustration *A Captive of the Blackfeet.*

10. Lewis Gwynne Thomas, *The Ranching Period in Southern Alberta.* Unpublished M.A. thesis, University of Alberta, 1935.

11. Sam Steele, *Forty Years in Canada* (London, 1915), 14.

12. Donald Edward Brown, *A History of the Cochrane Area.* Unpublished M.A. thesis, University of Alberta, undated.

13. Calgary *Tribune,* October 23, 1889.

A grand reception followed the powwow, and there were dancing and displays of skill. Several of the younger braves got wound up during a war dance; and Villiers thought that Lady Alice and Miss Liston, both keen amateur photographers, "braved the possibility of being tomahawked by taking shots of one of the most bellicose of the tribe." A tragic postscript followed. Toward the end of the visit, a little white girl of nine was brought into camp on a pony. Dressed in a richly bead-embroidered shift, she sat to be drawn and "Kodaked." Villiers learned she had been captured during a raid in Montana in which her father, an American cavalry officer, was killed. (9)

After a break of four enjoyable days at Rush Lake, where Lord Stanley indulged in his favorite pastime, trout-fishing, the viceregal party next turned its attention to the Chinook belt of southern Alberta. This was the country which had prompted the Marquis of Lorne to make the much-quoted remark that if he had his life to live over again, he would be a rancher. (10) Already, by the mid-1880's, ranching was firmly established as a prosperous industry. Ex-traders and Mounties had been first, but now they were joined by young Englishmen from several well-known aristocratic families, anxious to establish cattle baronages for themselves. Lord Stanley must have found this the most congenial part of his entire tour; a leisurely stay among a vigorous colonial land-owning caste with an abhorence of republican attitudes and philosophy. Even the cowboys were different, as the Mounties came down hard on anyone even wearing guns, let alone using them. In the well-policed Canadian West, the cowboy was more an ordinary working man than was his·flamboyant counterpart south of the border. Still, they were cowboys; they rounded up six thousand cattle at the Cochrane Ranch in great style, besides treating the party to a superb display of roping and branding. (11) Cochrane was the site of the first company cattle ranches that were to have such a big influence on the development of Alberta. (12) Impressed by what he had seen of the Chinook and Calgary, Lord Stanley told Mayor March that during the whole course of his travels he had seen no community more prosperous. (13)

The West, now that the tour was almost at an end, made the party a gift of more memorable moments. There were handshakes and salutes as Colonel Herchmer and his stalwart troop once again took their leave of a viceregal party. "No finer, smarter or picturesque body of men can be seen anywhere," wrote Villiers, with patriotic pride. Then at Banff, the party bathed in the Cave and Basin, took trips to Devil's Lake and the Hot Springs , and ended with a ball given by the Canadian Pacific in the megalomaniacal grandeur of the new Banff Spring Hotel. Taking a stroll before retiring that night, Villiers was startled by the sight of the king-sized crutch hanging from a pine outside Dr. Brett's Sanitarium, and the shingle, "The Man Who Used this Crutch is Cured and Gone Home," and wondered if perhaps he had had one too many!

On October 22, the party left the little alpine resort for their journey

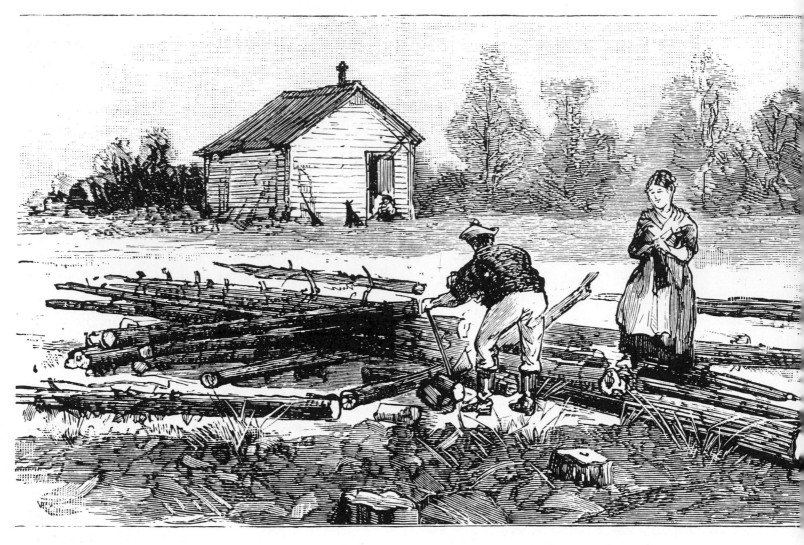

Home for the First Year in the New West (Above). Wood engraving. *Graphic,* November 9, 1889. The loneliness of a prairie wife, with the nearest house miles away, depressed Lady Stanley. "We sit with Mrs. P.," she wrote in her diary. "Oh! such a dirty miserable house and making prairie life not appear at all attractive."

Indians Outside Assembly Room, Blood Reserve (Right). Photomechanical line engraving after pencil sketch. *Graphic,* November 30, 1889. The Blood Indians demanded their share of the palaver. "But this," wrote Villiers, "the viceroy really enjoyed, for the Indians did most of the talking."

Lady Constance Stanley with Lady Alice Receiving Cree Indian Chiefs at the Cree Reserve, Grenfell, Saskatchewan (Far Right). Wood engraving after pencil sketch. *Graphic,* November 30, 1889.

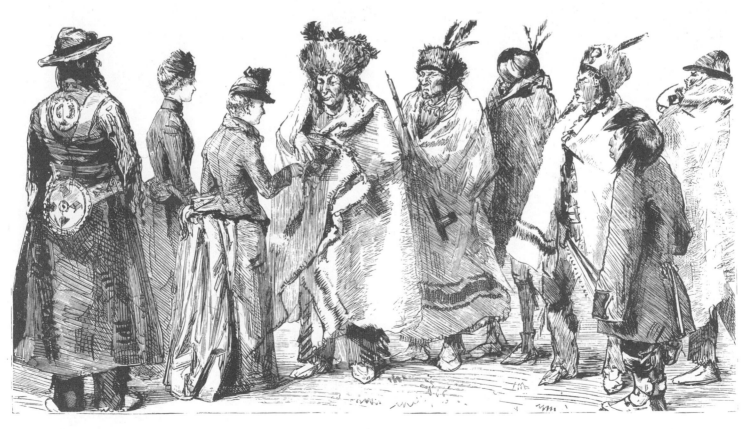

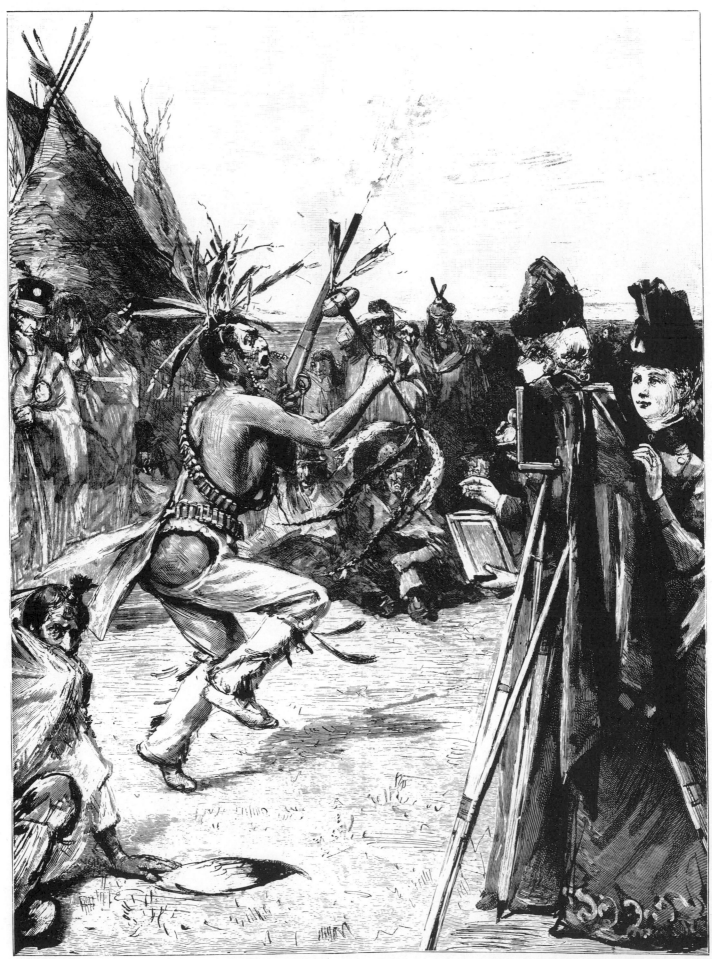

Lady Constance (first right) and Lady Alice "Fixing" a War-Dance at the Blackfeet Reserve, Gleichen (Alberta). Wood engraving after pencil sketch. *Graphic,* December 14, 1889.

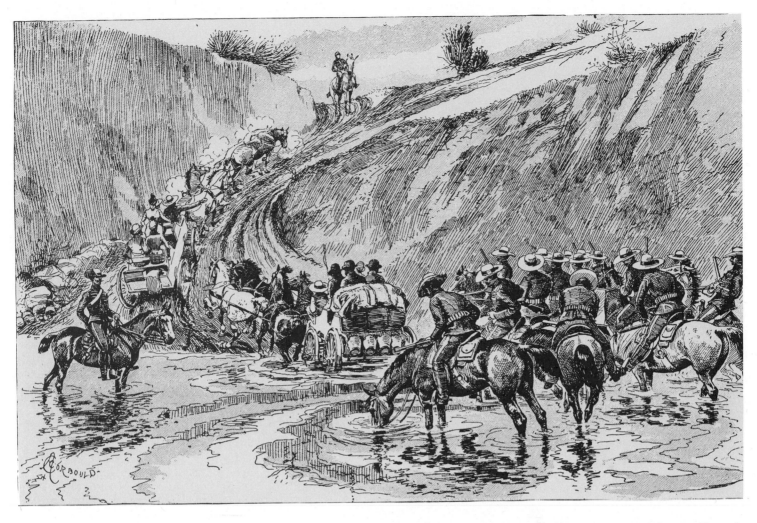

The Viceregal Party en route to the Cochrane Ranch, Alberta (Above). Photomechanical line engraving after ink drawing by A. C. Corbould, from pencil sketch by Frederick Villiers. *Graphic,* December 7, 1889. "After the Pow-wow [at the Blackfeet reservation] and Indian dances," wrote Lady Stanley, "we drove on to Mr. Cochrane's ranch. The wind was too high to make the drive pleasant and the prairie dust was simply awful. Sir James Grant and Mr. Villiers who were in the last carriage arrived with their faces black with it. Mr. V. *very* cross indeed!"

A Captive of the Blackfeet (Left). Photomechanical line engraving after ink drawing by C. J. Staniland, from pencil sketch by Frederick Villiers. *Graphic,* November 30, 1889. Bands of Blackfeet braves periodically crossed the frontier into the United States to hunt game and to skirmish with American garrisons. Villiers learned that the little white girl had been captured during such a skirmish in Montana in which her father, an American cavalry officer, had been killed.

to the Pacific Slope and Vancouver. Again, Lord and Lady Stanley took their places on the cowcatcher to view the awe-inspiring scenery of the Rockies. At first, all was shrouded in mist, then, at Field, a dozen miles down Kicking Horse Pass, the clouds lifted to permit the breathtaking spectacle of the monumental dome of Mount Stephen. The party spent the night at Glacier House, beyond Rogers Pass, surrounded by the majestic snow-covered peaks of the Selkirks.

As the train penetrated into British Columbia, huge flocks of wild fowl scattered along the surface of the Shuswap Lakes. Beyond lay rose-colored mountains, sparsely wooded and less wild than the Rockies. Past Kamloops, the line followed the source of the Thompson River; accentuated by rounded treeless hills, the stream rushed between steep banks. More pine-clad, snow-capped mountains lay beyond the narrow gorge along the face of precipitous cliffs which grew in size toward the confluence of the Thompson and Fraser rivers. Then, on October 26, a thicket of tapering masts was seen. A few minutes later the train entered the Pacific Terminus Station at Vancouver.

It was now the end of October, and after spending five days in Vancouver and Victoria, the party entrained on November 1 for the return journey to Ottawa. Villiers went on to Montreal, and made for New York to stay at the Players Club and meet Charles Dana Gibson, Thomas Nast, and other celebrities before returning home to England.

Lord Stanley's term of office ended in 1893, and his successors would continue the viceregal tour of the West into the twentieth century. But after 1889 these tours would no longer be covered by the Special Artist. (14) Through the 1890's and by the end of the century, the Canadian West developed at a tremendous rate of growth. An orgy of railway building broke out from Winnipeg to Vancouver. Faster-moving schedules, based on more and faster railway services, speeded up Western travel enormously. A six-week coast-to-coast tour could be reduced to three, even two weeks. (15) Under such conditions, the photo-reporter could do a much better job than the Special Artist.

Villiers himself saw that times were changing. On his second transcontinental trip by Canadian Pacific Railway (which he reported for the *Daily Graphic* and *Black and White*), (16) while en route to cover the Korean War of 1894, he relied more on his Kodak than on his pencil. In his autobiography, he observed that Lady Stanley made excellent photographs of the tour and printed them herself. "It was in the early days of the Kodak cameras," he added, "and I remember she had one of them." (17) Perhaps it was her facile and effortless use of the camera that made him realize that as a means of literally reporting events for a newspaper, the drawing had become obsolete.

14. The royal tour made in 1901 was an exception. Most members of the British royal family had an aversion to the camera and preferred to take along an artist of their own choice as member of their entourage —in this instance, Sydney Prior Hall, who also reported the trip for the *Graphic* and *Daily Graphic* (see the Biographical Notes at the back of this book). Melton Prior as a member of the press party also reported this tour (again, see the Biographical Notes).

15. The 1901 tour of the Duke and Duchess of Cornwall (later King George V and Queen Mary) is an example. According to a news item in *ILN*, October 5, 1901, the Duke and Duchess left Montreal September 19, and arrived in Winnipeg September 24. The route lay through Regina to Calgary, where the party attended a powwow. After stopping at Banff, they arrived in Victoria, B.C. on October 1. The royal party had therefore spent seven days in the West.

16. See the Checklist of Published Illustrations of Western Canada by Frederick Villiers in the notes at the back of this book.

17. Frederick Villiers, *Peaceful Personalities and Warriors Bold* (London, 1907), 261. The Kodak box camera was on sale in 1888, and it achieved immediate popularity with almost everyone who traveled abroad.

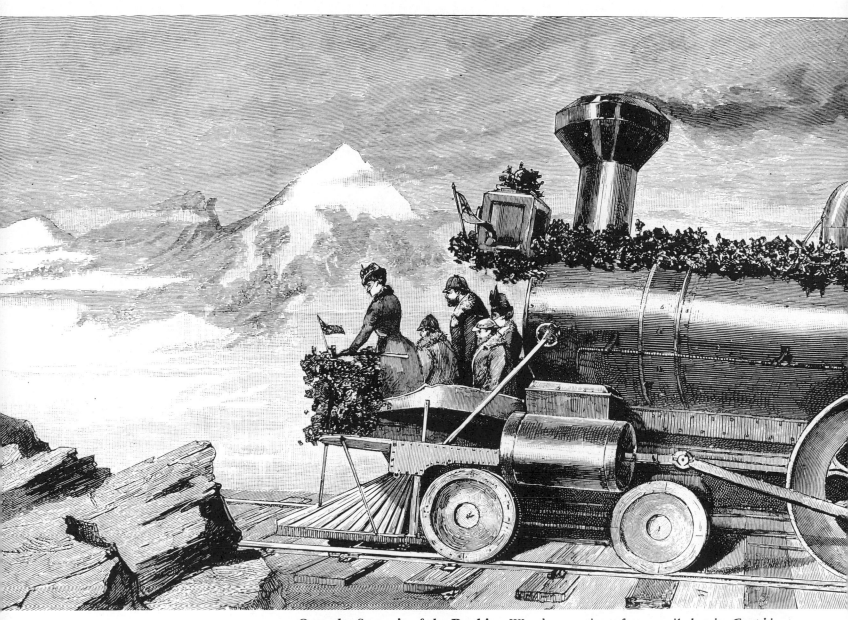

Over the Summit of the Rockies. Wood engraving after pencil sketch. *Graphic,* January 23, 1890. "Left Banff at 9," continued Lady Constance, "cloudy morning but became fine enough for us to see the beauties of the Rockies and when we reached Field the clouds lifted from off the top of Mt. Stephen. It was very grand indeed and we all saw the beauties of the line to perfection as we were on the cow-catcher."

9.
Gun and Palette
Richard Caton Woodville
1890

"There is scarcely a soldier, to say nothing of civilians, whose pulse does not beat higher as he looks on the realistic productions of Mr. Caton Woodville's wonderful brush."
Roy Compton (*The Idler*, 1896)

Richard Caton Woodville **(1856–1927).** From a photograph by H. T. Leman, London.

IN THE EARLY DAYS of December, 1890, a handsome, well-built Englishman of thirty-five might have been seen presenting his credentials to General John R. Brooke, the officer commanding the troops investigating the Sioux outbreak at the Pine Ridge Indian agency, South Dakota. He would have been none other than Richard Caton Woodville, military painter and Special Artist of the *Illustrated London News,* the latest arrival to join the large group of correspondents covering the first sign of renewed resistance on the northern plains since the campaigns of 1876–77.

After having found accommodation at the crowded log hut known as Finley's Hotel, the Englishman would almost certainly have joined the motley throng of scouts, soldiers, and newspapermen at James Asay's trading post. As yet there was no war to report, but in the meantime, fiction sufficed. He would have listened to the rumors that the Sioux were preparing to descend on farms and ranches with torches and tomahawks. He would also have stood at least one round of drinks in appreciation of tall tales and lurid anecdotes supplied by thirsty scouts and vengeful troopers. Then, tired after a long railroad journey from the Black Hills, and a spine-jolting, thirty-mile stage ride from Chadron, Nebraska, the Englishman probably would have swallowed his second whisky and decided to make an early night of it. For the artist was an experienced campaigner. He had been waiting for wars to break out since he was twenty-three.

Young Woodville first inhaled the smell of war among the cluttered memorabilia of long-gone battles in the Düsseldorf studio of William Kamphaussen, court painter of military subjects to Kaiser Wilhelm I, and friend of his father, the American genre painter, Richard Caton Woodville, Sr. (1825–55), whose interest in the American West is shown by various pencil studies of Indian braves on the warpath. (1)

Richard Caton Woodville, Jr. was born in London, in 1856, shortly after his unfortunate father died from an overdose of morphine in a London hospital. From childhood, he was an artist prodigy; he was encouraged by his German mother, Antoinette Schnitzler, also a painter, and by his aunts, who educated him privately in St. Petersburg and Düsseldorf. Later, he studied at the Royal Academy, Düsseldorf, under Von Gebhardt, a painter of Biblical history.

In the 1870's, Düsseldorf was a pleasant and picturesque city; the Academy, a little past its heyday, was still the most famous institution of its type in Europe, (2) where the manly arts of hunting and dueling were as much a part of the curriculum as were the supercharged historicism, derived from the Nazarenes, (3) and the romantic chivalry of Carl Friedrich Lessing. (4) Woodville led a gay and adventurous life there, but was asked to leave after a scandal which involved the daughter of Jenny Lind, the famous Swedish singer. (5)

Leaving Germany in 1875, he went to London and completed his training in 1876 at the Royal Academy schools. Success soon followed.

1. Woodville's boyhood pencil studies appear to have been inspired by the American illustrator, Felix Octavius Carr Darley (1822–88), whose work, like Catlin's, was widely known in both England and Germany through his illustrations of Indian adventure books for boys, the majority of which (notably *Scenes in Indian Life,* 1843) were published in England shortly after their appearance in the United States.

2. The fame of the Düsseldorf Royal Academy, or *Düsseldorfer Malerschule,* was mainly due to Wilhelm Von Schadow, director, 1826–59, who instituted the Masterclass, based on the Nazarene ideal of collective working. Its strength lay in the vigor of its classes in landscape, portraiture, and genre painting which made the Academy a mecca for many foreign artists

interested in painting contemporary history in the epic romantic style. Such artists included the American painters, Wimar, Bierstadt, Farny, and Whitteredge, all specifically concerned with Western life and landscape.

3. The Nazarenes was the name given to the *Lukasbrüderschaft,* or Lukas Brethren, a group of German artists of the early nineteenth century, who opposed the Academy of their time with the motto of Truth. Following the example of the painter's guilds of the Middle Ages, they chose as their patron saint the evangelist St. Luke, and returned to Dürer, early German painting, and the Italian painting of the fourteenth century in order to revive German art on the basis of religion, patriotism, and truth to nature. In England, the Pre-Raphaelite Brotherhood followed their example.

4. Carl Friedrich Lessing, after Schadow, was the most important painter of the Düsseldorf school. His frescoes for Heltorf Castle near Düsseldorf (of battle scenes from the Crusades) were probably familiar to Woodville. One of the designs for the frescoes, *The Assault on Ikonium by Friedrich of Swabia,* was seen at the Victoria and Albert Museum, London, 1968, at the exhibition "Nineteenth-Century German Drawings and Water-Colours," and revealed Lessing to be a major source of inspiration in the powerful movement, violent action, and dramatic expression of his composition.

5. Richard Caton Woodville, *Random Recollections* (London, 1914).

6. *Army and Navy Gazette,* January 4, 1890. See also, Woodville's illustrated account, "Tiger-hunting in Mysore," *Harper's Weekly,* 85:706.

In July of that year, a rebellion of the southern Slavs against Turkish rule broke out and spread throughout present-day Yugoslavia. Because of their distrust of Mother Russia, the sympathies of Britain's conservative government lay with Turkey. The young artist, who had hunted in Bosnia and Herzegovina, lost no time in establishing the foundations of his future career; he painted a scene of a skirmish between Serbian rebels and a Turkish patrol and quickly sent it off to the *Illustrated London News.*

The picture created a mild sensation in the editor's office. Mindful of a possible repeat performance of the Crimean War and its stimulating effect on circulation, the famous weekly welcomed the work of an artist able to capture the atmosphere of conflict with such a wealth of closely observed detail. William Ingram promptly offered him a place on the freelance staff, and shortly afterward, an assignment to cover his first real war, the Russian-Turkish, as Special Artist. He was the first military painter trained in the romantic tradition of German historical painting to accept the deadlines of pictorial journalism. It was a flying start to a long and successful career.

During the next ten years, Woodville traveled over most of the world. After covering the Russian-Turkish War, he went on to report the poverty and unrest in Ireland. He saw a little of the Egyptian War in 1882, and campaigns in Albania and the eastern fringe of the British Empire. In 1887, he accompanied Sir William Kirby Green on an official mission to Morocco. In 1889, he joined a party to tour India, headed by Prince Albert Victor, Duke of Clarence. No Special Artists were allowed, so Woodville joined in his capacity as an officer of the Royal North Devon Hussars, in which he had recently been commissioned. The party was frequently the guest of native princes (Woodville seldom lost the opportunity to paint a well-rewarded portrait of the host on these visits), and there were many hunting expeditions. One notable experience was a tiger hunt in Mysore, where the artist became the hero of the day after shooting a tigress in the act of springing" within a few feet of her intended victim"—Lord Claud Hamilton, aide-de-camp to Prince Albert himself. (6)

Although his successful career as a military painter largely derived from his travels on behalf of the *Illustrated London News,* Woodville felt his true vocation was that of a historical painter. Indeed, his early fame rested on the huge battle pieces he exhibited at the Royal Academy as much as it did on his magazine work. Initially, these dealt with such subjects as *Frederick the Great on the Eve of the Battle of Leuthen,* and *Blenheim.* But in 1881, deriving fresh inspiration from his travels, he turned to such subjects as *The Second Fight before Kandahar,* an incident from a recent campaign in the East. Other pictures included the salutary *Tel-el-Kebir,* painted on royal command of Queen Victoria, and *Too Late,* which dramatically represented the attempted relief of Metamneh, another reversal in the Egyptian campaign against the

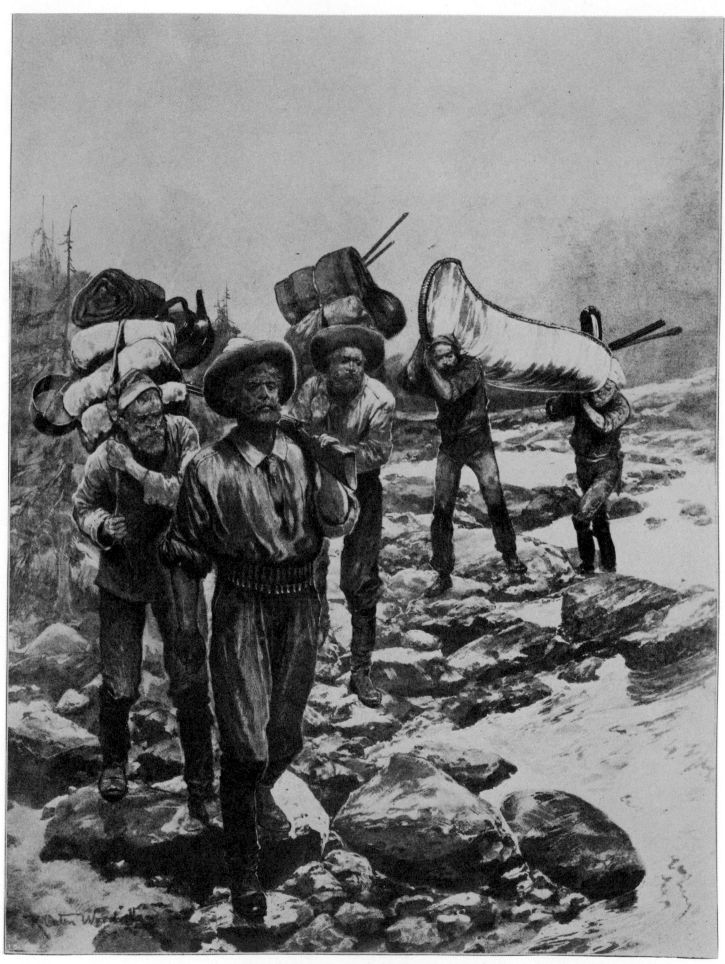

Prospecting for Gold in British Columbia: A Portage. Photomechanical half-tone engraving after gouache drawing. *Illustrated London News,* January 16, 1897.

nationalist forces of Arabi Bey. Such pictures brought Woodville lavish tributes. The *Times* hailed him as the most distinguished of British military painters, although one hostile critic insisted that they represented nothing but an artist's victory over British defeat! He became the favorite artist of Queen Victoria (although she did not approve of his many love affairs), and built himself a luxurious mansion at Windsor on the proceeds of his paintings.

Meanwhile, large double-page and single-page illustrations of every campaign fought by the British Army from 1882 to World War I made Woodville the idol of an even larger public. Almost weekly, stirring episodes depicted gallant soldiers of the Queen holding out against Sudanese dervishes, Afghan tribesmen, Zulu warriors, and Boer farmers. Bullets found their marks, to the moans of the wounded and the pounding of horses' hooves. The spellbinding realism of these pictures made everyone proud to be British. Tacked up or framed, they could be found on the walls of barber shops, clubs, pubs, log cabins and barracks throughout the Empire. As the poet Andrew Lang was moved to write:

> O pictured page! O happy age!
> O combinations quaint!
> An empire's agony, the rage
> Of war, were things to paint! (7)

In spite of these formidable commitments, Woodville also found the time to be the most prolific European delineator of the West. "Show Caton Woodville the rusty spur of a Mexican hunter," said one critic, "and he will evolve a buffalo hunt out of it!" (8) Even before his visit to North America, he had, between 1884 and 1889, contributed some remarkable illustrations—largely of big-game hunting (9) and frontier life—to the *Illustrated London News*. He was also the leading British illustrator of the popular Bret Harte (living in England at the time), and illustrated Western yarns for that Peter Pan of Victorian journalism, the inimitable *Boy's Own Paper*.

But now he was actually in the West. Since the late summer of 1890, he had traveled about western Canada and the United States on a roving assignment. The *Illustrated London News,* encouraged no doubt by the free facilities offered by the Northern Pacific's publicity department, believed that the American West was now ripe for promotion as a select tourist attraction for the more affluent of its readers. Woodville was asked to picture the delights of outdoor life in the western wilds.

This assignment took him across Canada on the Canadian Pacific to the Kootenay district of British Columbia. Here, he took advantage of a long-standing invitation to stay with an old friend and former hunting companion, the famous British sportsman and author, William Adolph Baillie-Grohman, now busily pioneering a colonization project at Kootenay Flats. (10) The artist made sketches of lumberjacks (11) and gold-seekers along the Kootenay River (12) before crossing the

7. "A Jubilee Ode" by Andrew Lang, *Illustrated London News,* May 14, 100, 1892: front page.

8. Quoted by T.H.L., "R. Caton Woodville and His Work," *Illustrated London News,* 107, 1895: supplement 3.

9. Two of these pictorial features (illustrations by Woodville, text by W. A. Baillie-Grohman) appeared in the New York *Harper's Bazaar* before they were published in the *Illustrated London News.* The titles are listed in the Checklist of Paintings, Drawings, and Published Illustrations of Western Canada and the United States by Richard Caton Woodville in the notes at the back of this book.

10. An undated letter in the possession of Humphrey Caton Wood-

ville reveals that Baillie-Grohman asked the artist where he was shooting that year, and (writing from British Columbia) adds, "Someday you must come and have a turn at the Wapiti." Before emigrating to Canada in the early 1880's, Baillie-Grohman and the artist had hunted together in various parts of Europe. He, too, had a cosmopolitan upbringing, and was bilingual in German and English. His mother was Irish and his father English, and his paternal grandfather, a noted botanist, was part Austrian. While searching for mountain goat in 1882, Grohman discovered the Kootenay Flats and formulated a reclamation scheme which he spent many years promoting and developing. He continued to indulge his passion for big-game hunting, contributing articles to leading American and British magazines of the review type. It was the shortened versions of these which provided Woodville with material for his earliest Western illustrations. Baillie-Grohman married in 1887, and lived at Grohman, B.C. until 1893. It is likely that Woodville stayed with the couple before continuing his travels in the United States. See, Mabel Jordon, "Kootenay Reclamation and Colonization Scheme and William Adolph Baillie-Grohman," *British Columbia Historical Quarterly*, 20, Nos. 3–4: 187–219.

11. A 4½" x 2¾" unsigned and undated oil sketch on canvas board inscribed "Lumberman at Work, Canada" was probably painted on this trip. It was customary for Düsseldorf-trained artists to paint these small sketches which were later developed into paintings or illustrations. Collection Humphrey Caton Woodville.

12. This appeared as a single-page illustration entitled *Prospecting for Gold in British Columbia: A Portage* (ILN, 110, 1987:85).

13. "Sport in the Rockies," *ILN,* 105, 1894:315, 412. The second of three illustrations on a single page is captioned *A Hungry Man Cooking*. It is a campfire scene with the artist watching Baillie-Grohman (?) stirring the pot. See Jordon, *op. cit.,* facing 209, for photograph of Baillie-Grohman.

14. *ILN,* 106, January 12, 1895:

line into Montana to take full advantage of the fall hunting season.

Just where Woodville did his hunting can only be guessed at: text notes accompanying the drawings give us only the name of the state (usually Montana or Wyoming). Certainly he would have made a trip or two with Baillie-Grohman, whose feudal-like domain could doubtless be cared for in his absence. My guess is that they hunted wapiti (elk) together either in the Selkirks or the Yellowstone country, as one of the characters portrayed in the illustrations devoted to such a trip closely resembles the sporting author of the best-selling *Camps in the Rockies,* Baillie-Grohman. (13)

More than likely, Woodville made Bozeman his headquarters for a bear-hunting expedition. Here, he could hire a guide or accompany local hunters on the trail of predatory grizzlies with bounties on their heads. Two splendid illustrations resulted. The first of these, *Bear-Hunters in Montana: Victors and Vanquished* (14) is a strongly drawn scene depicting a young hunter and an older westerner talking over their adventures in bagging the most dangerous quarry of all, the grizzly bear, or as he was nicknamed out West, Old Ephraim, or Moccasin Joe. The second, *Victor and Vanquished,* (15) is a highly dramatic climax to a struggle between a lone hunter and a tree-climbing black bear.

Woodville's next objective was the Yellowstone country, which was almost as well known as the Swiss Alps to average London clubmen. Traveling to and across the United States had become so fast and comfortable that a sporting holiday in the American West was no longer the preserve of adventuresome wilderness hunters like the Earl of Dunraven. The two-thousand-mile trip from New York to Cinnabar (the terminus of the Park Branch line) took forty-eight hours, and the Atlantic crossing six days. This placed such a holiday well within the two-month period usually favored by Englishmen of wealth, high position, or noble blood. (16)

Here, at one of several palatial hotels (again, possibly the Association at Mammoth Hot Springs), Woodville probably met several such English tourists. In another illustration, *Holiday Time in the Wild West,* (17) he depicts a monocled and bewhiskered tourist in a deer-stalker, literally savoring the delights of outdoor life by tasting the campfire stew in the company of his guide and cook. Such tenderfoots prompted the artist to reflect that civilization had spread so rapidly that former notions of Far West and Wild West had become rather mixed. (18) But, as he was to discover, there was still plenty of the latter around!

Very probably the large British investment in the cattle industry directed Woodville's choice of his next subject—a fall roundup at a ranch in the vicinity of the Big Horn Mountains of Wyoming. The artist may have been a guest at one of the British-owned spreads, (19) and was thus able to see the start of a big drive bound for the nearest railhead of the Northern Pacific. Woodville gives us an energetic

unpaged. Being a hunter himself, the artist took care to get the guns right. The bear-hunter nursing his injured hand has an 1886 Winchester carbine, or "Yellow Boy," as it was called out West, because of its shiny brass frame. It was particularly suitable for hunting, as it was easily carried on the saddle of a horse.

15. *ILN,* 107, 1895:400–1.

16. By 1890, according to Frank C. Bowen, the White Star's *Majestic* and *Teutonic* and the Inman Line's *City of New York* all achieved record-breaking crossings in little over six days. See, Bowen, *A Century of Atlantic Travel* (London, 1930), 188.

17. *ILN,* 99, 1891:385.

18. *Ibid.*

19. British (particularly Scottish) ranch-owning cattle companies were famous in Wyoming and Montana, although very much reduced in number after the severe winter of 1885–86. See, Robert C. Athearn, *Westward the Briton* (Lincoln, 1953), 8:102–8. For a more exhaustive study, see W. T. Jackson, *The Enterprising Scot* (Edinburgh, 1968).

20. Quoted from caption. This scene appeared as a double-page illustration entitled *North American Indians Running Cattle into a Ranch* (*ILN,* 99, 1891:444–5).

21. A second oil sketch, 4½" x 2¾", unsigned and undated, and inscribed in pencil "Wyoming, USA," depicts a horseman riding out of a blazing pine forest. Collection Humphrey Caton Woodville.

22. James Mooney, *The Ghost Dance Religion and the Sioux Outbreak of 1890,* Fourteenth Annual Report, Bureau of American Ethnology, 2 (Washington, D.C., Smithsonian Institution, 1896), quoted by Robert M. Utley, *Last Days of the Sioux Nation* (New Haven, 1963), 67. Unless otherwise stated, this background account is drawn from Utley.

23. Utley, *op. cit.,* 69.

composition full of the violent urgency of the occasion. The party of Indians who took part in the task, he wrote, "were not always free from danger amid the crowd of angry, horned beasts. Only such bold and skillful horsemen could perform so rude a service. How well they ride, and how readily the sturdy and nimble bronchos, or ponies of the prairie adapt their swift movements to the incessant turning and twisting of this fierce struggle." (20)

After his stay at the ranch, he witnessed a devastating forest fire in the district. (21) He then resumed his journey eastward to the Black Hills, where, at Lead, he may have read the local papers and learned of the latest activities of the Ghost Dancers. Smelling powder, he probably telegraphed London for further instructions. One can imagine that he must have felt reluctant to continue his travels and seek out, of all elusive subjects, a guerrilla war. But after receiving an urgent request that he send illustrations of whatever he could possibly find, he forgot his fatigue and caught an eastbound train on the Fremont, Elkhorn, and Missouri Valley Railway, taking him to Chadron, Nebraska, the terminal point for Pine Ridge, the main trouble area.

As on other Sioux reservations, trouble had been steadily brewing at Pine Ridge throughout 1890. A mishandling of Indian administration had sorely tried the patience of the Sioux. But the real causes of the trouble lay in the natural reluctance of a militant and nomadic people to abandon their traditional way of life and adjust to a new one based on faith in a white man's god and agriculture. Although the more progressive chiefs tried their best, the land and climate more often than not conspired to defeat their efforts. Both white and Indian farmers faced the unpredictable hazards of plains farming; hail, drought, and grasshopper plagues devastated crops. A white man could abandon a homestead and try his luck somewhere else, but the Indian could not leave his reservation lands. The proud Sioux longed for the old days of free-wheeling independence. Thus, their more conservative-minded leaders were able to regain influence.

Paradoxically, they did so through the pacifist doctrine of the Paiute shaman, Wovoka, who, according to Mooney, (22) promised his followers to regenerate the earth. A new world, he said, was being prepared by a Messiah, and that this was already advancing from the West and would arrive in the spring of 1891. The Indians would be raised up into the sky and this new land would roll over the earth, pushing the white people before it, back across the ocean to where they came from. Then the Indians would lower themselves from the sky to find dead relatives, friends, and ancestors brought back to life again. Together, all Indians would enjoy eternal life, untouched by sickness, pain, poverty, or death. Deer, elk, and antelope would roam in abundance and herds of buffalo would once again blacken the prairie. (23)

By dancing the Ghost Dance and singing the Ghost Dance songs, Indians could briefly visit this utopia before it actually appeared. They

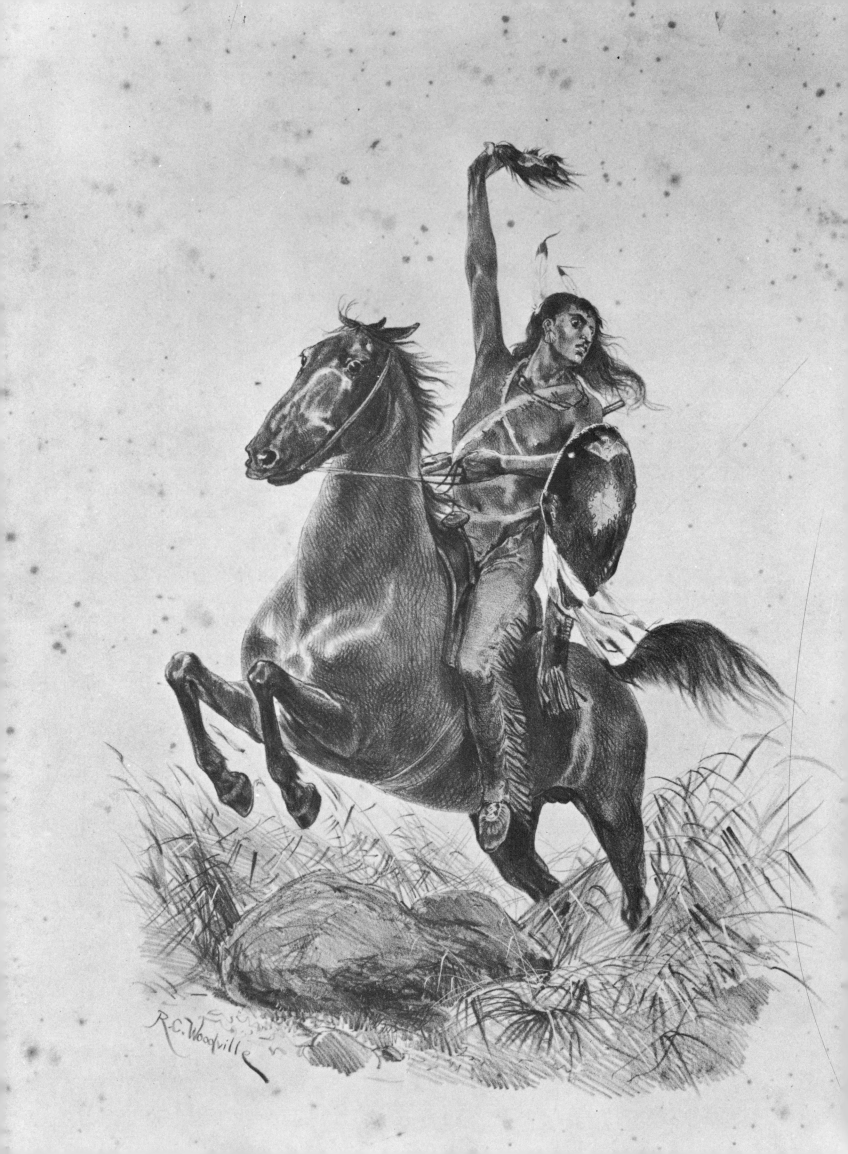

Indian on Horseback Holding Scalp (Left). Undated.
14⅜ x 11. Lithograph. Courtesy Humphrey Caton Wood-
ville. This lithograph was probably based on sketches made at
Buffalo Bill's Wild West Show, London, 1887, which the
artist visited on behalf of the *Illustrated London News*.

Indians Scouting (Above). 6½ x 10. Pencil. Undated.
Courtesy Humphrey Caton Woodville.

Canadian Lumberjack. Undated. 4½ x 2¾. Oil on canvas board. Courtesy Humphrey Caton Woodville.

would work themselves into emotional frenzies and go into trances enabling them to "die" and see the millennium. At the same time, the faith imposed a strict moral code based on the repressive commandments of the Old Testament. Wovoka taught that Indians should do no harm to anyone, renounce fighting, tell no lies, and do right always. Thus, as Robert Utley in his book *The Last Days of the Sioux Nation* points out, Christianity and paganism were united to form the common denominator of a doctrine offering grounds for belief to all Indians, progressive and nonprogressive alike. (24)

24. *Ibid.*, 70.

As the new religion spread across the West, each tribe shaped Wovoka's teachings to the framework of its own mythology. All absorbed the commandment to renounce violence except the Sioux. The bitterness caused by broken agreements, reduced rations, and above all, the total failure of the 1890 harvest, rekindled the flame of old hatreds. The militant Sioux therefore proclaimed that the whites were not to be merely pushed back across the ocean but violently destroyed. A doctrine of peace became a doctrine of war, and as Utley so aptly demonstrates, a revolutionary doctrine to a people whose highest values were based on success in war. (25)

25. *Ibid.*, 73.

Neither the agents nor the Army seemed to take the new religion very seriously. But as the consequences of the disastrous harvest made themselves felt, the belligerent attitudes of various nonprogressive chiefs became causes for concern. From Standing Rock to the Cheyenne, Rosebud, and Pine Ridge agencies, reactionary chiefs sensed a favorable climate for a comeback. All that was needed was a catalyst to turn smoldering resentment into the flame of violent protest.

Wisdom and understanding might have averted a crisis. But ignorance and inexperience prevailed and played into the hands of the nonprogressive chiefs: a new agent at the Pine Ridge agency, alarmed at the obsessive frenzy of emotion displayed at the Ghost Dances, lost his head and on November 15 telegraphed for a thousand soldiers. The troops came, and large bands of Indians, fearing reprisals, fled to the safety of the inaccessible Badlands. Here the rebel chiefs made an effort to involve Sitting Bull in the rising, which caused his arrest and murder on December 15. On December 27 came the tragic climax, the massacre at Wounded Knee, followed by an attack on Pine Ridge. A few more skirmishes followed, but at last the spirit of the Sioux had been well and truly broken. All were rounded up and returned to the reservations by the end of January, 1891.

The Sioux Outbreak, as it was called, attracted more newspapermen than all the previous Indian wars put together. Shortly after the Indians fled to their Badlands stronghold, editors had sent in reporters and Specials. Besides Richard Caton Woodville, the large press corps quartered at Pine Ridge included Frederic Remington, Special Artist of *Harper's Weekly,* and J. H. Smith, Special Artist for *Leslie's.* (26)

Remington, who was thirty at the time, must have soon discovered that

26. Oliver Knight, *Following the Indian Wars* (Norman, 1960), 313, cites lists of the more important cor-

respondents, but does not include Woodville or Smith. Further checks with the Military History of the Army and the index of the Elmo Scott Papers in the Newberry Library, Chicago, did not reveal Woodville or mention of him in contemporary news accounts. These however, do not claim to be complete, i.e., the names of J. H. or Dan Smith of *Leslie's Weekly* are not included either. Woodville was a passing observer, a painter rather than a regular accredited correspondent and probably made use of letters of introduction to obtain the facilities he required, although he would have presumably needed a pass from General Miles' office to enter the Pine Ridge agency. See also, Taft, *Artists and Illustrators of the Old West* (London and New York, 1953), 375.

27. John C. Ewers, *Artists of the Old West* (New York, 1965), 209–10.

28. *ILN,* January 10, 1891: front-page. Text note, 35. According to Knight, the stories of the correspondents at Pine Ridge had to be taken by courier to the Rushville telegraph office 30 miles away. Woodville's illustration would probably take two weeks to reach London and a further week to engrave for publication. This brings the date of the illustration to roughly December 15, the day Sitting Bull met his death at the Standing Rock agency at the hands of Indian police.

29. *Western Cavalry Troop.* Signed R. Caton Woodville, dated 1905. Oil on canvas, 60″ x 40″. A comprehensive search of all English and American periodicals Woodville is known to have worked for revealed that this picture was never published before 1910. It was probably painted for the series written and illustrated by the artist entitled "The World's Best Riders," published by *Illustrated Sporting and Dramatic News* through 1904–5.

he had a great deal in common with Woodville. Apart from the remarkable similarity of their respective styles, both were hearty mixers who enjoyed the company of soldiers and the outdoor life, no less than producing the stirring dramas they were called upon so frequently to paint. Both capitalized so heavily on the impulse to historicize the epoch of imperialism that it is a matter of genuine regret that no evidence of their meeting has yet come to light.

Harper's had sent Remington to the Northwest early in the autumn of 1890. He had attached himself to General Miles and kept in touch with much that had happened, including an Oglala Sioux performance of the Ghost Dance on the Pine Ridge reservation. His watercolor drawing of that event which had already appeared in *Harper's* on December 6, established him, along with J. H. Smith, as the only artist to depict the dance as well as to cover much of the background material. (27) In view of this, Woodville may have decided that he need only provide dramatic backgrounds for comment on events that would materialize after he had left the United States. Few as these were, they comprise a highly dramatic finale to his travels.

Being an experienced observer who could create a genre subject out of an incident that might escape a pictorial journalist, Woodville was able to find his subjects without any trouble. His first, *The Indian Rising in America: Latest News,* appeared on the front page of the *Illustrated London News* (January 10, 1891), and pictures a courier breathlessly informing local worthies and newspapermen of the latest news, possibly Sitting Bull's death. (28)

A second and much more impressive painting, *Braves Leaving the Reservation,* appeared the following week (January 17, 1891). This illustrated the exodus of Brûlé and Oglala bands from Pine Ridge on December 29. It is characteristically Woodville, and follows his personal dictum that there should be only two turning points in history an artist should depict: the moment before action and the moment of its result. Woodville chose the former to hint of the attack to follow; the somewhat shifty-eyed noble savage is treacherously about to bite the hand that has fed him. Yet, the history painter also rises to the occasion to capture the pathos of a closing chapter in the final military defeat of the Plains Indian.

Woodville's affirmation of war, emphasizing its positive aspects without necessarily leaving out its horrors, made him a leading British exponent of imperialism in the sphere of the visual arts. Like Remington, he rode with the cavalry, and in a later unpublished painting, *Western Cavalry Troop,* (29) he celebrates the American soldier's heroism with the same sentiments, self-sacrifice for the idea of race superiority and duty to one's country, that had imbued his treatment of the British soldier. His sympathies, therefore, reveal the extent to which the imperialist spirit had brought the two nations close to each other as never before.

HUNTING WITHOUT HUNGER

The wildlife of the Old West was shot indiscriminately for a variety of reasons. Smaller animals, particularly the antelope and the bighorn sheep, supplemented the pioneer diet of buffalo meat, and as the numbers of buffalo diminished the slaughter of these other animals increased. Later they became unwelcome competition for the pasture land needed to sustain huge flocks of sheep and herds of cattle. What wildlife remained moved to the higher ground of remote mountain ranges. Then, during the 1880's, as the railroads opened up the more remote parts of Montana and Wyoming, a new influx of hunters appeared on the scene. Mainly, they were wealthy Americans from the East, but a great number were British ex-army officers, aristocrats, and outdoorsmen-extraordinary, and they were usually experienced wilderness hunters. Elk, or wapiti, was a favored target: the huge, spreading antlers of the bull made the ideal take-home trophy. Also popular was the curly head of the bighorn ram, as well as the skin of the grizzly and the black bear to make into the obligatory smoking-room rug.

Wapiti-Hunting in North America. Wood engraving. *Illustrated London News,* November 6, 1886. The abundance of elk, or wapiti, in the Rocky Mountain region from Wyoming to British Columbia was thought important enough for a cover story. The illustrations were based on notes sent by the artist's friend and celebrated sportsman, W. A. Baillie-Grohmann, who also contributed an article of a hunting expedition in the Big River range of western Wyoming.

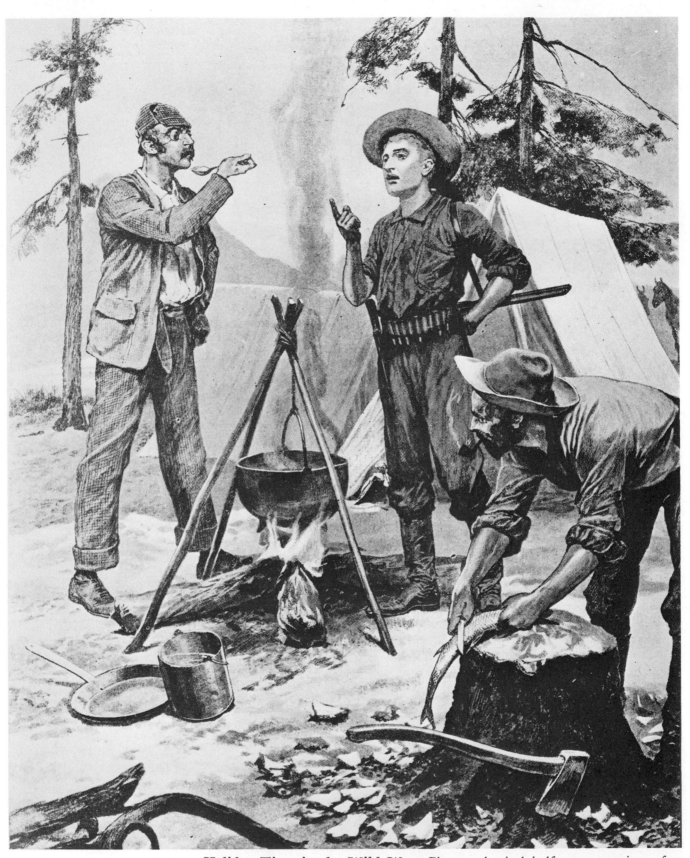

Holiday Time in the Wild West. Photomechanical halftone engraving, after pencil and wash drawing. *Illustrated London News*, September 19, 1891. A comfortable transatlantic crossing which had been shortened to six days, and a transcontinental railroad trip which took only three, brought an influx of affluent English tourists to spend a summer holiday in Yellowstone National Park, where palatial hotels catered to every need. Woodville was moved to reflect that "former notions of the Far West and the Wild West here have become rather mixed!"

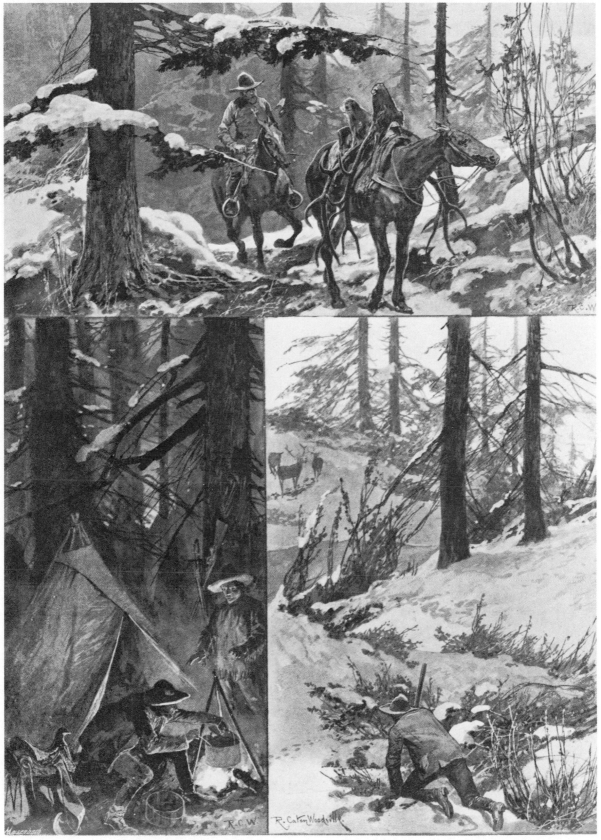

Sport in the Rockies: (top) **Packing Wapiti Heads Back to Camp**; (left) **A Hungry Man Cooking**; (right) **An Easy Stalk Rewarded by a Good Head**. Wood engraving. *Illustrated London News,* September 29, 1894. Taxidermists did a roaring business mounting the huge spreading antlers of bull elks as souvenirs for tourists visiting Yellowstone National Park. Woodville accompanied a "herd-hunting poacher" who kept them well supplied.

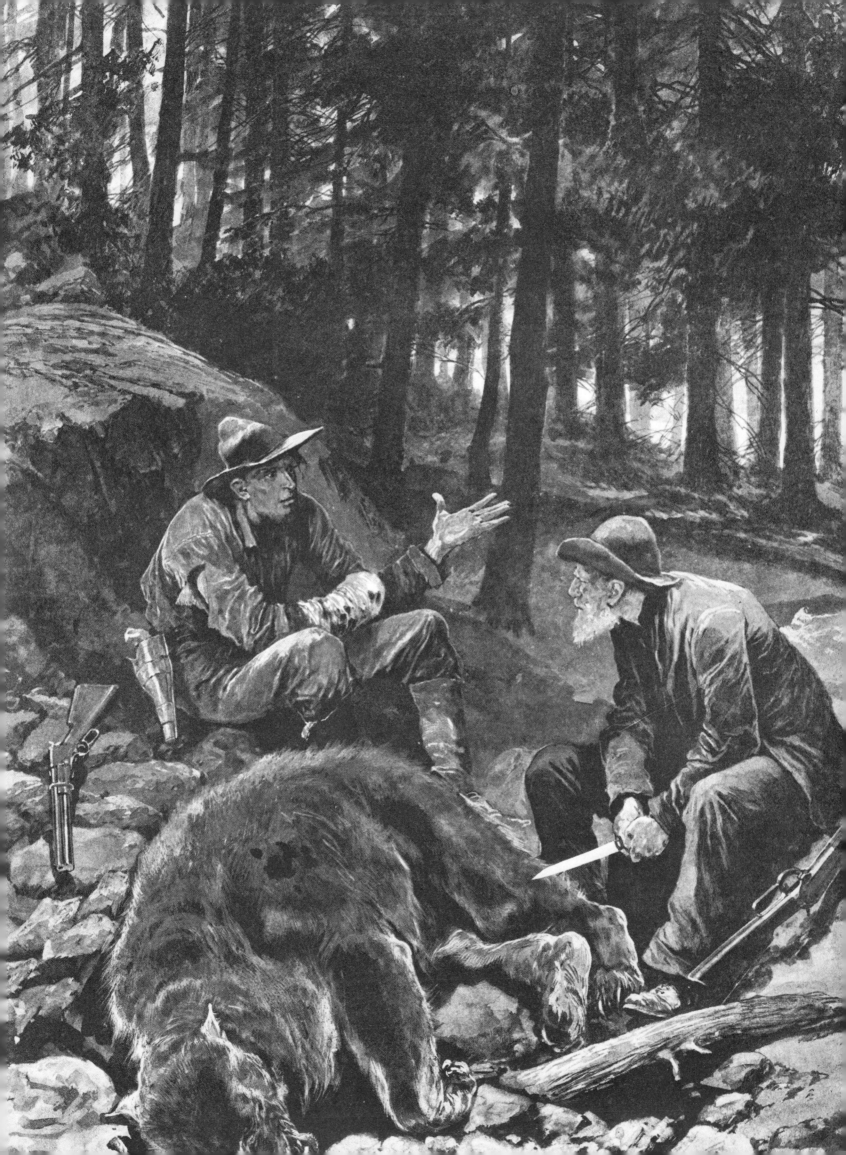

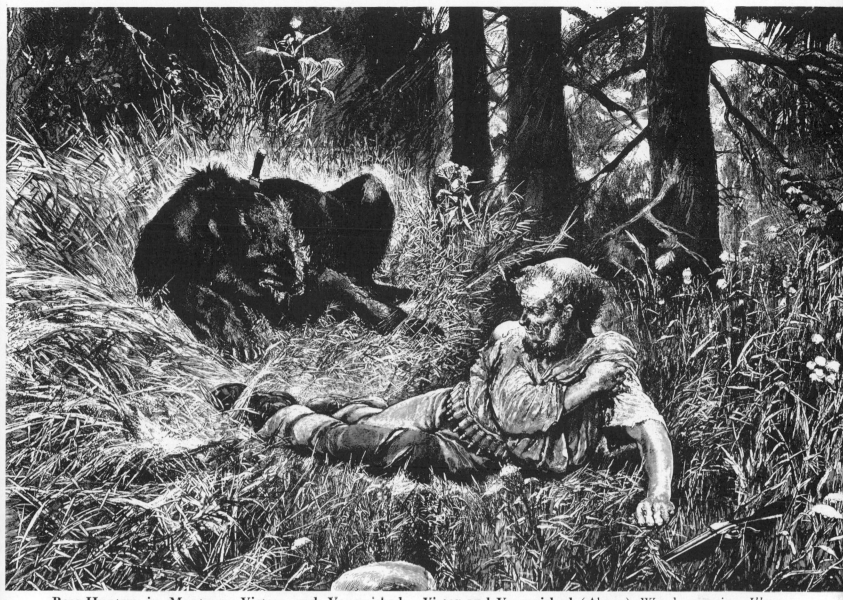

Bear-Hunters in Montana: Victors and Vanquished
(Left). Photomechanical halftone engraving after oil paint-
ing. *Illustrated London News,* January 12, 1895. Sheep and
cattle were easy prey for despotic grizzly bears. So much so
that several western states labeled them dangerous predators
and placed a bounty on their heads to encourage professional
hunters to kill them.

Victor and Vanquished (Above). Wood engraving. *Illus-
trated London News,* September 28, 1895. Woodville cer-
tainly found adventure on his third hunting trip. A tree-
climbing black bear challenged the artist and his guide; a life
and death struggle took place before a knife could be plunged
into the beast's shaggy shoulders.

Forest Fire [in Wyoming] (Left). 4½ x 2¾. Undated. Oil on canvas board. Courtesy Humphrey Caton Woodville.

North American Indians Running Cattle into a Ranch (Above). Wood engraving. *Illustrated London News,* October 3, 1891. A fall roundup in the Big Horn country of Wyoming gave the artist a taste of the ranchman's West. Separating beef cattle for shipment from a bedlam of bellowing cows, bawling calves, and angry bulls was arduous, skilled work. When it was over, shots and shouts started the beef herd on its journey to the nearest railhead on the Northern Pacific. "Only bold and skillful horsemen," wrote Woodville, "as those employed in the work, both white men and their Indian allies, could perform so rude a service."

PINE RIDGE POSTSCRIPT

Woodville was on his way home when he heard of the Ghost Dancers of the Sioux reservations of South Dakota. As a veteran war artist, he smelled powder. He stopped off at Rushville, where he depicted the arrival of an exhausted courier bringing the latest news, possibly of Sitting Bull's death on December 15, 1890. The artist went on to the Pine Ridge agency. Here he witnessed the exodus led by the Oglala chiefs Little Wound, Big Road, and No Water of Big Foot's band of frightened Indians from the agency on December 29 to join Short Bull and Kicking Bear at White Clay Creek.

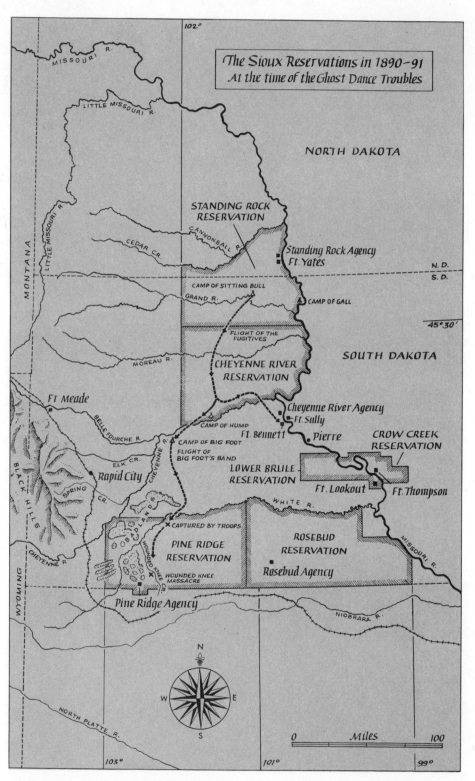

The Sioux Reservations at the Time of the Ghost Dance Troubles. From Ralph K. Andrist, *The Long Death* (New York: The Macmillan Company, 1964). Reproduced by permission of the publisher.

The Indian Rising in America: Latest News! Wood engraving. *Illustrated London News,* January 10, 1891.

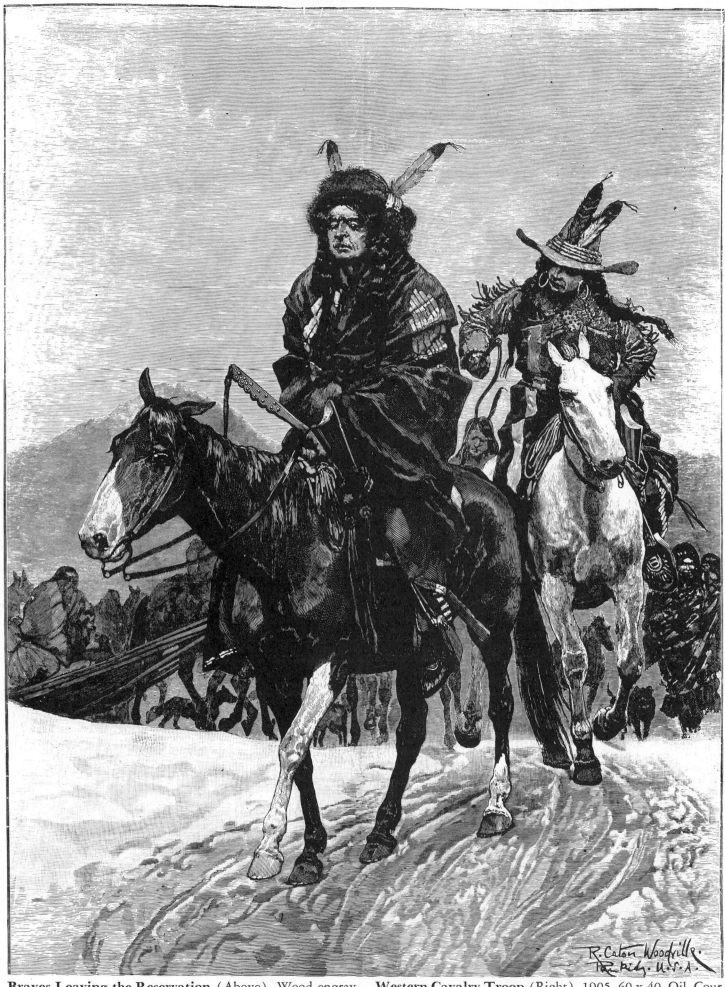

Braves Leaving the Reservation (Above). Wood engraving, *Illustrated London News,* January 17, 1891.

Western Cavalry Troop (Right). 1905. 60 x 40. Oil. Courtesy Trigg–C.M. Russell Foundation, Inc., Great Falls, Montana. Gift of Dr. Franz Stenzel, Portland, Oregon.

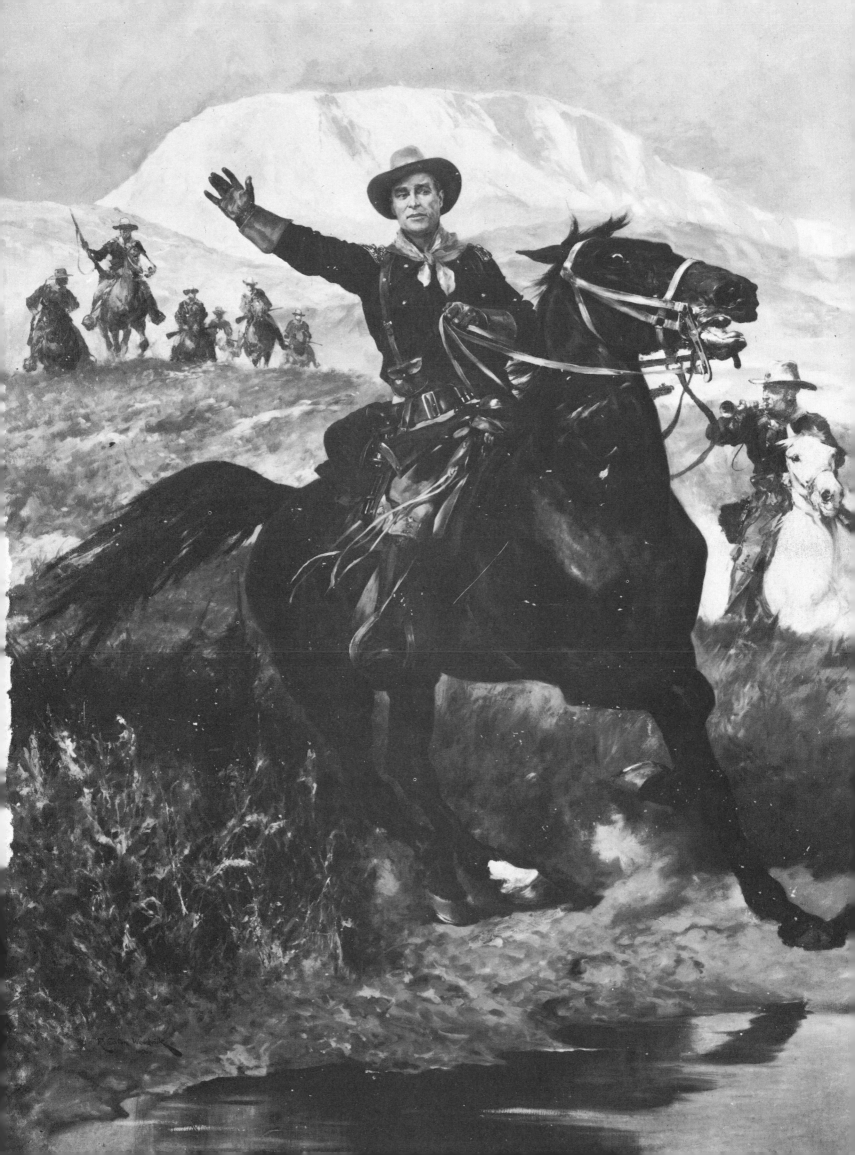

10.
Ho,
for the
Klondike!
Charles
Edwin
Fripp
1898

"It is a truly modern Pilgrim's Progress; it is affecting to contemplate all that has been endured by so many noble fellows, forming . . . the thin end of the wedge of our nineteenth-century civilisation, which borne on the wings of steam and electricity, constructed by the marvellous ingenuity of that high-souled creature Man, is now opening the oyster of the earth for gold . . ." Charles Edwin Fripp (*Graphic,* 1898)

Charles Edwin Fripp (1854–1906). Photograph: *Daily Graphic,* October 6, 1906.

MEN HAD KNOWN THAT there was gold in the Yukon for years, but the Hudson's Bay Company thought fur much more important. At first, rumors that gold did exist brought a trickle of prospectors; but it was not until 1896, when an Irish-American squaw man, George Washington Carmac, locally known as "Siwash George," panned gold out of a stream afterward known as Bonanza that the strike was made which brought on the most extraordinary pilgrimage of modern times.

Every prospector in the Yukon and Alaska rushed to stake a claim. Even a detachment of Mounties joined in. By the end of October, 1897, every yard along Bonanza Creek and neighboring streams had been staked out. Nevertheless, the gold fever spread. Spurred on by the triumphant return home of newly rich prospectors in the treasure ships *Excelsior,* at San Francisco, and *Portland,* at Seattle, in July, 1897—tens of thousands of men and women dropped everything and made for the wilds of northwest Canada! (1)

As the dream of enrichment gathered momentum, it became an obsession tinged with fantasy. The more gullible sought gold dust, which they thought lay on the ground; the more practical, however, sought to profit from supplying vital articles and services. (2) One way or another, everyone believed it was the chance of a lifetime. By the following spring, it was all over; the outbreak of the Spanish-American War caused the gold rush to collapse as suddenly as it had started.

Out of the thousands of men and women who set out on the trails, only a handful reached their objective before the winter freeze. Those who did not had to spend the winter in frontier towns like Skagway, Wrangell, and isolated trading posts like Glenora and Telegraph Creek, waiting for the Yukon River to thaw the following June. Thousands more, despite official warnings to ensure that they had sufficient resources, made frantic efforts to join them. Avalanche, rapids, frostbite, scurvy, starvation, suicide, and insanity would take a heavy toll, but nothing could stop one hundred thousand hopefuls from attempting a wilderness journey a seasoned traveler would think twice about.

As in America, the popular press of Europe had a field day reporting the gold fever. The more responsible journals sought to satisfy the insatiable interest of their readers with more authenticated accounts of high adventure. Just as soon as it became practicable to do so, the *Illustrated London News* and the *Graphic* assigned Specials to join the stampede and send back firsthand pictorial reports. The older paper sent Julius Price, who started out from London in May and traveled to Dawson via the Dyea Trail, the most commonly used route. (3) The *Graphic,* however, was first off the mark in March, and sent Charles Fripp, who traveled as a member of a package tour organized by the Klondike Mining, Trading and Transport Corporation, (4) a British-Canadian venture, which aimed at providing a service from Victoria to Dawson via the Stikine Trail.

The Englishman's report was not complimentary. He was suspicious

1. Pierre Berton, in *The Klondike Fever* (London and New York, 1958), 3:101–3, notes causes for the intensity of the gold-fever could be attributed to the world shortage of gold, which had brought the United States to its knees economically. Gold production had not kept pace with the soaring population and this drop was accentuated by demands from European countries that had adopted the gold standard. Panic came in 1893 as a result of foreign fears that the U.S. could not maintain payments in gold. Conditions, too, he adds, were almost exactly right. The world was at peace, and for six months the Klondike had no rivals for public attention. Rail and water transport had reached a state of efficiency which made it possible to move large masses of people swiftly and inexpensively. Rich men could, in theory, travel all the way by boat, while poor men could speedily reach the passes and travel by foot and homemade boat on a fast current. Moreover, the Pacific ports, hungry for trade, promoted themselves as outfitting posts. Their greatest talking-point was the apparent wealth of the new fields. California, Australia, and South Africa had fields far larger but some of the Klondike claims proved to be richer, even though the area might not be as extensive. Berton, *op. cit.*

2. Eggs, for example, were literally worth their weight in gold. Berton cites a story of a Seattle entrepreneur who reached Dawson City with 2,400 eggs and disposed of them all in less than an hour for $3,600. The man who had dragged a grindstone

over the Chilkoot sharpened miner's picks for an ounce of gold per pick. Yet another, who had brought a boatload of kittens, got an ounce of gold per kitten from lonely miners craving the companionship of a pet. Berton, *op. cit.*, 9:291.

3. See, Julius M. Price, *From Euston to Klondike: The Narrative of a Journey through British Columbia and the North-West Territory in the Summer of 1898* (London, 1898); also, *Illustrated London News*, 113, 1898.

4. This abortive enterprise was an English company, registered on December 11, 1897, in Victoria with a capital of £250,000. The chairman of the board of directors was Sir Charles Tupper, veteran conservative leader and former Prime Minister of Canada. In trading and transportation, the department was headed by Edgar Dewdney, former Indian Commissioner (he had accompanied the Marquis of Lorne on his Western expedition) and recently retired Lieutenant Governor of British Columbia. Late in December, the company began advertising their service as "a great through Water Route from Victoria to Dawson City." Walter N. Sage (ed.), "Record of a Trip to Dawson, 1898: The Diary of John Smith," *British Columbia Historical Quarterly*, 16, January–April, 1952:94.

5. *The Klondike Official Guide,* Introduction: "Railway and Steamboat Communication by an All Canadian Route" (Toronto, Department of the Interior, Dominion of Canada, 1898).

6. These included the two campaigns against the southern African tribes, the Kaffir (1878) and the Zulu (1879); and the Boers in the Transvaal (1881). He had witnessed many horrors on these campaigns, including the terrible aftermath of Isandhlwana, in which the Zulu army wiped out the largest British column, inflicting the worst defeat a modern army had yet suffered at the hands of men without guns. He had also accompanied Lord Wolsey's expedition to relieve the besieged General Gordon at Khartoum (1885) and reported the Chinese-Japanese War (1894–95) and the Matabele War (1896). After the Klondike assignment, he was attached to the U.S. Army and

of the wildly optimistic statements of officials and individuals alike; most of all, those of the Canadian Government itself for stating that arrangements had been completed "to remove the great difficulties which have heretofore stood in the way of travel and transport to the Yukon District." (5) For in reality, thousands ascended the Stikine to find a trail so difficult that only the most intrepid could negotiate it. As only a gold rush could develop such virgin territory quickly, the Canadian Government was naturally not disposed to admit the truth. It was left to Fripp to do so. In eighteen phlegmatic letters, the artist told his readers of the miseries as well as the hilarious difficulties which led to a fruitless climax of finding fifth-rate diggings, or none at all. Profusely illustrated by fifty part-documentary and part-humorous drawings, these letters enlivened the pages of the *Daily Graphic* between April–December, 1898. A further twenty-two illustrations were published in the weekly *Graphic* between April, 1898–April, 1899.

Charles Edwin Fripp had seen much of the world as a Special Artist and war correspondent before he took part in the Trail of '98. Earlier travels, which had taken him throughout Africa and the Far East with various British colonial expeditionary forces, (6) made him a veteran campaigner accustomed to camp life and the handling of guns and animals. He was now forty-four and had held commissioned rank for thirteen years in the Artist Volunteers, a militia regiment commanded by Lord Leighton, President of the Royal Academy.

Fripp began his travels early in childhood in Italy, Switzerland, and Germany. His father, a favored landscape painter of the Victorian era, George Arthur Fripp (1815–96), frequently took his family with him on his search for subjects. At the age of fifteen young Fripp was sent to study at Nuremburg, and later, at the Royal Academy of Munich. (7) His adult life, however, is largely an enigma. References are seldom made to him or his work in the pages of the *Graphic* and the *Daily Graphic* although he was a regular contributor for over twenty-five years. The few existing facts reveal him to have been something of a solitary, soldierlike personality, passionately fond of the outdoor life, although Mrs. Jocelyn M. Ellis, the granddaughter of his younger brother, the noted Canadian painter, Thomas W. Fripp, quotes her mother's description of him as "self-opinionated, cantankerous, and difficult to live with." (8) For most of his life he remained a bachelor; he died at the early age of fifty-two. (9)

If Fripp frankly expressed his distaste for much of what he saw of the Klondike gold rush, he nevertheless relished the adventure. As was usual with the European artist-traveler in North America, his sympathies lay more with the long-suffering Indians, who watched the drama open-mouthed from the sidelines, than with the whites. Prior to leaving for the Klondike, he had been living on and off in western Canada for several years. His first visit to the Dominion was made in the spring of 1889 en route to Japan, and his illustrations and comments on the young

covered the Philippines campaign of the Spanish-American War (1899). Finally, he spent the year 1900 in South Africa covering the Boer War (1898–1902) before returning to Canada.

7. Obituary note, *Daily Graphic,* Friday, October 6, 1906:76. Munich in the 1870's was regarded as the Athens of Germany and, with Düsseldorf and Dresden, shared international fame as a center for the training of artists. It was a firmly classical school, which placed great importance on drawing. A two-year course from the antique was the beginning of a formidable curriculum.

8. Mrs. Thomas W. Fripp, quoted by Mrs. Jocelyne M. Ellis of Pritchard, B.C. in a letter to the author dated December 8, 1969.

9. Charles Edwin Fripp, R.W.S., was born September 4, 1854, at Carlton Hill, London, N.W.6. He died in Montreal on his journey home to England on September 21, 1906. His body was cremated and the ashes buried in the Fripp family vault in Highgate Cemetery, Highgate, London.

10. "The Old and the New North-West," *Graphic,* August 31, 1889: 272.

11. These commenced in February, 1889, before the artist visited Japan, and were continued whenever possible between the artist's commitments as a Special Artist covering the Philippine Campaign of the Spanish-American War (1899–1900). Walter N. Sage (*op. cit.*) cites a report in the Vancouver *Daily News-Advertiser* (February 7, 1889) that the artist made sketches on the Harrison River of Indian trappers and their activities. On his way back East, in the autumn of 1890, Fripp also visited southern Alberta, where he stayed at the ranch of a newly married Canadian friend called "Alec," some forty miles east of the Rockies. See the *Graphic* (1893:79–80) for the artist's light-hearted and entertaining illustrated account entitled "A Logging Trip in Western Canada."

Later excursions included a trip to the Cascade Mountains, and probably the Fraser Valley, a favorite sketching ground of his brother Thomas. Most of these he illustrated with watercolor drawings, ac-

nation's changing frontier were among the earliest promotional features sponsored by the London office of the Canadian Pacific. In the notes accompanying the illustrations, Fripp expressed regret that the old Northwest of the Indian was dying fast, replaced by the new Northwest of the ranchman and the farmer. Change was inevitable, and the region would become one of the most prosperous and flourishing on the great American continent. (10) The majestic valleys of British Columbia, on the other hand, aroused feelings of a more personal nature. Some years previously, his elder brother, the architect Robert MacKay Fripp, had settled in Vancouver. Feeling his age keenly, after many years of travel in the tropics, Charles longed to follow him and live the outdoor life of a country gentleman between his *Graphic* assignments.

With this vision of a new and more agreeable way of life, he returned to England in the autumn of 1890 to persuade his younger brother, Thomas W. Fripp, to join him. The Fripp family was large and their income inadequate; British Columbia was the place to go. The two brothers left England in 1893 and filed a homestead claim near Hatzic, B.C. Here, for several years, Charles endured the hardships of pioneer life to help the newly married Thomas establish a ranch. Ill health, lack of sufficient capital, and wanderlust prevented Charles from ever having his own place, but he indulged his fondness for the outdoor life and made several hunting and sketching expeditions to the Cascade Mountains and the Fraser Valley. (11) Then, probably during January, 1898, William Luson Thomas cabled and asked him to undertake the Klondike assignment.

Fripp sailed for Wrangell on March 3, 1898, aboard the K.M.T. & T. steamer *Amur.* The voyage, which took four days, skirting the rugged coast of British Columbia, caused the artist to reflect on the formidable difficulties of travel in such country. Snow-covered peaks, shimmering inlets, and wreathing vapors were elements of a great and marvelous beauty, but closer acquaintance with the vast fir-clad heights and somber, rockbound shores depressed him, particularly when the gray clouds sank down to discharge rain and snow upon a lowering wilderness of forest, rock, and water. (12)

On landing at the Alaskan port, Fripp found the city bursting at the seams. Stampeders lounged about the wharves, eating-houses, and liquor shops, clad in every kind of heavy clothing and headgear; time weighed heavily on their hands until the weather would permit them to leave for the Stikine River. Along Front Street, he was startled by the apparition of two women pilgrims clad in fur-lined Mackinaw coats, rubber boots, and knickerbockers of voluminous proportions! Not counting a gunfight and falling through a rotten plank on a duck-board footway, no incidents of special note befell the artist in the lurid frontier city. But after a visit to one of Soapy Smith's traps for the unwary, a gambling stew known as "The Club," (13) Fripp concluded that the town was emptying the pockets of those who, "instead of proceeding

companied by notes or articles. The titles are listed in the Annotated Checklist of Watercolor Paintings, Drawings, and Original Illustrations of Western Canada by Charles Edwin Fripp at the back of this book.

12. *Daily Graphic,* April 15, 1898: 4.

13. Jefferson Randolph Smith, better known as Soapy Smith, was a Georgia-born confidence man who ran Skagway and Wrangell from late summer, 1897, until he was shot and killed by a vigilante in July, 1898. See, Berton, *Klondike Fever,* 6:229, *et. al.*

14. *Daily Graphic,* April 18, 1898: 4.

promptly when a favourable opportunity offers, prefer to hang around the luxuries." (14)

Fripp was eager to move on, but nature herself had conspired to thwart the carefully laid plans of Klondike Mining, Trading and Transportation. From January to March, when traveling was supposed to be good, heavy falls of snow and fierce winds made the trail totally useless as a winter route; progress was almost impossible in the lower half of the Stikine River below Glenora. Then, unexpectedly mild weather followed to cause a premature softening of the ice, reducing its surface to a wet, treacherous slush. Glowingly publicized by the outfitting merchants of Victoria and Vancouver as the best "All Canadian Route" and the only practical way to reach the diggings, the Stikine Trail turned out to be the most impractical.

On receiving such an unfavorable report from his agent, C. J. McLennan, Edgar Dewdney, K.M.T. & T.'s transportation director, abruptly decided to completely abandon the project of a winter transportation service. He returned to Victoria with men, horses, and equipment. Fripp and five other passengers, however, had paid their fares ($500.00 each man), and elected to proceed to the edge of the Stikine ice on Cottonwood Island. They were promised K.M.T. & T. facilities, as far as they existed, for making the hundred-and-fifty-mile sleigh trip on the frozen river to Telegraph Creek, where they would have to wait until navigation opened before continuing to Teslin Lake and along the Hootalinqua River and finally up the Yukon to Dawson.

They found the starting point of the Stikine Trail—Cottonwood Island, Alaska—a chaotic scene of feverish activity. Clustered among the severed stumps of what was once a forest of pines were clusters of tents of every size and shape, and huge snow-covered mounds of goods and mining paraphernalia. New arrivals sorted out their belongings, harnessing yapping, quarrelsome sled dogs, or dragging sleds themselves to look for campsites further up the island. McLennan directed the party to stow their gear in a large, circular tent which served as K.M.T. & T. headquarters, before guiding them to a tent restaurant, identified by a chunk of salmon and a deer carcass hung from a nearby bough.

Ravenously hungry, the five companions joined other Klondikers in tucking into enormous plates of venison stew, potatoes, beans, stewed fruit, coffee or tea, bread and butter—which at fifty cents a meal, Fripp thought astonishingly cheap. Another commodious tent served as a hotel; this was considerably less of a bargain, and an uncomfortable first night was spent in a confusion of bedding, blankets, dirty tin cups, and piles of discarded rubbish. The artist was reminded of Kipling's story, "The Drums of the Fore and Aft," in which a mythical regiment camped like pigs. "There are many who travel," he sighed, "there are few who understand how to do so properly or who have any sense of cleanliness and order." But despite the disorder and the intolerable heat of the stove kept up throughout the night by an unfortunate

15. *Op. cit.*, June 28, 1898:4.

stampeder recovering from pleurisy, the artist found it a welcome change from the cramped berth of the *Amur*. (15)

Meanwhile, the population of Cottonwood Island increased daily, as a growing fleet of steamers, boats, and canoes brought hundreds of new arrivals. Soon a further string of encampments began to line the other side of the island. Spring was approaching and the weather was steadily becoming warmer. Drizzle and sleet descended as the men, often with inexperienced hands, harnessed dogs, horses, and bullocks, provoking laughter or blind rage according to the respective viewpoints of spectator or participant.

Most of the animals were new to working on snow. Horses, particularly, were completely demoralized when they sank through the softened crust. "Sleighs," wrote Fripp, "are allowed to run down a slope on the heels of the horse which immediately begins to dance in the loose dragging traces and sit down on the sleigh, if it does not put its hoofs there and scatter goods and sleigh." Stampedes with a general smash-up among the tents became a frequent occurrence. Dogs were even more aggravating, some wriggling out of harness to sit down wagging their tails or to rejoice in this acquired liberty by attacking the nearest comrade with whom they had a standing quarrel. With such clumsy handling, dogs strayed from their owners, running wild about the camps in packs and harassing lone stampeders on the trail like starving wolves.

16. Fripp does not name the five original fare-paying members of the party. But the two who accompanied him from Cottonwood Island he describes as "both English"— "C" from Dorset, and "D," who had sought gold in Australia. A third member of the party, "B," or Bill (the cook), is not mentioned after arrival at Teslin Lake, June 17.

17. *Op. cit.*, July 27, 1898:4.

For two weeks, the continued warm weather made Fripp and his companions postpone their departure for Telegraph Creek. At last, on March 20, a bright, cold night temporarily restored the hard surface of the trail. Three of the party, (16) including Fripp, seized the opportunity to make an early start. "The sun had not risen," he wrote, "above the whitened mountains, and with my legs wrapped in a blanket I sat on the sacks and bags very comfortably, in spite of the chilly air. The horses in excellent condition, trotted easily over the trail, now smooth and hard, refrozen after the late thaw. A few solitary hand sleighers, doggedly tugging along, dotted the broad expanse of river. The sole denizens natural to the whitened wilderness around us, were the ravens hopping about the abandoned camp sites." (17)

At first, traveling was easy. Three hours later, the companions made Porcupine Point, fifteen miles from Cottonwood Island. But the sun was already softening the surface, and they had to wait until night when the frost would harden it again. After a midnight supper of beans and bacon, and a short sleep, the journey was resumed; the glare of northern lights flared up as they passed silently through the awesome mountains, which loomed above like enormous, threatening shadows. A further fifteen miles brought them to the boundary line between Alaska and British Columbia. Here, sleighs were left in line for Canadian customs inspection while the weary travelers slipped into their sleeping bags for a much needed sleep in the K.M.T. & T. tent at the post.

Gradually the ten-day journey up the frozen Stikine became increasingly arduous. Sometimes, it took a day to move even five miles on the punctured ice, which covered one of the most dangerous torrents in the Yukon. Only half-loads could be taken on the sleighs. Even so, men and their outfits disappeared through the brittle ice and drowned in the icy waters. The artist himself had a narrow escape when he suddenly fell through; fortunately, by flinging himself forward, he was able to scramble out. On another occasion, he suffered from a temporary loss of sight from snow-blindness.

The indomitable artist was seldom short of subject matter. When not rendering the towering mountainscape, he was observing comic and tragic incidents on the trail. The extraordinary variety of sleighs and sleds of the Klondikers intrigued him. They were pulled by men, horses, bullocks, goats, and dogs—and even by women in bloomers. It was reserved as a special attraction one day to witness a complete novelty: a sleigh drawn by a horse in bloomers! "The poor brute," wrote Fripp, "had hurt itself on the ice, and had been humanely treated to a pair of sacks to shield the injured limbs." (18)

18. *Op. cit.,* August 8, 1898:5. Illustrated by three-column line drawings: *Rival Bloomers.*

Man's inhumanity to his sometimes delinquent animal friends provided the theme of two further drawings, entitled *How the Friend of Man is Treated on the Stikine River.* The savage, thought the artist, was bad enough, although to be just, the punishment given by the Indian to the poor sled dog was largely confined to mittens and moccasins. Civilized man, represented by the Klondiker, used nailed boots and heavy sticks applied with a vigor which made it surprising that the animal did not give up the ghost altogether. (19)

19. *Op. cit.,* July 27, 1898:4. See also, two three-column line drawings: *The Savage is Bad Enough— But the Civilised Man is Worse.*

But man himself could also earn the artist's sympathy. Like the strange old frontiersman he glimpsed holding a light branch with a line frozen as thick as the stick itself above a hole in the ice. The bait used was a stream of tobacco juice squirted, with a facility peculiar to adept Americans, at long range to attract the fish. The artist concluded that the Waltonian enthusiast sought consolation in misery, as some seek greatness. (Izaak Walton, 1593–1683, British writer and fisherman.)

Others, however, had misery thrust upon them. Like the man who was seen one evening on the trail crouching among the dung and litter with two horses in a hollow shoveled out of the snowbank, trying to warm himself with a bull's-eye lantern under two wet blankets. "The poor fellow's sleigh," Fripp wrote, "had been in the water, and he was too dead tired to make a fire. But our cook Bill, a good-natured fellow, taking no notice of his sourness, prevailed upon him to accept assistance and returned him to some better view of life in this world." (20)

20. *Op. cit.,* August 8, 1898:5.

Some days later, the party reached Glenora, at the head of the Stikine. The old Hudson's Bay trading post had slumbered since the Stikine gold rush of 1862. Now it swarmed with stampeders. On March 31, Fripp and his companions finally arrived at their objective, Telegraph Creek, only to discover that the worst was yet to come!

21. *Klondike Official Guide*, Introduction.

22. *Daily Graphic*, October 6, 1898:4.

Fripp now publicly condemned the route as "a dismal failure," quoting relevant passages from the Klondike Official Guide, (21) and matching them with the stark realities. At this stage of the journey, a wagon road was supposed to lead from Telegraph Creek to Teslin Lake, one hundred and fifty miles distant. But Fripp and his companions found only a narrow trail, leading up to a ravine so narrow that ordinary horse sleighs had to be cut down in width, and so steep that only small loads could taken. "It was," he wrote, "a mere track in the snow—not for 150 miles but for 180 miles—to Teslin Lake, winding about through scrub and timber, up and down hills, over snow drifts, swamps and lakes. This track, known as the trail, was so far from being a road that sleighs had to be unloaded and goods packed on men's backs." (22)

Drizzly rain steadily reduced the country to one vast quagmire of melting snow, adding to the ordeal. Half of those who had come so far lost heart and turned back. The rest pushed on, mud-bespattered, divesting themselves of everything but a minimum of food and equipment. One thousand four hundred feet above the Stikine Valley the rugged, tortuous trail was littered with sacks of sugar, discarded clothing, broken sleds, and the rotted carcasses of dogs and horses. Food became scarce and some members of the party started taking whatever they could pick up along the trail. The artist reached Teslin Lake on June 17, angrily noting that all of his treasured delicacies, which included preserved fruit, vegetables, soup, and milk, not to mention curry powder and a favorite folding lantern, had been "rustled." But he bore such losses with dignity, losing none of his determination.

Once over the pass, the stampeders either had to face the exasperating chore of whipsawing green timber in the fir-clad hills above Chismaina and Long lakes or buy a flat-bottomed boat, or scow, that would carry them and their outfits the remaining six hundred and fifty miles to Dawson. The average stampeder had no choice, but thanks to the *Daily Graphic* expense account Fripp immediately purchased one of the ready-made boats stockpiled by an enterprising sawmill.

It was a bright summer day when they set sail, and for two days the trio sailed or rowed down Lake Teslin and Hootalinqua River. But despite idyllic surroundings, mosquitoes made life a misery; as soon as they stepped ashore to make camp, great clouds of the insects would descend in bloodthirsty onslaughts. Contrivances of netting were hastily erected but were not always effective. The artist, having experienced many such attacks before, had brought along a headpiece of metal wire mesh; an important item in a Special Artist's equipment. Winged pests of every kind buzzed and crawled over the wire in frustration, vainly seeking entry. Although not anything like as bad as the mosquitoes of China and India, their "music" was nevertheless sufficient to chase away much-needed sleep. This additional problem was solved by placing a large colored handkerchief over the mask, deadening both noise and the daylight which now endured for twenty-four hours.

23. *Op. cit.,* October 11, 1898:5.

On reaching the Hootalinqua, the present Teslin River, the party gathered speed down the broad channel linking lake and river. Osprey nests were seen in the willows and a pair soared about overheard. "It seemed as if the birds watched as sentinels of the stream we were about to enter, leading through the wilderness." (23)

So far, Fripp had seen scarcely any bird life on the lake, but here at the entrance to the Hootalinqua the skies were full of them. Ducks scattered over the shining water and loons gave their deep call before they dived out of sight. Tens of thousands of sand martins, whose holes could be seen in the towering bluffs, darted about, amidst the chatter of numerous other small birds in the willow scrub. Just as they were looking out for a spot to camp, the artist caught sight of wild geese and shot a couple with his rifle to supplement the rancid bacon they had eaten for weeks.

After leaving the mountain lakes, the pace quickened again. Soon Fripp and his companions found themselves moving toward their objective with exhilarating speed along a succession of fast-flowing currents: first the Hootalinqua, then the Lewes, and finally the Yukon River itself. Then the last obstacle, the Five Fingers Rapids, (24) presented itself with little warning on June 29. Fortunately, the party had caught sight of a board inscribed "Rappids" before they were swept into the swirling waters. Fripp felt grateful to the man who put up the sign, but he would have been even more grateful if the mispelled warning had been placed a quarter of a mile further upstream! "The water rushed suddenly in a wave," he wrote, "our ears were filled with the rush of tumultuous waters. As the boat made the plunge to be lifted on the foaming crests of a succession of short waves a few hasty strokes were necessary to keep her end on, but beyond taking some water in over the bows, we rode over safely . . . rejoicing at our successful experience of the only bad water on our journey." (25)

24. John Smith, another English pilgrim of the Stikine Trail, described the Five Fingers, or Rink Rapids, as four huge rocks, some 100 or more feet high. They stood in the bed of the Lewes River, breaking it up into five swirling channels. The right-hand channel being the only navigable one. Smith did not think it dangerous if the boat were kept well in the middle and allowed to take the dip as slowly as possible. Nevertheless, in less expert hands, many boats capsized. Sage, *op. cit.,* 94.

25. *Daily Graphic,* October 12, 1898:11.

After the junction of the Pelly and Lewes rivers just above Fort Selkirk, the journey down the Yukon to Dawson assumed all the characteristics of a fantastic procession. Boatloads of men from every route—the Dyea, Skagway, and Edmonton trails—joined the pilgrims of the Stikine to swell what was now the mainstream of the stampede. For hundreds of miles, the once empty, silent river was crowded with boats of every size and shape, heavily laden with men, animals, and supplies. Fripp was moved to describe the spectacle as "a truly modern Pilgrim's Progress." (26)

26. *Op. cit.,* October 19, 1898:4.

Then, at long last, shortly before noon on July 3, three months to a day since they had left Victoria, Fripp and his comrades swept around the rocky bluff and saw before them the city that had been so much a part of their thoughts. Beyond a broad spit where the waters of the Klondike rushed into the Yukon rose a mountain. At its feet lay Dawson, a phantasmagoria of tents, shacks, and false-fronted buildings, fringed by a huge armada of boats clustered along the waterfront.

Several days in the city of gold provided Fripp with food for further thoughts on the gold rush as well as subjects for his facile pen. It did not take him long to realize that the stampeders of '98 had lost the race by a very large margin. The best ground had long since been pegged out, as one sourdough put it, "up to the tops of the hills!" He disputed too, the richness of the claims; the general verdict of the miners he talked to was that gold had been found in rich streaks but only in a few places in proportion to the area worked. He quoted the opinion of a group of Australian miners whose experience was not limited to North America, who ranked the Klondike as "fifth-rate diggings."

Nevertheless, there were those for whom the pay dirt was rich. Seldom, however, was their hard-won good fortune applied to any purpose more elevating than impressing their comrades with tall tales of the trail and offering unlimited hospitality. Round after round of whisky was bought for friend and foe alike, until a poke of gold was gone! The process would repeat itself a few days later.

Added to the activities of the saloon-keepers and the gamblers were those of the dance-hall hostesses and the gaudy females of Paradise Alley. After all the hardships the stampeders had gone through, the Englishman was bewildered by such prodigality. He seemed not to realize that for many the Klondike was a leave of absence from the isolation of prairie life, or from the prisonlike conditions of an office or factory; it was an escape from every kind of failure to adjust to an increasingly mechanical age; an escape to the freedom of the wild and woolly frontier adventure that everyone had long been waiting for.

Not knowing the frontier towns of the United States, Fripp did not have much of a yardstick to measure Dawson by. Thanks to the Mounties, it was probably the most law-abiding of them all. Nevertheless, it depressed him to see men drinking away their hard-earned gold dust instead of using it to "better themselves," not to mention the bad example this behavior set to the unhappy heathens still groping in darkness. (27)

Actual physical darkness, on the other hand, was unknown in Dawson. With daylight prolonged through all twenty-four hours, Fripp found sleep impossible. No sooner had he retired just before midnight on July 3, when he was rudely awakened by a pistol shot, followed by others in rapid succession. "Goodness!" he exclaimed in his diary, "here's a mining row, that'll be something for the *Daily Graphic*!" Then from Dawson and Klondike City came a general crackle of fire-arms, increasing in intensity, "like the commencement of infantry manoeuvres at Aldershot." It then dawned on him that it must be the Fourth of July and that almost everyone must be a Yankee! He was not to know until later that Dominion Day was being celebrated too, the Mounties having tactfully decreed that both be celebrated on the same day.

The longer Fripp remained in Dawson, the more he seemed to regret that for him the adventure was over. He lamented the disappearance of

27. *Op. cit.,* November 5, 1898:4.

the snow and ice which added dignity to mountains and lent piquancy and enchantment to the dark forests. There were also the sleighs, the dog teams, and the winter attire of the men, which constantly delighted his sense of the picturesque. But now, with the advent of summer, he thought that the white pioneers of the Yukon offered no comparable artistic delicacies to charm the eye.

He compared the winter clothing of the stampeders to that of the butterfly in summer. "One should," he concluded, "be able to realise that spring and summer, which transforms the sombre garb as it discards the wrappings into a gorgeous butterfly, has in these regions a contrary effect upon man, who on shedding his picturesque winter clothing exposes only the grub, the 'gold grub' in all the prosaic ungainliness of late nineteenth century attire." (28)

28. *Op. cit.,* November 9, 1898:10.

Back in the civilized world, the Klondike story began to recede rapidly in importance. After Dewey's crushing victory over the Spanish fleet at Manila, and the sensational defeats of the British Army in South Africa, editors called home their reporters and sent them to Cuba, the Philippines, and South Africa. Fripp quickly made preparations to leave. He booked a passage on the steamboat *W. K. Merwyn,* which took him up the Yukon to St. Michael. At the tiny Alaskan port on the Bering Sea, he changed to the *Humboldt,* which returned him to Victoria, and his home at Enderly, near Vancouver.

The West Fripp loved had little in common with an age which had devoted itself to the art of making money. Again, it was the unspoiled wilderness, with its roaming bands of Indian trappers and fishermen (overlooking that they, too, had been corrupted by the gold rush) that fascinated him. "The flow of gold-mad adventurers to the Yukon would," Fripp thought, "soon dwindle. Then there would be little to disturb the rugged raven whose coarse cry mingles in weird harmony with the wind sighing among the yellow and purple flowers covering the thick soft moss below; and the grey clouds and mists wreathing across the snow-patched mountain and dulling the sheen of the inland waters, will no longer look down upon the feverish activities of the restless gold-greedy white man." (29)

29. *Op. cit.,* December 14, 1898:9.

And dwindle they did. The bubble burst. Most sold their claims to companies which sent up dredges and introduced less haphazard techniques of gold recovery. But other sources of wealth lay beneath the surface, and those unable to establish claims on the Klondike spread over the vast territory of Alaska and the Yukon. Many would turn to other occupations. Thus, stampeders and their descendants became the principal factor in the settlement and development of the last great frontier.

FRIPP'S
FIRST
LOOK WEST

Fripp got his first good look at Canada's boundless West in the Spring of 1889 when he made a pictorial report along the line of the newly completed Canadian Pacific. White settlement was rolling over the richest lands, and the Indian was being crowded out by ranchers and by squatting homesteaders. "Where the redskin wigwam once formed the only human habitation," he wrote, "straggling villages and busy townships have now sprung up, and the old warrior chiefs and their devoted squaws have been replaced by the sturdy but more commonplace British settler and his no less hard working helpmeet." Fripp went back again in 1892 to indulge his fondness for hunting in the Cascade Mountains and the Fraser Valley of British Columbia.

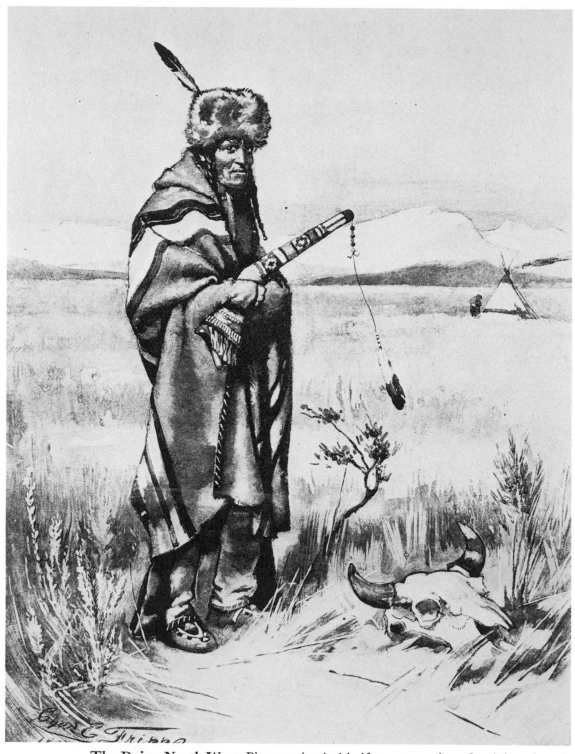

The Dying North-West. Photomechanical halftone engraving after ink and wash drawing. *Graphic,* August 31, 1889.

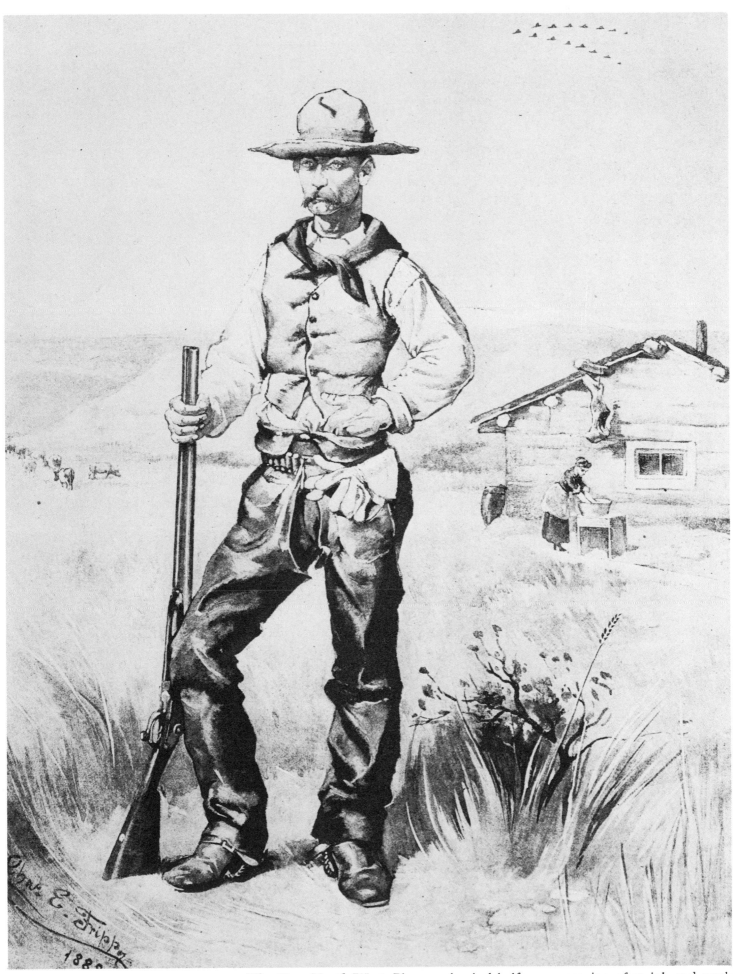

The New North-West. Photomechanical halftone engraving after ink and wash drawing. *Graphic,* August 31, 1889.

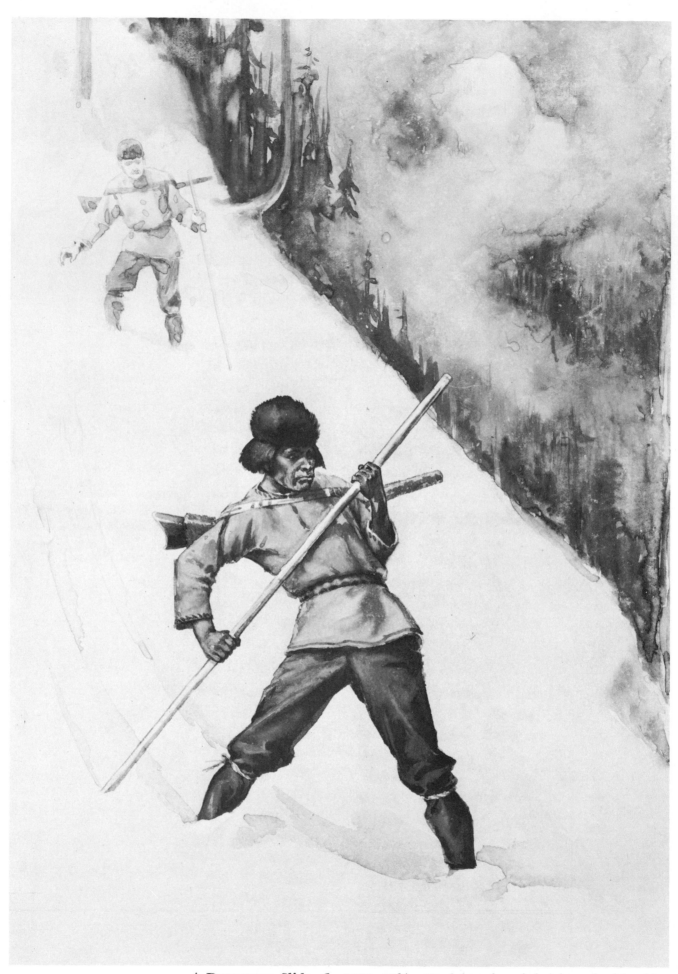

A Dangerous Slide. *Ca.* 1892. 18¾ x 13. Ink and wash heightened with white.
Graphic, April 8, 1893. Courtesy McCord Museum, McGill University, Montreal.

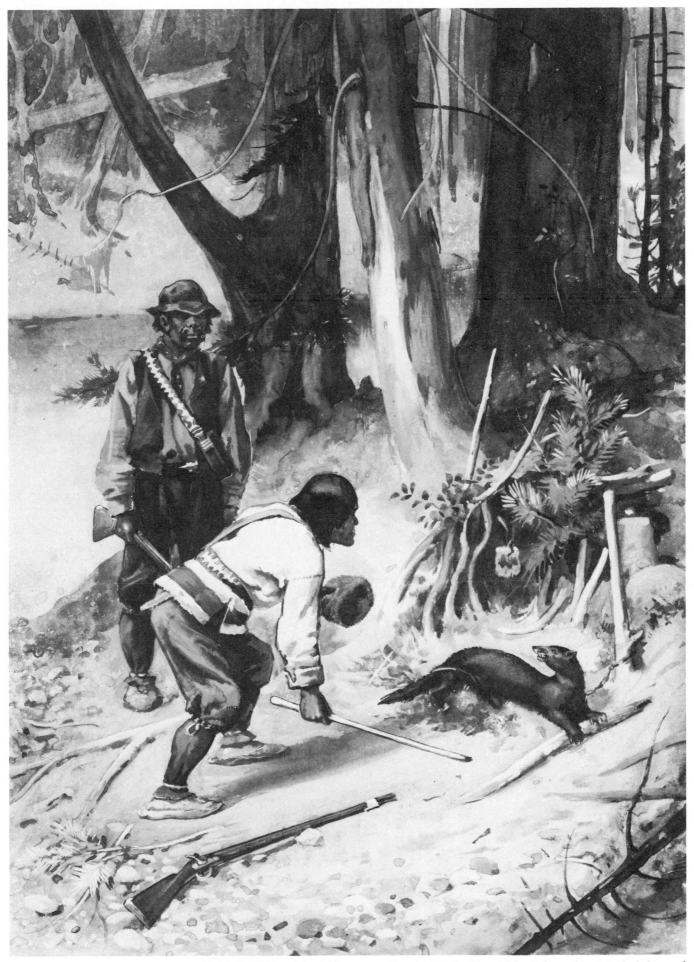

British Columbia Trappers. *Ca.* 1892. 13½ x 9¼. Ink and wash heightened with white. *Graphic,* April 8, 1893. Courtesy McCord Museum, McGill University, Montreal.

THE TRAIL OF '98

The Victorian Age was drawing to a close when Fripp was asked to cover the Klondike gold rush for the London *Graphic* and *Daily Graphic*. It was an assignment he would remember for the rest of his life. During the epic six-month journey from Victoria, British Columbia, to Dawson City and back via Alaska, he traveled over 6,000 miles to report on what had been publicized as the best and "All Canadian Route." In fact, Fripp found little or no trail at all. Although critical to the point of indignation, his pictorial report is laced with humor and compassion.

Editor's Note: The original spelling of Klondike as it appeared in the titles of Fripp's drawings for the *Graphic* and *Daily Graphic* has been retained throughout.

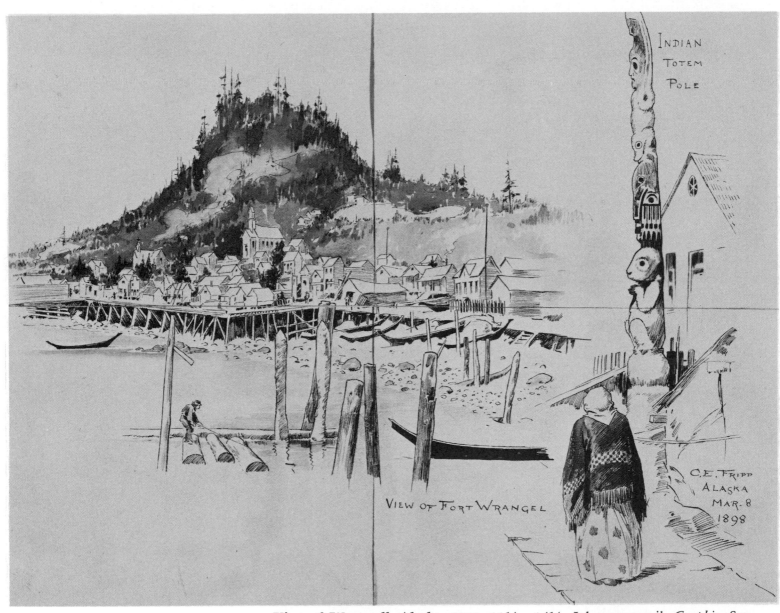

View of Wrangell, Alaska. 1898. 11½ x 14½. Ink over pencil. *Graphic,* September 3, 1898. Courtesy McCord Museum, McGill University, Montreal. The Stikine Trail started in United States territory at Wrangell, Alaska, on the mouth of the Stikine River. The town itself had a lurid history from earlier gold rushes. Fripp thought it picturesque and still faintly Russian, embellished with totem poles and old Indian houses.

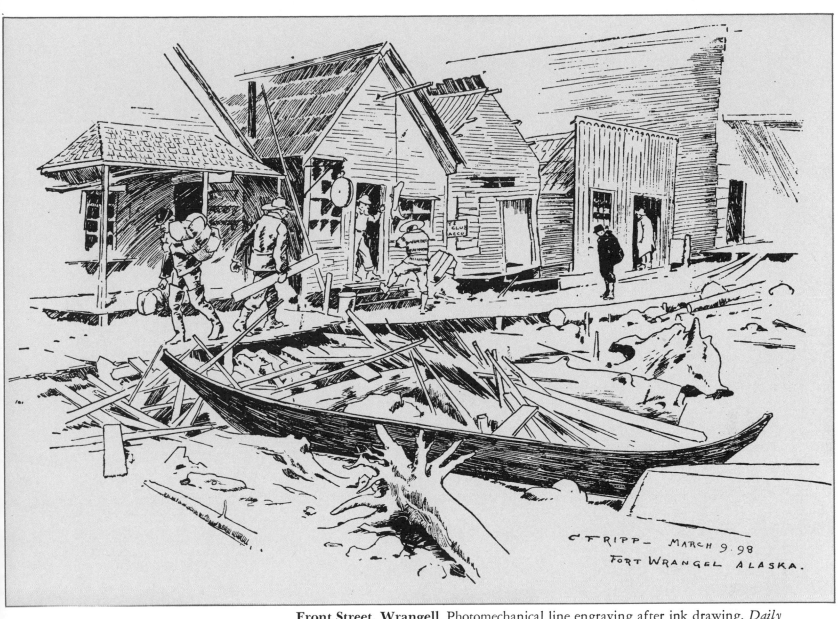

Within the image: C FRIPP — MARCH 9.98
FORT WRANGEL ALASKA.

Front Street, Wrangell. Photomechanical line engraving after ink drawing. *Daily Graphic,* April 18, 1898. Wrangell had revived on the mass influx of Klondikers who hung around the gambling saloons, liquor shops, and bawdy houses waiting for colder weather to harden the surface of the trail. Fripp looked in on a roulette game at "The Club" on Front Street, to see some action, but all he found was a huge billboard of Gladstone, behind the croupier. "The association of the vulgar-looking faces," he wrote, "with the refined head of the venerable politician was absurdly incongruous."

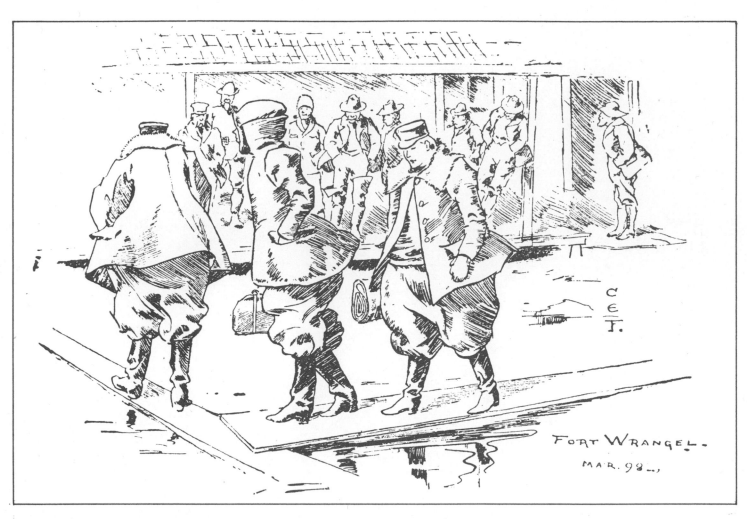

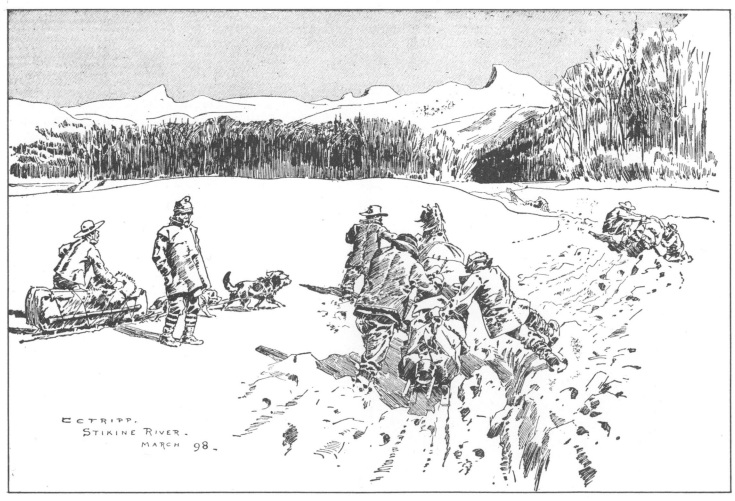

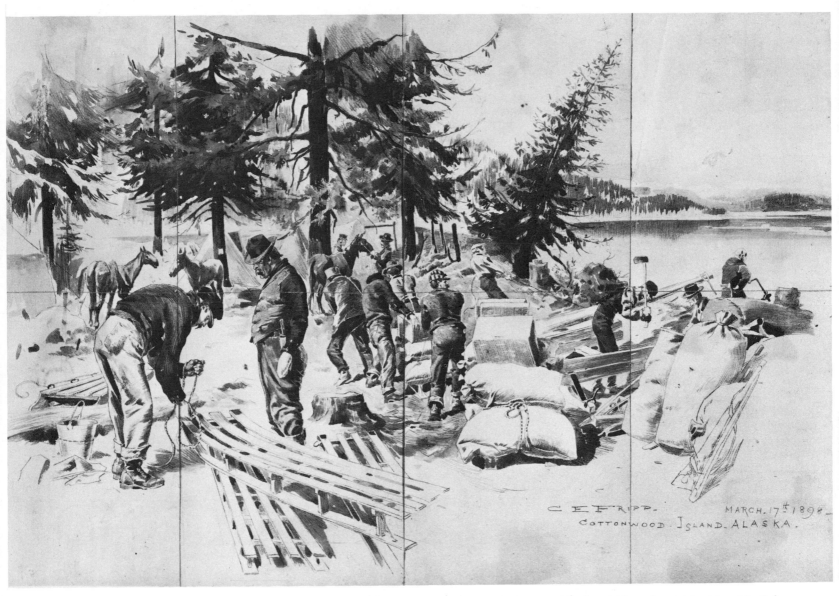

Bloomers for Klondyke (Above Left). Photomechanical line engraving after ink drawing. *Daily Graphic,* April 18, 1898. Further along Front Street, Fripp was startled by a trio of strange-looking figures picking their way along the planks laid over the slush. "They were," he wrote, "those of women clad in costumes of fur-lined duck, rubber boots, and—ahem! —breeches or Knickerbockers of voluminous proportions: not elegant I fancy, but practical enough for rough camp life."

Cottonwood Island, Alaska (Above). 1898. 13 x 19. Ink over pencil. Courtesy McCord Museum, McGill University, Montreal. *Graphic,* April 27, 1898. Fripp and his companions were taken by the steamer *Louise* to Cottonwood Island, six miles from Wrangell at the mouth of the Stikine River. Here, among mounting piles of equipment, sleighs, and animals, they sorted out their belongings and waited for the first opportunity to start up the frozen river.

Helping an Overladen Sleigh through a Snowdrift (Left). Photomechanical line engraving after ink drawing. *Daily Graphic,* July 27, 1898. Over more difficult parts of the trail, the rate of the slowest was sometimes the rate of all. Here, an inexpert Klondiker with a half-starved horse and overladen sleigh had to be helped out in order to clear the way. Fripp (on the left in woolen cap and striped socks) waited with Bill the cook for his two companions to finish the job, recalling the assurances he had been given in Victoria that the Stikine Trail was undoubtedly the easiest route to Dawson. "In common with other town dwellers of Puget Sound," he raged, "they know as much about taking horses and supplies up the frozen river as the average Londoner."

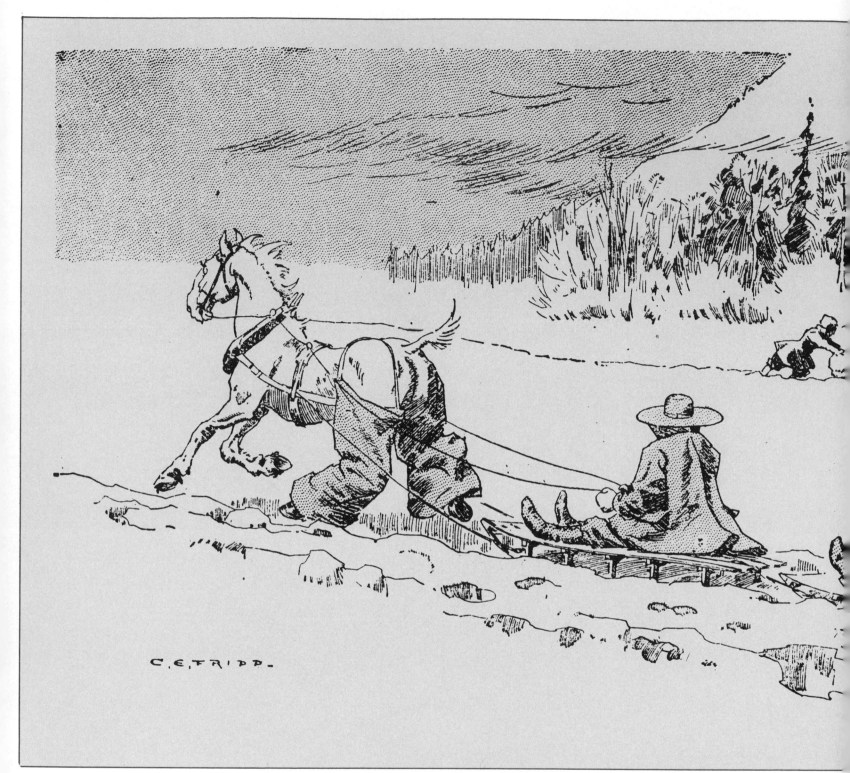

On the Frozen Stikine River: Rival Bloomers. Photomechanical line engraving after ink drawing. *Daily Graphic,* August 8, 1898. One Klondiker had proved himself an exception and had treated his horse to a pair of sacks to shield its injured limbs. "We have," wrote Fripp, "seen sleighs drawn by men, horses, bullocks, goats, dogs, and women in bloomers, but it was reserved for this day to witness a complete novelty, namely, a sleigh drawn by a horse in bloomers!"

Settling a Small Dispute. Photomechanical line engraving after ink drawing. *Daily Graphic,* July 27, 1898. The difficulties of struggling along a trail punched full of holes from overuse in soft weather inevitably strained the tempers of stampeders. "We now had to witness," wrote Fripp, "the sad spectacle of an infuriated man, chasing a bosom friend round his tent with an axe while a third man of the party rushed after him to mollify him."

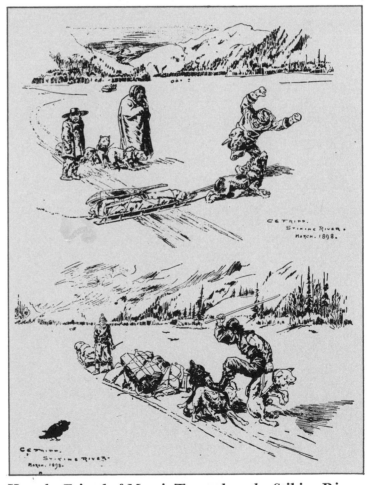

How the Friend of Man is Treated on the Stikine River: The Savage is Bad Enough—But the Civilised Man is Worse. Photomechanical line engraving after ink drawing. *Daily Graphic,* July 27, 1898. Animals were blamed for every misdemeanor and savagely beaten by irate stampeders. "Friendship with that noble creature Man is a very one-sided affair on the Stikine River," wrote Fripp.

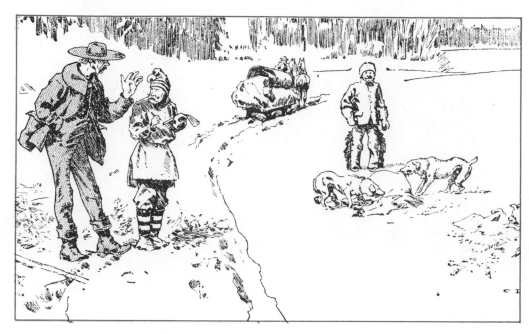

The Owner of a Departed Horse Offers a Few Reminiscences. Photomechanical line engraving after ink drawing. *Daily Graphic,* August 8, 1898. Coping with the curious was all in a day's work for a Special Artist. Fripp (left) had found a dead horse being torn to pieces by coyotes, and was busily making a sketch. Unfortunately, the owner made an appearance, looking closely over the artist's shoulder to comment and talk at great length about the virtues of his late departed friend.

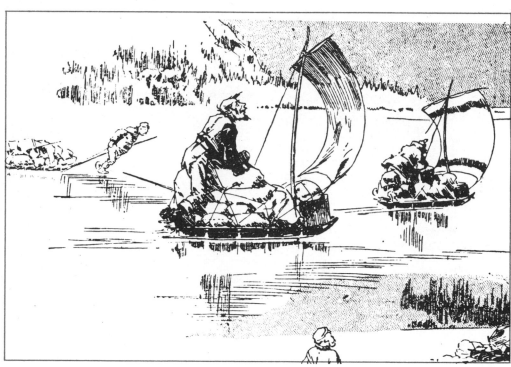

Rival Sleighs on the Frozen Stikine River: The Tortoise and the Hares. Photomechanical line engraving after ink drawing. *Daily Graphic,* August 20, 1898. Anxious to make up for lost time, many Klondikers took advantage of strong winds by fixing sails of canvas or tarpaulin to their overladen sleighs. But many came to grief when they were unable to lower sail before running into snowdrifts, with disastrous results.

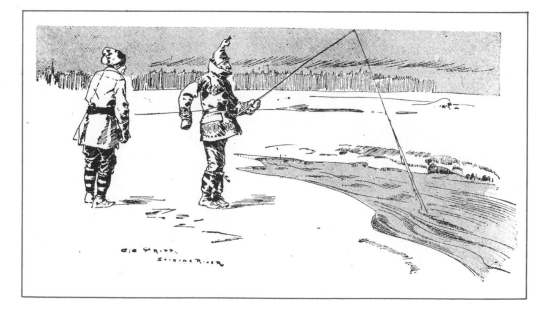

A Disciple of Isaak Walton: The Complete Angler on the Stikine River. Photomechanical line engraving after pen drawing. *Daily Graphic,* August 8, 1898. Frostbite and starvation claimed their victims among the less experienced Klondikers. Few were used to such conditions. Their courage went when their heavily-laden sleighs plunged into the icy river. Fripp (left) encountered this unfortunate, standing motionless, holding a branch with a frozen line.

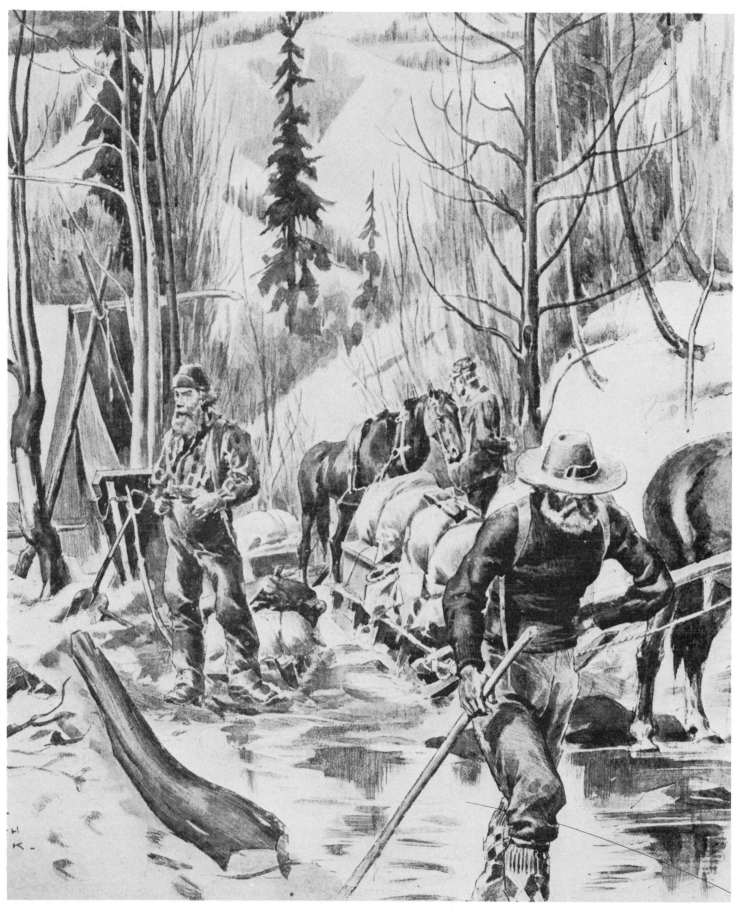

Mounting the Summit of the Divide Above Telegraph Creek, Stikine River.
Photomechanical halftone engraving after ink and pencil drawing. *Graphic*,
August 27, 1898. After completing their journey on the ice of the Stikine River
to Telegraph Creek, the Klondikers climbed the rugged, precipitous trail to the
Little Tahltan River and Teslin Lake. Nine miles up, Fripp paused at the summit
to depict the scene, and to write in awe of the "grand expanse of snowy wilderness"
below. The party was 2,000 feet up and 1,400 feet above the Stikine Valley.
"Silvery vapours were rising," he added, "spreading over light clouds drifting in
the blue sky above the white peaks of mounted ridges."

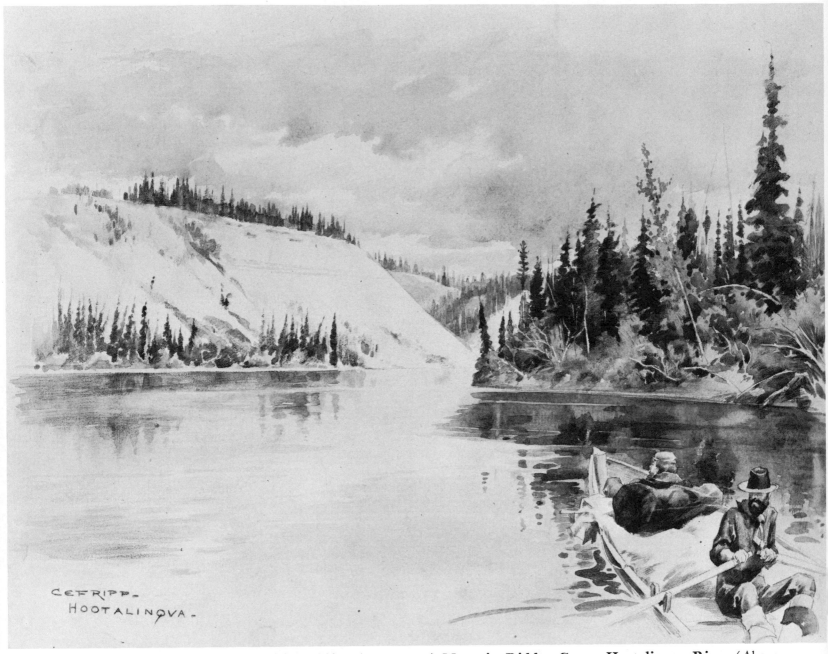

Prospectors on the Hootalinqua River (Above). 1898. 10 x 13. Ink wash over pencil. *Graphic,* December 24, 1898. Courtesy McCord Museum, McGill University, Montreal. Fripp purchased a boat at Lake Teslin and continued up the lake and the Hootalinqua (Teslin) River.

A Mosquito-Ridden Camp, Hootalinqua River (Above Right). Photomechanical line engraving after ink drawing. *Daily Graphic,* October 11, 1898. Mosquitoes made life difficult, but Fripp thought the bite of Yukon mosquitoes nothing like those of China, India, or even British Columbia.

Preparing a Feast (Right). Photomechanical line engraving after ink drawing. *Daily Graphic,* October 11, 1898. "The soup turned," wrote the artist, "the bacon was burnt up, and the bread suffered from someone's heavy boots. But this did not affect our appetites nor our spirits."

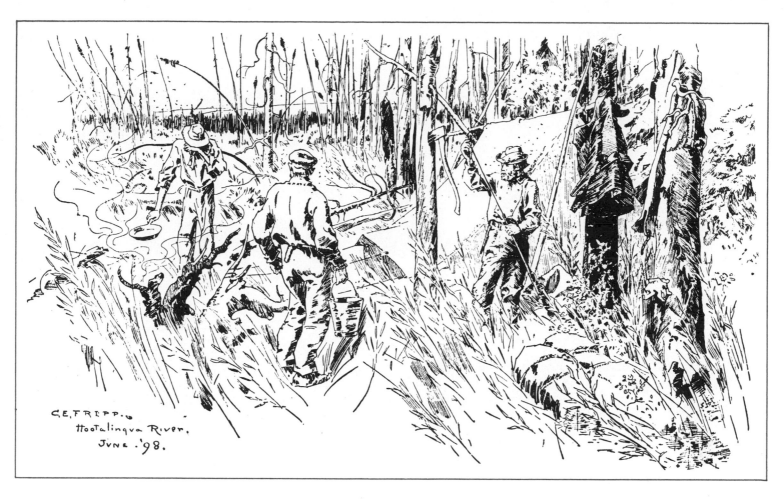

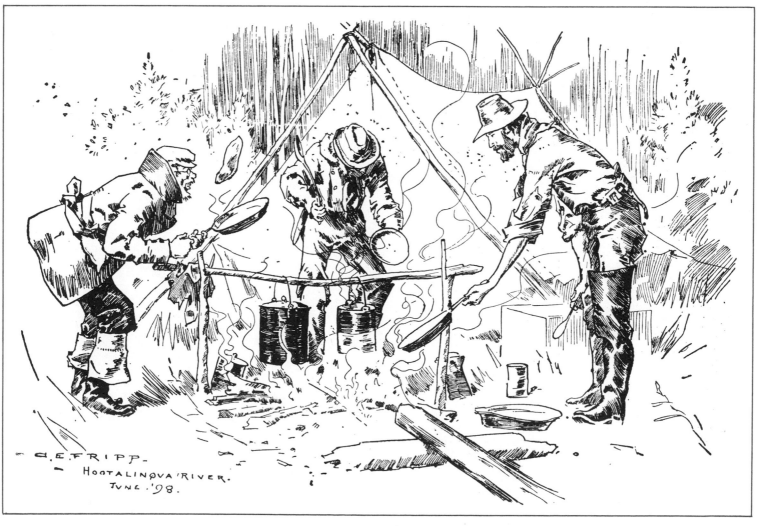

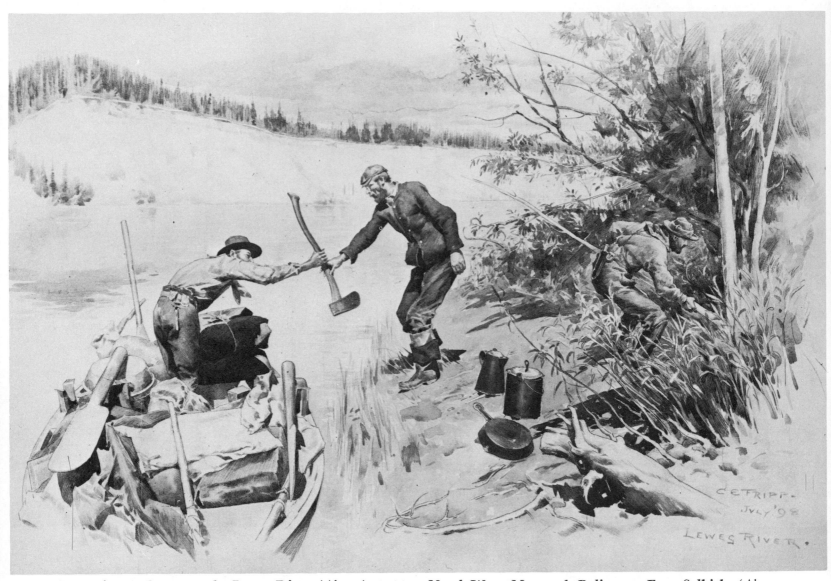

Preparing to Camp on the Lewes River (Above). 1898. 13 x 19½. Ink wash over pencil. *Graphic,* January 7, 1899. Courtesy Centennial Museum, Vancouver. After their arrival at Teslin Lake, Fripp and his companions accomplished the rest of their journey to Dawson by water. At first, progress was slow. Laden with 1,000 pounds of baggage and provisions it became impossible, because there was no current, to pull against a head wind on the Lake. On the Hootalinqua (Teslin) and Lewes rivers, however, they found the current too strong to be pleasant. When the day's journey was done there was more work to do; a camping ground had to be found and prepared. The artist depicts himself (right) clearing undergrowth for space to pitch a tent.

North-West Mounted Police at Fort Selkirk (Above Right). Photomechanical line engraving after ink drawing. *Daily Graphic,* October 12, 1898. Fort Selkirk, a Hudson's Bay Company post since 1848, was used by the Northwest Mounted Police to keep a fatherly eye on the Klondikers.

The Modern Pilgrim's Progress: Down the Yukon to Dawson City (Right). Photomechanical line engraving from an ink drawing. *Daily Graphic,* October 19, 1898. The once silent and empty Yukon River now became the mainstream of the stampede. Men frozen in for the winter along every trail which led to the great river were now on the move. With a touch of irony, Fripp was moved to describe the spectacle as a "modern Pilgrim's Progress." Boats of every size and shape—large sidewheelers, junks, skiffs, canoes, tiny coffin-shaped boxes—floated lazily downstream.

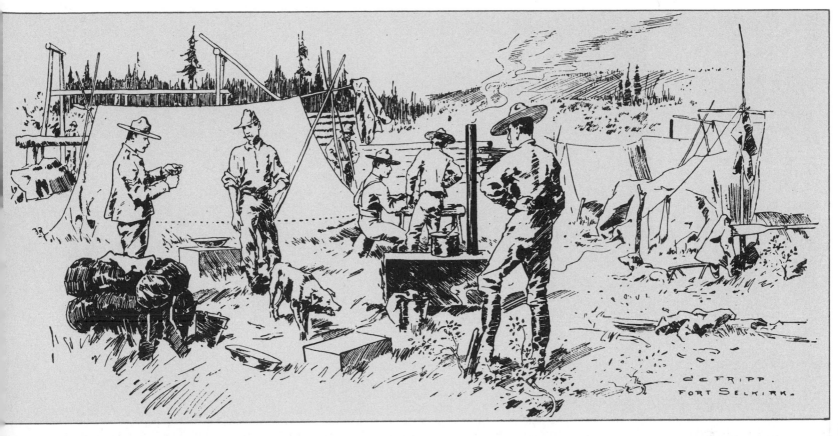

FORT SELKIRK.

C.E.FRIPP.

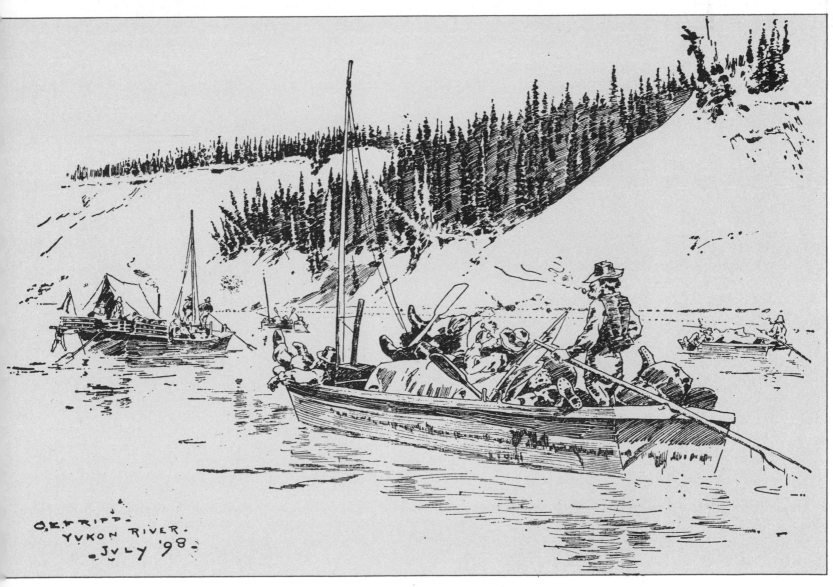

O.E.FRIPP.
YUKON RIVER.
JULY '98.

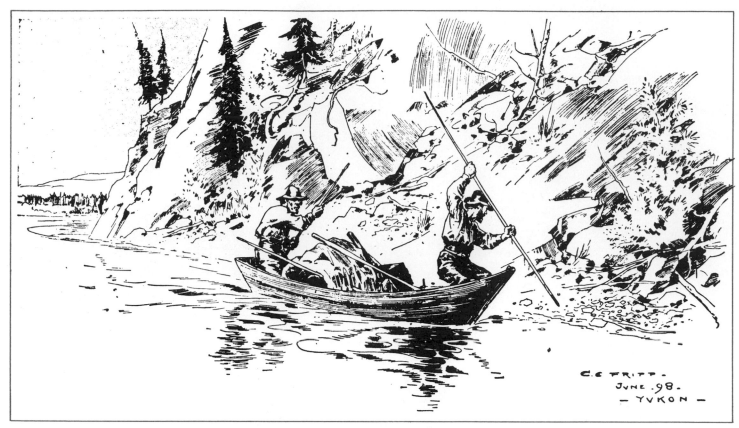

By the Yukon to Dawson City: Poling Up Stream. Photomechanical line engraving. *Daily Graphic,* October 19, 1898. There were treacherous rapids above White Horse. Fripp sketched these two Klondikers poling their fragile, heavily-laden boat past dangerous rocks in Miles Canyon.

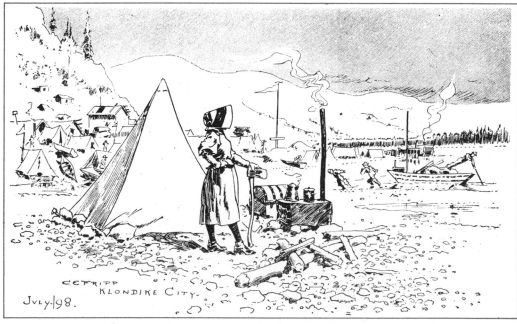

Salvation Army Outpost at Klondyke City. Photomechanical line engraving after ink drawing. *Daily Graphic,* October 26, 1898. On the south bank of the Klondike River opposite Dawson was Klondike City or "Lousetown." Enterprising merchants had placed large signs which read "Danger Below: Keep to the Right" to mislead stampeders and prevent them going on to Dawson. Like many others, Fripp and his friends were deluded and pitched their trailworn tent on a shingly spit at the mouth of Klondike Creek, closely watched by a Salvation Army lassie in a red blouse standing guard over the afternoon teapot with an axe!

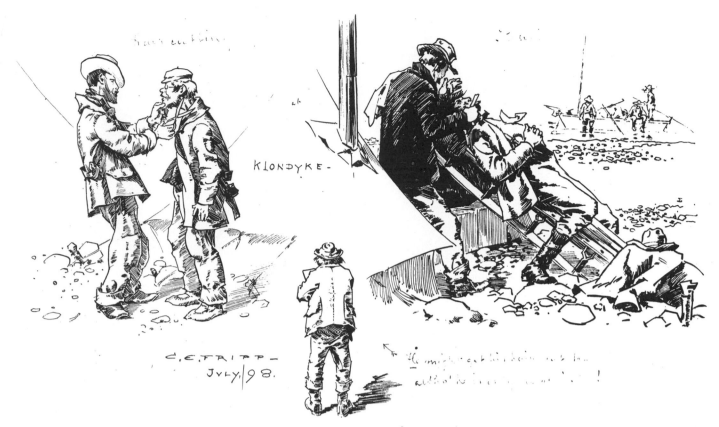

Civilisation on the Klondyke. 1898. 7½ x 11¼. Ink drawing. *Daily Graphic,* November 5, 1898. Courtesy Centennial Museum, Vancouver. Gaunt, with bewhiskered, sunburnt faces, Fripp and his friends found bliss in the hands of a Klondike City barber. That is, until they paid up. With haircuts and beard-trims at ten dollars and a shave at five, the Klondike was clearly a barber's El Dorado.

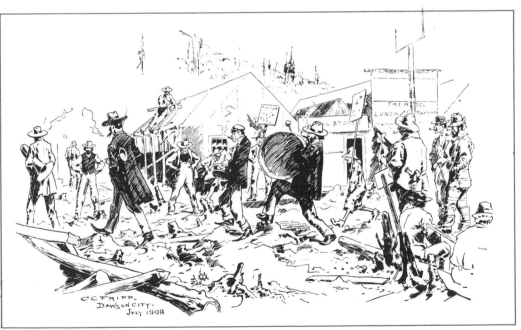

The Fourth of July on the Klondyke. Photomechanical line engraving after ink drawing. *Daily Graphic,* November 9, 1898. The Mounties had tactfully decreed that Dominion Day (July 1) and Independence Day be celebrated on the Fourth of July, and shortly after midnight shots filled the air with an intensity that made sleep impossible. Unable to resist his curiosity, Fripp grabbed a sketchbook and joined the vast throng of miners shuffling up and down the main street.

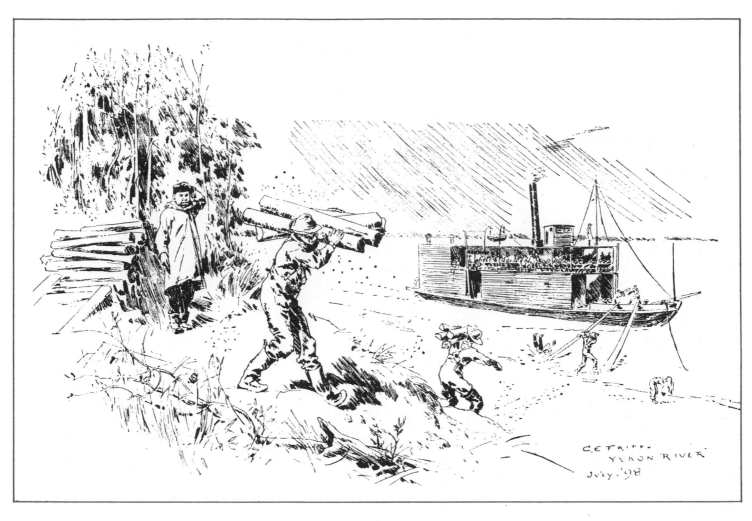

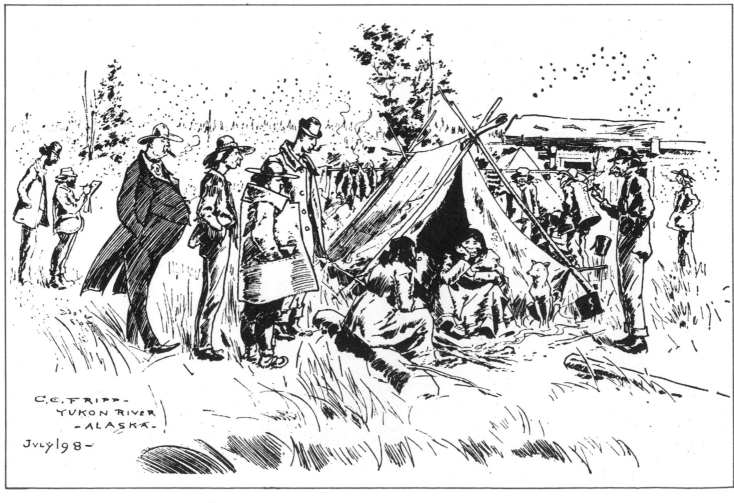

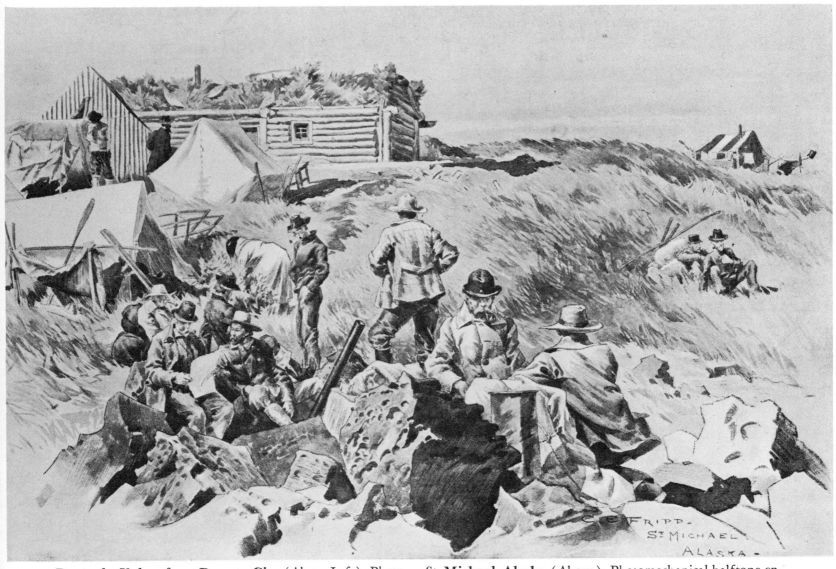

Down the Yukon from Dawson City (Above Left). Photomechanical line engraving after ink drawing. *Daily Graphic,* November 30, 1898. Stops for taking fuel on board were frequent, and as the wood only lasted a few hours, they occurred nightly as well as daily. This was usually the signal for the boat to be invaded by swarms of mosquitoes, "which," added Fripp, "drove everybody out of the bunks until the vessel had again been under way for half an hour."

St. Michael, Alaska (Above). Photomechanical halftone engraving after ink wash drawing. *Graphic,* April 8, 1899. Some two weeks later, the *Merwyn* disembarked its long-suffering passengers at the wet, gloomy port of St. Michael, on the Bering Sea. Here, Fripp was relieved to change to the *Humboldt* which took him back to Victoria, British Columbia.

An "At Home" on the Yukon (Left). Photomechanical line engraving after ink drawing. *Daily Graphic,* December 8, 1898. St. Michael was still eight hundred miles distant, but the *Merwyn* took her time, refueling at camps and settlements along the inhospitable wilderness of the upper Yukon. "All these places," wrote Fripp, "are the same; a store, a few log cabins." Passengers diverted themselves by going ashore to look at the Kutchin Indians, whose encampments lay on clearings of the timbered river banks.

Driving Cattle into a Corral, Valentine Walter Bromley. Wood engraving. *Illustrated London News,* August 21, 1875. The original title and accompanying text note refers to this cattle roundup as taking place in Nebraska. But it is more likely to have been a roundup at the Crow agency for slaughter and issue to the Crow Indians on their reservation south of the Yellowstone River.

Epilogue

THE SUBSEQUENT CAREERS of the Special Artists who covered the Old West for the British picture press show them to have been a professionally substantial group of men with remarkable powers of endurance. Most were in the middle of their careers during the time they rode the Western trails. Although Houghton and Bromley died young, the others continued their itinerant lives until they either died or went into enforced retirement. Most paused to toss off at least one large painting—and some produced several—as a result of their travels. Almost all came to be regarded in England as authorities on the West, contributing to various magazines devoted to travel and adventure in distant lands.

Arthur Boyd Houghton went on to report Paris under the Commune, as well as his beloved London. But his time was running out, and five years later he died from cirrhosis. Somehow, between assignments and bouts of drinking, he found time to execute a postscript to his Western trip in the form of a large realistic picture, euphemistically entitled *Hiawatha and Minnehaha,* which he exhibited in 1871 at the Water-Colour Society. It was not well received. Although set in the context of the Pawnee village he had visited on the Loup River, in Nebraska, in February, 1870, and considerably nearer to the truth than Longfellow's mystical hero and spiritual Minnehaha, it lacked the conviction and lyricism of his *Graphic* illustrations. "Hiawatha" walks with stately steps, but "Laughing Water"—none other than the artist's beautiful wife—toils along under the combined burden of a papoose and a back-breaking load of firewood. The *Art Journal* thought it "weird in imagination; the colour hot and the action wild." (1) The art critic of the *Times* felt it might serve a more useful purpose as a processional banner for some women's rights association. (2) F. G. Stephens, a prominent critic writing in the *Athenaeum,* went further: "Art," he raged, "requires something better . . . than the poetry of the savage. . . . Art is the exponent of Man's ideas by means of beauty . . . pictures of savages are rarely good for anything better than ethnological diagrams." (3) Houghton's picture represents a lapse in his pictorial powers, if not as a draughtsman, at least as a painter.

William Simpson continued his world travels. Probably no artist before or since has investigated remote regions with such thoroughness and sympathy. He returned to England to cover the Indian Tour of the Prince of Wales, the Afghan Boundary Commission, and such royal marriages as those of Czar Alexander III of Russia, Prince William of Prussia, and Princess Louise of the United Kingdom. He also found time to enter a new and untrodden field as architectural archeologist, which later established him as an authority on Indian archeology. He became a Fellow of The Royal Geographical Society and addressed the Royal Institute of British Architects, The Royal Asian, and other learned societies.

Throughout his career, Simpson had a great faculty for making and

1. *Art Journal,* 1876:47.

2. *Times,* May 6, 1871.

3. *Athenaeum,* May 6, 1871:566. F. G. Stephens, a founder of the original Pre-Raphaelite Brotherhood, had abandoned painting to become a much-feared critic. He still sought to hold those influenced by Pre-Raphaelitism to the straight and narrow path of creative achievement.

4. Quoted by George Eyre-Todd, in his Preface to *The Autobiography of William Simpson* (London, 1903).

keeping friends. Perhaps something of the secret was discovered in a letter written by a fellow *Illustrated London News* artist who knew him well. "There was none of us," wrote this correspondent, "who ever had such an interest as Simpson had in the deeper studies of archaeology and history, of philosophy and religion, and I have never known his equal for truthfulness, and to set it forth by pen and pencil." (4)

Pictorial journalist par excellence, Simpson nevertheless sought to maintain his original reputation as a topographical artist, and he regularly exhibited the fruits of his travels in London. After his return from America, he had shown his California pictures—including many of the Modoc War scenes—in 1874, in a one-man exhibition at the Burlington Galleries, entitled "Round the World." Meanwhile, his American illustrations, including several additional Western scenes, continued to appear in the *Illustrated London News* up until 1881. Although the somewhat labored quality of his work leaves much to be desired, Simpson's pictures possess a certain undefinable romantic charm. For, in his passionate zeal to get at the truth and report what he saw with fidelity, he usually sacrificed everything for the sake of accuracy. The Californian series, at least from the four originals that have so far been discovered, are a welcome exception.

Valentine Walter Bromley did not have the good fortune to have such a long and fruitful career. Three years after his return, he died of small-pox, at the age of twenty-nine, after only a few days' illness. Yet, he was so much more successful than the other Special Artists in creating an oeuvre memorable for its evocation of the mystery and grandeur of the Old West. Dunraven had commissioned him to paint a group of twenty huge oils of life and landscape along the line of their travels. Unfortunately for posterity, the artist completed only five of these before his tragic and untimely death in 1877. Yet they helped to establish his reputation as a painter of promise, as he exhibited them widely to some-what intrigued audiences at The Royal Academy, the Water-Colour Society, and now the Royal Institute of Painters in Water-Colours.

Sydney Prior Hall returned to England and was discouraged to find that his next assignment was to cover the Egyptian War of 1882–83. His involvement with the Canadian West, however, continued up to his retirement sometime after, during the 1900's. He also covered several performances of Buffalo Bill Cody's Wild West Show, which visited London in 1887 and 1892. The Marquis of Lorne, afterward Duke of Argyll, had become an influential and prominent figure in Anglo-Canadian circles, and he was especially active in fostering emigration by means of books, articles, and pamphlets. Hall illustrated many of the former governor general's recollections and tales of his Western travels. In 1887–88, he executed his most ambitious picture for his patron, a huge oil entitled *The Last Great Indian Council*. Based on his earlier *Graphic* drawing, *The Pow-wow at Black Feet [sic] Crossing,* the paint-

ing is a masterpiece of imperialist art. Meanwhile, he contributed illustrations of Canadian pioneer life to the *Graphic,* and continued to do so up until 1900. Finally, he topped off his lifelong connection with Canada when he returned in 1901, at the age of fifty-nine, as Special Artist of the *Graphic* and the *Daily Graphic,* to cover the tour of the Duke and Duchess of Cornwall and York (King George V and Queen Mary). He remained a close friend of the Duke of Argyll, and painted his portrait in 1910 as a genial, silver-haired laird of sixty-five, seated in his library at Inverary Castle, Argyllshire. Hall died in 1922, a distinguished member of the Victorian Order.

Inglis Sheldon-Williams also lived to a ripe old age. Strangely enough, his later career, that of a somewhat self-conscious painter and Special Artist, and, later on, as an official war artist for the Canadian War Records, never exceeded the adventurous spirit of his less responsible contemporaries. He dabbled in Regina real estate and made use of his connections with local political leaders. This resulted in some heavily conventional portraiture, although he did produce some fine prairie landscapes and scenes of Indian and farming life in Saskatchewan in the 1920's. After World War I and the completion of his war pictures, he traveled in France and Italy, publishing two illustrated books of his impressions. Nothing of the spectacular movements of the time, however, touched him. He continued to pay lip service to what he described as "Art for Art's Sake," although, of course, his work was anything but that. He outlived all the other Specials and died in 1940 at one of the last havens of the English imperial gentry—Tunbridge Wells, in Kent.

Frederick Villiers also continued his world travels, revisiting western North America on several occasions. In the early years of his career as a Special Artist, he had exhibited an occasional picture at the Royal Academy, but later he appears to have dropped the habit. His Western drawings, therefore, remain as published illustrations or as mere sketches. The last of the Victorian Specials, he was still at work during World War I, covering the action with the French Army for the *Illustrated London News.* Villiers visited North America for the last time in 1919 on a coast-to-coast lecture tour, talking about his many experiences as a Special Artist. One of his greatest wishes was to visit Hollywood and meet Charlie Chaplin—and this he did, staying with Mr. and Mrs. Andrew Storrows of Pasadena. He then continued north through California to Oregon and British Columbia. His itinerary was to have taken him across Canada to Montreal, but he fell ill in Indian Head, Saskatchewan. He was put up by one Reverend Beauchamp Payne, then was moved to Montreal General Hospital, where he spent several weeks. He died in 1922 at Bedhampton, Hampshire.

Richard Caton Woodville went on to become the most prolific delineator in Europe of the Western myth. His notes and field sketches, coupled with a prodigious memory, enabled him to meet the demand for docu-

mentary and literary illustrations which were an inseparable part of a now enormously popular literature of travel and adventure in the "Western wilds." Military painting was at this time being produced by a large school of competent young academic painters. Woodville turned more and more to magazine work. For twenty years, up through World War I, Woodville produced hundreds of Westerns for picture weeklies, sporting papers, and boys' magazines, which were eagerly read by young men who worked from nine to six and lived in the new red-brick suburbs of turn-of-the-century Britain.

His earlier career continued to bring him many exotic honors. After his return from America in 1892, he received the Order of Medgidieh from the Sultan of Turkey, in recognition of his drawings of the Russian-Turkish War. In 1896, he was awarded the Imperial Order of Egypt by the Khedive for his services in designing the uniforms of the Egyptian Army. He was given the Silver Medal of the Red Cross of Spain and the Academy Palms of France. But for his divorce, he would have received a knighthood; in the days of Queen Victoria, no divorced person was given this honor.

In spite of the honors, his fame and wealth, and a succession of luxurious houses, Woodville's life ended tragically. During the 1920's, a leg wound from the Egyptian Campaign (in which several artists and journalists lost their lives), then a hunting accident to the same leg, confined the artist to his studio in Abbey Road, St. John's Wood, London. For many years he had been living happily with a mistress. When she died early in 1927, he felt unable to face living any longer and shot himself in August of the same year.

Charles Edwin Fripp went on working for the *Graphic* and the *Daily Graphic*. Shortly after he returned to his home at Enderly, British Columbia, he sailed for Manila to cover the Philippines Campaign of the Spanish-American War. Six months later, he returned, then was off again, this time to South Africa. After a year covering the war against the Boers, he returned to British Columbia, where he painted what were his last pictures from his expeditions in the thickly wooded valleys. Although he had regularly exhibited paintings and watercolors from his earlier travels at the Royal Academy, the Water-Colour Society and the Royal Institute of Painters in Water-Colours, he appears to have found it impossible to keep up the practice. The rigors of his restless life finally caught up with him in September, 1906; while on his way back to England on a visit, he collapsed in Montreal and died of lung cancer and chronic inflammation of the kidneys. (5)

The British reporting of the Old West took place during a period of increasing economic and political cooperation between the Old Country and the young republic. It encompassed the years between the early, questing, radical journalism and the later, strident, imperialist journalism. Each artist, therefore, tends to reflect differing, even conflicting

5. As stated on the Certificate of Cremation issued by Crematorium Limited, Montreal, Fripp died at the Homeopathic Hospital, Montreal, of chronic nephritis, cancer of the lungs, and cardiac dilation, on September 22, 1906. His last place of residence was given as Enderly, B.C.

attitudes. These, in general terms, express either sympathy for the Indians or support for the advancement of white civilization.

The most sympathetic were the earliest travelers in the West, Houghton, Simpson, and Bromley. In the degree of their sympathy for the Noble Savage—indeed, for all who did not possess the advantages of wealth, rank, and education—they were typical products of the early, more romantic climate of Victorian England. Houghton, and possibly Bromley, too, rejected what they felt to be calculating and crass in the gilded cities of the East. They favored what was thought of as a primeval West, with simple, "natural" man, unspoiled by the sophisticated tastes of the rich and the educated. The spectacle of the red man, fighting and doomed to near extinction, troubled all three artists. Romanticism had taught them to feel for and understand the less fortunate. "If the Red man is cruel," Houghton wrote, "so is the White, not only cruel intentionally, when he shoots down the Indian, but unintentionally, when he pushes his settlements still farther into the waste lands, because his advance, however pacific, means destruction to men who live by the chase." It is no accident, therefore, that Houghton was responsible for what was esthetically the best English art inspired by the Old West.

Hall, Woodville, Villiers, Sheldon-Williams, and Fripp were more a part and parcel of the imperialist age that followed. By the 1870's, the Indian was in retreat; nation after nation was driven from its lands into reservations. This is not to say that these artists did not have misgivings about what they sometimes saw, both in the United States and in Canada. Generally, however, they went along with the thoughts and feelings of the military or governing proconsuls. The exuberent optimism of imperialism was too strong to resist. Artists, like everyone else, were carried away by the current of Anglo-Saxon superiority, which expressed itself in the fulfillment of pioneering remote settlements, heroism, inner renewals, and, above all, dedication to climbing the ladder of progress, come what may.

Yet, as adventurous as their experiences often were, one is struck by the comparatively unadventurous forms in which they chose to depict such colorful subject matter. The work of the Special Artist meant long and weary hours; riding trains, stagelines, and on horseback for days and even weeks; looking for material which, when found, was either less interesting than expected or demanded more time and energy than could be spared. Those with a flair or special training for dramatizing fact had the advantage: they alone could impregnate what they saw with the heightened visual awareness necessary to capture the elation of high adventure.

Houghton was by far the most successful in doing this. In his Western illustrations, all the restrictions of time and place are transcended to create a highly esthetic narrative. He alone possessed the essential ingredient of a creative temperament: an extreme emancipation of the emotions that can handle major experience. To a lesser extent, and in

his paintings, Bromley also had this magic touch. Hall, too, was able to rise above his subject for time to time. Woodville tried hard, but his emotions were like the well-rehearsed histrionics of a veteran actor. But it is only when one turns to Simpson, Villiers, Sheldon-Williams, and Fripp that one feels a drop in standard, a lack of personal response to the subject. Certainly, they produced some memorable work. But the editorial convention that they make an exact record of appearances, equal to that of a camera, stopped them from effectively communicating the excitement of what was going on. Moreover, by the end of the century, the Special Artist was no longer just an artist whose fundamental task was to send pictures; he was also a correspondent whose cabled dispatches were every bit as important, and sometimes more so.

During his Western travels, each artist must have felt he was addressing himself to a particular kind of reader. Houghton, a freewheeling illustrator in the Pre-Raphaelite tradition, was a bohemian radical who could not resist a new experience. He was just in time; pictorial journalism had yet to be perfected as an instrument of information and propaganda. When it was, there certainly would be no place for an artist of his type. Meanwhile, he addressed himself to those whom he felt would receive his impressions and ideas with attention, the sophisticated radical intelligensia centered in the influential Hogarth Club. (6) His complex imagery, composed of satire, sentiment, and humor must, therefore, have seemed off-the-beam to other readers. For them, he was, as William Luson Thomas put it, "an artist who did not know his place." (7)

But the other Specials did. After all, it was very much in their interest to know their place. Imperialism involved the educated middle class in a widening range of practical tasks which effectively absorbed many earlier reservations about serving God and Mammon. Explorers, engineers, geographers, doctors, and numerous other independent specialists, including writers and artists, found themselves involved in a close relationship with the military and diplomatic establishment. Very soon they discovered that their entire careers were dependent on the patronage and goodwill of statesmen, army commanders, and governors general who, in turn, found it useful, and even essential, to keep close contact with magazine proprietors and their representatives.

Simpson, the pioneer war correspondent, depended heavily on the confidence of the top brass, whose martial virtues, in turn, he reported to his readers—most probably the military-minded, or more likely the large readership of regular army officers. Woodville, who saw war in much less qualified terms, enjoyed an enormous popularity with the ranks. His propagandist celebration of sublime heroism in the guise of an eyewitness drawing made everyone, combattant and noncombattant alike, feel as if he were fighting for a just and worthy cause. No less propagandist were his Western scenes of big-game hunting and fishing expeditions, cattle roundups, forest fires, and the U. S. Cavalry: he

6. The Hogarth Club was founded in 1857 by Ford Madox Brown, William Morris, Edward Burne-Jones, and other members and associates of the Pre-Raphaelite circle. It was named after the great eighteenth-century English painter William Hogarth, who concerned himself so much with the everyday scenes of his time, and whose style, like that of the Pre-Raphaelites, was "true to nature." The club was founded partly as an exhibiting society and partly as a meeting place for those who sympathized with its aims. Brown, who introduced the variety of intense realism that became characteristic of Pre-Raphaelite art, was very much its father figure, and after the club officially disbanded, much of its social activities continued at his house in Kentish Town, London. Houghton was a regular at both the Hogarth Club and at Brown's house, and met emigrés and distinguished visitors such as Mazzini and Turgenev. See, Ford Madox Hueffer, *Ford Madox Brown—A Record of His Life and Work* (London, 1896). For the Pre-Raphaelites and their interest in radical politics, see Donald Drew Egbert, *Social Radicalism and the Arts* (New York, 1970).

7. Quoted by Sullivan, *Print Collectors' Quarterly,* 10, 1923.

propagandized the joy of adventure, which could only be found in the great outdoors of the Anglo-Saxon universe. All you needed were the guts to join the fun.

Hall, from all accounts, was also much sought-after by royal princelings and the ducal nobility. To a lesser extent, so was Villiers. Fripp and Sheldon-Williams did not appear to meet with such warm official approval, although their accounts appealed to those whose sons were busily pioneering in the far-flung settlements of western Canada.

With the advent of improved news photography in the 1900's, the day of the Special Artist eventually came to an end. The daily and weekly picture press of the new journalism turned to a more efficient tool of reporting life and events in the now not-so-distant West.

The Special Artist shared the fate of 'all those who had been a part of his world: the fur traders, the mountain men, the steamboat pilots, the goldseekers, the gamblers, the con-men, the buffalo-hunters, the cavalrymen, the scouts, the stage-drivers, the cowboys, the harlots, the missionaries, the Indian agents, the warrior-chiefs, and the homesteaders. He fell back into the dark corner of history, buried under an avalanche of dusty bound volumes of the magazines he had spent a lifetime traveling for.

Sources of Reference

1: Illustrated Journalism

My outline essay on illustrated journalism in England and its coverage of the North American frontier is based on a wide assortment of materials. The more important included Mason Jackson, *The Pictorial Press: Its Origin and Progress* (London, 1885), which contained a great amount of information on the early years of the *Illustrated London News* and its forerunners. The most candid and revealing sidelights on Ingram and the earlier years of the *Illustrated London News* were found in Charles MacKay's autobiographies: *Forty Years' Recollections,* 2 vols. (London, 1877), and *Through the Long Day,* 2 vols. (London, 1887). Factual material was also found in the following articles: anon., "The Founding of the *Illustrated London News,*" *Illustrated London News,* 50, 1892:579–84; Peter Biddlecombe, "As Much as the World can Show," *Illustrated London News,* One Hundred and Twenty-fifth Anniversary Issue, May 13, 1967:40–6; Edwin Sharpe Grew, "William L. Thomas of the *Graphic* and *Daily Graphic,*" *Sketch,* May 17, 1894:637–8. Many years of personal research in the University Library, Cambridge, and the British Museum Newspaper Library, Colindale, London, revealed the details of Western coverage by the periodicals themselves during the following periods: *Illustrated London News,* 1842–1914; *Graphic,* 1869–1906; *Daily Graphic,* 1889–1910; *Black and White,* 1892–1906; *Sphere,* 1898–1910; *Illustrated Sporting and Dramatic News,* 1880–1910.

More information on the English picture papers of the nineteenth century and on their artist-contributors was found in James Thorpe, *English Illustration: The Nineties* (London, 1935), while the same author's article "Some Draughtsmen of the Early *Daily Graphic,*" *Alphabet and Image* (2, 1946:59–71), told the story of what was Europe's first illustrated daily newspaper.

References to English nineteenth-century opinion of the United States were found in Allan Nevin's admirable sourcebook, *American Social History as Recorded by British Travellers* (London, 1947); in Max Berger's no less valuable *The British Traveller in America, 1836–1860* (New York, 1943); and in Clarence Gohdes' *American Literature in Nineteenth-Century England* (New York, 1944), which also revealed the wide degree of interest in American literature and its influence as a contributing factor to the popularity of Western pictures in the illustrated press. These works also revealed the conflicts of opinion between conservatives, radicals, and liberals concerning the United States. I also found Denis Judd's *The Victorian Empire* (London, 1970) a useful vantage point from which to assess the relationship between the United Kingdom and Canada on one hand, and between the United Kingdom and the United States on the other.

Additional references were found, to British emigration to the United States and Canada, in Wilbur S. Shepperson's *British Emigration to North America* (Oxford, 1957), and to British investment, in W. Turrentine Jackson's *The Enterprising Scot: Investors in the American West After 1873* (Edinburgh and Chicago, 1968). While singling out the important part the Scots played in financing the economy of the West, Jackson also covers the general background of British investment. James B. Hedges' *Building the Canadian West: The Land & Colonization Policies of the Canadian Pacific Railway* (New York, 1939) notably Chapter 5, "Advertising the West," 94–125—provided valuable information about the extraordinary efforts made by the Canadian Pacific Railway to settle Canada's western provinces, as did Walter Vaughan's biography of its remarkable president, *The Life and Work of Sir William Van Horne* (London and New York, 1920).

2: The Special Artist

My general outline of the Special Artist is based primarily on Mason Jackson, *The Pictorial Press: Its Origin and Progress* (London, 1885). Despite a somewhat breathless enthusiasm, it remains the most definitive book on the subject. Much useful information was also found in the more critical essay by Harry V. Barnett, "The Special Artist," *Cassell's Magazine of Art* (6, 1883:163–70).

My main source for the lives and idiosyncrasies of the artists themselves has been an enormous literature of interviews, profiles, memoirs, reminiscences, and autobiographical accounts, as well as the texts and articles accompanying their published illustrations. These are credited in the notes in each chapter.

3: Arthur Boyd Houghton

Many of Houghton's American illustrations, including the Western series, appeared in the Boston *Every Saturday,* as well as in *Harper's Weekly. Every Saturday* arranged with the *Graphic* to receive electrotypes of the illustrations, so that they often appeared simultaneously in the United States and England, if not before they did in England. *Harper's Weekly,* after pirating the series, made the same arrangement.

My account of Houghton's travels in the West derives from several sources in England and the United States. Primarily, it is based on his own fulsomely descriptive notes accompanying the illustrations (*Graphic,* 1–4, 1870–73). These are personal and prosy in style and only occasionally refer to places and individuals. Notes and addresses found in the artist's sketchbook in the Victoria and Albert Museum, London, provided a few clues; I was able to identify some of the actual locales of the illustrations when I followed, in 1965, Houghton's itinerary from Omaha to Cheyenne. A search in the National Archives, Washington, D.C., revealed the special order authorizing the buffalo-hunting expedition. I have not, however succeeded in discovering the identities of the other members of the party, although these may have included Mr. Flynn, a British sportsman; very probably Cody's sister, Helen Cody Wetmore; and Dr. Frank Powell, then a journalist in Omaha and a contributor of Western yarns to *Beadle's Boy's Library.*

Additional references to the artist's adventures appear in Edmund J. Sullivan's informative tribute "An Artist's Artist," *Print Collector's Quarterly* (10, 1923).

More data on Houghton's life, work, and ideas, as well as critical appraisals of "Graphic America," were found in Laurence Houseman, "A Forgotten Book-Illustrator," *Bibliographica* (London, 1, 1895); in the same author's monograph *Arthur Boyd Houghton* (London, 1896); and in Robert Allerton Parker's sympathetic and admirable essay "Boyd Houghton's Graphic America," *The Arts* (5, 1924:1). The Dalziels' autobiography, *The Brothers Dalziel: A Record of Work: 1840–90* (London, 1901), also contained useful information, as did Forest Reid's definitive study of Victorian book illustration, *Illustrators of the Sixties* (London, 1928).

A centennial exhibition of the illustrations of Winslow Homer and Arthur Boyd Houghton took place at The Metropolitan Museum of Art, New York, in 1936 (both artists were born in 1836). I therefore read with interest the American views of "Graphic America" in these articles: Sinclair Hamilton, "Arthur Boyd Houghton and his American Drawings," *Colophon* (1, No. 2, 1939); Alice Newlin, "Winslow Homer and Arthur Boyd Houghton," *Bulletin of The Metropolitan Museum of Art* (31, 1936).

Van Gogh's references to Houghton and his American drawings were found in *Letters to an Artist: from Vincent Van Gogh to Anton Ridder Van Rappard, 1881–85* (London, 1936) and in the *Complete Letters of Vincent Van Gogh,* Vols. 1 and 3 (London, 1958).

I would like to express my appreciative thanks to Graham Reynolds and the Victoria and Albert Museum, London, for permission to reproduce various sketches from Houghton's sketchbook.

4: William Simpson

My account of Simpson's travels in California is based on his five published letters, which accompanied the illustrations appearing in the *Illustrated London News* (62, April–June, 1873), and on the extended versions of these letters which appeared later in his article "The Modoc Region, California," *Proceedings of the Royal Geographical Society* (19, 1875:292–302), as well as on his autobiographical account of his "Round the World" trip of 1872–73 in *Meeting the Sun* (London, 1874), 26:354–83. Additional references to the artist's adventures appear in his own descriptive text for the album *Picturesque People* (London, 1876) and in his *Autobiography* (London, 1893).

A general outline of Simpson's life, work, methods, and ideas was found in the *Dictionary of National Biography,* 1217–19, and in the following articles: John Latey, "The Doyen of Special War Artists—Mr. William Simpson," *Illustrated Naval and Military Magazine* (5, November, 1884: 309–12); Archibald Forbes, "Famous War Sketchers, II: Mr. Simpson of the *Illustrated London News,*" *Sketch* (February 8,

1893); and in an interesting personal account by Simpson himself, "The Special Artist," *Illustrated London News* (Jubilee number, May 14, 1892:604).

The description of the events leading up to and during the Modoc War were based on J.P. Dunn's *Massacres of the Mountains: A History of the Indian Wars of the Far West, 1815–75* (New York, 1886; new edition, London, 1963), updated by Keith Murray's more scholarly *The Modocs and Their War* (Norman, 1959).

Chapter 4 ("The Modocs Hold off U.S. Army") of Oliver Knight's *Following the Indian Wars* (Norman, 1960), contains many new facts, as well as an interesting account of the various newspaper correspondents covering the Modoc War.

I am indebted to John Barr Tompkins of the Bancroft Library, University of California, Berkeley; to Mrs. Katherine B. Edsall of the Peabody Museum, Harvard University, Cambridge, Massachusetts; and to The Holden Arboretum, Mentor, Ohio, for their courtesy in allowing me to reproduce Simpson's original watercolor drawings and field sketchbook studies from their collections.

5: Valentine Walter Bromley

Valentine Walter Bromley is, undeservedly, a forgotten Victorian painter known only for his inadequately reproduced illustrations for the Earl of Dunraven's *The Great Divide* (London, 1876). Yet the rediscovery of several important paintings—as well as the originals of the above illustrations—plus his work as Special Artist for the *Illustrated London News*, reveal him to be one of the most interesting British artists to set foot on Western trails. Perhaps the fact that nowhere in his book does the Earl mention the artist's presence on the trip, other than to briefly acknowledge his illustrations, contributes to Bromley's relative anonymity. Marshall Sprague, for example, in his otherwise admirable study, *Gallery of Dudes* (Boston, 1966), suggests that Bromley did not get his material firsthand, but that the Earl gave Bromley photographs of Western scenes for background and his own sketches of how the various members of the party looked.

There is no doubt in my mind, however, that he was a member of the party and that he did make his drawings on location. During a personal visit to Adare in September, 1966, Lady Olein Wyndham-Quin, grandniece of the 4th Earl of Dunraven, and at the time manager of the Adare estates, informed me that Bromley did accompany the Earl. She had always supposed there was not much social contact between them. "They did not," she said, "hit it off." Bromley's health was frail. He was not a sportsman, and probably found the trip exhausting. Sir Roy Harrod, the artist's nephew, also states that there is no doubt that Bromley did go to America with Lord Dunraven, adding that as a small boy he used to hear about the trip. The tour was always referred to as a "man-hunting" expedition.

Numerous references in the English press and other biographical sources also refer to Bromley making the six-month trip, as do reviews which greeted the exhibition of the pictures in London. The more important of these sources include the following obituary notices: *Athenaeum* (May 5, 1877:585); *ILN* (May 19, 1877:469); *Art Journal* (39, 1877:205); *Dictionary of National Biography*, 2 (London, 1909), 1311. See the Annotated Checklist on p. 274 for press notices.

I have not, however, succeeded in discovering any manuscript or published notes, articles, or interviews, although both the paintings and the published illustrations themselves are intimately related to the 1874 Dunraven expedition. I have, therefore, largely derived my account from the Earl's *The Great Divide* and from his autobiography, *Past Times and Pastimes* (London, 1922), which added a few more details. I also referred to Dr. George Kingsley's *Notes on Sport and Travel* (London, 1900), edited by his daughter, Mary H. Kingsley, and to Marshall Sprague's sympathetically observed "The Dude from Limerick," Chapter 6 of *A Gallery of Dudes*. The same chapter was also published in *American West* (3, 1966:53–61).

The itinerary of the Dunraven party was followed partly on location during my return journey from Alberta to Pennsylvania in autumn, 1969, partly through the foldout maps in the Earl's book, and also through Richard Bartlett's excellent article on the origins and early history of Yellowstone National Park, "Will Anyone Come Here for Pleasure?" *American West* (6, 1969:10–16).

Bromley's sudden and unexpected death from smallpox on April 30, 1877, tragically cut short a promising career. He was apparently a much-loved young artist and had been married only several months to Ida Forbes-Robertson, the oldest daughter of the well-known Victorian art critic, John Forbes-Robertson. Data on his life and work is scant, and was found mainly in the before-cited obituary notices, *DNB*, and in the following sources: *Art Journal*, 1873:358, 372; Clement and Hutton, *Artists of the Nineteenth Century* (London, 1893), 99; M. Byran, *Dictionary of Painters and Engravers*, 1 (London, 1903), 198; Algernon Graves, *Royal Academy Exhibitors: 1769–1904*, 2 (London, 1905–06; reprinted 1970), 296.

I am also indebted to Watson Parker's illuminating account, *Gold in the Black Hills* (Norman, 1966), and to Oliver Knight's *Following the Indian Wars* (Norman, 1960), for an appreciation of the events preceding and precipitating the Sioux War.

Finally, I would like to express my grateful appreciation to the present Earl of Dunraven for allowing me to visit Adare Manor and see the three Bromley paintings in his collection, as well as to reproduce *The Great Scalper, Crow Indian Woman*, and *Crow Indian Burial*. I would also like to thank the Earl of Meath, who so graciously allowed me to examine the original gouache and watercolor drawings which illustrated *The Great Divide*, as well as the painting *Midday Rest, Soux Indians*.

6: Sydney Prior Hall

The principal source for my account of the travels of Sydney Prior Hall with the Marquis of Lorne and his party in western Canada derived from a large volume of unpublished letters, official and private correspondence, newspaper accounts, magazine articles, and biographical and autobiographical works. Among the more important are *The Lorne Papers* (microfilm A-717) and *The Lorne Papers*, Scrapbook 4 (microfilm A-718—this includes clippings of the series by the correspondent of the Toronto *Globe*) in the Public Archives of Canada, Ottawa, as well as *Lord Lorne's Expedition to the North-West, Articles Contributed to the Scotsman and the Courant by James MacGregor*, a scrapbook of clippings in the Glenbow Library and Archives. Sydney Hall's own personal impressions appeared as text notes with his drawings (*Graphic*, 24–25, August, 1881–February, 1882).

Information on the artist's life, work, and later career was found in Archibald Forbes, "Famous War Sketchers, 1: Sydney Hall of the *Graphic*," *Sketch* (February 1, 1893) and in Lewis Lusk, "A Famous Journalist, Sydney P. Hall, MVO," *Art Journal* (1905:277–81).

Additional references to the artist, and to the adventures and impressions of various members of the party, also appear in the Duke of Argyll's autobiography, *Passages from the Past* (London, 1907), and in Lady Francis Balfour, *Life and Letters of the Reverend James MacGregor* (London, 1912).

The events leading up to and during the Marquis of Lorne's term of office as governor general, as well as the political and economic development of Canada, were based on *The Cambridge History of the British Empire—Volume 6, Canada* (Cambridge, 1930); J. M. Careless' admirably concise *Canada—A Story of Challenge* (Toronto and New York, 1963); and W. Stewart MacNutt, *Days of Lorne* (Frederickton, 1955), an excellent and authoritative account of Lord Lorne's impressions of his years in Canada, as it is based on his private papers, now in the possession of the present Duke of Argyll.

Lord Lorne's own writings on his travels and impressions of Canada and the United States are extensive, but his *Canadian Pictures* (London, 1884), written as a guide for the prospective emigrant and published by the Religious Tract Society, is of particular interest, as it is profusely illustrated with both his own and Sydney Hall's drawings.

The artist's sketchbook, inscribed "Canada 1878, North-West 1881," was found in the collection of the Public Archives of Canada, Ottawa. It is a scrapbook assembled by Hall after the *Graphic* had returned the originals, and includes 270 sketches, studies, and illustrations from both visits to Canada. Of these, 120 are Western subjects, and not all were published. His continued interest in Indians is indicated by the inclusion of several color drawings of the Indian performers in Buffalo Bill's Wild West Show, which visited London in 1887. A further series of thirteen illustrations based on sketches from the artist's travels in western Canada appeared in the *Graphic* (35, 1887:44–5) under the title "A Hunt for a Christmas Dinner."

I am grateful for the courtesy of the Thomas Gilcrease Institute of American History and Art, Tulsa, Oklahoma, for permission to reproduce *The Last Great Indian Council*, and to the Department of Paintings, Drawings and Prints of the Public Archives of Canada, Ottawa, for allowing me to reproduce Hall's original pencil sketches and field sketchbook studies.

7: Inglis Sheldon-Williams

Inglis Sheldon-Williams' drawings of his early life in western Canada appeared as illustrations for articles he wrote for the London *Daily Graphic*. The first of these, "A Surprise Party in Manitoba" (*Daily Graphic*, February 26, 1890), was probably sent from Canada while he was living at Cannington Manor, which at that time was generally thought to be in Manitoba (Saskatchewan was organized as a province in 1905). The second, "Farming in Manitoba: A City Clerk's Experiences" (*Daily Graphic*, August 10, 1894), was also drawn while he was living in Canada. It is a strip of four drawings satirizing misguided gentlemen-emigrants duped into paying a premium to learn farming. These articles and illustrations are unsigned, but drawings as well as text match the artist's artistic and literary style of the time in almost every detail; they also correspond to the characters he met and the places he visited.

A further series of illustrations appeared in the *Sphere* (August 22, 1903) to illustrate the risks of prairie farming in Canada. The artist was living in London at this time (1901–03) and probably worked them up from sketches previously made at Cannington Manor.

In addition to the artist's references to his adventures, an autobiographical fragment in the form of a ballad, the ms. *Farmer Leckie's Homestead*, provided details of his first job as a young emigrant. Mary B. Galloway's paper on the Inglis Sheldon-Williams Collection acquired by the Glenbow Foundation of Calgary summarized his life and later career, as did the introduction by Jed Irwin to the catalog of a retrospective exhibition shown at the Regina Public Art Gallery (October–November, 1969). Sheldon-Williams' original drawings and illustrations of this period were not available, with the exception of the watercolor drawings owned by Mrs. Duthie, and a wash drawing, *Cutting Out Steers on an Alberta Ranch*, in the possession of the Kennedy Galleries, New York. No checklist of

titles has been included, as their present whereabouts is unknown to me.

My background account of Cannington Manor was based primarily on Mrs. A.B.M. Hewlett's informative pamphlet, *Cannington Manor* (Saskatchewan Diamond Jubilee and Canada Centennial Corporation, 1965), and on the following articles: Grace Howard Schierholtz, "A Manor in Saskatchewan," *Quest* (May, 1951); A.B.M. Hewlett, "England on the Prairies," *Beaver* (December, 1952); Mary Ann Fitzgerald, "The Fabulous Venture at Cannington," *Winnipeg Free Press* (October 16, 18, and 20, 1952). Several autobiographical and fictional works have Cannington Manor as their subject. Of these, the best known is a Victorian novelette by Harold Bindloss (probably a pen name) entitled *A Sower of Wheat* (London, undated). In spite of its melodrama, the characters are based on actual settlers and much is revealed about the life and tensions of the colony.

James B. Hedges' authoritative *Building the Canadian West* (New York, 1939) provided the details of the tasks of prairie settlement, while Professor William J. Reader's *Life in Victorian England* (London and New York, 1964) and A. P. Thornton's *The Imperial Idea and Its Enemies* (New York, 1968) helped trace the events which contributed to the emigration of the English gentry, as well as establish the phenomenon of imperialism as a motivating factor.

Grateful appreciation is expressed to the Glenbow Foundation of Calgary, Alberta, for allowing me to quote from the extensive Inglis Sheldon-Williams ms. collection in their archives, and for granting permission to reproduce the artist's self-portrait.

8: Frederick Villiers

My account of Lord Stanley's Western tour of 1889 derives from both printed and unpublished manuscript sources. Villiers himself wrote several descriptive notes which appeared with his illustrations in the *Graphic* (40–41, November–January, 1889–90); his principal autobiography, *Five Decades of Adventure*, 2 vols. (New York, 1920; London, 1921), contains additional material. At the Public Archives of Canada, Ottawa, I found a microfilm of Lady Constance Stanley's fascinating ms. *Journal* of the tour, a refreshingly personal commentary on places and personalities. On the same reel (microfilm A-673) I also found selected items of Lord Stanley's correspondence during his term of office (1885–93), the C.P.R. timetable for 1889, and the detailed official itinerary of the tour. Colonel Sam Steele of the Northwest Mounted Police, who provided the escort, filled in several details in his autobiography, *Forty Years in Canada* (London and Toronto, 1915).

Rudyard Kipling, whose job as assistant editor of the influential *Civil and Military Gazette* put him in touch with the mainstream of imperial life in India, throws a revealing sidelight on Victorian journalism in his novel *The Light that Failed* (1891). His hero, Dick Heldar, was based on Villiers, with whom Kipling had become acquainted after his return to England in 1889.

Information on the artist's life and work was found mainly in his autobiographical works, principally the one cited, and the earlier *Peaceful Personalities and Warriors Bold* (London, 1907), as well as in F. Lauriston Bullard's study of Victorian war correspondents, *Famous War Correspondents* (London, 1914), which devotes a chapter to Villiers. Additional references were also found in the following articles: Frank Banfield, "Battle and Boys—A Chat with Mr. Frederick Villiers," *Chums* (2, 1894:407); anon., "Off to War: An Interview with Our Special Artist, Mr. Frederick Villiers," *Black and White* (August 18, 1894:201); Archibald Forbes, "Famous War Sketchers, IV: Frederic Villiers," *Sketch* (April 26, 1893).

The background for Lord Stanley's tour was based largely on James B. Hedges, *Building the Canadian West* (New York, 1939) and Douglas Hill's more recent general account, *The Opening of the Canadian West* (London, 1967). D. G. Creighton's definitive biography, *John A. MacDonald: The Old Chieftain*, 2 (Toronto, 1955), was particularly revealing in regard to Canada's problems during this period, while the history of Alberta and its ranching period derives from Lewis Gwynne Thomas, *The Ranching Period in Southern Alberta* (unpublished M. A. thesis, University of Alberta, 1935) and Donald Edward Brown, *A History of the Cochrane Area* (unpublished M.A. thesis, University of Alberta, undated), both kindly made available by the Glenbow Library, Calgary. My sketch of Lord Stanley himself was based on references and information found in Randolph Churchill's biographer of Edward, the 17th Earl of Derby, *The King of Lancashire* (London, 1959); *The Complete Peerage*, 4 (London, 1916); and *Who was Who: 1897–1915* (London, 1920).

I can only regret that Villiers' original sketches and drawings of Lord Stanley's Western tour have not been available. No checklist has been included, as their present whereabouts is unknown to me.

9: Richard Caton Woodville

Many of Richard Caton Woodville's Western scenes appeared as lavishly reproduced illustrations on both sides of the Atlantic. Part documentary and part fiction, they fall into four series. The first (1885–89) consists largely of hunting scenes in British Columbia, Montana, and California drawn from acknowledged pencil sketches sent in by readers, or from photographs, and published in the *Illustrated London News* with short articles or with full-page pictures and short or extended captions. Several of these appeared in *Harper's Bazaar* before publication in England.

A second series of mainly literary illustrations for various Western adventure stories appeared almost concurrently (1880–90); these include two sets of illustrations for novelettes by Bret Harte in the *Illustrated London News* and *Harper's Weekly*, as well as numerous tales of high adventure in *Boy's Own Paper*.

A third series (1891–1910) was the result of Woodville's Western travels of 1890–91 and was found only in the *Illustrated London News*. It includes a wider variety of subject matter: gold-prospecting in British Columbia; bear-hunts in Montana; wapiti-hunting and a cattle roundup in Wyoming; two illustrations relating to the Sioux Outbreak of 1890–91. In most cases, the illustrations are accompanied by short texts or extended captions, which I assume to have been based on the artist's written notes. Many appeared several years after they were delivered to the *Illustrated London News*. Interviewed in the *Idler* (10, 1896:759–75), the artist acknowledged that the illustrations then appearing were four or five years old. Woodville continued to draw on recollections of his visit well into the 1900's.

The fourth and final series (1904–07), published almost entirely in the *Illustrated Sporting and Dramatic News*, is made up largely of reconstructions for an additional crop of adventure stories set in western Canada and the United States.

My account of Woodville's travels derives almost entirely from a study of his published and unpublished sketches, illustrations, and paintings. But the absence of a specific reference in press interviews, the lack of relevant personal correspondence, journal, or diary notes, as well as of anecdotes of friends and acquaintances, does leave a slight element of doubt that he actually crossed the Atlantic. The early scenes of big-game hunting in Montana and British Columbia show a fidelity of observation many have supposed could only have been the result of working on location. Actually, as a letter from Baillie-Grohman (written from the Union Club,

Boston, Massachusetts, July, 1886) reveals, they were done in Woodville's London studio. Woodville was a highly trained and resourceful artist with a prodigious capacity to evolve large, elaborate paintings or illustrations from memory or from notes, photographs, and written description. Yet it is highly unlikely that an artist of Woodville's reputation and background would not have made a trip West; indeed, the evidence does point toward him having done so in 1890. A short biographical note which appears in the Jubilee number of the *Illustrated London News* (50, May 14, 1892) describes the artist as the "English Meissonier," and mentions that he had served as a Special Artist in India, Morocco, North America, and other parts of the world.

A further clue was provided by the artist's method of separating his work from supplied references from that based on actually witnessing the subject, although there is no marked difference in technique or handling. His studio work was invariably signed "RCW" or "R. Caton Woodville," followed by the name of a town, city, or country. For example, the illustration *Braves Leaving the Reservation* is signed "R. Caton Woodville, Pine Ridge, USA." I have checked both his published work as a Special Artist in Turkey, Ireland, India, and Morocco and his work as a literary illustrator and military painter, and find that he scrupulously adhered to this form of signing his work.

Primary sources include the ms. *Family History* compiled by the artist's grandson, Humphrey Caton Woodville, and the artist's personal book of press clippings, updated by his son, Antony Caton Woodville. The artist's autobiography, *Random Recollections* (London, 1914), only referred to events prior to 1890, but contained much useful information; although in the opinion of his son, the truth of some of it is dubious. Mrs. Mabel Jordon of Calgary, who has made an exhaustive study of Baillie-Grohman, was good enough to inform me of his colonization project. Her paper, "The Kootenay Reclamation and Colonization Scheme and William Adolph Baillie-Grohman," *British Columbia Historical Quarterly* (20, Nos. 3–4:187–219), revealed absorbing details of his years in Canada, as did his own article, "Homo-hunting in the Kootenay Valleys of British Columbia," *Illustrated London News* (90, 1887:280).

Additional data on the artist's life, work, and ideas were found in the following articles: anon., "Battle-Painters of the Nineteenth Century, 1: Richard Caton Woodville," *Illustrated Naval and Military Magazine* (1, 1886:50–2); anon., "R. Caton Woodville and His Work," *Illustrated London News* (107, 1895: supplement 2–3); Roy Compton, "A Chat with Caton Woodville," *Idler* (10, 1896–97:759–75); anon., "Sights Seen by a War Artist: An Hour with Mr. R. Caton Woodville," *Chums* (4, 1896: 807); anon., "Mr. R. Caton Woodville," *Boy's Own Annual* (18, 1897:620–1). James Thorpe's comprehensive survey, *English Illustrators: The Nineties* (London, 1935), contained some useful information, as did the early autobiography of a colleague, *Graphic* war artist Frederick Villiers, *Peaceful Personalities and Warriors Bold* (London, 1907).

A comprehensive exhibition of nineteenth-century German drawings and watercolors at the Victoria and Albert Museum, London, 1968, provided an opportunity to identify the influences on Woodville's art, and to once more remind me of the close relationship of German and British painting in the Victorian era. I also read with interest the admirable essay by Dr. Dieter Graf, Keeper of the Print Room at the Düsseldorf Museum, published as an introduction to the catalog.

My background account of the Sioux Outbreak of 1891, as well as British involvement in the West and the phenomenon of imperialism as a motivating theme for Woodville, was based on Robert N. Utley's masterly study, *The Last Days of the Sioux Nation* (Yale, 1963); Robert

Athearn's excellent *Westward the Briton* (Lincoln, 1953); and Professor Heinz Gollwitzer, *Europe in the Age of Imperialism* (London, 1969), which contains an interesting, if incomplete, essay on imperialism in literature and art.

I would like to express my grateful appreciation to Humphrey Caton Woodville of Cambridge, England, for allowing me to read his ms. of the Woodville *Family History,* as well as the artist's scrapbook, and for allowing me to publish various pencil studies and oil sketches; and to the Trigg–C.M. Russell Foundation, Inc., Great Falls, Montana, for permission to reproduce the painting *Western Cavalry Troop.*

10: Charles Edwin Fripp

My account of the Klondike adventures of Charles Edwin Fripp is based on the artist's own articles, which accompanied his illustrations in the *Daily Graphic* (34, 35, 36, April–December 14, 1898), and also the extended caption notes accompanying a further series of illustrations in the *Graphic* (57–59, 1898:99). These were based on a diary kept by the artist and probably refer to places and individuals in even greater detail, but unfortunately its present whereabouts is unknown.

Collecting the outline facts of Fripp's life and career presented little difficulty, but critical appraisal of his art appears not to exist. He was an industrious and serious-minded man who did not seek or attract publicity, nor was his work the subject of popular or informed interest. Like his father, he was a member of the Royal Water-Colour Society, and an occasional exhibitor at the Royal Academy. He may have thought of himself as a genre painter rather than as merely a reporter. My outline is therefore compounded from a miscellany of primary and secondary sources.

References to his work as a Special Artist for the *Graphic* were found in Harry V. Barnett, "The Special Artist," *Magazine of Art* (6, 1883); in an obituary notice in the *Daily Graphic* (Friday, October 6, 1906:76); and in *Who was Who* (London, 1916). Additional references were found in "A Logging Trip to the Rockies," written and illustrated by the artist for the *Graphic* (47, 1893:79–80), in which Fripp describes some of his adventures in the Northwest Territory while "in search of health and subjects." A review of Fripp's exhibition of Japanese watercolors, "The Land of the Rising Sun," *Black and White* (I, 1891:353), refers to his stay in British Columbia, as does the article on his brother, Thomas W. Fripp, by D. A. MacGregor, "Fripp Painted B.C.'s Beauty," Vancouver *Province* (July 24, 1952). This article, together with Edgar I. Fripp's "George Arthur Fripp, 1813–96," *Walker's Quarterly* (1928), also supplied material concerning the large and indefatigable Fripp family. I would also like to acknowledge the assistance of his niece, Mrs. Jocelyne M. Ellis of Pritchard, British Columbia, for personal notes and reminiscences concerning her uncle.

My background account of the Klondike gold rush is drawn mainly from Pierre Berton's definitive *The Klondike Fever* (London and New York, 1958). Berton lived in Dawson as a child. His father, having failed to reach the city by the Stikine Trail, retraced his steps to eventually cross by the Dyea route. Other sources do not have the merit of providing the same overall picture, but being eyewitness accounts, they did enable me to get the respective trails in perspective. These include William Ogilvie, *Early Days on the Yukon and the Story of its Gold Finds* (London and New York, 1913); Colonel Sam Steele, *Forty Years in Canada* (London and Toronto, 1915); Tappan Adney, *The Klondike Stampede* of 1897–98 (New York, 1900); and Hamlin Garland, *Trail of the Goldseekers* (New York, 1899).

Many of Fripp's original drawings and watercolors of the Klondike series, and from other expeditions in British Columbia, were found in the collections of the McCord Museum, McGill University, Montreal, and in the Centennial Museum, Vancouver, British Columbia. I would like to express my grateful appreciation to Mrs. Dobell of the McCord Museum and James B. Stanton, formerly Historian of the Centennial Museum, for their permission to include the examples from their respective collections.

Checklists of Artists' Work

Checklist of Published Western Illustrations by Arthur Boyd Houghton

GRAPHIC, VOLS. 2–7 (1870–73)
"GRAPHIC AMERICA" ("SKETCHES IN THE FAR WEST")

—— **2, July 9, 1870**:40–2, "Going Westward." 39–42, three illustrations: *Pig-Driving in Cincinnati; On Board a River Steamer—Playing at "Seven-Up;" A Scene in the Prison at Chicago* (reprinted *Every Saturday*, 1, September 8, 1870:576, under title *Chicago Prisons—Chorus of Inmates—"Five Cents for a Candle"*).

—— **2, July 16, 1870**:57, "The West." 57–60, three illustrations: *Doing Niagara* (reprinted *ES*, 1, August 20, 1870: 544); *Sisters of Charity in Chicago; Hiawatha and Minnehaha* (reprinted *ES*, 1, August 13, 1870:525). Reproduced Houseman, *Arthur Boyd Houghton* (London, 1896).

—— **2, July 23, 1870**:88–9, "Among the Aborigines." 88–9, four illustrations: *Ute Squaws* (reprinted *ES*, 3, July 8, 1871:40); *Cards on the Prairie; A Pawnee Camp in Midwinter; Pawnees Gambling.*

—— **3, January 14, 1871**:29–32. *Coasting at Omaha* (reprinted *ES*, 2, February 22, 1871: 144). 31, "Buffalo-Hunting." Two illustrations: *In Search of Buffalo* (reprinted *ES*, 2, February 11, 1871:136); *Coming to Grief* (reprinted *ES*, 2, February 18, 1871:160).

—— **March 4, 1871**:204. One illustration: *North American Sports.*

—— **March 11, 1871**:222, "Swapping in the Far West." 221, one illustration: *In the Western States of America—Bartering with Indians* (reprinted *ES*, 2, April 8, 1871:316).

—— **June 17, 1871**:567, "Crossing America by Rail." 569, two illustrations: *The Foot Warmer; Taking a Nap* (reprinted *ES*, 3, July 15, 1871:64).

—— **4, July 8, 1871**:41, "Among the Mormons." Three illustrations: *A "Scallawag;" Cornered* (reprinted *ES*, 1, October 15, 1870: 672); *The Bishop and the Gentile* (reprinted *ES* under title *Among the Mormons—A Dangerous Gentile*, 1, August 5, 1871:789).

—— **4, July 29, 1871**:111–2, "Sketches in the Far West." 116, 117, three illustrations: *Carrying the Mail; The First Buffalo; Crossing a Canyon* (reproduced *Harper's Weekly*, 15, August 26, 1871:796).

—— **4, August 5, 1871**:135–6, "Buffalo-Hunting." 136, one illustration: *Camping Out.*

—— **4, September 2, 1871**:230, "Great Salt Lake City and the Mormons." 228–9, one illustration: *Service in the Mormon Tabernacle, Salt Lake City* (reprinted *ES*, 3, September 30, 1871:320–1; reproduced *HW*, 15, September 30, 1871:912–13, under title *"Sacrament" in the Mormon Tabernacle, Salt Lake City, Utah*).

—— **4, September 9, 1871**:261, "Great Hawk and Small Mormon." 260, one illustration: *Great Hawk and Small Mormon* (reproduced *HW*, 15, October 7, 1857:941).

—— **4, September 23, 1871**:291, "Buffalo-Hunting." 300, one illustration: *A Jamboree.*

—— **4, November 4, 1871**:446, "A Smoke with Friendlies." 445, one illustration, *Sketches in the Far West—A Smoke with Friendlies.* 447, "The Mormon Difficulty." 448, one illustration, *A Mormon Family on their way to Salt Lake City* (reprinted *ES*, 3, December 2, 1871:540–1).

—— **4, December 23, 1871**:603, "Shooting Wild Turkeys in America." 605, 616, two illustrations: *The Triumphant Turkeys; Shooting Turkeys in an American Forest* (reproduced *HW*, 16, supplement, February 3, 1872: 116, 117, under titles *Hunting Wild Turkeys —The Retreat* and *Hunting Wild Turkeys— The Attack*).

—— **4, December 30, 1871**:627, "An Indian Squaw and Her Papoose." 645, one illustration: *Indian Woman and Sick Papoose* (reproduced *HW*, 17, supplement, June 14, 1873: 520, under title *Squaw and Papoose*).

—— **5, February 17, 1872**:142, text note. Front page, one illustration: *The Grand Duke Alexis of Russia under Niagara Falls.* 141, "Utes on the March." 145, one illustration: *Utes on the March.*

—— **5, March 9, 1872**:215, "On the Scout." 220, one illustration: *On the Scout—A Scene in the Backwoods* (reproduced *HW*, 16, April 13, 1872:292).

—— **6, November 30, 1872**:512–13. Double-page illustration: *Between Decks in an Emigrant Ship—Feeding Time.*

—— **7, February 22, 1873**:185. One illustration: *Indians in North America—Pawnee Squaws* (reproduced *HW*, 17, May 3, 1873: 372, under title *Interior of an Indian Wigwam*).

Annotated Checklist of Paintings, Proofs, and Sketches of the Western United States by Arthur Boyd Houghton

1. *Hiawatha and Minnehaha*, 30 x 42. Watercolor. Collection Victoria and Albert Museum, London. Signed ABH. Exhibited Water-Colour Society, London, 1871. Formerly in collection of William S. Caine. Exhibited Glasgow International Exhibition, 1901; Irish International Exhibition, Dublin, 1907; Franco-British Exhibition, Paris, 1908. Ref: *Athenaeum*, May 6, 1871:566; *Graphic*, May 6, 1871:415; *Times*, May 6, 1871. A finely executed picture which depicts Pawnee village, Genoa, Nebraska, which Houghton visited in February, 1870. The figures are based on the illustration of the same title (*Graphic*, 2, 1870:60); the village itself on the illustration *A Pawnee Camp in Midwinter*, 2, 1870:89.

2. *Sketchbook*, 3 x 4¾. Pencil studies. Collection Print Room, Victoria and Albert Museum, London. Contains sketches of figures and scenes made in the eastern as well as the western United States. Some of these formed the basis of various illustrations which appeared in the *Graphic*, Vols. 1–2, 1870. Scattered through the book are notes, names, and addresses. There are fifty-five pages (some have been torn out). Sketchbook has

brown morocco binding with brass clasp and is inscribed "This is Houghton's Sketch Book/the one eye Artist/Scenes in America."

		Titles
	10	Studies for *Pig-Driving in Cincinnati*
facing	15	Ute and Papoose. Study for *Indian Woman and Papoose*
facing	18	Sketch for *Service in the Mormon Tabernacle, Salt Lake City*
	18	Sketch of Pawnee, dated February 3, 1870
		(top) Sketch of market entitled "Syracuse"
		(bottom) Sketch of wagon entitled "Chicago"
facing	29	Sketch of Pawnee and oxen
	29	Heads of buffalo. Study for *Buffalo-Hunting: Camping Out*
facing	37	Study for *Boston Pets*. Inscribed "Boston young lady lifts the veil to sob!" (*Graphic*, 1, 1870:512)
	42	Sketch of woman. Inscribed "Bed Maker, McPhersons, Tuscola"
facing	54	Study of gamblers for *On Board a River Steamer—Playing at "Seven-Up"*

3. *The Embarkation*, 9 x 11¾. Proof from original woodblock. Collection Print Room, Victoria and Albert Museum, London. (*Graphic*, 1, 1870:322).

4. *Hiawatha and Minnehaha*, 10½ x 8¾. Proof on mulberry paper from original woodblock engraved by Swain. Layard Collection, Department of Prints and Drawings, Museum of Fine Arts, Boston, Massachusetts. (*Graphic*, 2, 1870:60).

5. *Coasting at Omaha*, 8¾ x 11¾. Proof on mulberry paper from original woodblock engraved by Swain. Layard Collection, Department of Prints and Drawings, Museum of Fine Arts, Boston, Massachusetts. (*Graphic*, 3, 1871:29).

6. *Bartering with Indians*, 9 x 11¾. Proof from original woodblock. Collection Print Room, Victoria and Albert Museum, London. (Published *Graphic*, 3, 1871:221, under title *In the Western States of America—Bartering with Indians*)

7. *A Cast of the Log*, 6 x 9. Proof on mulberry paper from original woodblock. Layard Collection, Department of Prints and Drawings, Museum of Fine Arts, Boston, Massachusetts. (*Graphic*, 1, 1870:345)

SKETCHES FOR "GRAPHIC AMERICA"

The following pencil studies of varying sizes from different sketchbooks were mostly made on the voyage from Liverpool to New York. They form part of various illustrations of emigrant life in the steerage of the *City of Brussels*. Layard Collection, Department of Prints and Drawings, Museum of Fine Arts, Boston, Massachusetts.

8. *Various Figures of Emigrants*, 5 x 4.
9. *Study of Bearded Man*, 2 x 2.
10. *Profile* (of Shaker Evans), 2 x 2. Before going West, Houghton visited the Shaker colony at Mount Lebanon, near Pittsfield, Massachusetts. Several illustrations resulted, including *Shaker Evans at Home*, for which this sketch was made (see *Graphic*, 3, 1871: 213).
11. *Various Figures of Emigrants*, 5 x 4½.
12. *Study of Couple*, 3¼ x 3¼. A sketch of Mr. and Mrs. Jones, the artist's traveling companions on board the *City of Brussels*.
13. *Study of Emigrant*, 4 x 3¼.
14. *Emigrants*, 6¾ x 4⅝.
15. *Seated Woman*, 6½ x 4¾. Study for figure in the illustration *The Embarkation* (*Graphic*, 1, 1870:322).
16. A second group of seven small pencil sketches used by Houghton in his "Graphic America" illustrations. These are of women and children and were made on the *City of Brussels*. Some form the basis of the artist's illustrations of emigrant life on the ship, notably the double-page *Between Decks in an Emigrant Ship—Feeding Time* (*Graphic*, 6, 1872:512-13). Dalziel, sold to Christie's, March 17, 1876; Colnaghi, 1949; sold to National Gallery of Canada, 1949. Collection Department of Drawings, National Gallery of Canada, Ottawa.

Checklist of Watercolor Drawings and Published Illustrations of California by William Simpson

1. *Captain Jack's Cave in the Lava Beds, Lake Tule, April, 1873*, 10¾ x 17¼. Watercolor over pencil. Collection Bancroft Library, University of California, Berkeley. (*ILN*, May 31, 1873:512)
2. *Modoc Indians in the Lava Beds*, 11 x 16½. Watercolor over pencil. Collection Peabody Museum, Harvard University. (*ILN*, June 7, 1873:536)
3. *The Grizzly Giant, Mariposa, California*, 9½ x 15¾. Watercolor over pencil. Signed and dated May 9, 1873. Collection The Holden Arboretum, Mentor, Ohio. (*ILN*, 79, 1881:460)
4. *Fallen (Big) Tree at Mariposa, California* (*The Fallen Monarch*), 10¼ x 13⅝. Watercolor over pencil. Signed and dated May 9, 1873. Collection The Holden Arboretum, Mentor, Ohio. Unpublished *ILN*. Reproduced Simpson, *Meeting the Sun* (London, 1874).
5. *Modoc Sketchbook*, 4½ x 6. Pencil studies. David I. Bushnell Collection, Peabody Museum, Harvard University. No. 101/41-72/ 477.

Artist's Titles

1 *Dead Modoc, 23 April, 1873*
3 *Dead Modoc, 23 April, 1873*
5 *Lava Beds, 24 April, 1873*
7 *Dead Modoc Squaw, 24 April, 1873*
9 *John, a Warm Springs Indian, 24 April, 1873*
11 *American Officer's Greatcoat, Lava Beds, 25 April, 1873*
12 *The Lava Beds, American Soldier, 25 April, 1873*
13 *American Soldier, Lava Beds, 25 April, 1873* (with detail of pistol in holster inscribed "pistol")
14-15 *Mount Shasta, from the East End of Butte Valley, 27 April, 1873* (2-page sketch)
16-17 *Cedars near Butte Valley, 27 April, 1873*
 Sage Brush
18 *Mount Shasta, from the North East, 29 April, 1873*
19 *McLeod Indians*
21-22 *Sacramento Valley, 1 May, 1873* (2-page sketch)

6. *Asia—U.S.A. Sketchbook*, 8½ x 10¼. Pencil studies. David I. Bushnell Collection, Peabody Museum, Harvard University. No: 100/

41-72/496. Inscribed "Hankow-Japan-Yosemite, 1872-3. WS. 64 Lincoln's Inn Fields, London."

Artist's Titles

i *San Francisco from Oakland, 2 April, 1873* (2-page sketch)
ii *The Witches' Cauldron, Geysers, 10 April, 1873*
iii *The Devil's Pulpit, Geysers, 10 April, 1873*
iv *The Devil's Tea Kettle, The Geysers, Sonoma C. California, 10 April, [1873]*
v *The Devil's Canyon, Geysers, Sonoma (County)*
vi *California, 11 April, 1873. 4343 (Gao Sur?)*
 St. Helena Mountain, Calistoga, 11 April, 1873
vii *Sequoia Gigantes "The Fallen Monarch" Lower Grove, Mariposa Group, 9 May, 1873* (study for watercolor *Fallen Tree at Mariposa, California*. Artist Bierstadt seated in tree?)
viii *The Grizzly Giant, Lower Grove, 9 May, 1873* (study for watercolor *The Grizzly Giant, Mariposa, California*)
ix *Pluto's Chimney* (burned stump of a big tree)
 Mariposa Group, Upper Grove, 9 May, 1873
x *The Nevada Fall, Yosemite, 11 May, 1873*
xi *Cap of Liberty & Nevada Fall, Yosemite, 11 May, 1873*
xii *The Vernal Fall. From Lady Franklin's Seat, Yosemite, 11 May, 1873*
xiii *The Sentinel Rock, Yosemite Valley, 11 May, 1873*
xiv Ditto
xv Two details inscribed "12 May, 1873"
xvi Two details inscribed "Yosemite, 13 May, 1873"
xvii Ditto
xviii Ditto
xix *Cathedral Rocks, Yosemite Valley, 11 May, 1873* (and small sketch inscribed "14 May, 1873")
xx *The Virgin's Tears, 14 May, 1873*
xxi Two small sketches inscribed "Yosemite, 14 May, 1873"
xxii-xxiv Three small sketches: *North Downs* (2 sketches); *The Virgin's Tears, 14 May, 1873*
xxv *The Royal Arch and North Downs, Yosemite, 15 May, 1873* (2-page sketch)
xxvi Two small sketches inscribed "Cathedral Rocks, Yosemite Valley, 15 May, 1873"
xxvii *Yosemite Valley, 15 May, 1873*
xxviii *Salt Lake from Salt Lake City, Utah, 20 May, 1873* (2-page sketch, with smaller sketch bottom left)
xxix *Railway Viaduct over Missouri at Omaha, 25 May, 1873* (with smaller sketch of same at top left)

ILLUSTRATED LONDON NEWS (1873-81)

—— **62, 1873**:496. Full-page illustration: *Lake Tule with the Lava Beds and Headquarters Camp.*

—— **62, 1873**. 522, "The Modoc Indian War." Seven illustrations: front page, *Eskenawah or Bob, Dalles Indian; Mainstake, Modoc Indian Woman, Wife of Long Jim; Scalp of Scar-faced Charlie; Medicine-flag of the Modocs;* 508-9 (double page), *The Mur-*

der of General Canby by the Modoc Indians; 512, *Captain Jack's Cave in the Lava Beds;* 522, *Modoc War Drum.*

—— **62, 1873**. 531, "The Modoc Indian War." Four illustrations: 512 (double page), *The Lava Beds, Lake Tule, California;* 536, *The Modoc Indians in the Lava Beds;* 537, *Mount Shasta, Siskiyou County; Entrance to Captain Jack's Cave.*

—— **69, 1876** (supplement). 411, "Chinese Emigrants to America." Between 428-9, double-page illustration: *Chinese Emigration to America: Sketch on Board the Steamship "Alaska," Bound for San Francisco.* (Text note, 411.)

—— **70, 1877**:248. Half-page illustration: *A Log Hut in California.*

—— **79, 1881**:454, text note. 460, full-page illustration: *The Grizzly Giant, Mariposa, California.*

Annotated Checklist of Paintings and Illustrations of Western Canada and the United States by Valentine Walter Bromley

1. *Midday Rest, Sioux Indians*, 48 x 60. Oil on canvas. Collection Earl of Meath. Exhibited Royal Academy, 1875. Ref: *Art Journal*, 1875:252; *ILN*, April 24, 1875:391.
2. *Shifting Camp, Nebraska*. Exact size unknown. Watercolor. Present whereabouts unknown. Exhibited Royal Institute of Painters in Water-Colours (autumn), 1875.
3. *Crow Indian Woman*, 42 x 72. Oil on canvas. Signed and dated 1876. Collection Earl of Dunraven. I have not succeeded in discovering the artist's title for this picture. As far as is known, it was not exhibited.
4. *Pahauzatanka, the Great Scalper*, 48 x 60. Oil on canvas. Signed and dated 1876. Collection Earl of Dunraven. Exhibited Royal Academy, 1876. Ref: *ILN*, May 13, 1876: 475; *Times*, May 31, 1876; *Graphic*, June 10, 1876:571; *Graves*, 1:296.
5. *Crow Indian Burial*, 42 x 72. Oil on canvas. Signed and dated 1876. Bromley's title for the picture unknown. Collection Earl of Dunraven.
6. *Canoe Shooting a Rapid*, 48 x 60. Oil on canvas. Signed and dated 1876. Collection Department of External Affairs, Ottawa, Canada. Sold Laing Galleries, Toronto, 1968.
7. *The Big Chief's Toilet*, 23¾ x 35¾. Watercolor. Signed and dated Valentine W. Bromley, 1875. Kennedy Galleries, New York. Described as *Indians in Camp, Canada, 1875*. According to Ewers this may be the famous Crow Chief Blackfoot whom the Dunraven party met. The scene, therefore, is more likely to be a Crow camp on the Crow agency. See, Dunraven, *Great Divide* (London, 1876), 62, 97. Exhibited Royal Institute of Painters in Water-Colours (spring), 1875; also at Fine Art Gallery, Crystal Palace, London, 1877, where it won artist a gold medal. Ref: *Graphic*, April 24, 1875: 399; *ILN*, May 5, 1875:430.
8. *Counting his Coups*, 10 x 14. Process wash drawing. Signed. Collection Earl of Meath. Reproduced *Great Divide*, frontispiece.
9. *Canoe Shooting a Rapid*, 10 x 14. Ink and gouache. Signed V. W. Bromley. Collection Earl of Meath. Reproduced *Great Divide*, opp. 27. Bromley based his large oil painting of the same title (No. 6) on this illustration.
10. *A Noble Savage in Town*, 16 x 18. Process wash drawing. Signed. Collection Earl of Meath. Reproduced *Great Divide*, opp. 64.
11. *Cache*, 10 x 14. Process wash drawing. Signed V. W. Bromley. Collection Earl of Meath. Reproduced *Great Divide*, opp. 99.
12. *Doubtful Friends*, 11½ x 16½. Process wash drawing. Signed VWB. Collection Earl of Meath. Reproduced *Great Divide*, opp. 118.
13. *Elk or Indians?* 12 x 16. Process wash drawing. Signed V. W. Bromley. Collection Earl of Meath. Reproduced *Great Divide*, opp. 130.

14. *Mule Packing*, 9⅝ x 13¼. Process wash drawing. Signed V.W. Bromley. Collection Earl of Meath. Reproduced *Great Divide*, opp. 139.

15. *Making Camp*, Size and whereabouts unknown. Reproduced *Great Divide*, opp. 144.

16. *A Yellowstone Highway*, 14 x 21½. Process wash drawing. Signed V.W. Bromley. Collection Earl of Meath. Reproduced *Great Divide*, opp. 149.

17. *Making the Best of it*, 10 x 14. Process wash drawing. Collection Earl of Meath. Reproduced *Great Divide*, opp. 173.

18. *Indians by Jove!*, 10 x 16. Process wash drawing. Signed VWB. Collection Earl of Meath. Reproduced *Great Divide*, opp. 210.

19. *Stalking the Ram*, 10 x 14. Ink and wash. Signed V.W. Bromley. Reproduced *Great Divide*, opp. 357.

20. *Mexican Saddle*, 3¼ x 2¾. Ink and wash drawing. Collection Peabody Museum, Harvard University. Reproduced *Great Divide*, 179.

21. *An Indian and his Horse*, 3 x 2½. Ink and wash drawing. Collection Peabody Museum, Harvard University. Reproduced *Great Divide*, 252.

22. *Papoose*, 3¾ x 2. Ink drawing. Peabody Museum, Harvard University. Reproduced *Great Divide*, 128.

23. *Sleeping Bear*, 1¾ x 2¾. Ink and wash drawing. Collection Peabody Museum, Harvard University. Reproduced *Great Divide*, 293.

24. *Bighorn Ram*, 3½ x 2¾. Ink and wash drawing. Collection Peabody Museum, Harvard University. Reproduced *Great Divide*, 377.

ILLUSTRATED LONDON NEWS, VOLS. 68–70 (1875–77)

——— **68, 1875**:187, "Driving Cattle into a Corral." 188–9, double-page illustration: *Driving Cattle into a Corral, Nebraska*.

——— **69, 1876**:344, "American Indians Traffic." 336, full-page illustration: *American Sketches: Indians at a Hide-Trader's Hut*. This may have been drawn at the Crow agency on the Yellowstone River.

——— **69, 1876**:405, "The Sioux Indians of North America: American Indians' Courtship." Full-page illustration: *American Sketches: Indian Courtship*. As the Dunraven party did not visit a Sioux camp, this is more likely Crow, the title having been changed to include a reference to the Sioux because they were very much in the news.

——— **70, 1877**:247, "American Prairie Travelling." 248, full-page illustration: *Prairie Travelling: Indians in Sight*. The Indians are referred to as Sioux in the text note.

Checklist of Published Illustrations by Sydney Prior Hall with Notes by the Artist

GRAPHIC, VOL. 17 (1879)

——— **February 22**:190, text by artist. 173, full-page illustration: *Moose-Hunting in Canada—A Night in a Shanty*.

——— **March 22**:295, text by artist. 300, full-page illustration: *Canadian Sketches—A Moose-Hunting Expedition: On the Road*.

GRAPHIC, VOLS. 24–25 (1881–82)

"TO THE GREAT NORTH-WEST WITH THE MARQUIS OF LORNE"

——— **24, August 13, 1881**:164, Part 1: "The Voyage to Quebec." 173, eight illustrations: *Emigrants "All Hope Abandoned"; John James McDonald, A Prince Edward Islander; The Captain's Patients; Dipping Her Nose into it; A Man Overboard; Newfoundland Padre; Veteran "Cod-banger" Captain Smart; The Skipper, S.S. Caspian*.

——— **24, August 20, 1881**: Part 2. 179–80, two illustrations: *Military and Naval Manoeuvres at Halifax; Quebec-Scalp Dressing in the North-West*.

——— **24, August 27, 1881**: Part 3. 203 and front page, seven illustrations: *Toronto—Goodbye to the Governor-General; In the Stern of the Francis Smith, Passing through Wilson's Channel; Thunder Cape, from Silver Islet; Bows of Francis Smith, Prince Arthur's Landing in the Distance; Quebec; The Governor-General out Sketching; Westward Ho! Sunset at Collingwood, Killarney, Georgian Bay*.

——— **24, September 5, 1881**:235, Part 4. 260, ten illustrations: *Nearing Devil's Gap, Rat Portage; Pow-wow, Garden River Reserve on St. Marie River; Eagle Lake; How Mr. Norquay Raised a Mountain in Manitoba; Arrival at Dryberry Lake; Wabegoon Lake, The Yacht Carrying His Excellency from the Tug; View of Winnipeg from St. Boniface College; Lake of the Woods, Line of Canoes; His Excellency Holding a Drawing Room on the Canadian Pacific Railway, an Indian Chief Introducing his Favourite Squaw; The Great Blackstone Laying Down the Law*.

——— **24, September 10, 1881**:267, Part 5. 281, seven illustrations: *A Sun Halo, Lake Superior; Prince Arthur's Landing; Chief Nauguabo and the Hon. Mr. Norquay; Old Fort Garry, Winnipeg; Winnipeg; Inside Barge on Eagle Lake; An Indian War-Dance*.

——— **24, October 1, 1881**: Part 6. 339, fifteen illustrations: *"Little Black Bear," Daughter of Cree Chief; The Captain of the Gate, Fort Qu'Appelle; Chief Cote, Fort Pelly; Chief Oscop, The Indian who Did not Want Tobacco; Ravine, Qu'Appelle River; Half-breeds, Fort Qu'Appelle; Crossing Assiniboine, Fort Ellice; Pow-wow, Fort Qu'Appelle; Interviewing a Settler; His Excellency Writing His Diary; The Marquis of Lorne; Under a Mosquito Tent; Waywaysacapo, A Salteaux Chief; The Governor-General's Ambulance*.

——— **24, October 22, 1881**: Part 7. Three illustrations: 411, *On East Bank of South Saskatchewan River*; 414, *Pow-wow, Fort Carlton*; 428, *Chippeway Indians Dancing the Sioux Dance, Rat Portage*.

——— **24, November 5, 1881**:459, Part 8. 464–5, one illustration: *The Pow-wow at Black Feet [sic] Crossing, September 10*.

——— **November 19, 1881**: Part 9. Two illustrations: 507, *A Buffalo Dance, Fort Qu'Appelle*; front page, *Dr. MacGregor at Fort MacLeod*.

——— **24, November 26, 1881**:531, Part 10. 533, one illustration: *A Buffalo Hunt in the Red River Valley—The "Coup de Grâce."*

——— **24, December 3, 1881**: Part 11. 448, seven illustrations: *Train of Red River Carts; Red River Pastorals; A Freighter's Nursery on the Road to Silver Heights, Winnipeg; Near Calgary, Dr. MacGregor Gauges Height of Straw; Lord Lorne and Suite Count the Grains; Bow River—Mr. McHugh's Indian Supply Farm, An Indian Farm Labourer; Mr. James Scott's Touchwood Hill Farm*.

——— **24, December 10, 1881**:579, Part 12. 584–5, one illustration: *Nearing the Last Portage on Clear Water Lake, July 28*.

——— **24, December 17, 1881**:607, Part 13. 608, eight illustrations: *Marquis of Lorne at Penitentiary, Winnipeg; The Times Correspondent Playing "Bete-Noir;" Dr. MacGregor, Mosquito Proof; The Graphic Meets a Brother Artist; Heir of the Bagots Gathering Prairie Fuel; Dr. MacGregor Annexes a Badger at Calgary; Colin Sewell M.D. Studies Indian Medicine; Dilapidated Condition of Lord Lorne and Suite*.

——— **24, December 24, 1881**:631, Part 14. 645, two illustrations: *Outside the Pale, while Dr. MacGregor is Preaching, Mission House, Fort MacLeod; Indians in Fort MacLeod*.

——— **24, December 31, 1881**:655, Part 15: "The North-West Mounted Police." 657, eight illustrations: *Horses Swimming the South Saskatchewan; Escorting Lord Lorne into Fort MacLeod; Crossing Old Man River; Pulling the Cook's Waggon; Putting out a Prairie Fire; Lieut.-Colonel Irvine, in Command Guard of Honour; Brevet-Lieut.-Colonel Herchmer NWMP and Major Crozier NWMP; Crossing the South Saskatchewan in the Scow*.

——— **25, January 14, 1882**: Part 16. 29–30, eleven illustrations: *Silver Island, Lake Superior; Quebec Mine, Michipiaten Island; Humboldt, Great Salt Plain; The Cathedral, Prince Albert; Emmanuel College, N. Saskatchewan; Hudson's Bay Company Mill on Banks of the Saskatchewan; Dr. McLean, Bishop of Saskatchewan; Fort Carlton; Bows of Hudson's Bay Co.'s Steamer Northcote; The Saskatchewan River near Battleford; The Old Roman Catholic Church at Battleford*.

——— **25, January 21, 1882**:51, Part 17. 53, two illustrations: *An Indian Mother; Abandoned*.

——— **25, January 28, 1882**:75, Part 18: "Progress in the Great North-West." 77, one illustration: *Blackfoot Crossing*.

——— **25, February 5, 1882**:99, Part 19: "Crossing the Boundary Line." 101, six illustrations: *Rolling Prairie; A Visit to the Blackfeet Lodges, Fort MacLeod; Chief Mountain, On the Boundary Line between British and American Territory; Our American Mule Team Ambulance and Lieutenant Rowe, U.S. 3rd Infantry Regiment in Charge of Escort; Across the Line, Lord Lorne Received in a Sibley Tent at the Indian Reserve; A Republic of Prairie Dogs*.

GRAPHIC, VOL. 35 (1887)

——— **January 8**:44–5. Double-page spread of thirteen illustrations based on sketches from artist's travels, entitled "A Hunt for a Christmas Dinner in Manitoba." (Text note, 30.)

GRAPHIC, VOL. 64 (1901)

——— **October 26**: front page. One illustration: *The Royal Tour in Canada: A Ride on a Cowcatcher* (drawn by W. T. Maud after pencil sketch by Hall). 541, full-page illustration with extended caption: *The Great Indian Pow-wow at Calgary*.

——— **November 2**:574. One illustration: *View from Banff Springs Hotel*. **Supplement**: 5. One illustration: *Nearing the Rockies: The Grand Prospect from the End of the Train*. (text, "The Duke of Cornwall's Tour," columns 1 and 2).

DAILY GRAPHIC, VOL. 49 (1901)

——— **October 26**: front page. Two illustrations: *On the Horns of a Dilemma: An Incident in the Royal Tour; A Loyal Lad of Laggan, Sir Wilfred Laurier, Encouraging Juvenile Patriotism at a Station in the Rockies*.

——— **October 29**: front page. One illustration: *The Last of the Buffaloes: The Duke and Duchess of Cornwall Inspecting the Herd at Banff* (drawn by Douglas MacPherson after sketch by Hall).

Annotated Checklist of Paintings, Watercolor Drawings, Pencil Drawings, and Sketches of Western Canada and United States by Sydney Prior Hall

1. *Last Indian Council Held on Canadian Soil between the Governor-General of Canada, and Crowfoot, Chief of the Blackfeet Indians, 1881*, 60 x 80. Oil on canvas. Thomas Gilcrease Institute of American History and Art, Tulsa, Oklahoma.

2. *Conference of the Marquis of Lorne and Blackfeet Indians, September, 1881*, 58 x 94. Charcoal and watercolor on paper. Study for the above painting. Public Archives of Canada, Ottawa.

3. *The Duke of Argyll* (Marquis of Lorne), 48 x 36. Oil on canvas. Signed and dated 1910. Collection Duke of Argyll, Inverary Castle, Argyllshire, Scotland.

4. *Sketchbook, Canada 1878, North-West 1881*. Pencil drawings and studies of varying sizes cut from sketchbooks of different sizes. Mounted in a large photograph album

and inscribed by the artist. Public Archives of Canada, Ottawa.

Artist's Titles

1 *Micmac Indians waiting to receive L[ord] Lorne in Halifax, 1878*
2 *Crossing the Pond—Man overboard!* (*Graphic*, August 13, 1881:173)
3-4 *Emigrants* (*Graphic*, August. 13, 1881:173)
5 Title unintelligible
6 Untitled (man on deck)
7 Untitled (clergyman)
8 Sketch for rigging in *Crossing the Pond—Man overboard!* (*Graphic*, August 13, 1881:173)
9 *Dipping her nose into it* (*Graphic*, August 13, 1881:173)
10 *A Newfoundland Padre* (*Graphic*, August 13, 1881:173)
11 *The Skipper, S. S. Caspian* (*Graphic*, August 13, 1881:173)
12 *The Captain's Patients* (*Graphic*, August 13, 1881:173)
13 *St. John's, Newfoundland, Amherst Light-house*
14 *Captain Heart [Smart], Commodore of the Fishing Fleet, Newfoundland* (*Graphic*, August 13, 1881:173)
15 *St. John's, Newfoundland, landing of the Governor*
16 *A Prince Edward Islander, John James MacDonald* (*Graphic*, August 13, 1881: 173)
17 *In the Steerage*
18 *Steerage!*
19 *In the Steerage*
20 *Sunday, July 17—Dipping our flag to the French Ship—"La Magicienne," Quebec*
21 *His X's [Excellency's] Suite in a barber's Shop, Quebec* (*Graphic*, August 20, 1881: 180)
22 *Quebec—The Gov[ernor] Gen[eral] out sketching on the P[or]t Levis side* (*Graphic*, August 27, 1881: front page)
23 *Quebec. Ruins of Church of St. Jean etc. burnt by late fire*
24 *Bush fires from the Citadel, Quebec·*
25 *Queen of the Lakes—Kingston*
26 *Westward Ho! Collingwood, July 21* (*Graphic*, August 27, 1881: front page)
27 *22 July, Killarney (Ont[ario] Manitoulin Co.)*
28 *Naugaubo [the] man who made first speech at Little Current*
29 *24 July. Apparently a kind of mirage on board ship* (*Graphic*, September 10, 1881: 281)
30 *Quebec Harbour—Michipicoten Island, Lake Superior* (copper mines)
31 *Quebec Mine—Michipicoten Island, Lake Superior* (*Graphic*, January 14, 1882:30)
32 *Golding*
33 *Stern of "Francis [sic] Smith"—passing through Wilson's Channel* (*Graphic*, August 27, 1881: front page)
34 *L[or]d Lorne and the Capt[ain], "S.S. Francis [sic] Smith" standing in bow—Prince Arthur's Landing in distance, 25 July*
35 *Bows of "S.S. Francis [sic] Smith." Prince Arthur's Landing in distance. 25 July* (*Graphic*, August 27, 1881: front page)
36 *Chiefs—Garden River Reserve waiting on the wharf for our boat*
37 *Pow-wow—Garden River Reserve on the St. Marie River* (*Graphic*, September 5. 1881:260)
38 *Thunder Bay, July 25*
39 *Thunder Cape from Silver Islet* (*Graphic*, August 27, 1881: front page)
40 *Silver Island from the "Hattie Vinton" tug as we approached*
41 *Prince Arthur's Landing, 25 July* (*Graphic*, September 10, 1881:281)
42 *Prince Arthur's Landing, 25 July*
43 *The Great Black Stone, Ojibway Indian* (*Graphic*, September 5, 1881:260)

44 *Indian War Dance—26 July* (*Graphic*, September 10, 1881:281)
44a *Indian Wigwam on the line of CPR, 26 July*
45 *Fort William, MacKay's Mountain, 26 July*
46 *Corner of a lake on the CPR where we halted to lunch. 26 July*
47 *26 July, River and Canoes*
48 *Webigon Lake, Lake of Flowers, July 27*
49 *Canoe towed by the yacht. Wabigon Lake. 27 July—Lake of Flowers*
50 *Yacht carrying His X [Excellency] sketched from tug* (*Graphic*, September 5, 1881: 260)
51 *Garden Island Camp, Eagle Lake. 27 July*
52 *Salute fired from Eagle River City in dynamite. Stone falling into waters of lake*
53 *28 July, Gentlemen, the Queen*
54 *Eagle Lake* (*Graphic*, September 5, 1881: 260)
55 *Clearwater Lake. 28 July*
56 *25 July* (boat or canoe)
57 *28 July* (sky and water scene)
58 *28 July. Dryberry Lake—Camp fire effect*
59 *29 July—Ho! Dryberry Lake. MacDonald—Blanchard—Kennedy*
60 *29 July—Dryberry Lake* (*Graphic*, September 5, 1881:260)
61 *29 July, Lake of the Woods* (*Graphic*, September 5, 1881:260)
62 *29 July* (study of canoes for above)
63 *29 July* (ditto)
64 *Leaving the Devil's Gap. Rat Portage, July 29* (*Graphic*, September 5, 1881:260)
65 *Chippeways dancing the Sioux dance at Rat Portage* (*Graphic*, October 22, 1881:428)
66 *Manitobenes*
67 *Squaws and papooses, July 28*
68 *Manitobenes*
69 Sketch inscribed "copy from Catlin's North American Indians (Wun-nes-tou, the White buffalo)"
70 *Old Fort Garry before the walls were taken down* (*Graphic*, September 10, 1881:281)
71 *How Mr. Norquay [Premier of Manitoba] raised a mountain in Manitoba* (*Graphic*, September 5, 1881:260)
72 *Mr. Cauchon's Garden Party, Fort Garry. August 4*
73 *Joseph Sabesta*
74 *Young Moose—Penitentiary*
75 *View from top of St. Boniface College* (*Graphic*, September 5, 1881:260)
76 *View of Winnipeg* (*Graphic*, September 10, 1881:281)
77 *Smudge! Fort Ellice, August 13*
78 Untitled portrait sketch of a man
79 *The Hon. Mr. Norquay, Premier of Manitoba,* (*Graphic*, September 10, 1881:281)
80 Study of man, inscribed "A half-breed, Buffalo Bill's go show." A note by the artist reads as follows: "This and other sketches in colour were made as studies for the picture [*The Last Great Indian Council*] painted for the Duke of Argyll [Marquis of Lorne] and commissioned in the year of Buffalo Bill's Show." (Part of the American Exhibition, Earl's Court, London, which took place in June, 1887.)
81 *Father Dugast*
82 *A View of Winnipeg from amongst the lightning rods of St. Boniface College*
83 *Sketch of L[or]d Lorne in helmet* (*Graphic*, October 1, 1881:339)
84 Untitled sketch of Indian, inscribed "From Buffalo Bill's Show" (London, 1887)
85 *A Red River pastoral* (*Graphic*, December 3, 1881:588)
86 *Indians perched on a railway track at Portage la Prairie*
87 *The last of the line, August 8* (the end of the C.P.R. tracks somewhere in the Shield country)
88 *Camp near Pine Creek in Sand Hills*
89 *Dr. Macgregor* (dated October 1, Silver Star, Montana)
90 *Dr. Macgregor of Tron* (*Graphic*, Decem-

ber 17, 1881:608)
91 *Lt. Governor of the North-West interviewed by Dr. Macgregor*
92 *Amazing! Dr. Macgregor at lunch hearing an account of the fertility of the soil in Canada*
93 *Little Touchwood HBC [Hudson's Bay Company] Store*
94 *Sketch of Dr. Macgregor. 24 September*
95 *The Doctor [Macgregor] in Montana*
96 *Sunrise in Qu'Appelle Valley, 17 August*
97 *9 August. Mr. Alcox's Pony at Mr. Murphy's hotel*
98 *Interviewing an Eighteen months' settler* (*Graphic*, October 1, 1881:339)
99 *Aurora Borealis. 12 August, 10 pm*
100 *Mr. Bishop* (inscribed "Man Marquette Co.")
101 *Rapid City*
102 *Correspondent* (probably Charles Roche)
103 *Colonel de Winton*
104 *Dr. Colin Sewell*
105 Untitled portrait
106 *Charles Austin of the "Times"*
107 *M. Boquet L[or]d Lorne's cook*
108 *SPH* (self-portrait)
109 *Major Percival*
110 *Dr. Colin Sewell*
111 *Captain Bagot*
112 *Sewell* (drawn in train in the United States. Inscribed "Council Bl[uffs].")
113 *Captain Chater*
114 *Teams crossing the Assiniboine at Fort Ellice, August 13* (*Graphic*, October 1, 1881: 339)
115 *Fort Ellice/1*
116 *Fort Ellice/2*
117 *Fort Ellice/3*
118 Untitled sketches of heads of Indians, inscribed "From Buffalo Bill's Show" (London, 1887)
119 *Pow-wow at [Fort] Ellice 13 August*
120 *Moo-soo-min (old "gooseberry") pleading for "grub"*
121 *Fort Ellice, August 13. Squaws and papoose*
122 Untitled study of Indian woman, inscribed "From Buffalo Bill's Show" (London, 1887)
123 *Halfbreed tents, Shoal Lake. The residence of Mr. Dewdney and the Barracks of the NWMP*
124 *Waywaysacapo, Chief of one band of the Saltaux.* Inscribed "The man that always stands right. His totem [at right] drawn by himself." (*Graphic*, October 1, 1881: 339)
125 *Major Crozier Supt., NWMP* (*Graphic*, December 31, 1881:657)
126 *Colonel Irvine* (*Graphic*, December 31, 1881:657)
127 *Colonel Herchmer NWMP* (*Graphic*, December 31, 1881:657)
128 *Corporal Shaw, NW Mounted Police Force.* Study for illustration *The Pow-wow at Black Feet [sic] Crossing* (*Graphic*, November 5, 1881:464-5)
129 *Mr. Dewdney. Chief of the Indian Department.* Study for illustration *The Pow-wow at Black Feet [sic] Crossing* (*Graphic*, November 5, 1881:464-5)
130 Untitled pencil and watercolor study of seated Indian, inscribed "From Buffalo Bill's Show" (London 1887)
131 *A relic of the past. August 16* (buffalo skull)
132 *Side of Ravine, Qu'Appelle Valley, August 17*
133 *A Valley of River* (prairie scene)
134 *The Ravine which runs into the valley of the Qu'Appelle River, August 17* (*Graphic*, October 1, 1881:339)
135 *Halfbreed from Catholic Mission*
136 *A group of chiefs assembled to meet Ex[cellency] Lord Lorne] at Qu'Appelle*
137 *The Captain of the Gate* (*Graphic*, October 1, 1881:339). This is a sketch of a little

Scots boy—Duncan McLean—son of a local pioneer.

138 *The Buffalo dance of the Sioux at Qu'Appelle Fort. August 18.* (*Graphic*, November 19, 1881: front page). Reproduced Argyll, *Canadian Pictures* (London, 1884), 157.

139 Group of sketches for the above illustration

140 Ditto

141 *Pow-wow at Fort Qu'Appelle. August 18. Standing Buffalo, Chief of the Sioux, addressing Lord Lorne*

142 *Portrait of an Indian*

143 *Little Black Bear. Daughter of Cree Chief [Black Bear]* (*Graphic*, October 1, 1881: 339)

144 *Chief Cote, Fort Pelly* (*Graphic*, October 1, 1881:339)

145 *Osoop Back Fat, Saltaux Indian* (*Graphic*, October 1, 1881:339)

146 *Touchwood Hill Farm: Candidates for Honours* (*Graphic*, December 3, 1881: 572)

147 *Touchwood Candidates for Honours* (the Indian harvest-hands, Red Eagle, Massan, and Going Round)

148 *Touchwood Hill Farm* (*Graphic*, December 3, 1881:572)

149 Large group of Indians, untitled

150 Missing

151 *Horses of Mounted Police Swimming S[outh] Saskatchewan. August 25* (*Graphic*, December 31, 1881:657)

152 *Indian Wigwams or Tepees (as called here) at Little Touchwood. H[udson's] B[ay] Co. Store, 20 August*

153 *On the East bank of the South Saskatchewan, August 24* (*Graphic*, October 22, 1881:428). Dog in sketch is Colonel de Winton's "Rab."

154 *Crossing South Saskatchewan. August 25* (*Graphic*, December 31, 1881:657)

155 *27 August, Emmanuel College. Prince Albert, Warden, Bishop of Saskatchewan* (*Graphic*, January 14, 1882:29–30)

156 *Saskatchewan Jack. Bishop of Saskatchewan (Rev. John McLean)* (*Graphic*, January 14, 1882:29–30)

157 *27 August. Prince Albert H[udson] B[ay] Co. Mill* (*Graphic*, January 14, 1882: 29–30)

158 *30 August N[orth] Saskatchewan*

159 *The North Saskatchewan between Carlton and Prince Albert*

160 *August 26. Bows of "Northcote"* (*Graphic*, January 14, 1882:29–30)

161 *23 Humboldt. Mrs. Leggatt's Shanty*

162 *Bastion Fort Carlton. August 26*

163 *Pahonan Waiting-place, Cree, Fort Carlton, H[udson's] B[ay] Co.*

164 *Mr. Clarke's plot during the Pow-wow August 26*

165 *White Cap shewing [sic] feather fan*

166 *Little Crow, White Cap, Sioux Chief*

167 *Cree Head-dress*

168 *The Great "Beardy" making a speech*

169 Missing

170 *Prickly pear, Red Deer River*

171 *Sleep of Argyll*

172 *Rough-barked poplar, Red River Valley*

173 *Boulder (U.S.A.)*

174 *August 16. Gov[ernor]-Gen[eral]'s ambulance one of the three wagons in w[hic]h L[or]d Lorne, the suite and servants are driven* (*Graphic*, October 1, 1881:339)

175 *His Excellency writing his diary during the midday halt* (*Graphic*, October 1, 1881: 339)

176 *A queer tenant in an odd upper storey* (buffalo skull)

177 *Battleford in the distance from North Saskatchewan* (*Graphic*, January 14, 1882: 29–30)

178 *Assembled chiefs*

179 *Jacob Red Deer. Addressing the gentleman "across the table," i.e. His Excellency*

180 *Crees. In solemn pow-wow assembled, Battleford*

181 *30 August. Battleford. Old Roman Catholic Church* (*Graphic*, January 14, 1882:29–30). Inscribed "House at left Mr. Wm Tanniers."

182 *Ugly Customers. Battleford August 30*

183 *Battleford Pow-wow*

184 *Ugly Customers at Smart's Store, Battleford. August 30.* Reproduced Argyll, *Canadian Pictures*, 157.

185 *Sunset on N[or]th Saskatchewan. August 29*

186 *The Red Deer River. 7 September*

187 *Midday halting place near Battleford. September, 1*

188 *The heir of all the Bagots collecting Prairie fuel* (*Graphic*, December 17, 1881:608)

189 *"Times" [correspondent Austin] in his tent on the prairie* (*Graphic*, October 1, 1881: 339)

190 *Threatened [sic] Storm, Shoal Lake*

191 Page of miscellaneous sketches of buffalo

192 Buffalo head and buffalo

193 *The coup de grâce. Cap[tain] Percival kills the wounded buffalo. September 7* (*Graphic*, November 26, 1881:533)

194 *High bush-Cranberry*

195 *3 September. Sunrise*

196 *Choke-Cherry. September 7*

197 *Johnny Longmore alias Saskatchewan*

198 *Johnny [Longmore] in shirt carrying picket and gun*

199 *Mr. John Longmore, Battleford*

200 *Prairie guide Poundmaker, a chief of the Crees (our guide).* Study for illustration *The Coup de Grâce* (*Graphic*, November 26, 1881:533)

201 *Laronde*

202 Three sketches: dead buffalo, Winchester rifle, horse tied to foreleg of buffalo

203 Untitled sketch of an Indian

204 *Blackfoot Crossing. First view of the Rockies. L[ord] Lorne sketching*

205 *Methodist Church of Canada. Blackfoot Mission* (Rev. John McLean)

206 *Indian "Medicine" at Blackfoot Crossing*

207 *Dr. Sewell studying Indian "Medicine." September 9* (*Graphic*, December 17, 1881: 608)

208 Untitled pencil and watercolor study of Indian on horseback, inscribed "From Buffalo Bill's Show" (London, 1887)

209 Page of miscellaneous sketches of Indians

210 Ditto

211 *Crowfoot at the Pow-wow. September 10.* Reproduced Argyll, *Canadian Pictures*, 163.

212 *Crowfoot addressing his people. Blackfoot Crossing. September 10*

213 *His Excellency and staff. September 10*

214 *Pow-wow.* Reproduced Argyll, *Canadian Pictures*, 162.

215 *Indians and horses on river bank* (study for illustration below)

216 *Blackfeet crossing the river. September 10* (*Graphic*, January 28, 1882:77). Reproduced Argyll, *Canadian Pictures*, 152

217 Sketches of (Blackfeet) Indians

218 *A visit to the Indian camp.* Reproduced Argyll, *Canadian Pictures*, 168

219 *Eagle Ribs* (Indian)

220 Untitled pencil and watercolor study of tepees, inscribed "From Buffalo Bill's Show" (London, 1887)

221 Untitled Indian on horseback

222 Indian on horseback, inscribed "Fort MacLeod"

223 Untitled sketch of prairie landscape

224 Untitled pencil and watercolor study of Indian woman, inscribed "From Buffalo Bill's Show" (London, 1887)

225 *The beginning of Calgary*

226 *The Rockies and "Benches" Mesas (South) Calgary*

227 Untitled sketch of mountaintops

228 *Shy at Oats* (sketch of NWMP on horseback)

229 *Horse "played out" left in middle of prairie too tired to try and follow the train. "Abandoned"* (*Graphic*, January 21, 1882:53)

230 *Devil's ghost. Lake of Legend*

231 Untitled sketch of children on horseback crossing river

232 *Pelly River*

233 Untitled pencil and watercolor study of Indian, inscribed "From Buffalo Bill's Show" (London, 1887)

234 Untitled sketch of prairie scene with mountains in background

235 Untitled sketch of prairie scene

236 Untitled sketch of prairie scene with shack in foreground, hills in distance

237 Untitled study of Western landscape

238 Untitled sketch of shack in foreground, hills in distance. Inscribed "Teton Range."

239 *Badger Creek.* Inscribed "Left us at Ogden to go to Winnipeg in his new suit of clothes" (probably a reference to Lorne's departure).

240 Untitled pencil and watercolor study of Indian, presumably from Buffalo Bill's Show (London, 1887)

241 *David*

242 *L[or]d Lorne and Staff*

243 *Crows Nest, North Fort Ridge*

244 Sketch of Indian, inscribed "Oronhnatekha Act[ing] President Grand Council at [?]"

245 Untitled sketch of man in hammock

246 Western scene with mountains in distance

247 *Badger Creek*

248 *Charles Müller, Fort Shaw, October 2* (sketch of U.S. Army private)

249 *Col[onel] Kent, C.O. Fort Shaw [Montana]*

250 Untitled sketch of stagecoach

251 Untitled sketch of coyotes

252 Untitled sketch of gophers. Study for illustration *A Republic of Prairie Dogs* (*Graphic*, February 4, 1883:101)

253 *Broadway Gold Co. Limited, London. Silver Star* (Montana)

254 *October 2. Silver Star* (untitled portrait sketch)

255 Untitled sketch of Western village (probably Silver Star, Montana)

256 Untitled sketch of stagecoach in front of hotel. Inscribed "Warm Spring" (Warm Spring House, some fifteen miles from Helena, Montana).

257 Untitled sketch of log cabin with deer antlers on roof

258 Untitled sketch of shack and several figures, depicting party examining rocks (presumably drawn at Silver Star)

259 Untitled sketch of Dr. MacGregor and Indian children. Study for Illustration *Dr. MacGregor at Fort MacLeod* (*Graphic*, November 19, 1881: front page)

260 *Sunset on prairie first day from Dillon*

261 Untitled sketch of Indian object

262 *Sioux Chief feathers head-dress*

263 Untitled sketch of Indian object

264 *Spear bound with strips of . . .* (remainder of title unintelligible)

265 *Coup stick from one of the Minnesota Massacre Indians*

266 Untitled sketch of Lord Lorne's Party

267 Untitled scene: river and falls (probably Niagara Falls) with town in distance

268 *Garrison Jim, Quebec*

269 *From the Citadel, Quebec*

Checklist of Published Illustrations of Western Canada by Inglis Sheldon-Williams

DAILY GRAPHIC (1890–94)

———— **2, February 26, 1890**:12–13, "A Surprise Party in Manitoba." Five line drawings: *The Bachelor at Home and Happy; The Unbidden Guests Arrive; Fixing Up the Room for the Ball; The Dance; The Bachelor has to Refurnish.*

———— **4, August 1, 1890**:5, "The Bucking Broncho of the Canadian North-West: a Tenderfoot's First Experiences" (text in form of

letter to the Editor and signed "A Canadian," probably Inglis Sheldon-Williams). Five line drawings: *He looks Mild Enough; What is the Beggar Looking At?; By Jove, Whoa you Brute, Whoa up!; I've Carried You Long Enough; Ta-ta—I'm Off!* (drawn by Reginald Corbould from sketches assumed to be by Inglis Sheldon-Williams).

——— 20, August 10, 1894:14. Strip of four line drawings ("Farming in Manitoba"): *Off to Manitoba; Sunrise—The Sheaves won't Stand Up; 4 p.m.—Collapse!; 9 p.m.—Selling Up. Off by the Next Boat.*

THE SPHERE, Vol. 14 (1903)
——— 164–5, "Canada as a Wheat-Grower." Four illustrations: *Threshing in Winter; Taking the Grain to Market—30 Degrees below Zero and the Snow Rising; Ploughing the Fireguard; The Fire Guardian.* Text, "Some of the Risks of Farming in Canada and How they are Circumvented."

A Checklist of Published Illustrations of Western Canada by Frederick Villiers
GRAPHIC, Vols. 40–41 (1889–90)
"A TOUR WITH THE GOVERNOR-GENERAL OF CANADA ON THE C.P.R."

——— 40, November 2, 1889:530, "Through the New West." 532, three illustrations: *Lord Stanley and his Family in a Drawing Room Car on the C.P.R.; The Crofter Question, Interior of a Crofter's Hut, Saltcots [sic] NWT; Arrival of the Governor-General in Winnipeg.*

——— 40, November 9, 1889:563–4, "Through the New West." Two half-page illustrations: *Home for the First Year in the New West; The Address at Winnipeg.*

——— 40, November 30, 1889. Four illustrations: 645 (front page), *Lord Stanley and Friends Watching a Prairie Fire from the Cow-catcher;* 648 (half-page), *Lady Stanley Receives a Deputation of Cree Indians from the Reserve* (text, 667, "The Indian Reserves"); 667, two illustrations: *Indians outside Assembly Room, Blood Reserve; A Captive of the Blackfeet* (redrawn by C.J. S[tani-land] after Villiers).

——— 40, December 7, 1889:683, "Through the Ranching Country." 696, half-page illustration: *Through the Ranching Country with the North-West Mounted Police—Water by the Way* (redrawn by A. C. Corbould after Villiers).

——— 40, December 14, 1889:709 (front page), *With the Blackfeet Indians, Lady Photographers "Fixing" a War-Dance.* Text, 714, "Photographing a War-Dance."

——— 41, January 25, 1890:96, "Over the Summit of the Rockies on a Cow-catcher." 112, half-page illustration: *The Summit of the Rockies.*

DAILY GRAPHIC, Vol. 18 (1894)
"ACROSS CANADA BY RAIL"

——— April 17:12, 14, "I—Montreal to Winnipeg." Three illustrations: (two single-column illustrations) *The Settler and the Jack Rabbit; A Relic of Lord Wolseley's Red River Expedition;* (one two-column illustration) *View of an Indian Encampment.*

——— April 18:4, "II—Winnipeg to Vancouver." Three illustrations in box ("Three Claimants to the Alberta Prairie Land and its Produce"): *The Settler at Work; The Kitfox and the Settler's Fowl; An Indian on his Cayuse.*

BLACK AND WHITE, Vol. 8 (1894)
"EN ROUTE TO THE FRONT: OUR SPECIAL CORRESPONDENT ON THE PACIFIC ROUTE TO KOREA"

——— September 22:356–8. Four illustrations: (two quarter-page illustrations) *My Fair Neighbour is Seedy and Takes Tea in Bed; Your Correspondent's Bath on the C.P.R.;* (quarter page) *Winnipeg Station;* (half page) *An Indian Raid on the Canadian Pacific Railway.*

Annotated Checklist of Paintings, Drawings, and Published Illustrations of Western Canada and the United States by Richard Caton Woodville

1. *Forest Fire,* 4½ x 2¾. Oil on canvas board. Unsigned and undated. Inscribed in pencil "Wyoming, U.S.A." Collection Humphrey C. Woodville.
2. *Canadian Lumberjack,* 4½ x 2¾. Oil on canvas board. Unsigned and undated. Inscribed in pencil "Lumberman at Work, Canada." Collection Humphrey C. Woodville.
3. *Indians Scouting,* 6½ x 10. Pencil on paper. Signed R. C. Woodville. Undated. Collection Humphrey C. Woodville.
4. *Indian on Horseback Holding Scalp,* 14⅜ x 11. Lithograph. Signed R. C. Woodville. Undated. Collection Humphrey C. Woodville.
5. *Western Cavalry Troop,* 60 x 40. Oil on canvas. Signed R. Caton Woodville. Dated 1905. Collection Trigg–C. M. Russell Foundation, Inc., Great Falls, Montana. Gift of Dr. Franz Stenzel, Portland, Oregon.

ILLUSTRATED LONDON NEWS (1884–1911)
——— 85, December 27, 1884:644. Full-page illustration: *Christmas in Canada: Going to Church*

——— 86, June 8, 1885 (supplement). Double-page illustration: *North American Indians Attacking a Mail Coach.* Text note, 581. An early illustration, which shows influence of Theodore R. Davis' *Cheyenne Attack on Butterfield's Overland Dispatch Coach* (*Harper's Weekly,* February 17, 1866). Reproduced Ewers, *Artists of the Old West* (New York, 1965), 197.

——— 86, June 20, 1885 (summer number, supplement): 2–35. Fifteen full-page illustrations for Bret Harte story, "Maruja."

——— 87, 1885 (extra supplement). Full-page color plate: *Hunting Old Ephraim in the Rockies.*

——— 89, October 23, 1886:436, "Buffalo Hunters in Montana: North America." Two illustrations: *Potting Buffaloes at 1,200 Yards; Killing the Wounded.*

——— 89, November 6, 1886:481 (front page), "Wapiti-Hunting in North America" (text by W.A. Baillie-Grohman). Two illustrations: *Wapiti-Hunting in North America.*

——— 89, November 27, 1886:569 (front page), "Hunting the Rocky Mountain Goat in North America" (text by W.A. Baillie-Grohman). Three illustrations: *Hanging by Your Eyelids; A Nasty Corner to Turn; An Old Ram at Bay After a Long Stalk.*

——— 91, November 12, 1887. Text note, 557. 559, full-page illustration: *Horse and Bicycle Race at the Agricultural Hall* (London). This was the famous six-day contest: two cycling champions, Englishman Richard Howell and American W. M. Woodside, versus two horsemen, cowboys Broncho Charlie and Marve Beardsley of Buffalo Bill's Wild West Show, currently performing in London.

——— 91, December 24, 1887:751. Full-page illustration: *Christmas in the New World* (Canada).

——— 91, December 31, 1887 (Christmas number): 1. One illustration (untitled) for Bret Harte story, "A Phyllis of the Sierras."

——— 92, April 21, 1888:424–30. "Lower California" and "California Sketches." Nine illustrations: 426 (four on page), *A Good Day for Bears, Mount Shasta;* 427, *Sketches in Lower California: A Fruitful Land;* 430 (four on page), *California Sketches: Mammoth Trees and Mountain Scenery.*

——— 96, March 1, 1890. "A Day's Antelope-Hunting in Nevada, North America." Front page, four illustrations: *4 a.m.—the broncho bolting; 8 a.m.—Chase interrupted by a canyon; 12 a.m.—Noon rest, to collect his thoughts; 12 p.m.—The camp at last, the horse comes back.* (Text note, 259, "A Day's Antelope-Hunting in Nevada.")

——— 96, May 10, 1890:594. Three illustrations on full page: *A Search; Stalking; Success.* Text note, 507, "After Rocky Mountain Sheep."

——— 98, January 10, 1891:35, "The Indian Rising in America." One illustration on front page: *The Indian Rising in America: Latest News!* (in U.S. edition, January 24, 1891).

——— 98, January 17, 1891:67. One full-page illustration: *Braves Leaving the Reservation.* Text, 81, "The Rising of the North American Indians" (in U.S. edition, January 31, 1891).

——— 98, June 27, 1891 (summer number). One illustration: *Eagle Joe,* for Henry Herman Western story.

——— 99, September 19, 1891:385, "Holiday Time in the Wild West." Full-page illustration: *Holiday Time in the Wild West.*

——— 99, October 3, 1891:444–5. Double-page illustration with extended caption: *North American Indians Running Cattle into a Ranch.*

——— 105, September 29, 1894:315, 412, "Sport in the Rockies." Three illustrations on full page: *Packing Wapiti Heads Back to Camp; A Hungry Man Cooking; An Easy Stalk Rewarded by a Good Head.*

——— 106, January 12, 1895: unpaged. No text. Full-page illustration: *Bear-hunters in Montana: Victors and Vanquished.*

——— 107, September 7, 1895:297–9. Two illustrations in chapters 1–4 of Morley Roberts story, "The Courage of Pauline Camacho" (a Western tale set in California).

——— 107, September 14, 1895:329–31. Two illustrations in chapters 5–6, "The Courage of Pauline Camacho."

——— 107, September 21, 1895:361–3. Two illustrations in chapters 7–10, "The Courage of Pauline Camacho."

——— 107, September 28, 1895:393–5. Two illustrations in concluding chapter, "The Courage of Pauline Camacho."

——— 107, September 28, 1895:400–1. No text. Double-page illustration: *Victor and Vanquished.*

——— 110, January 16, 1897:85. No text. Full-page illustration: *Prospecting for Gold in British Columbia: A Portage.*

——— 110, February 13, 1897:208. No text. Two half-page illustrations on single page ("Hunting Wapiti in Montana"): *Surprising a Herd in a Fog; Not so Dead as he Seemed.*

——— 110, April 3, 1897:447–50. Three illustrations for "Frozen Margit" (a narrative about Edom Lanyon, Commander in the service of the East India Company and survivor of a shipwreck off the Northwest Coast of North America, 1807–08. He and his family lived among the Quinaiult Indians).

——— 110, April 10, 1897:485–8. Three illustrations for concluding part of "Frozen Margit."

——— 119, August 24, 1901:277. Full-page illustration: *Into the Jaws of Death: Execution of Three Rebel Sioux Indians,* with extended caption note.

——— 137, October 29, 1910:664–5. Double-page illustration: *Cowpunchers Tackle an Old Enemy: Bagging a Bear,* with extended caption, quoting description of cowpunching by Lieutenant Colonel S. Charles Morgan, ex. U.S. Army.

——— 138, January 28, 1911:121. Full-page illustration: *America's Horse-Racing as it is Practised on the Ice.* Extended caption quotes popularity of trotting races on icebound lakes. Location appears to be a Western scene.

ILLUSTRATED SPORTING AND DRAMATIC NEWS (1904–07)
——— 61, May 14, 1904:396. No text. One illustration: *The World's Best Riders: The Noble Savage.*

——— 62–63, December 3, 1904:550. One illustration to Antony Harwich Deane story, "My Bedfellow Bruin" (traveler's tale in for-

ests west of Saskatchewan River).

—— 63, December 10, 1904:599. No text. Full-page illustration: *President Roosevelt Big-Horn Shooting in the Rockies.*

—— 64, February 10, 1906:945. Two illustrations for W. F. McCartney story, "My First Broncho" (an experience in Canadian Northwest).

—— 67, October 20, 1906:288. Two illustrations for article "Sport in Vancouver" by O. Moore (trout-fishing on Cowitchin Lake, Victoria, B.C.).

—— 67, January 5, 1907:805. Two illustrations for article, "The Prairie Chicken," by F. Cartwright (prairie-chicken shooting in Manitoba and Northwest territories of Canada).

A Checklist of Published Illustrations of Western Canada by Charles Edwin Fripp *

GRAPHIC (1889–1903)

—— 40, May 18, 1889:526, "Indians Racing in the North-West Territory [Territories]." 528–9, double-page illustration: *Race between Indians in the North-West Territories, Canada.*

—— 40, August 31, 1889:259, "The Old and the New North-West." 272-3, two illustrations: *The Dying North-West; The New North-West.*

—— 40, November 30, 1889:650, "Notes on the Canadian Pacific Railway." 644, page of seven illustrations of Indian and pioneer life in and around Fort William and Winnipeg.

—— 41, January 4, 1890: front page. *Mountain-Goat Hunting in British Columbia.*

—— 47, January 28, 1893:79-80. "A Logging Trip to the Rockies." Twelve line drawings: *The Start in the Waggon; Shooting a Prairie Chicken; The Delights of Racing After the Team in a Hot Sun; The Waggon Going Over a Bank; Making a Sketch for "The Graphic" Under Difficulties; The Waggon is Declared First-Class; "That's All That's Left of our Grub;" Food and Lodging in a Hospitable Hut; Jogging Along Superbly; Going to Work in the Early Morning; A Suitable Tree for Felling; Home Again at Last.*

—— 47, April 8, 1893:379-82. "Hunting Life in the Rockies on the Canadian Pacific Railway" (text by Marquis of Lorne). Five illustrations: *Indians of British Columbia Pitching a "Dug-out" Canoe; Trappers in British Columbia Finding an Animal in their Trap; The Hunter's Departure from his Hut in the Early Morning; Interior of a British Columbian Indian's Hut at Dinner Time; A Dangerous Snowslide in the Mountain Ranges West of the Rockies, B. C.*

—— 52, November 30, 1895:675, "Goat-Shooting in the Cascade Mountains, British Columbia." 676-7, double-page illustration: *Goat-Shooting in the Cascade Mountains, British Columbia.*

—— 57, April 23, 1898:512. Full-page illustration: *The Rush to Klondyke: New Arrivals Moving Their Goods from the Landing Place on the Stikine River at Cottonwood Island, Alaska.*

—— 58, August 27, 1898. Three illustrations: front page, *On the Road to Klondyke Mounting the Summit of the Divide Above Telegraph Creek;* 284 (two half-page illustrations), *The Little Canyon on the Stikine River; Taking Light Loads over the Snow; Arriving at Telegraph Creek on the Stikine River.*

—— 58, September 3, 1898:316, 317, "To Klondyke for Gold" (quotes artist's experiences). Two illustrations: (half page, with extended caption) *View of Fort Wrangell;* (full page) *View Below the Canyon on the Stikine River.*

—— 58, September 10, 1898:356, 357. Two illustrations: (full page, with notes) *To*

* *Editor's Note:* Klondyke, original spelling for Klondike, retained throughout.

Klondyke by the All Canadian Route: the Fourth of July in Dawson City; (full page, with extended caption) *Crossing a Snowdrift on the Stikine River.*

—— 58, November 5, 1898:601, 604. Two illustrations: (full page, with notes) *A Block on the Stikine River;* (full page, with extended caption) *From Klondyke to the Coast by the St. Michael's Route: the Village of Nulato.*

—— 58, November 12, 1898:629. Full-page illustration with notes: *Law and Order in the Yukon District: the Headquarters of the North-West Mounted Police in Klondyke City.*

—— 58, December 24, 1898:812. Half-page illustration with notes: *In Search of Wealth: Prospectors on the Hootalinqua River Making for Klondyke.*

—— 59, January 7, 1899:13. Full-page illustration with notes: *On the Way to the Yukon: Preparing to Camp on the Lewes River.*

—— 59, January 21, 1899:72. Two half-page illustrations with notes: *On the Way from Dawson City to the Coast: Sunset at Midnight at Circle City; On the Way Up the Lewes River: At the Mouth of the Little Salmon River.*

—— 59, February 4, 1899:148. Half-page illustration: *Basketmaking at an Indian Monument on the Yukon* (Novikakat, Alaska).

—— 59, February 18, 1899:212, 213. Two half-page illustrations with notes: *Old Russian Village in Alaska* (Illiuliuk); *Waiting for Payment for Wood used on the Yukon Steamers.*

—— 59, March 25, 1899:364. Half-page illustration: *To Klondyke and Back: An Eskimo Encampment at St. Michael, Alaska.*

—— 59, April 1, 1899:404. Half-page illustration with extended caption: *To Klondyke and Back: Fort Selkirk.*

—— 59, April 8, 1899:444. Half-page illustration: *To Klondyke and Back: Waiting for a Steamer at St. Michael, Alaska.*

—— 59, April 15, 1899:476. Half-page illustration: *Panning for Gold on the Yukon River.*

—— 67, May 16, 1903:652, 653. Three illustrations: (half page, with notes) *Indian Life on Lake Winnipeg: Returning Home After a Trapping Expedition;* (two half-page illustrations) *Traders Returning from an Expedition After Fur: Striking Inland from the Frozen Lake with a Heavy Haul; Indian Fishing: Overhauling the Nets in the Evening.* (All drawn from sketches by F. A. Disbrowe.)

DAILY GRAPHIC, VOL. 34 (1898)
"ON THE WAY TO THE YUKON"

—— April 14, 1898:4-5, Part 1: "The New Canadian Pacific Route Through the Rockies." Six illustrations: *Pioneers at Work; An Accident at the "Dump;" An Idyll at Wardner; In Wardner; Interesting Operations with Dynamite; Sunday Morning in the Rockies: A Study at Crow's Nest.*

—— April 15, 1898:4, Part 2: "By Steamer to Fort Wrangell." No illustrations.

—— April 18, 1898:4-5, Part 3: "A Mushroom City in Alaska." Three illustrations: *Front Street, The Main Thoroughfare of Fort Wrangell, Alaska; The Promenade: Our Special's Misadventure; Bloomers for Klondyke.*

—— 35, June 28, 1898:4-5, Part 4: "Waiting for the Ice to Break." Five illustrations: *An Alaska "Whiteley;" A Roadside Camp; A Miner's Shanty—Winter Quarters; Something for Supper* (from photographs); *Harnessing up a Bullock sleigh. Cottonwood Island, Alaska.*

—— July 27, 1898:4-5, Part 5: "Up the Frozen Stikine." Four illustrations: *The Balance of Power on the Stikine River: Settling a Small Dispute; Helping an Overladen Sleigh through a Snowdrift; The Savage is Bad Enough—But the Civilised Man is Worse.*

—— August 8, 1898:4-5, Part 6: "Up the Frozen Stikine. The Mystery of the Canyon."

Three illustrations: *The Owner of a Departed Horse Offers a Few Reminiscences; The "Compleat Angler" on the Stikine River; Rival Bloomers.*

—— August 20, 1898:4, Part 6: *"Still on the Frozen Stikine River. Attacked by Snow Blindness."* Two illustrations: *Rival Sleighs on the Frozen Stikine River; Making a Bridge of Brush.*

—— September 15, 1898:4, Part 7: "To the Little Tahltan River. The All Canadian Route Condemned." One illustration: *A Halt for Refreshment.*

—— 36, October 6, 1898:4, Part 8: "More About the All Canadian Route. Sweeping Condemnation." Two illustrations: *Dressing under Difficulties; Camp Enjoyment—15 Degrees of Frost and a Strong Wind.*

—— October 11, 1898:4-5, Part 9: "The Journey Continued. Down Lake Teslin and the Hootalinqua." Three illustrations: *Preparing a Feast; A Mosquito-ridden Camp; A Mid-day Meal on Teslin Lake.*

—— October 12, 1898:9-11, Part 10: "Still Down the Hootalinqua River." Two illustrations: *"Customs Again!" An Interview on the Way to the Yukon; North-West Mounted Police at Fort Selkirk.*

—— October 19, 1898:4-5, Part 11: "Last Stages to Dawson." Three illustrations: *"At First we Fancied it was a Steam Launch"— But it was Only the Stoker Tossing Flapjacks; The Modern Pilgrim's Progress; Poling up Stream.*

—— October 26, 1898:10, Part 12: "Arrival at Dawson City. Killing the Goose with the Golden Egg." One illustration: *The Salvation Army on the Yukon: A Dragoon Post at Klondyke City.*

—— November 5, 1898:4-5, Part 13: "In Dawson City. Only Fifth-Rate Diggings." Four illustrations: *Caches on the Klondyke; Civilisation on the Klondyke: The Complete Barber* (panel of three sketches).

—— November 9, 1898:9-10, Part 14: "More Notes about Dawson." Two illustrations: *The Fourth of July on the Klondyke: A Yankee Procession in the Main Street of Dawson City; An Apparition at Dawson.*

—— November 24, 1898:9-10, Part 15: "From Dawson City to St. Michael. A Pigsty of a Steamer." Two illustrations: *Enough of the Golden North: Disappointed Diggers Hailing the Steamboat "Merwin;" Washing Accommodation on Board the "Merwin"* [sic].

—— November 30, 1898:9-11, Part 16: "From Dawson City to St. Michael." Three illustrations: *Life on the Yukon: A Newspaper! Down the Yukon from Dawson City: How the Steamer's Crew took Firewood Aboard; From Dawson to St. Michael: Aground on the Yukon.*

—— December 8, 1898:10-11, Part 17: "Arrival in Alaska. Esquimaux and Indians." Two illustrations: *The Dawn of Civilisation: An Indian Group on the Banks of the Yukon; A Voyage down the Yukon: the Effect of High Feeding.*

—— December 10, 1898:9-10, Part 18: "At St. Michael's, Alaska." Two illustrations: *A Table Study on the "Humboldt";* 10, *Our Steamer Committee at Work at St. Michael's.*

—— December 14, 1898:9, Part 19: "A Russian Village in Alaska." One illustration: *A Proud Moment for the Skipper.*

Annotated Checklist of Watercolor Paintings, Drawings, and Original Illustrations of Western Canada by Charles Edwin Fripp

BRITISH COLUMBIA SERIES: 1892

1. *British Columbia Trappers,* 13½ x 9¼. Ink and wash on paper, heightened with white. Unsigned and undated. McCord Museum, McGill University, Montreal. (Published *Graphic,* 47, April 8, 1893:380, under title *Trappers in British Columbia Finding an Animal in their Trap*)

2. *The Hunter's Departure,* 9 x 13½. Ink and wash on paper, heightened with white. Unsigned and undated. McCord Museum, McGill University, Montreal. (Published *Graphic,* 47, April 8, 1893:381, under title *The Hunter's Departure from His Hut in the Early Morning*)

3. *Meal in British Columbia Indian's Hut,* 9½ x 13¾. Ink and wash on paper, heightened with white. Unsigned and undated. McCord Museum, McGill University, Montreal. (Published *Graphic,* 47, April 8, 1893: 381, under title *Interior of a British Columbian Indian's Hut at Dinner Time*)

4. *The Canadian Pacific Canoe,* 9 x 13¼. Ink and wash heightened with white. Unsigned and undated. McCord Museum, McGill University, Montreal. (Published *Graphic,* under title *Indians of British Columbia Pitching a "Dug-out" Canoe*). Reproduced as *Mending Canoe,* Harper, *Painting in Canada* (Toronto, 1967), Plate 318:349, and erroneously attributed to Thomas Fripp.

5. *A Dangerous Slide,* 18¾ x 13. Ink and wash heightened with white. Signed C. E. Fripp in margin. Undated. McCord Museum, McGill University, Montreal. (Published *Graphic,* 47, April 8, 1893:382, under title *A Dangerous Snowslide in the Mountain Ranges West of the Rockies, B. C.*)

6. *The Winter Home,* 6½ x 13½. Watercolor.

Unsigned and undated. Collection Dr. Russell Harper, Ontario. Unpublished. Reproduced Harper, *Painting in Canada,* Plate 319:350, and erroneously attributed to Thomas Fripp.

KLONDYKE SERIES: 1898

7. *View of Fort Wrangell,* 11½ x 14½. Ink and wash over pencil. Signed C. E. Fripp, Alaska, March 8, 1898. McCord Museum, McGill University, Montreal. (*Graphic,* 58, September 3, 1898:316)

8. *Cottonwood Island, Alaska,* 13 x 19. Ink and wash over pencil. Signed C. E. Fripp, March 17, 1898. McCord Museum, McGill University, Montreal. (Published *Graphic,* 57, April 23, 1898:512, under title *The Rush to Klondyke: New Arrivals Moving Their Goods from the Landing Place on the Stikine River at Cottonwood Island*)

9. *The Little Canyon on the Stikine River: Taking Light Loads Over the Snow,* 13 x 19. Ink and wash over pencil. Signed C. E. Fripp. McCord Museum, McGill University, Montreal. (*Graphic,* 58, August 27, 1898:284)

10. *Preparing to Camp on the Lewes River,* 13 x 19½. Ink wash on paper. Signed C. E. Fripp, Lewes River. Centennial Museum, Vancouver, B. C. (*Graphic,* 59, January 7, 1899:13)

11. *Hootalinqua River,* 10 x 13. Ink and wash over pencil. Signed C. E. Fripp. McCord Museum, McGill University, Montreal. (Published *Graphic,* 58, December 24, 1898:812, under title *Prospectors on the Hootalinqua River Making for Klondyke*)

12. *Civilisation on the Klondyke,* 7½ x 11¼. Ink drawing. Signed C. E. Fripp, July '98. Centennial Museum, Vancouver, B.C. (Published *Daily Graphic,* November 5, 1898:5, under title *Civilisation on the Klondyke: the Complete Barber*)

13. *A Voyage down the Yukon,* 5½ x 9. Ink drawing. Signed C. E. Fripp. Centennial Museum, Vancouver, B. C. (Published *Daily Graphic,* December 8, 1898:11, under title *A Voyage down the Yukon: the Effect of High Feeding*)

14. *Life on the Yukon: A Newspaper!,* 7½ x 11¼. Ink drawing. Signed C. E. Fripp, Minook, Alaska. Centennial Museum, Vancouver, B. C. (*Daily Graphic,* November 30, 1898:9)

15. *Russian Village of Illinlink (Unalaska),* 12¼ x 15. Ink and wash over pencil. Signed C. E. Fripp, Illiuliuk [*sic*], Unalaska, '98. McCord Museum, McGill University, Montreal. (Published *Graphic,* 59, February 18, 1899:213, under title *Old Russian Village in Alaska*)

Biographical Notes

The following is a selected checklist of British and other European Special Artists, illustrators, and artist-correspondents who traveled throughout the Canadian and American West between 1850 and 1910 and whose work appeared in the British picture press.

George Henry Andrews (1816–98)

B. Lambeth, London, England. Marine and landscape painter. Special Artist for *ILN* and *Graphic*. Accompanied Prince of Wales (later Edward VII) on royal visit to upper and lower Canada, 1860, as Special Artist, *ILN*. Depicted scenes of frontier life in Ontario along line of Grand Trunk Railway and trans-Canada canoe route as far as Lake Superior. (See *ILN*, 37, 1860:167–479, plus frontispiece of bound volume. For a further series, published as "Sketches of Canada," see *ILN*, 40, 1862:5–382, large and excellent collection of original watercolors of royal visit to Canada in Royal Library, Windsor Castle, Windsor, England.) Also represented in Sigmund Samuel Canadiana Collection, Royal Ontario Museum, Toronto. Member Old Water-Colour Society, 1840–50. Exhibited Royal Academy, 1850–93. D. Hammersmith, London, England.

Stanley Berkeley (active 1878–1902)

Military painter and illustrator. Exhibited hunting scenes, battle pictures, and genre scenes at Royal Academy, 1881–1902, at Royal Institute of Painters in Water-Colours, and at Royal Society of British Artists. Style largely derived from Richard Caton Woodville, Jr. From 1882, heroic episodes of adventure appeared in *ILN* as full-page black and white illustrations whenever Western events broke into news headlines. Also contributed series of dramatic scenes as color plates to celebrated boys paper *Chums*. See following for typical examples: *Twixt Life and Death* (buffalo pushes horseman off precipice), 93, May 16, 1894; *In the Enemy's Grip* (settler and U. S. cavalryman are prisoners of hostile Indians), 103, August 29, 1894; *On Death's Threshold* (two white boys almost fall off precipice in storm), 137. April 24, 1895.

For biographical note and interview see, "A Battle-Painter at Home—Mr. Stanley Berkeley and His Work," *Windsor Magazine*, 10, 1899: 123–32, which reproduces black and white wash drawing, *Cornered at Last,* an incident of lynch law, exhibited Royal Academy, 1897. No evidence that he actually visited North America to gather material firsthand. D. 1909.

John David Borthwick (1825–ca. 1900)

B. Edinburgh, Scotland. Painter. Father, Dr. George Borthwick. Educated Edinburgh Academy. Nostrand & Coulter think it likely that he studied under Edinburgh painter, Robert Innes, also portrait painter John Borthwick. During 1840's, left for U. S. to seek fortune. Lived in New York. In 1851, started for San Francisco via Chagres. Remained in California as gold-seeker and artist until 1854, when he left for Nicaragua. (See *Blackwoods Magazine, 79*, 1856: 314–27 for article describing his impressions.)

He then continued to Australia, returning to England in 1860. In California, he acted as artist-correspondent for *ILN*. (For article with illustrations, see "Gold in California," *ILN, 20,* 1852:73–4. See also important autobiographical account of his adventures, *Three Years in California*, Edinburgh, 1857, illustrated with eight excellent lithographs, and *Hutchings' California Magazine*, 2, 1857:72–416, for serial version with introductory editorial note. These also appeared in *Harper's Weekly*, October 3, 1857: 632–3.) He is known to have made series of paintings of California, some of which were exhibited at Royal Academy (1862) and British Institute (1865). Borthwick paintings may be in private hands throughout U. S., as *ILN* refers to the artist "taking portraits of successful adventurers, chiefly to be sent to their friends at a distance."

Valentine Walter Bromley (1848–77)

B. London, England. Painter and illustrator. Belonged to family of artists. Father, William Bromley, painter; grandfather, William Bromley, mezzotint engraver; great-grandfather, William Bromley, A.R.A. (1769–1842), well-known engraver. Bromley is one of the more artistically outstanding of the European artists who journeyed in the Old West. By training and background he was an historical painter, exhibiting regularly at the Royal Academy and the Royal Institute of Painters in Water-Colours. He worked for *ILN* as Home Artist, redrawing the field sketches of Special Artists for publication, and for a short time he contributed to *Punch*. He is known primarily for his illustrations to the Earl of Dunraven's travelogue, *The Great Divide* (London, 1876). He accompanied Dunraven on his third visit to the West in 1874 for a hunting expedition in the Upper Yellowstone. The party traveled via Montreal, Toronto, then by railway to Collingwood and steamer across lakes Huron and Superior, stopping at Fort William before continuing south to the Northern Pacific railhead at Bismarck and thence to Montana Territory and the Yellowstone. Redgrave states that Dunraven also commissioned Bromley to paint twenty large pictures, but only six of these have been located. He also acted as Special Artist for *ILN*, contributing full-page illustrations of Indian life, trading posts, prairie travel, and a cattle roundup. These appeared under title "American Sketches." (See *ILN, 68,* 1875:188–9; 69, 1876:188–9, 336, 405; 70, 1877:247–8.) Before delivery to Dunraven, four completed paintings were exhibited in London: *Big Chief's Toilet* was shown at Royal Institute of Painters in Water-Colours, spring, 1875, and also won the artist a gold medal at Crystal Palace; *Shifting Camp, Nebraska,* was also shown that year in the autumn exhibition of the Institute; *Midday Rest, Sioux Indians,* and *The Great Scalper* were shown at the Royal Academy in 1875 and 1876, the latter attracting considerable press comment. A fifth painting, entitled *Canoe Shooting a Rapid,* is in the collection of the Department of External Affairs, Ottawa. Almost all of Bromley's Western pictures remain

with the Dunraven family or its branches. D. Fallows Green, Harpenden, near London, England.

John Charlton (1849–ca. 1910)

B. Bamborough, Northumberland, England. Military painter and illustrator. Studied Newcastle School of Art under Pre-Raphaelite William Bell Scott and at Royal Academy schools. Exhibited hunting scenes and battle pictures at Royal Academy in 1870's and 1880's. Was a friend of Richard Caton Woodville, Jr. Contributed full-page illustrations of Western subjects to various illustrated periodicals, including *Graphic,* but there is no evidence to suggest that he actually visited North America. Member of team reporting second London visit of Buffalo Bill's Wild West Show, 1892. (See *Graphic, 46,* 1892:5, for *The Wild West at Windsor.*) See also *Graphic, 44,* 1891:104, for interesting, well-painted picture of settlers crossing the plains; *A Scene in the Far West; 51,* 1895:633, for full-page scene, *Sport in California: A Rabbit Drive;* and *Art Journal,* 1892, 33–7, for further biographical data.

Cyrus Cuneo (1878–1916)

B. San Francisco, U.S.A. Described himself as "an Englishman by preference and adoption, an American by birth and citizenship." Became professional boxer to obtain art training in Paris, where he became a favorite student of Whistler. Later settled in London and became prolific illustrator and Special Artist, notably for *ILN*. In 1908, made extended trip to California and western Canada as Special Artist.

For series of double-page and single-page reproductions of paintings of problems of modern, affluent Far West see the following: *ILN, 137,* July–December, 1910:318–19 (double page), *The Sledge-Hammer Cure for Gambling: Raiding a Chinese Lottery Den in San Francisco;* 210–11 (double page), *Combining Business with Pleasure in California: A Gigantic Jack Rabbit Drive;* 608–9 (double page), *Ploughing the Fields That Flames May be Starved: Fighting to Save Human Life, Crops and Forests. ILN, 138,* January–June, 1911:80–1 (double page), *Railway Crossing. Look out for the Cars. An Express in an American Roadway;* 859 (single page), *Peter-Panism: Pale-face Boys as Redskin Braves, San Francisco; ILN, 139,* July–December, 1911:269 (single page), *Advertising by Artiste: a Blondin Acts as a Magnet* (San Francisco); *ILN, 140,* January–June, 1912:174 (single page), *In the Immense Network: Consulting the Oracle's Red Sticks* (San Francisco); *ILN, 141,* July–December, 1912:354–5 (double page), *Mixed Travelling: The Difficulties of an American Sleeper.*

For striking landscapes along C.P.R. between Calgary and Vancouver, see the following: *ILN, 136,* January–June, 1910:859 (single page), *Cornered! Bear-Hunting in the Rockies; 951* (single page), *The Return of the Hunters. Sport in Canada. ILN, 138,* January–June, 1911:166–7 (double page), *Betrayed by their Blowholes in the Snow;* supplement, February 18, xviii–xix (2 single pages), *In the Dominion which is as Large as Europe; Pleasure and Business in Can-*

ada; 584 (single pages, 4 on page), *Pioneers: The Scottish Development of Canada. ILN,* **139,** July–December, 1911:155 (single page), *The Scourge of Canada: Fighting a Forest Fire. ILN,* **140,** January–June, 1912: supplement, March 9, xiv–v (double page), *On Dizzy Heights in the Dominion: Mountaineering in Canada;* supplement, June 8, iii (single page), *Wild Beasts as After-dinner Entertainers. Bruin as a "Turn." ILN,* **142,** January–June, 1913:345 (single page), *A Most Romantic Journey. "Joseph Voyageur at Work."* The latter series, executed as special commission, also appeared in *Illustrirte Zeitung* (1912–13). Illustrated John M. Gibbon's *Steel of Empire* (1935), the story of the C.P.R., with scenes of Canadian pioneers. Originals of C.P.R. series are said by his son, British painter Terence Cuneo, to have been destroyed in Liverpool during World War I. Member Royal Institute of Oil Painters. Exhibited Royal Academy, 1905–12. Western paintings in National Gallery of Art, Sydney, Australia, and Hotel Saskatchewan, Regina. D. London, England.

Charles Edwin Fripp (1854–1906)

B. Hampstead, London, England. Painter, Special Artist, and war correspondent. Belonged to a Quaker Bristol family which produced many artists. Father, George Arthur Fripp (1813–96), well-known landscape painter active in Old Water-Colour Society; uncle, Alfred Downing Fripp, R.W.S., also a landscape painter; younger brother, who died in Vancouver, 1931, was the landscape painter, Thomas William Fripp. Educated London and Nuremburg; studied art in Munich at Royal Academy. A prolific artist whose thorough training and articulateness as a writer make him an important and authoritative observer of Old West. Worked mainly for *Graphic* and *Daily Graphic,* but work also found in *Pall Mall Magazine* and *Black and White.* Exhibited fruits of his travels at Royal Academy, Royal Water-Colour Society, and at Japanese Gallery, Bond Street. Began life of continuous travel as Special Artist for *Graphic* when sent to Africa to cover Kaffir War, 1878; Zulu War, 1879. Returned to record Boer War, 1881. Made world trip in yacht, "Ceylon," 1881–84. Was in Sudan, 1885; Far East, 1889–90, and again 1894–95 for Chinese-Japanese War. Back to Africa for Matabele War, 1896–97, and then to Canada, Klondike, and Alaska, 1898, before covering the Philippines Campaign of Spanish-American War and South African War, 1900. Made first visit to western Canada in 1889 via C.P.R. on way to Japan. Made many drawings en route and on his way to England during 1890. See checklist (p. 279) for scenes along C.P.R. line and of Indian and settler life in western Ontario, Manitoba, and Alberta; also hunting scenes in British Columbia. In early 1890's, decided to settle in British Columbia, making Hatzic, and later, Mission City, base for world travels. Was particularly fond of hunting and recording Indian life (sometimes accompanied by his brother T. W. Fripp) in various districts of the province. See checklist (p. 279) for illustrations published over period of several years in *Graphic.* Was living in Canada when he undertook assignment to cover Klondike gold rush. See checklist (p. 281) for series of documentary (in *Graphic*) and humorous (in *Daily Graphic*) line or wash drawings which illustrate his written account of a four-month trip via the Stikine Trail to Dawson and back via St. Michael, Alaska, to Victoria, British Columbia. Representative collections of his work, including examples from earlier travels in British Columbia as well as of the Klondike and Alaskan series, can be seen at the McCord Museum of McGill University, Montreal, and the Centennial Museum, Vancouver. His marriage in 1901 to Lois Renwick brought adventurous days in Canada to close. Lived in London during 1900's, but again visited Canada during 1905. D. Montreal on his journey back to England. Was cremated and his ashes buried in Fripp family vault, Highgate Cemetery, London, England.

Sydney Prior Hall (1842–1922)

B. Newmarket, Cambridgeshire, England. Painter and Special Artist. Father, Harry Hall, well-known painter of sporting scenes. Studied at Heatherley's, Royal Academy, and with Pre-Raphaelite painter, Arthur Hughes. M. A. Pembroke College, Oxford. Joined freelance staff of *Graphic* in 1870 and was Special Artist covering Franco-German War. Remained with *Graphic* for over forty years. Strength lay in informal reporting of royal tours and diplomatic missions. These started in 1874 when he joined entourage of Prince of Wales (later Edward VII) on royal visit to India. Hall made his first visit to North America in winter of 1878 when he accompanied Marquis of Lorne (9th Duke of Argyll) and Princess Louise on their inaugural journey to Ottawa. He depicted pleasures and occasions of viceregal life, including a moose-hunt in western Ontario. (For latter, see *Graphic,* **19,** 1879:300.) Made second and longer visit to Canada (June–October, 1881) attached to Lorne expedition through the Northwest Territories as Special Artist of *Graphic.* This was an epic three-month journey of 6,000 miles via lakes Huron and Superior, Fort William, Winnipeg, the Qu'Appelle Valley, forts Ellice and Carlton, Rat Portage, Battleford, Calgary, and Fort MacLeod. (See *Graphic,* **24–25,** 1881–82.) See also checklist, "To the Great North-West with the Marquis of Lorne" (p. 275). At close of expedition, party crossed into U. S. and Hall made many interesting sketches of frontier life and landscape between Fort Shaw and Dillon, Montana. Some of these were published in concluding installment of above series, but most remain unpublished. After returning to England, Hall was commissioned by Lord Lorne to paint large oil of one of historic highlights of tour entitled *Last Indian Council Held on Canadian Soil between the Governor-General of Canada and Crowfoot, Chief of the Blackfoot Indians, 1881,* now in Thomas Gilcrease Institute of American History and Art, Tulsa, Oklahoma. A large charcoal and watercolor cartoon study for the painting entitled *Conference of the Marquis of Lorne and Blackfeet Indians, September, 1881* is in Department of Paintings, Drawings and Prints, Public Archives of Canada, Ottawa, which also possesses complete collection of Hall's sketches, drawings, and final illustrations from Lorne expedition. These include the Montana series and several unpublished watercolor drawings of Indian performers in Buffalo Bill's Wild West Show visiting London, 1887. (For member of team reporting the second visit of the show in 1892, see *Graphic,* **46,** 1892:360.) The artist's familiarity with Canada also brought him assignments to reconstruct certain Western scenes from photographs. (See *Graphic,* **58,** 1898:576, for illustration of Klondike gold rush entitled *At Foot of the Chilcoot Pass.*) Hall made third and final visit to western Canada in 1901, while accompanying Duke and Duchess of York and Cornwall (later King George V and Queen Mary) on royal world tour. These include scenes in the Rockies (Banff), the great Indian powwow at Calgary, and a royal ride on the cowcatcher. (See *Graphic,* **63,** 1901:415; **64,** 1901:478; **supplement 5,** 541, 574. See also *Daily Graphic,* **48,** 1901:365.) D. London, England.

Sydney Higham (active 1890–1905)

Contributed mainly to *Graphic* and *Daily Graphic.* Visited Canada in 1904 as Special Artist of *Graphic* to report on high tide of British immigration to prairie provinces. Also made drawings of Banff and Rocky Mountains. (See introductory text concerning his trip, *Graphic,* **72,** 1905:806, col. 3, supplement.) For interesting series entitled "With Emigrants to the Promised Land," see *Graphic,* **72,** 1905: July supplement.

Arthur Boyd Houghton (1836–75)

B. Bombay, India. Painter, illustrator, caricaturist, and Special Artist. Fourth son of Captain Michael Houghton, R. N., private secretary to Sir John Malcolm, Governor of Bengal. After returning with his father from India, studied medicine before training as a painter at Leigh's Academy, London. Exhibited genre scenes of London life at the Portland Gallery and began to exhibit at the Royal Academy in 1861. Turned to publishing and achieved reputation as leading artist of group (Keene, Pinwell, Walker, and Du Maurier) who contributed to illustrated magazines and books of 1860's. Also drew inspiration from Pre-Raphaelite movement (then in its second phase). As caricaturist, contributed to humorous weekly *Fun* (1866–67). In boyhood, lost sight of one eye and suffered from handicap. In spite of this, output was prolific. Undertook series of travels in America and Europe as Special Artist and artist-correspondent for London weekly *Graphic* (1869–74). First of these was extended trip to U. S. (October 1869–April 1870). This took him first to New York, where he depicted city life, before visiting Shakers at Mt. Lebanon, N. Y., and going on to Boston. He then left for the West, depicting scenes in Cincinnati, Chicago, Tuscola, Michigan, and Omaha. From Omaha he traveled on Union Pacific, stopping off at Genoa, Nebraska, where he depicted life on the Pawnee reservation before continuing to North Platte and Fort McPherson. Here he met Buffalo Bill Cody, who took him on a buffalo-hunt. Final stage of Western travels was short stay in Salt Lake City, where he made series devoted to Mormon life. For Western series, "Sketches in the Far West," see checklist (p. 273). Originals of his Western work scarce, as artist worked on wood block from sketchbook pencil studies and more finished ink drawings. Eight pencil drawings of emigrants and Shaker Evans in Layard Collection, Department of Prints and Drawings, Museum of Fine Arts, Boston. One of the artist's American sketchbooks (mostly pencil studies for Western subjects) and large watercolor painting, *The Return of Hiawatha* (based on studies made on Pawnee reservation, Genoa, Nebraska), are in collection of Victoria and Albert Museum, London. D. Hampstead, London, England.

Phil May (1864–1903)

B. Wortley, Leeds, England. Caricaturist and illustrator. Second of three sons of Phillip May, an executive engineer, and Sarah Jane, daughter of a theatrical manager. After age of nine (upon father's death) received little education. Sent to work as office boy before he was thirteen. As artist, self-taught. Became friendly with son of scene painter at Grand Theatre, Leeds, who allowed him to make sketches and full-length portraits of vaudeville performers and actors. Joined touring theatrical company as actor, 1879–81. This gave him confidence to try luck as thespian and caricaturist in London. Contributed political cartoons to *St. Stephen's Review* in 1884 and following year was appointed to staff. Turning-point came in 1885 when he accepted three-year contract as staff artist on Sydney *Bulletin.* Returned to Europe in 1888 and spent two years in Rome and Paris before returning to London, where he established himself as leader of new school of black and white draughtsmen. Became social commentator of popular life, using salty dialogue of music hall. Made only visit to America in 1893 (April–July), accompanied by Edwin Sharpe Grew of *Daily Graphic.* Visit intended as first stage of a world tour. After two weeks in New York, spent further two weeks in Chicago, covering World's Columbian Exposition. Was primarily interested in depicting impact of the unfamiliar on visitors; made humorous as well as documentary drawings. (See *Daily Graphic,* **7–15,** 1893: June 17–August 19, for Chicago series.) Many of the New York drawings were subsequently included in several of the many collected anthologies of his work, notably, *Phil May's Graphic Pictures* (London, 1897); *Here, There and Everywhere*

(London, 1903); *A Phil May Medley* (London, 1904). But only Chicago subject found is in *The Phil May Folio* (London, 1904), 243: a Scotsman unable to sleep in a Chicago hotel because he is paying a then-exhorbitant four dollars a night for a bed. Literally hundreds of Phil May's drawings exist in both private and public collections in U.K., U.S., and Australia. Few of his Chicago drawings, however, are among them. Alan Fern, of Washington, D. C., has an original drawing of scene outside Turkish Theatre in the Midway Plaisance. There is a symbolic caricature of Chicago in the Phil May Collection of the City Art Gallery, Leeds, England. One of the artist's sketchbooks containing several pencil studies for various drawings of subjects found in New York and Chicago is in the Victoria and Albert Museum, London. D. St. John's Wood, London, England.

Julius Mendes Price (*ca. 1860–1924*)

B. London, England. Painter, Special Artist, and war correspondent. Son of merchant. Educated University College School. Studied art at Ecole des Beaux-Arts, Paris. Exhibited Royal Academy and Paris Salon. Joined freelance staff of *ILN* in 1884: covered Bechuanaland Campaign, 1884–85; accompanied expedition to open up Nordenskiold Route to interior of Siberia via Kara Sea to Peking, 1890–91; accompanied expedition through goldfields of western Australia, 1895; with Greek Army, Greco-Turkish War, 1897; to Klondike, 1898; with Russian Army in Manchuria, Russo-Japanese War, 1904–5; on French front and, later, Italian front, World War I. Went to Klondike from Vancouver via Dyea Trail over Chilcoot Pass and Lake Lindemann to Dawson; returned via St. Michael, Alaska. (For interesting and detailed account, profusely illustrated with pencil and watercolor drawings of uneven quality, see Price, "From Euston to Klondike," *ILN,* 113, 1898:157, 207, 275, 313, 349, 385, 485, 523, 543, 603, 643, 679. Several of the illustrations were redrawn as dramatized illustrations by Richard Caton Woodville, A. Forestier, and S. Begg.) See also his books, *From Euston to Klondike* (London, 1898) and *On the Path of Adventure* (London, 1919). D. London, England.

Melton Prior (1845–1910)

B. London, England. Special Artist and war correspondent. Learned to draw fluently as boy and worked as an assistant to father, landscape painter, William Henry Prior. Began working for *ILN* at age of twenty-three, and remained with that journal until his death. Prior was a world-famous figure, and every part of the world was familiar to him. Worked almost entirely in black and white, usually with a pencil. Sketches frequently redrawn and signed by other artists. Represented *ILN* on more than two dozen campaigns and revolutions, but also depicted more peaceful expeditions, including numerous tours of British royal family and wedding ceremonies of foreign notables. Also found time to see a great deal of the western United States and Canada, mainly along the lines of the transcontinental railways of the 1870's and 1880's. Made first visit to U.S. in 1876 on occasion of Centennial Festival and International Exhibition, Philadelphia. Joined party of foreign and American journalists traveling on Jarrett and Palmer "Lightning Express," first transcontinental express on the Union and Central Pacific to San Francisco. (For series illustrating episodes, especially in California, see "Across America—Express Railway Trip," *ILN,* 69, 1876, 56–7, 59.) Was sent to Canada in 1878 to cover the arrival and reception of Marquis of Lorne and Princess Louise, crossing later into the United States to collect material for large series devoted to scenes along line of Northern and Central Pacific, and also made excursion to mining towns of Colorado. (See "Sketches in the American Far West," *ILN,* 76, 1880:371–2, and "Sketches in Colorado," *ILN,* 77, 1880:579, 584; 78, 1881:

519–20. See also "Sketches in the Dakotah Territory," *ILN,* 78, 1881:412, which depicts beginnings of Bismarck.) Made a third visit to North America in 1888 on way to draw Melbourne Exhibition. Arrived in New York in early summer, then went on to Toronto, crossing western Canada to Vancouver by the newly completed C.P.R. (See "The Canadian Pacific Railway," *ILN,* 93, 1888:560–2, 614, 657–8, 687–8; 94, 1889:212–14. An interesting series, more notable for the historical importance of the artist's written impressions than for his crudely reproduced drawings. An original pencil drawing of Calgary from this series is in collection of Glenbow Foundation, Calgary.) Was again in western Canada in 1901 when he covered the tour of the Duke and Duchess of Cornwall and York. (See "The Royal Tour," *ILN,* 119, 1901:566, 600, 605, 607, 609. Original pencil drawing from this series, entitled *Indian Chiefs Welcoming Duke and Duchess of Cornwall at Pow-wow, Shaganappie, Calgary,* is in Samuel Canadiana Collection, Royal Ontario Museum, Toronto.) D. London, England.

Felix Elie Regamey (1844–1907)

B. Paris, France. Painter, engraver, and illustrator. Father, L. P. G. Regamey. Pupil of the celebrated Leococq de Boisbaudran at Ecole des Beaux-Arts, Paris. Prolific illustrator, contributing to *Journal Amusemant; La Vie Parisienne; L'Illustration; Monde Illustré; Illustrated London News; Graphic; Harper's Weekly.* Member of *ILN* team reporting the Siege of Paris and Commune. Left France after fall of Commune and spent 1871–76 traveling about world as roving Special Artist for *ILN, Harper's Weekly,* and *Monde Illustré.* Drawings of West African native life, South African diamond fields, marriage of Emperor of China, and opening of first railway in Japan were among fruits of these travels. Lived and worked in U.S., 1874–76, contributing various scenes of American life in the eastern and southern states to *ILN* and *Harper's Weekly.* Made drawings of Shoshone Indians at Elko, Nevada; also of Gros-Ventre and Sioux, probably on his way from San Francisco to New York via the Central and Union Pacific. During spring, 1876, was in Philadelphia; worked with Melton Prior to report the Centennial Exhibition for *ILN.* (See interesting cover illustration, *ILN,* 68, 1876:457, which depicts street scene with Indians.) Returned to France in 1877; was again in U.S. in 1880 as Special Artist for *ILN* and *Monde Illustré.* Visited eastern cities, went on to St. Louis and Chicago, then returned to New York via Toronto. More Western studies made as a result of this trip, but these largely remained unpublished until 1891 when final defeat of the Sioux at Pine Ridge revived editorial interest. Sketchbook studies from this trip and earlier one of 1874 appeared as illustrations to an article, "Les Derniers Peaux Rouge" (The Last Redskins), *Monde Illustré,* 68, 1891:15–18. These comprise pen sketches of Indians seen in Northwest and Southwest (Kiowa and Apache). One excellent drawing shows Shoshone squaws hitching a free ride on a train, and there are also scenes of Indian life in the Iroquois village of La Chine, Ontario. Regamey was back in America again in 1884 to cover the commemoration of Yorktown for *Monde Illustré,* but there is little evidence that he ever made a further trip to the West. His enthusiastic recording of the life and customs of people throughout the world made him a valued collaborator of the well-known orientalist, Emil Guimet. D. Juan-les-Pins, France.

Albert B. Richter (1845–98)

B. Dresden, Germany. Illustrator and celebrated painter of hunting scenes in his day. Bryan (*Dictionary of Painters and Engravers*) describes him as a great traveler and sportsman whose pictures of stags and other animals of the forests became popular by means of elaborately produced reproductions. Richter was a highly trained painter

who studied at the academies of Dresden, Munich, and Vienna. Lived in Austria for fourteen years, where he acquired a taste for big-game hunting on the estates of wealthy noblemen in Bavaria, Hungary, and Russia. Also traveled and hunted in Corsica, Sardinia, Algeria, Tunis, and Morocco. On his return to Vienna in 1877, became illustrator and Special Artist for *Illustrirte Zeitung,* contributing illustrations and drawings of country life, festivals, and hunting subjects. Moved to Dresden in 1878, where he married the daughter of General Otto. In this year, according to Thieme-Becker in his obituary (*Illustrirte Zeitung,* 111, 1898:24), made a trip to U.S. to execute commission to paint the horses for two battle friezes, or panoramas, in St. Paul and Chicago. Both paintings and illustrations resulted from the visit, although latter were not published until 1890's. They include well-drawn and elaborate full-page scenes of Indian and pioneer life in Northwest and appeared both in Germany and England. (See *Illustrirte Zeitung,* 94, 1890:191, 585, 733–6, and 108, 1897:121–2; *Black and White,* 8, 1894:459; *Illustrated Sporting and Dramatic News,* 6, 1894:157.) His best Western picture is entitled *Winter in the Far West* (*Illustrated Sporting and Dramatic News,* 36, 1892:777), and depicts a German settler bringing home a buck he has shot and a Christmas tree to his cabin in the wilderness, where his wife and child await him. See also, Frank Knight, "Everyday Life in the West," *Boy's Own Paper,* 17, 1894–95:829–33, for illustration of the Sioux; Major Gorgos, "The Red Man's Last Battle," *BOP,* 18, 1895–96: 380–2, for illustration of account of Battle of Little Big Horn. Richter also contributed short but knowledgeable articles as texts for his Western illustrations. D. Langebrück, near Dresden, Germany.

Inglis Sheldon-Williams (1870–1940)

B. Elvetham, Surrey, England. Painter, illustrator, and Special Artist. Father, Alfred Sheldon-Williams, painter of animals and sporting scenes. Educated Merchant Taylor's School. Studied at Slade School, London, and Ecole des Beaux-Arts, Paris. Emigrated as youth to Manitoba, later moving to Saskatchewan where he established family farm at Cannington Manor (1887–96). Worked summer of 1887 in Alberta as ranch hand. Contributed illustrated impressions of prairie life to *Daily Graphic.* For details of these, see checklist (p. 277). A further series of illustrations, devoted to scenes of prairie farming, appeared in *Sphere,* 14, 1904:164–5. Was also illustrator of Jack London. (See *Today,* 1902, for illustrations of collection, "Tales of the Far North.") After completing formal art training, lived in Europe, mainly England. Was Special Artist for *Sphere* (1899–1904), covering South African War; the Coronation Durbar of Edward VII at Delhi, India; and Russo-Japanese War. In 1916, was back in Canada. Established Department of Fine Art, Regina College. In 1917, was war artist for the Canadian War Records. Became landscape and portrait painter after World War I and frequently revisited Canada to solicit patronage. During these extended visits, painted scenes on farms, ranches, and Indian reservations (mainly in Saskatchewan). Much of this work—paintings, studies and drawings—is in the Norman MacKenzie Art Gallery, Regina, Saskatchewan, and the Regina Public Library Art Gallery. The Art Department of the Glenbow Foundation, Calgary, Alberta, also possesses sketchbooks, memorabilia, and mss. relating to early life in Canada and later career as painter, Special Artist, and illustrator. D. Tunbridge Wells, England.

William Simpson (1823–99)

B. Glasgow, Scotland. Topographical painter and Special Artist. Son of marine engineer. Acquired taste for drawing as office boy in Glasgow architect's studio. Completed apprenticeship as lithographic artist with Allan & Ferguson of Glasgow

before moving to London where he was engaged by Day & Son to illustrate topographical books and albums. Sent by them to depict Crimean War (1855–56). His scenes, reproduced as plates for album *The Seat of War in the East* (London, 1856), are classics of documentary art. Began lifelong connection with *ILN* (1866–85) as Special Artist, and was regarded as doyen. Reported every major campaign in Europe, notably the Franco-German War and Paris Commune (1870–71). Impressive personal appearance and ability as linguist also made him ideal choice as artist-correspondent covering various royal occasions. It was on way home from depicting marriage of Emperor of China in Peking that he made his first and only visit to U.S. From Yokohama he crossed Pacific to San Francisco, arriving shortly after murder of General Canby and Dr. Thomas by Captain Jack and his rebel Modoc Indians. En route, reported Chinese immigration to West. (See *ILN*, 68, 1876:411, 428–9, supplement.) For Simpson's illustrations with eyewitness dispatches of Modoc War, see "The Modoc Indian War," *ILN*, 62, 1873:495, 496, 508–9, 512, 522, 531, 532–3, 537. The American painter Albert Bierstadt made arrangements for a trip to the Yosemite Valley. Simpson depicted big trees of California. (See *ILN*, 69, 1876:587, 588; 79, 1881:454, 460.) Also visited Salt Lake City and interviewed Brigham Young and other Mormon leaders, but neither illustrations nor text appeared in *ILN*. Continued eastward to Omaha, St. Louis, Indianapolis, and Louisville. From Louisville made an excursion to the Mammoth Caves before visiting General Sherman in Washington. After a trip to Niagara, concluded three-month stay and sailed for Liverpool from New York in June, 1873. For Kentucky series on Mammoth Caves of Kentucky, see *ILN*, 69, 1876: 337, 345, 346, 356–7, 404–8. See autobiographical *Meeting the Sun* (London, 1874) for detailed account of American travels. Originals of Simpson's Western watercolor drawings are rare. To date, only four have been located: *Captain Jack's Cave in the Lava Beds, Lake Tule, California,* Honeyman Collection, Bancroft Library, University of California, Berkeley; *Modoc Indians in the Lava Beds,* Peabody Museum, Cambridge, Massachusetts; *Fallen Tree at Mariposa* and *The Fallen Monarch,* The Holden Arboretum, Mentor, Ohio. Pencil sketches and studies are more numerous. Three of the artist's American sketchbooks are in the Bushnell Collection, Peabody Museum, Cambridge. The first contains studies of the Modoc Campaign and landscape sketches of the Butte and Sacramento valleys; the second, landscape studies of San Francisco, the Yosemite Valley, the big trees, Salt Lake, and the railway viaduct over the Missouri at Omaha. The third is devoted to his visit to the Mammoth Caves and Niagara Falls. D. London, England.

N. Tindall (active 1870's)

Little is known about this artist other than that he visited western U.S. in 1874 as Special Artist of *Graphic*. Visit took him along Union Pacific to Ogden and Salt Lake City, with stagecoach trip to mining town of Ophir. Also went to Dodge City, Kansas, and hunted with Colonel R. L. Dodge ("good sportsman and entertaining host") out of Fort Dodge. For interesting scenes of Western life, including Mormons, buffalo-hunting, U. S. Cavalry, Indians, mining, gun-fighting, and stagecoach travel, see "An Artist in the Far West," *Graphic*, 9, February 21–March 28, 1874, published in five installments, each with a short text.

Frederick Villiers (1852–1922)

B. London, England. Special Artist and artist-correspondent. Father, Henry Villiers. Educated Guines, Pas-de-Calais, France. Studied British Museum and South Kensington Schools (Royal College of Art) 1869–70; Royal Academy schools, 1871. While still a student at R. A., accepted invitation from William Luson Thomas of *Graphic* to cover Serbian Campaign of 1876. Thus began long, adventurous career in which he covered over twenty campaigns, ending with World War I. Best work done for *Graphic*, but also worked for *Black and White* and *ILN*. A frequent visitor to America both as artist and lecturer. First visit to U.S. in 1880, when he returned from Sydney International Exhibition via San Francisco on Central and Union Pacific. No illustrations known to have resulted from this trip. He visited U. S. again in 1891, when he depicted Sherman's funeral, before returning to England after two-month assignment for *Graphic*, covering viceregal tour of Canadian West by Governor General of Canada, Lord Stanley, 16th Earl of Derby. (See checklist, p. 278.) In U. S. again in 1893 to cover Chicago World's Fair for *Black and White*. (See *Black and White*, 5, 1893:605, 607, 663; 6, 1893:134, 225, for illustrations which include frontiersman in buckskins gazing open-eyed at Egyptian exhibit.) Made second trip to Canada during winter of 1894. (See *Daily Graphic*, 18, April 17–18, 1894 for illustrated articles, "Across Canada by Rail," describing changing Canadian West.) A further series of Western scenes along the C.P.R. was made while on his way to Korea later in same year. (See *Black and White*, 8, 1894: 356–7.) Final visit to North America took place after World War I, when artist made coast-to-coast lecture tour, visiting Southern California and staying with Andrew Storrows of Pasadena. Visited Hollywood and was introduced to Charles Chaplin. Continued travels northward to Riverside, Mt. Wilson, Columbia River, and Vancouver. Breakdown occurred in Indian Head, Saskatchewan, where he was to have delivered lecture; ended up in Montreal General Hospital before returning to England. *Times* obituary describes him as one of the most prolific of old school war correspondents; also as man with air of swashbuckler. He used a Kodak No. 3 in his later years instead of a pencil and was said to have been first to use movie camera (1897) in history of war-reporting. Original drawings or illustrations by Villiers are difficult to locate. None exist in major public collections of Western documentary art. See later autobiography, *Five Decades of Adventure* (New York, 1920; London, 1921). D. Bedhampton, Hampshire, England.

Stanley L. Wood (active 1880's–1930's)

Animal painter and Western illustrator. This once well-known English magazine illustrator made trip to America in 1888. Visited Rosebud Cheyenne reservation in South Dakota. (For interesting feature entitled "Sketches from an Indian Reservation," see *ILN*, 94, 1889:74–5.) Shortly afterward, illustrated Bret Harte's *A Waif of the Plains* (London, 1890) with sixty spirited drawings. Covered Buffalo Bill's Wild West Show at Earl's Court, London, in 1892. (See *Black and White*, 3, 1892:660, 777, for vigorously executed wash illustrations of Indian horse race and broncho rider.) Also contributed illustrations of Western adventure stories and paintings reproduced as color plates to *Boy's Own Paper*, which regarded him as one of their greatest artist-contributors. For typical example, see *BOP*, 26, 1903:37, *A Critical Moment*, depicting bear-hunt in forest. See also *Graphic*, 72, 1905:773, *Exciting Sport in the Far West: The End of a Coyote Hunt*, a full-blooded scene on the Canadian prairies which reveals Wood as a leading exponent of the English school of Western illustrators working in the manner of Richard Caton Woodville and Frederic Remington. D. England in early 1940's.

Richard Caton Woodville, Jr. (1856–1927)

B. London, England. Painter, illustrator, and Special Artist. Son of American genre painter, Richard Caton Woodville. Studied at Royal Academy, Düsseldorf, under von Gebhardt (*ca.* 1872–75); Royal Academy, London (1876). Thieme-Becker states that he also worked in Paris studio of J. L. Gérôme. Established lifelong connection with *ILN* in 1876 and was prolific contributor. During 1870's and 1880's covered numerous campaigns in Europe and Africa as war artist and accompanied diplomatic and royal missions. Considered himself primarily a military painter. His huge battle pictures exhibited regularly at Royal Academy brought him fame and fortune as well as patronage of Queen Victoria and the military establishment. Between 1884 and 1890, prior to visit to America, contributed many dramatic Western illustrations of Canada and the U. S. to *ILN*. These include Indian raids, Christmas in the wilderness, and hunting scenes in British Columbia, Wyoming, and upper California. He was also illustrator of Bret Harte ("A Phyllis of the Sierras," *ILN*, 91, 1887:1). See also, *ILN* 107, 1895:297–9, 329–31, 361–3, 393–5, for illustrations for Morley Roberts story, "The Courage of Pauline Camacho." In 1890, *ILN* sent him to Canada and United States to depict outdoor life in the West. This took him to British Columbia, where he made studies of lumberjacks and gold-seekers before crossing into Montana and Wyoming to depict hunting scenes. Also painted a forest fire, cattle-drive in the Big Horn Mountains, and English dudes on holiday in Yellowstone Park. (See *ILN*, 99, 1891:385, 444–5; 105, 1894:315, 412; 107, 1895:400–1; 110, 1897:85, 298.) On hearing news of Sioux Ghost Dancers, Woodville traveled east to Pine Ridge to portray aspects of Sioux Outbreak of 1890–91. (See *ILN*, 98, 1891: 35, 67, 81.) Further Western scenes, largely reconstructions to illustrate tales of adventure in Alberta, Saskatchewan, Manitoba, and British Columbia appeared between 1904 and 1907 in *Illustrated Sporting and Dramatic News*. (See checklist, p. 278.) Originals of the artist's Western pictures rare. The Trigg–C.M. Russell Foundation, Inc., Great Falls, Montana, has large oil, *Western Cavalry Troop*; the artist's grandson, Humphrey C. Woodville of Cambridge, England, has a miscellaneous collection of sketches and studies, several of which date from his visit to America. In spite of his fame, property, and honors, Woodville died almost penniless by his own hand in St. John's Wood, London, England.

Henry Charles Seppings Wright (1849–1937)

Marine painter, Special Artist, and war correspondent. Son of Reverend E. H. A. Wright. Represented *ILN* in many campaigns throughout the world. Began work as Special Artist in 1870's: depicted discovery of Kimberley Diamond Fields; covered Spanish-American War (Cuba), South African War, Russo-Japanese War, and World War I. Date of first visit to America not known. See *ILN*, 96, 1890:118, for note introducing series of sketches of social life in U.S. entitled "America Revisited." This may have been the occasion of visit to western Canada. See *ILN*, 111, 1897:290, for excellent full-page illustration *Winter on the Plains of Manitoba* in the manner of Remington. Scene depicts cowboys rounding up stray cattle. See "A Chat with Seppings Wright," *Idler*, 11, 1897:89–101, for further information and for portrait. D. Bosham, Sussex, England.

Index

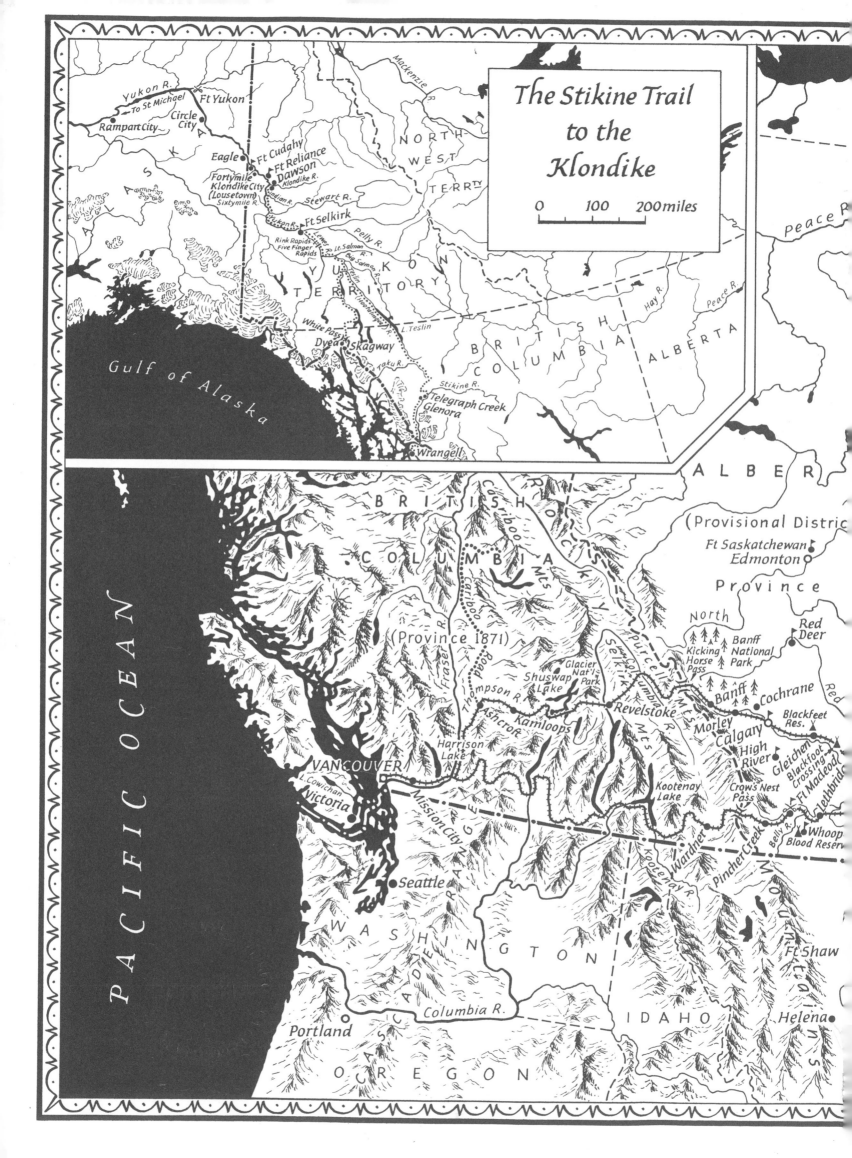

The Stikine Trail to the Klondike

0 100 200 miles